D1365961

WITHDRAWN

The Figure in American Sculpture

The Figure

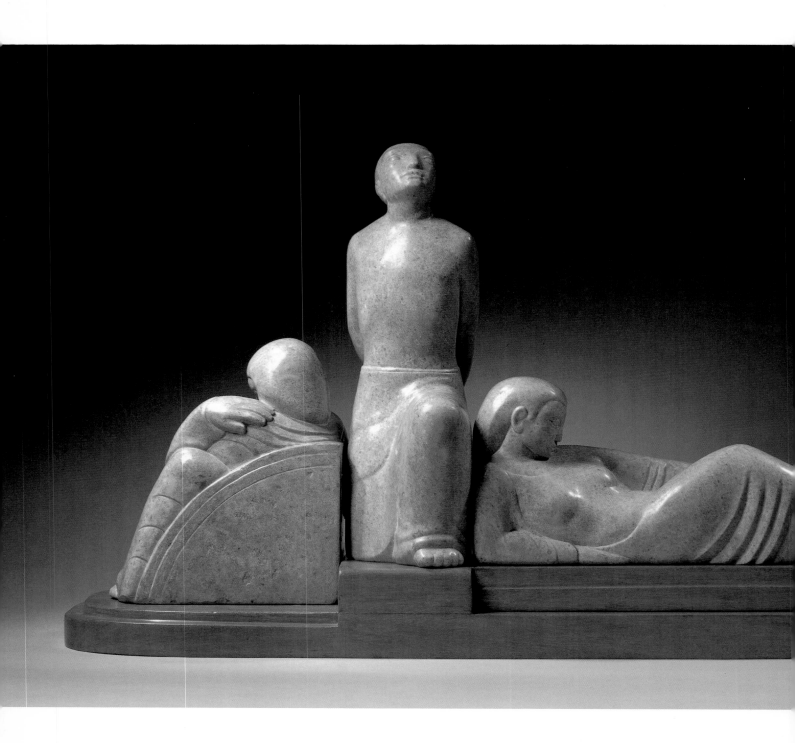

VILLA JULIE COLLEGE LIBRARY
STEVENSON, MD 21153

in American Sculpture

A QUESTION OF MODERNITY

Ilene Susan Fort

with contributions by Mary L. Lenihan

Marlene Park

Susan Rather

Roberta K. Tarbell

LOS ANGELES COUNTY MUSEUM OF ART

in association with UNIVERSITY OF WASHINGTON PRESS

NB
1930
.F67
1995

*The Figure in American Sculpture:
A Question of Modernity*

Exhibition itinerary

Los Angeles County Museum of Art
February 26–April 30, 1995

Montgomery Museum of Fine Arts
June 22–September 10, 1995

Wichita Art Museum
October 22, 1995–January 7, 1996

National Academy of Design,
New York City
February 15–May 5, 1996

*The Figure in American Sculpture:
A Question of Modernity* was made
possible by a generous grant from
the Lila Wallace-Reader's Digest
Fund. Additional support was pro-
vided by the National Endowment
for the Arts and the Los Angeles
Cultural Affairs Department.
Transportation was provided by
United Airlines.

Published by
Los Angeles County Museum of Art
5905 Wilshire Boulevard
Los Angeles, California 90036

Distributed by
University of Washington Press
P.O. Box 50096
Seattle, Washington 98145-5096

ISBN 0-295-97437-0

Copyright © 1995 by Museum
Associates, Los Angeles County
Museum of Art. All rights reserved
under international copyright con-
ventions. No part of this book may
be reproduced or utilized in any
form or by any means, electronic or
mechanical, including photocopying
and recording, or by any informa-
tion-storage and -retrieval system
without permission in writing from
the publishers.

99 98 97 96 95 5 4 3 2 1

Library of Congress number:
LC 94-072856

Editor: Mitch Tuchman

Designer: Scott Taylor

Photographer: Peter Brenner

Printed and bound by
Toppan Printing Co., Ltd.,
Tokyo, Japan

Note to reader
Wherever available three dimen-
sions are given for sculpture, they
are height x width x depth. Where
only two dimensions are given,
they are height x width.

Front cover
José de Creeft (Spain, 1884–1982),
The Cloud, 1939, greenstone,
16³⁄₄ x 12³⁄₈ x 10 in. (42.6 x 31.4 x
25.4 cm), Whitney Museum of
American Art, purchase

Frontispiece
Eugenia Everett (United States,
b. 1908), *Cooperation,* c. 1933–34,
marble on mahogany base,
19 x 33³⁄₄ x 10⁷⁄₈ (48.3 x 85.7 x
27.6 cm), Los Angeles Unified
School District

Right
Turku Trajan (Austria-Hungary,
1887–1959), *Eaglet,* c. 1930s–40s,
polychromed Keen's cement, 64 x
20 x 13 in. (162.6 x 50.8 x 33 cm),
collection of Daniel J. Hirsch

Back cover
Marion Walton (United States,
b. 1899), *Alone,* 1932, stained
mahogany, 32⁷⁄₈ x 9 x 8 in. (83.5 x
22.9 x 20.3 cm), the Mitchell
Wolfson, Jr., collection, courtesy,
the Wolfsonian Foundation, Miami
Beach, Florida, and Genoa, Italy

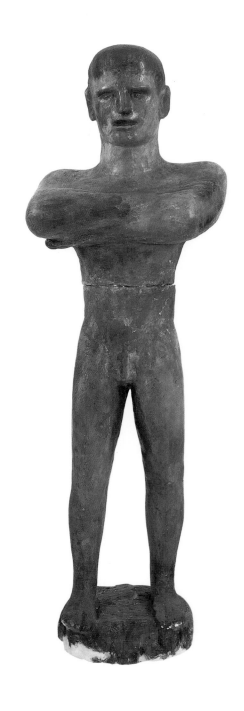

Contents

6 Foreword STEPHANIE BARRON

8 *Introduction* ILENE SUSAN FORT

22 *The Cult of Rodin and the Birth of Modernism in America*
ILENE SUSAN FORT

54 *"Sculpture Has Never Been Thought a Medium
Particularly Feminine"* MARLENE PARK

74 *"Mere Beauty No Longer Suffices": The Response of
Genre Sculpture* ILENE SUSAN FORT

108 *Primitivism, Folk Art, and the Exotic* ROBERTA K. TARBELL

140 *Creating the New Black Image* MARY L. LENIHAN

158 *Avant-Garde or Kitsch?* Modern *and* Modernistic
in American Sculpture between the Wars SUSAN RATHER

171 Artist Biographies and Exhibition Checklist

237 Suggested Readings

240 Acknowledgments

243 Lenders to the Exhibition

244 Photo Sources and Credits

245 Index

Foreword

ALTHOUGH THE HUMAN figure was the primary leitmotif of American sculpture before World War II, many questions about its role in modern sculpture remain unanswered. By focusing on the work of a few major masters, published accounts and exhibitions have traditionally presented twentieth-century American sculpture in terms of a development from representational art to abstraction and the nonobjective. Such an evolutionary interpretation based on formalist analysis is much too simplistic and narrow. The need for a study that would revise previous histories by presenting American modernist sculpture in a larger cultural and social context was the impetus for this exhibition and accompanying catalogue.

With the example of Auguste Rodin for inspiration, Americans at the turn of the century began to perceive sculpture differently, abandoning the commemorative function of late nineteenth-century art. The rethinking of sculpture as a more personal mode of expression enabled artists to explore numerous new issues relevant to themselves and their times. During the first four decades of this century sculptors documented everyday activities around them, often critically attacking the social ills of the day, and found escape from the growing technological advancements and materialism of American society by turning to cultures historically or geographically distant which they deemed primitive and therefore superior. As the works in this exhibition demonstrate, the result was that genre, classicism, archaism, and the search for the exotic became popular themes, enticing a greater number of progressive artists than did pure abstraction. Sculpture in general became less elitist. Many more women, African Americans, and other previously marginalized groups became active members of the sculpture community. While past studies have isolated artists according to race, ethnic group, and gender, this exhibition is the first to place minorities in the mainstream. Consequently, the names of many of the sculptors represented here will be unfamiliar, but in their own day they all received critical attention for their willingness to experiment with new concepts, styles, techniques, materials, and themes.

The Los Angeles County Museum of Art is proud to present this exhibition on the provocative theme of what constitutes a modern work of art in American sculpture, which has been organized by Ilene Susan Fort, curator of American art. It follows in the tradition of the museum's other landmark sculpture exhibitions and publications: *The Romantics to Rodin: French Nineteenth-Century Sculpture from North American Collections* (1980), *German Expressionist Sculpture* (1983), and *Rodin in His Time: The Cantor Gifts to the Los Angeles County Museum of Art* (1994). Due to the generosity of Iris and B. Gerald Cantor the museum has an impressive collection of work by Auguste Rodin, and it is all the more fitting that this documentation of modern sculpture dates the beginning of modernism in America to the influence of Rodin. *The Figure in American Sculpture: A Question of Modernity* is the result of five years' effort by Dr. Fort, who has assembled a remarkable group of works for the exhibition and written three provocative essays for this volume.

Our sincere thanks go to the numerous lenders to the exhibition, who have kindly agreed to part with their works for an extended time. Without them this exhibition would not have been possible. We especially appreciate the generosity of those institutions that willingly lent a significant number of works from their important permanent collections and wish to thank in Washington, D.C.,

6

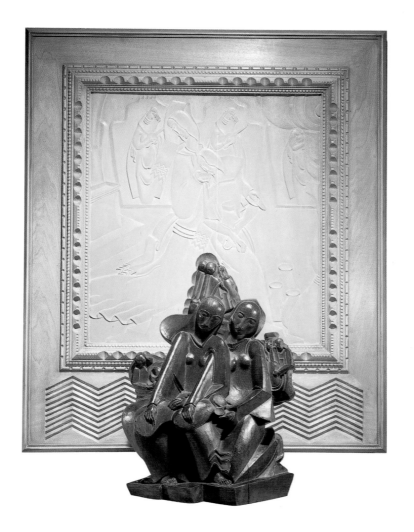

Karoly Fulop
(Austria-Hungary, 1893–1963)
THIRST
c. 1936; walnut and poplar;
statue: 21½ x 14½ x 13 in.
(54.6 x 36.8 x 33 cm); relief:
39½ x 32¾ in. (100.3 x 83.2 cm);
Berman-Daferner Gallery
and Conner-Rosenkranz,
New York City

James T. Demetrion, director of the Hirshhorn Museum and Sculpture Garden, and Elizabeth Broun, director of the National Museum of American Art, and in New York City Philippe de Montebello, director of the Metropolitan Museum of Art, and David Ross, director of the Whitney Museum of American Art.

The exhibition will be seen in four regions of the country. Realizing the importance of the exhibition, the Montgomery Museum of Fine Arts, Wichita Art Museum, and National Academy of Design, New York, joined the national tour. We are delighted by their participation.

The Figure in American Sculpture was supported in part by a grant from the National Endowment for the Arts; the funds assisted with the extensive research that an exhibition of this magnitude requires. The museum is particularly grateful for the generosity of the Lila Wallace-Reader's Digest Fund for underwriting the national tour and a variety of related educational and outreach components. The Lila Wallace-Reader's Digest Fund invests in programs that enhance the cultural life of communities and encourage people to make the arts part of their everyday lives. The fund's enlightened attitude is to be saluted.

STEPHANIE BARRON
Coordinator of Curatorial Affairs

Introduction

THE ADVENT OF MODERNISM *in American art has been dated traditionally to 1913,*

the year avant-garde European painting and sculpture were presented to the American public

on a massive scale at the Armory Show in New York City. Despite this introduction of

vanguard ideas, abstraction was a negligible factor among American sculptors until the 1930s,

and not until World War II did nonobjective sculpture reign supreme. Modern sculpture

nevertheless blossomed as Americans enthusiastically adopted the human figure as the primary

vehicle of exploration and experimentation.

The late flowering of abstraction has been rightly attributed to the potency of figuration. During the early twentieth century an artist could demonstrate progressive ideas in a variety of ways — through theme, style, and conception — while retaining some reference to the figure. Historians writing after World War II have been apologetic concerning this allegiance to the figure.[1] Viewing abstraction and the figure as mutually exclusive, they have minimized the contributions of American sculptors working in the figurative vein and have consequently failed to deal with the nature of their art. By doing so, they denied that a depiction of the figure could be equated with anything progressive, an idea totally formalist in orientation.

Formalism as a theoretical approach to art began with Roger Fry in the early twentieth century, but its hegemony after World War II was due to the critic Clement Greenberg. From 1939 through the 1950s he promoted the idea that a work of art must avoid dependence upon any order of experience not present in the medium per se. Insisting that modern art should strive for such purity, formalists promoted

1

José de Creeft
(Spain, 1884–1982)
HEAD OF GERTRUDE
LAWRENCE
1931, ceramic and shell, 5½ x
3½ x 2⅝ in. (14.0 x 8.9 x
6.7 cm), National Museum of
American Art, Smithsonian
Institution, museum purchase

8

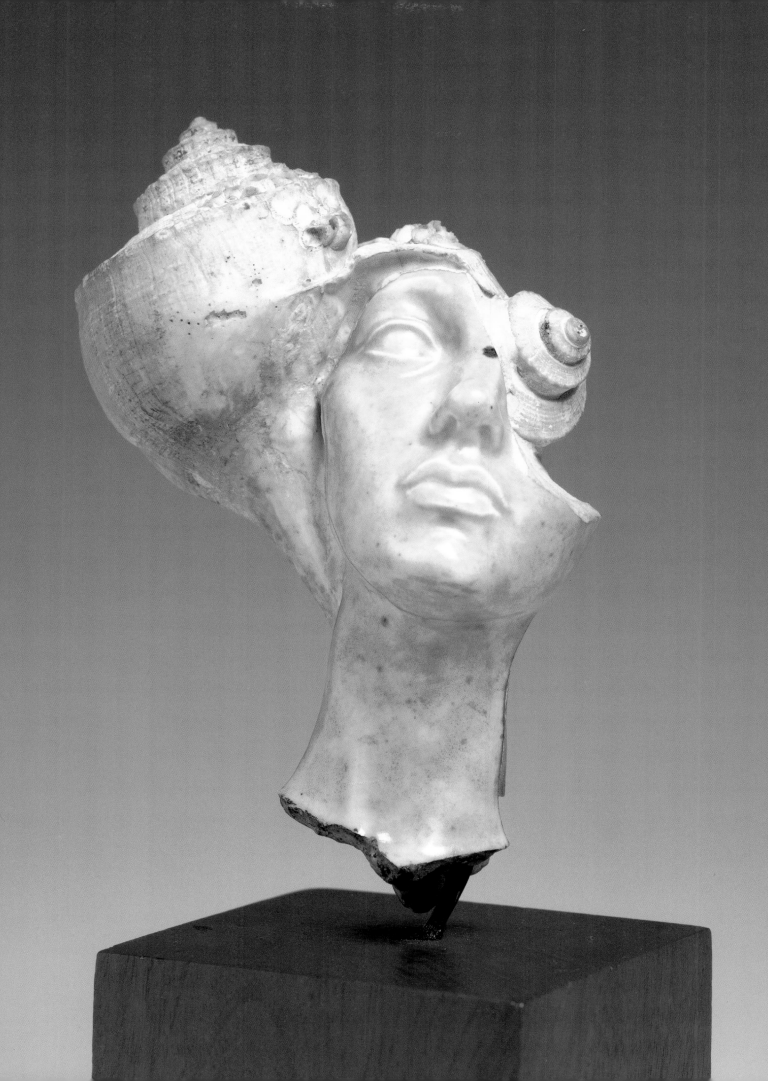

the supremacy of line, shape, composition, and color; any elements that referred to an outside world, such as illusion and representation, became irrelevant. Greenberg believed that modernist aesthetics were most fully realized in the constructions and welded sculptures artists began creating in the late 1930s.[2] His teleological premise assumed that artistic advancement must always be a process from representation to abstraction with the nonobjective constituting the ultimate goal. The concept of modernity, however, did not originally mean this.

The term *modern* was first used in the late sixteenth century to distinguish the present from ancient and medieval times. At the dawning of the era of Darwinian thought in the late nineteenth century it had also come to connote improvement and, consequently, conveyed a favorable, progressive connotation. In popular dictionaries and encyclopedias modern art is commonly defined as a nineteenth-century movement that veered away from the past in an effort to reform contemporary art. Nowhere is the rejection of the figure mentioned.

Even during the early decades of the twentieth century figuration was not the determining factor distinguishing conservative, traditional art from more progressive trends. As A. M. Hammacher stated in *The Evolution of Modern Sculpture*, modern sculpture in the twentieth century "began slowly and gradually, so gradually in fact that a survey of the first two decades of the century leaves us with the impression…that sculpture was still dominated by the pictorial qualities that had characterized the nineteenth century."[3] The abandonment of the figure as a required stage of reformation did not occur until decades later, after World War II in the art of the abstract expressionists.

SCULPTURE IN THE nineteenth century was figurative and followed three courses: the idealization of nude and partially clothed figures as allegories of culturally accepted constructs such as patriotism and justice; the realistic depiction of actual personages for public or private commemoration; and the representational depiction of certain archetypes, for example, ministers and doctors, as a means of instruction or entertainment. That sculpture had to serve a specific function, preferably one of an elevated character, was the rationale for its existence throughout most of the nineteenth century, and the rejection of this theoretical basis was essential for the birth of modern sculpture in the following century.

Symbolism at the turn of the century caused artists to look inward, investigating their own emotions rather than extolling contemporary ideology. Sculpture, no longer a public document primarily, could be reconceptualized as a more personal expression. The roots of modernism lay in the art of Auguste Rodin (1840–1917). From his first Salon contributions of the late 1870s until his death, Rodin presented the public with sculpture that was startlingly original. In response to the female nude, for example, he conveyed sensuality and eroticism to a degree never before approached. While most art historians agree that the great French master initiated modern European sculpture, none has associated the introduction of modernism to America with Rodin.

Roberta K. Tarbell, the historian who has worked most extensively on early twentieth-century American modern sculpture, dates the appearance of vanguard trends in the United States to the period around 1910.[4] She, along with Daniel Robbins, claims that the revolutionary Armory Show caused little change in American sculpture.[5]

What both scholars failed to realize was that the transformation of American sculpture had already begun two decades earlier, initiated by the enthusiasm and controversy Rodin's art caused in Europe and America. While publications on Rodin have discussed his American patrons, no historian has extensively explored the connection between Rodin and American sculptors.[6] Exhibitions have been similarly limited, organizers preferring to see the Rodin phenomenon as uniquely French.[7] Yet Rodin was a popular subject in turn-of-the-century English-language periodicals, and contemporary critics frequently mentioned his influence on American artists. This volume revises traditional histories of American sculpture by locating the source of American modernism in the art of Rodin, making it apparent that modern American sculpture was not born in the mid-1910s, but much earlier, in the 1890s.

By the 1920s Rodin's influence had almost run its course. Few sculptors still found introspection and romanticism satisfying. Instead sculptors began to look at the changing world around them for inspiration. As the late nineteenth-century French theorist Hippolyte A. Taine asserted, to understand the choices artists make one must look to the "social and intellectual condition of the times to which they belong."[8]

During the early modernist period the United States underwent significant changes as the nation became an imperialist power and a leader in technology. Its population was transformed by a massive influx of immigrants, most of whom settled in the cities. These new Americans were often from ethnic, religious, and racial groups not previously present to any great extent. In addition, minorities, such as African Americans, continued to struggle for their rightful place in society. The public image of America was further altered as women in significant numbers were liberated from their domestic duties and entered the work force.

As the face of America changed, so did its art. The human form, although it appeared in new guises, remained the major leitmotif, easily identified by all people no matter what their education. The sculpted figure became a paradigm for America's new industrial, urban, and multicultural society. Some sculptors chose to depict what they knew best: people at work, at play, on the streets, at home. Genre, the depiction of everyday activities, particularly appealed to many sculptors, a large number of whom were new citizens, and enjoyed a long life, flourishing until World War II. Historians nevertheless have accorded it minimal attention.[9]

Robbins, writing in the bicentennial exhibition catalogue *Two Hundred Years of American Sculpture*, was the first to identify the genre movement and to note, astutely, the importance of this type of art in the development of a modern twentieth-century American sculpture: "This shift to genre realism was actually the first challenge to the hegemony of Beaux-Arts sculpture in the early twentieth century."[10] Robbins failed to acknowledge (perhaps he did not realize) that genre remained a vital and substantial movement for more than four decades. It also spawned an offshoot: sculpture with a critical message. Although most genre works are positive and uplifting in spirit, artists also used the medium to express their discontent with social conditions, yet this sculptural equivalent of American social realism has never been acknowledged by historians.

Artists wanting to invigorate their works with fresh ideas also looked farther afield, beyond the country's borders and even beyond the sphere of

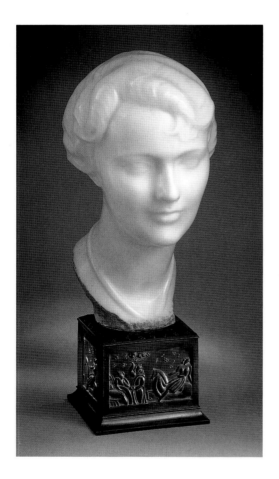

2

Elie Nadelman
(Russia, 1882–1946)
MARIE SCOTT
1919, marble on bronze base,
26½ x 8½ x 10 in. (67.3 x 21.6 x
25.4 cm), Los Angeles County
Museum of Art, gift of Mrs.
Stevenson Scott

contemporary Europe, finding new sources of inspiration in archaic, folk, and primitive cultures. Archaism and primitivism were related turn-of-the-century phenomena of international scope. Both were based on the romantic premise that cultures that were earlier than or geographically or culturally distant from twentieth-century Western society produced art purer in form and expressive content than that of the West because their "simple" societies were not hampered by centuries of tradition. Artists at first turned to Egypt, the Cyclades, and preclassical Greece but eventually also recognized the significance of African, Mesoamerican, Indian, and Asian as well as folk art from an even wider

array of cultures, including that of the United States. These new tastes found receptive audiences by the second decade of the century and remained strong throughout the 1930s.[11]

Even though the definition of modern seems to preclude a reliance on the past, progressive twentieth-century artists did reexamine older traditions. Ancient Greek and Roman art and culture had impelled several revival movements throughout the centuries. In fact, the birth of modern painting and sculpture is usually located within eighteenth-century neoclassicism. The twentieth-century revival emerged about a decade after the appearance of genre sculpture. Simultaneously with his experimentation with cubism, Elie Nadelman explored classicism in a series of marble heads. He even combined the two aesthetics as in the portrait head of Marie Scott (plate 2) poised on a base decorated with bas-reliefs of abstract, crescent-shaped figures. Although the primacy of the idealized nude remained, modern classical art in no way could be mistaken for earlier neoclassical statuary, because the other revival movements had found their source of inspiration in the golden age of classical Greece, while modern neoclassicists responded more to the archaic, naive renderings of the figure from even earlier periods.

Greek and Roman mythology continued to provide subject matter for most of the modern classical sculptors, yet a viewer need not have been familiar with the complex legends of the gods and goddesses, for twentieth-century sculptors were not interested in delineating these tales. The myths were merely pretexts for depicting the idealized nude. American sculptors sometimes used notorious femmes fatales, such as Salome, who had been so popular in the nineteenth century, but just as often they preferred

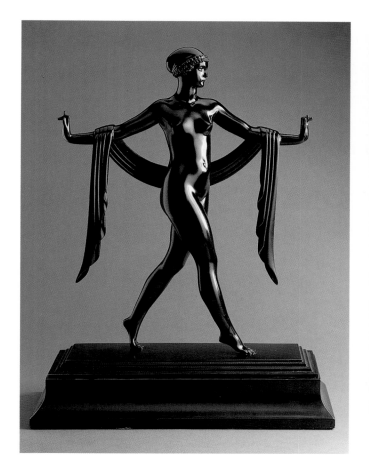

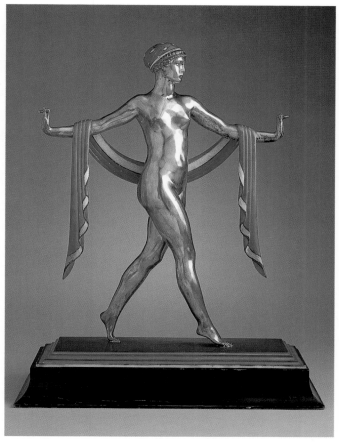

the generic "Greek" (plates 3–4). Focus was placed on the single female figure or on one person shown together with an animal. The Rape of Europa was a popular theme, used by sculptors as disparate as Gleb Derujinsky (plate 5), Waylande Gregory, Boris Lovet-Lorski, and Paul Manship.

The so-called classical nude even became a favorite motif of abstractionists and other artists who would never have deemed themselves classicists. Unlike the earlier neoclassicists who excelled in conveying the naturalism of flesh and the sensuality of a soft female body, twentieth-century artists thought of the classical harmony of proportion and graceful movement as simply the formal elements

3
C. Paul Jennewein
(Germany, 1890–1978)
GREEK DANCE
1925, bronze, 20½ x 16 x 6¼ in.
(52.1 x 40.6 x 15.9 cm),
Los Angeles County Museum
of Art, gift of 1994 Collectors
Committee

4
C. Paul Jennewein
(Germany, 1890–1978)
GREEK DANCE
1925, silvered and polychromed
bronze on polychromed wood
base, 20½ x 16⁷⁄₁₆ x 6½ in.
(52.1 x 41.8 x 16.5 cm), San
Diego Museum of Art, gift of
Mrs. Henry A. Everett

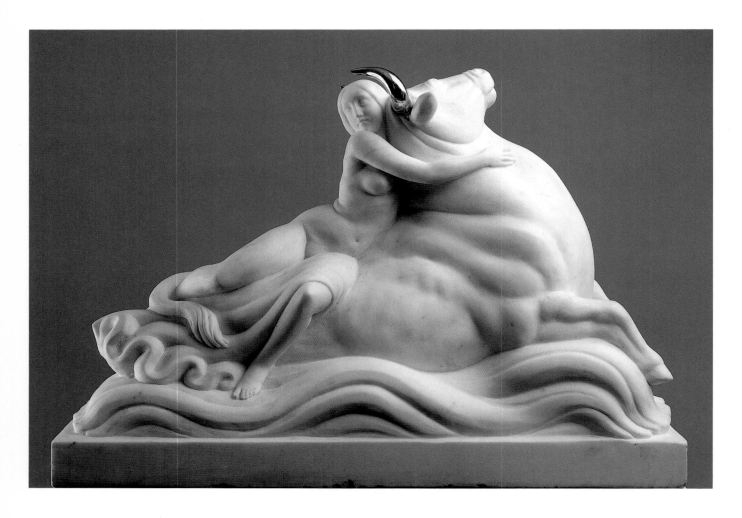

5
Gleb Derujinsky
(Russia, 1888–1975)
RAPE OF EUROPA
c. 1932, marble with silver,
15½ x 21½ x 8½ in. (39.4 x
54.6 x 21.6 cm), collection of
Robert Pincus-Witten and
Leon Hecht, New York City

of line, shape, and color. The anatomy of their figures is even distorted for design purposes. In a series that dominated his art of the 1930s, Archipenko pared the female body to a minimalist torso that seems to float buoyantly in space (plate 6). The sleekness of the human body also characterized the oeuvre of Lovet-Lorski (plate 7); his streamlined figures parallel the angularity and controlled movement of the Machine Age aesthetic and consequently fit perfectly into art deco interiors. The purity of white marble was also challenged. Artists learned that archaeologically correct neoclassical sculpture required polychromy, since statuary in antiquity was painted bright colors. Consequently, white, the color that dominated earlier neoclassical revivals, was often replaced by painted and patinated surfaces in blues, oranges, and other vibrant hues.

The American fascination with primitive, folk, and exotic cultures began its long history with Robert Laurent's wood carvings of the 1910s. Young sculptors no longer went abroad solely to study classical and European art; anthropological and art museums devoted to non-Western cultures now tempted them. Some preferred to travel to distant lands, learning firsthand about the people and art of different races and religions by immersing themselves in these exotic cultures. Such journeys often replaced the traditional grand tour of Europe and obligatory study in France and Italy. When Allan Clark asked to join the Fogg Art Museum expedition to China in 1925, Langdon Warner, the research fellow leading the expedition, compared the experience Clark would have with winning the Prix de Rome and explained: "He [Clark] begged to be taken along to complete his education.... His presence will make the seventh American to study Tung Huang, he will contribute something in the way of technical knowledge of sculpture, illustrations for the report, schematic sketches of big walls unreachable by the camera.... I believe that the chance will have a deep effect on his future."[12] Although European artists were strongly influenced by African and Oceanic art, reflecting the regions of the world that had fallen to the imperialist expansion of their nations, with Americans the search for inspiration became truly worldwide: Emma Lu Davis visited the steppes of Russia and hinterlands of China; Ahron Ben-Shmuel, Africa; Beniamino Bufano, Japan and China; Jacques Schnier, Southeast Asia and India. Other Americans tended to look closer to home for exotic experiences, finding the Mesoamerican and Hispanic cultures south of the border rich. West Coast sculptors in particular tended to turn their backs on European and African cultures.

6

Alexander Archipenko
(Russia, 1887–1964)
TORSO IN SPACE
1936, bronze, 8⅞ x 26⅞ x 6 in.
(22.5 x 68.2 x 15.2 cm), The
Museum of Fine Arts, Houston,
given in grateful memory of
Alice Pratt Brown by the Board
of Governors of Rice University

7

Boris Lovet-Lorski
(Russia, 1899–1973)
SALOME WITH HEAD OF
JOHN THE BAPTIST
By 1937, Belgian marble,
17 x 29 x 11 in. (43.2 x 73.7 x
27.9 cm), John P. Axelrod,
Boston

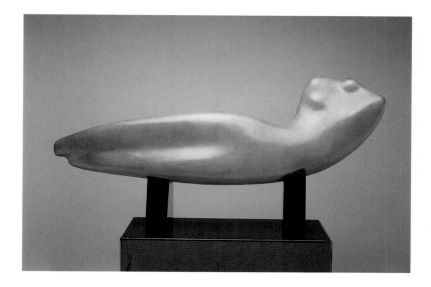

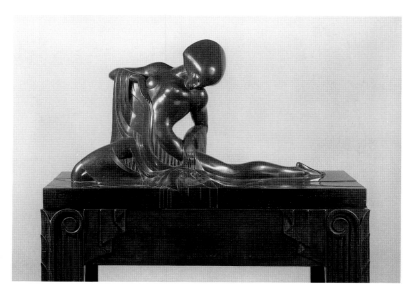

8

Cesare Stea
(Italy, 1893–1960)
MAN WITH BOOK
c. 1938, cast aluminum, 31 x
8½ x 8 in. (78.7 x 21.6 x 20.3
cm), the Mitchell Wolfson, Jr.,
Collection, courtesy, the
Wolfsonian Foundation,
Miami Beach, Florida, and
Genoa, Italy

9

Warren Wheelock
(United States, 1880–1960)
MEDITATION
1935, wood, 21 x 9 x 8 in.
(53.3 x 22.9 x 20.3 cm),
Ron and Jane Lerner

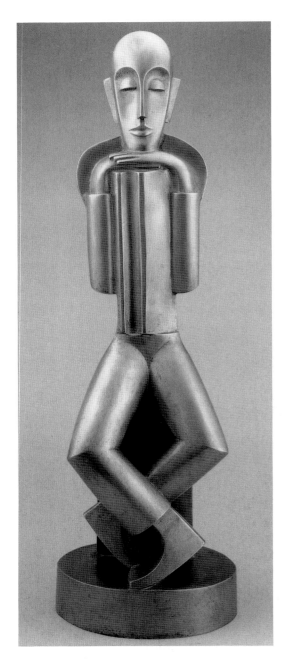

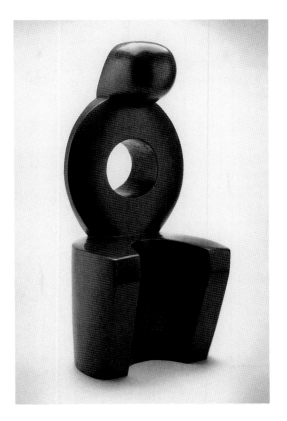

In the 1940s several books surveying contemporary modern sculpture concentrated on the recent primitivist trend.[13] Schnier, a sculptor and author of one such survey, began his text:

Thirty years ago the word sculpture brought to the minds of most Americans visions of classical Greek statues, carvings in marble of Apollo…. Modern sculpture… was thought to be the collective whim of a handful of individuals eager for innovation. Now the scene has changed. We no longer feel bound to measure art according to the standards of Greek aesthetics. A modern sculpture has emerged based on present-day economic, social, and aesthetic standards.[14]

Still little serious attention has been accorded the early American primitivists since then. The phenomenon in general has been the subject of many historical articles and other publications since Robert Goldwater's landmark *Primitivism in Modern Painting*, not surprisingly published in 1938, while the first phase of the trend was still strong.[15] A historical analysis of primitivism throughout the century was not fully broached, however, until 1984, when William Rubin at the Museum of Modern

Art organized *"Primitivism" in 20th Century Art: Affinity of the Tribal and the Modern*, which focused on the phenomenon in Europe. In the two-volume catalogue accompanying the exhibition the American experience (apart from contemporary art) was relegated to a single chapter primarily devoted to painting.[16] Sculpture was accorded an entire chapter in Frederick W. Peterson's dissertation on American primitivism (1961), but his subject was the first generation; he omitted the younger artists of the 1930s.[17]

THE CRITICAL ATTENTION historians have devoted to the American exploration of cubism, futurism, and constructivism has been quite disproportionate given the output of sculptors during this era.[18] Abstraction and nonobjective art were a minor voice. To a great extent artists were discouraged from exploring progressive ideas by a lack of understanding evinced by the general public and patrons. Unable to sell his more radical, noncommissioned work (plate 8), Cesare Stea claimed, "Modern art is not accepted by people other than artists."[19] Warren Wheelock gave up carving his spare, geometric wood abstractions (plate 9) because no one would look at them.[20] Others, such as Isamu Noguchi early in his career, alternated their experimental work with portraiture and other remunerative commissions in order to support themselves. Even Alexander Archipenko and José de Creeft, artists who were among the vanguard in Europe, were somewhat more conservative after they immigrated to America, preferring to develop earlier ideas rather than to introduce fundamentally new conceptions of form and space. A small number, men of means like Alexander Calder, Elie Nadelman, and John Storrs, were able to pursue their independent courses.

Before the mid-1930s and the advent of constructivism and biomorphic surrealism few sculptors in the United States conceived of abstraction solely in terms of pure form, surface, mass, and space, that is, as a reality apart from the physical world. Calder did manipulate wire to form linear figure drawings in space (plate 10), experiments that eventually led to his creation of the stabile and mobile. Noguchi also constructed several abstractions out of sheet metal cut into amorphous shapes and combined with metal rods, and Storrs spent years creating inlaid, stone relief panels akin to the architectural designs of Frank Lloyd Wright and metal constructions of forms in space that suggest skyscrapers.

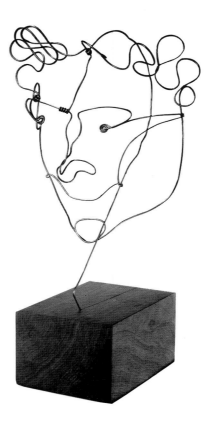

10

Alexander Calder
(United States, 1898–1976)
HEAD OF CARL ZIGROSSER
c. 1928, wire, 20 x 10 x 12 in.
(50.8 x 25.4 x 30.5 cm),
Philadelphia Museum of Art,
purchased, Lola Downin Peck
Fund from the Carl and Laura
Zigrosser Collection

17

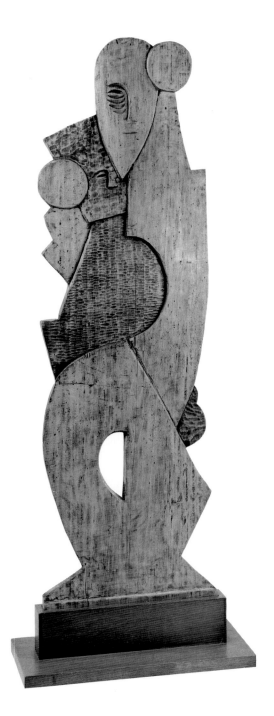

11
Chaim Gross
(Austria-Hungary, 1904–91)
HOOVER AND ROOSEVELT
IN A FIST FIGHT
c. 1932, mahogany, 72 x 20 x
1½ in. (182.9 x 50.8 x 3.8 cm),
The Renee & Chaim Gross
Foundation, New York City

With the exception of the Belgian emigré Adolf Wolff, none of the artists active in America followed the Europeans in infusing their abstract aesthetics with a political agenda. The Russian constructivists desired to create a new world order through the collaboration of art, technology, and industry, exploring the concept of motion and new industrial materials, yet when Calder responded to their aesthetics, he demonstrated none of their passion for a utopian world. To most Americans abstraction did not mean the creation of an alternative, ideal universe. Quite the contrary. Abstraction signified style. It offered artists new modes of expression far beyond the limitations of realism. As Saul Baizerman explained:

It is a habit with us to call abstract art the work done in sharp angles and the rounded one presenting a closer familiarity with the human body—realistic. I know of no such distinction. I do not believe there is any abstract art, though I have employed flat formations in my labor figures since 1920. Or if we should desire so, we may say that every art is abstract.

For all the art forms convey and use thoughts, ideas. If a piece looks less recognizable it is no reason to place it into another category. Much simpler to think of it as of another variation of combinations. And this is highly important. It places sculpture on its proper base. We must never forget that the forms are only the elements, the notes of music, combinations of which create rhythm of expression and the illusion of a symbol.[21]

Most of the sculptors who used abstraction worked in an idiom clearly derived from cubism. Chaim Gross conceived the figures of two politicians in *Hoover and Roosevelt in a Fist Fight* (plate 11) as an arrangement of angular planes similar to an analytic cubist painting. However, some did not fully grasp its intellectual basis. Instead of analyzing the structure of forms and their position and

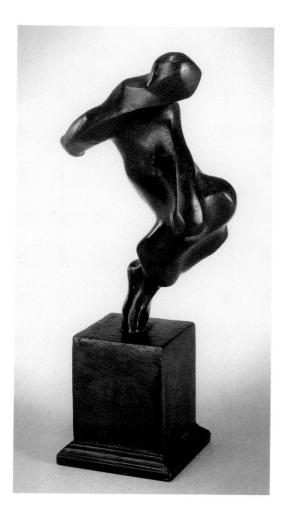

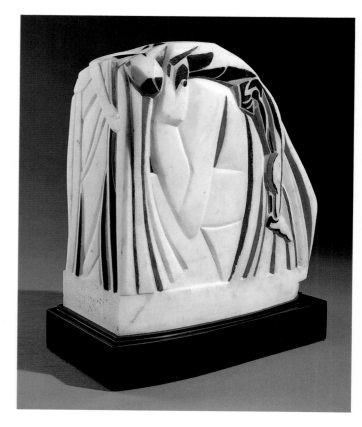

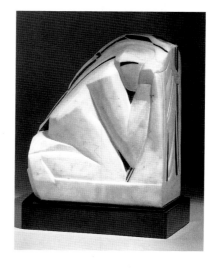

relationships in space, they thought cubism meant the simplification of volumes into basic geometric structures. Consequently, their figures were often more cubic than cubist. Occasionally their interest extended to futurism, with its emphasis on movement and the implication of the fourth dimension of time. Alice Morgan Wright was one of the first Americans to depict the popular motif of a dancer as a series of successive fractured planes (plate 12), and Storrs designed some of his cubist figure compositions so that the viewer was forced to walk around them in order to see all the parts of a complete figure, thereby implying the concept of time (plates 13A–B). Calder was the only American who incorporated actual motion into his sculptures, first in his miniature circus figures (plate 14), which during a performance were propelled by the artist himself. Eventually he incorporated motion into the actual design of his abstract, motor- and wind-driven mobiles.

12

Alice Morgan Wright
(United States, 1881–1975)
WIND FIGURE
1916, bronze, 10⅝ x 5 x 3¼ in.
(27.0 x 12.8 x 8.1 cm),
Hirshhorn Museum and
Sculpture Garden,
Smithsonian Institution, gift
of Elinor Fleming, 1983

13A

John Storrs
(United States, 1885–1956)
PIETA *(front)*
c. 1919, polychromed marble,
11⅛ x 9¾ x 4¹⁵⁄₁₆ in. (28.3 x 24.8
x 12.5 cm), courtesy, Hirschl &
Adler Galleries, New York City

13B

John Storrs
PIETA *(rear)*

14

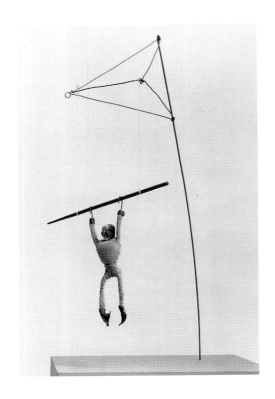

*Alexander Calder
(United States, 1898–1976)*
ACROBAT AND TRAPEZE
*c. 1929 (trapeze is a reconstruc-
tion); steel wire and cloth;
acrobat: 6 x 4¾ x ¾ in. (15.2 x
12.1 x 1.90 cm); trapeze: 21¼ x
13½ x 9 in. (55.3 x 34.3 x 22.9
cm); University Art Museum,
University of California,
Berkeley, gift of Margaret
Calder Hayes, class of 1917*

Numerous sculptors determined that the cubist simplification of form accorded well with certain contemporary themes. Human anatomy, conceived as a series of smooth, faceted planes and sharp angles, shared formal properties with the machine aesthetics that became popular during this period of intensified urbanization and mechanization. So cubism was appropriated by Baizerman and others as the most fitting means of depicting the builders of the new skyscraper cities. By the 1930s this synthesis of form and content was crucial for many artists, thereby blurring further the distinction between abstract and representational art. As Anita Weschler explained, her art was not abstract, but she hoped to create "works of formal and human significance through traditional and experimental means," by utilizing the principles of abstraction **20** "to heighten an impression of reality."[22]

BY THE TWENTIETH century communication had improved to such an extent that developments in art could be reported almost simultaneously throughout the land. Most sculptors did continue to work in or around New York City; a significant number were New York natives. Nevertheless, many who were responsible for pioneering new attitudes toward sculpture hailed from the Midwest and Far West and continued to work in these regions. Away from the established art center of New York, artists may have felt less constrained by traditional ideals and standards. Illinois sculptor and the first historian of American sculpture Lorado Taft observed this independent streak when discussing the art of George Grey Barnard: "In the character of Barnard there is something of the largeness of the West, something of the audacity of a life without tradition or precedent, a burning intensity of enthusiasm."[23] Gender, religion, race, and ethnic origin were also strong factors in determining the choices sculptors made. If they and their work are taken in their historical context, it is obvious that to be progressive definitely did not require an artist to be concerned solely with abstraction. Modernity was not so monolithic a concept. For Americans it meant an openness toward subject matter, style, cultural ideals, and personal beliefs and attitudes.

Notes

[1] For example, Wayne Craven, *Sculpture in America* (New York: Crowell, 1968), p. 555.

[2] Clement Greenberg, "The New Sculpture," in *Art and Culture: Critical Essays* (Boston: Beacon, 1961), pp. 139–45. The essay was first published in 1948.

[3] A. M. Hammacher, *The Evolution of Modern Sculpture: Tradition and Innovation* (New York: Abrams, 1969), p. 8.

[4] Roberta K. Tarbell, "Sculpture in America before the Armory Show: Transition to Modern," in Joan M. Marter et al., *Vanguard American Sculpture, 1913–1939*, exh. cat. (New Brunswick: Rutgers University Art Gallery, 1979), p. 1.

[5] Daniel Robbins, "Statues to Sculpture: From the Nineties to the Thirties," in Tom Armstrong et al., *Two Hundred Years of American Sculpture*, exh. cat. (New York: Whitney Museum of American Art, 1976), p. 117.

[6] For example, the recent biography by Ruth Butler, *Rodin: The Shape of Genius* (New Haven: Yale University Press, 1993), pp. 398–417.

[7] For example, Cécile Goldscheider, *Rodin: Ses Collaborateurs et ses amis*, exh. cat. (Paris, Musée Rodin, 1957). This situation should be rectified by Hélène Pinet and Véronique Wiesinger, who are organizing an exhibition on Rodin and his American patrons, students, and models to be held at the Musée Rodin in Paris.

[8] Hippolyte A. Taine, *Lectures on Art*, trans. John Durand (New York: Holt, 1875), 1:30. Taine espoused his theories through teaching at the École des Beaux-Arts, Paris, and numerous publications on art, literature, and culture, which were published in French and English from 1869 until well into the twentieth century.

[9] For example, although Craven summarizes Mahonri Young's career in *Sculpture in America*, he mentions no other genre specialist or the genre movement in general.

[10] Robbins, "Statues to Sculpture," p. 133.

[11] Susan Rather, *Archaism, Modernism, and the Art of Paul Manship* (Austin: University of Texas Press, 1993), pp. 7–8.

[12] Langdon Warner to Edward W. Forbes, 27 March 1925, in Edward W. Forbes papers, archives, Fogg Art Museum, Harvard University. This letter differs from all published literature on Clark, which uniformly states that the sculptor was asked by the Fogg expedition to join their group.

[13] For example, W. R. Valentiner, *Origins of Modern Sculpture* (New York: Wittenborn, 1946); and Charles Seymour, Jr., *Tradition and Experiment in Modern Sculpture* (Washington, D.C.: American University Press, 1949).

[14] Jacques Schnier, *Sculpture in Modern America* (Berkeley: University of California Press, 1948), p. 1.

[15] Robert Goldwater, *Primitivism in Modern Painting* (New York: Harper, 1938). One of the best publications on the phenomenon in sculpture is Alan G. Wilkinson, *Gauguin to Moore: Primitivism in Modern Sculpture*, exh. cat. (Toronto: Art Gallery of Ontario, 1981).

[16] Gail Levin, "American Art," in *"Primitivism" in 20th Century Art: Affinity of the Tribal and the Modern*, exh. cat. (New York: Museum of Modern Art, 1984) 2:453–74.

[17] Frederick W. Peterson, "Primitivism in Modern American Art," Ph.D. diss., University of Minnesota, 1961.

[18] During the last two decades, for example, *Two Hundred Years of American Sculpture, Vanguard American Sculpture, 1913–1939*, and P. Andrew Spahr, *Abstract Sculpture in America, 1930–1970*, exh. cat. (New York: American Federation of Arts, 1991).

[19] Cesare Stea, quoted in "Decorative Bas Relief Is Hung in Lobby of Local Postoffice," unidentified 1939 clipping, in Cesare Stea papers (on microfilm, reel N68–86, frame 355), Archives of American Art.

[20] Warren Wheelock's sentiment was recalled years later by Milton Hebald. The author thanks Douglas Berman for providing this information.

[21] Saul Baizerman, "Journal," 28 April 1947, pp. 60–61, in Saul Baizerman papers (on microfilm, reel N61–2, frames 586–87), Archives of American Art.

[22] Anita Weschler, "A Sculptor's Summary," *Magazine of Art* 32 (January 1939): 26–27.

[23] Lorado Taft, quoted in W. H. Van der Weyde, "Dramas in Stone: The Art of George Grey Barnard," *The Mentor* 11 (March 1923): 19.

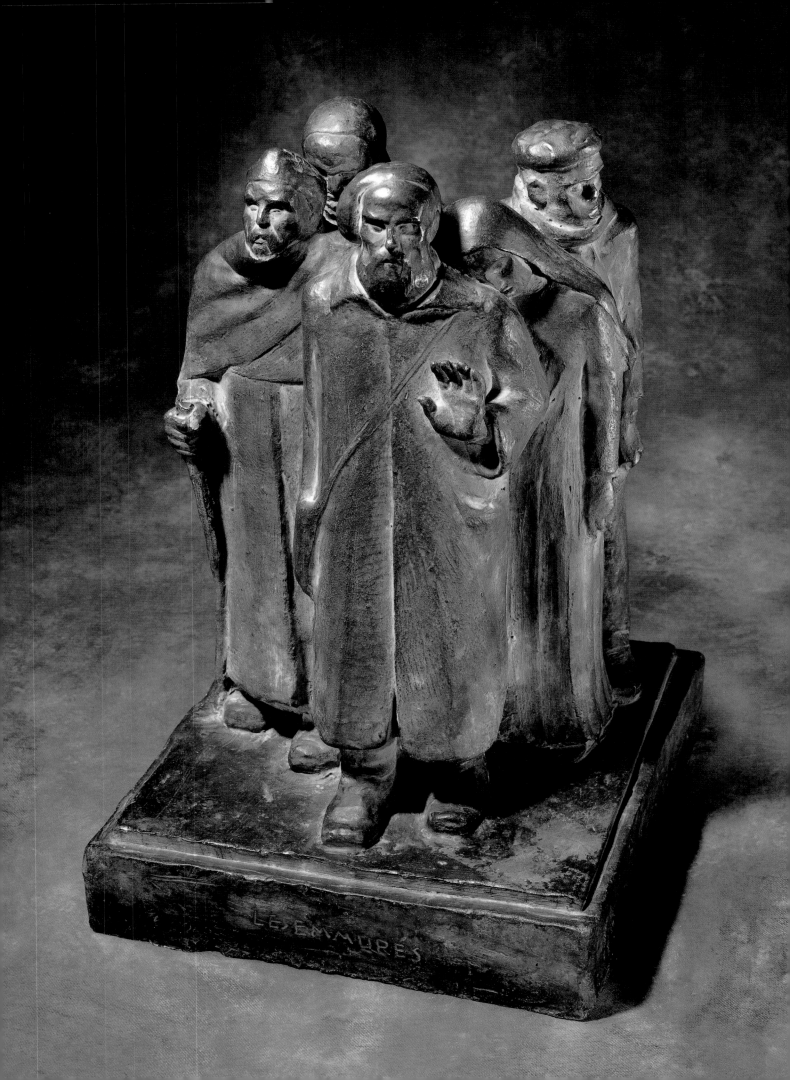

The Cult of Rodin
and the Birth of Modernism
in America

IN THE WINTER OF 1909 *the American sculptor Gutzon Borglum wrote wistfully to*

Auguste Rodin, "America has greater need of you than Europe and it will always be a source of

regret for me that this young country…has not been able to profit from your great personality

and from your presence. We are young, and courageous in all except in the art which ought to

express our emotions."[1] Borglum recognized the role Rodin played in revitalizing the field of

sculpture but was inaccurate in his assessment of Rodin's impact in the United States: the great

French master's influence was far from negligible.

ILENE SUSAN FORT

By the time of Borglum's letter Rodin and his art were widely known and his influence on American sculpture substantial. His admirers did not form a school or organize into a separate group dedicated to propagating his art, nor did they promote a single aesthetic, style, or subject matter. Rather, their experimentation with various aspects of Rodin's daring art enabled them to break the constraints of Victorian literalism and ideality. Consequently, Rodin and his art signaled the introduction of a modernist aesthetic to American sculpture.

At the beginning of the last quarter of the nineteenth century American sculptors pursued commissions for commemorative monuments of a historical or allegorical nature and for architectural decorations while often supporting themselves through portraiture. Their sculpture was dominated by French academicism as taught at the École des Beaux-Arts and promoted in the annual Paris Salon. This aesthetic had been exhausted by generations of banal repetitions. Rodin, the most innovative and modern master of the late nineteenth century, altered this situation. By liberating the human figure from its mimetic function and restrictive social mores, he created sculpture that was more

15
Onorio Ruotolo
(Italy, 1888–1966)
BURIED ALIVE
(also known as WALLED IN*)*
1918, painted plaster, 17½ x 11 x
11½ in. (44.5 x 27.9 x 29.2 cm),
Los Angeles County Museum
of Art, gift of Lucio Ruotolo

23

ILENE SUSAN FORT

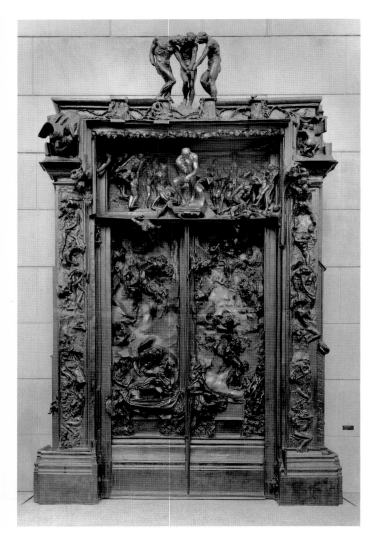

16

Auguste Rodin
(France, 1840–1917)
THE GATES OF HELL
1880–c. 1900, bronze, 240 x 129
in. (609.6 x 327.7 cm), Stanford
University Museum of Art,
gift of B. Gerald Cantor Art
Foundation

a private and emotive art form. As Royal Cortissoz, an American critic, explained, Rodin's "was a profoundly sensuous art," for elevated themes did not matter, only the opportunity "to caress in his marble or bronze a living form."[2] In addition, Rodin's emphasis on processes led to the modernist dictum that sculpture was foremost a work of art created for its own sake.

American sculptors initially responded at the beginning of the century by creating more personal works of a romantic and symbolist sensibility which utilized the human form for expressive purposes. Rodin's fascination with the creative process did not find complete fruition in American art until a later generation, in the 1920s and 1930s, when sculptors produced some of the most progressive and even abstract sculpture in the United States by virtually reinventing the human figure.

Rodin first gained critical attention in France during the late 1870s and by 1880 had won the prestigious public commission for bronze doors (eventually known as *The Gates of Hell* [plate 16]) of a planned museum of decorative arts. During the course of the decade he exhibited at the annual Paris Salon busts of French dignitaries, preparatory sketches of individual figures for *The Gates of Hell*, studies for his second prominent public commission, *The Burghers of Calais* (plate 17), and in the second half of the decade, more romantic, marble carvings of nude females and lovers (plate 18).[3] The variety of his display at the *Sixth International Exhibition of Paintings and Sculptures* (1887) stunned the Paris art world, stirred critical debate, and led to the publication of significant articles on him. Although Rodin's art was readily accessible in Paris during the decade, it seems to have attracted little interest among Americans studying sculpture

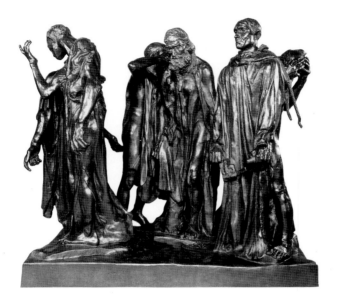

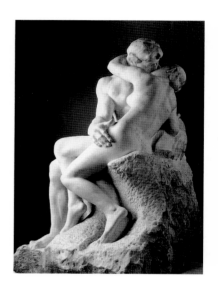

there. Only Charles Grafly (1862–1929) admitted familiarity with his work.[4]

Beginning in 1889, it became difficult for American artists in Paris to deny Rodin's presence, for in that year he participated in the Exposition Universelle and was accorded a two-man show with Claude Monet at the Galerie Georges Petit. Even Americans at home could have been introduced to his oeuvre through a series of ten illustrated articles appearing that year in *The American Architect and Building News*. Written by Truman H. Bartlett (1835–1923), a New England expatriate sculptor living in Paris, the series was based on interviews with Rodin and constituted the first extensive account in English of the iconoclast's art.[5] Bartlett's son, the aspiring sculptor Paul Wayland Bartlett (1865–1925), had been responsible for introducing his father to the French sculptor.[6]

According to the American critic William C. Brownell, the 1890s witnessed the transformation in Rodin's reputation in France from an eccentric spirit with few admirers to an internationally acclaimed master with popular and official support.[7]

Not surprisingly, it was during the 1890s that Americans first accorded Rodin patronage.[8] In 1893 he received much public attention over the issue of morality when *Cupid and Psyche* (c. 1893) was exhibited in Chicago at the World's Columbian Exposition along with one of the figures from *The Burgers of Calais* and a portrait of a man.[9] The controversy did not discourage — in fact, it may have encouraged — the Art Institute of Chicago and Metropolitan Museum of Art from acquiring that year their first Rodin works.[10] Private citizens were equally attuned to the increasing importance of the Frenchman: *Cupid and Psyche* and *Orpheus and Eurydice* (c. 1893), the first sculptures Rodin created expressively for an American collector, arrived at the home of Chicago streetcar magnate Charles T. Yerkes the year of the fair.[11] In 1898 another Chicagoan, Arthur Jerome Eddy (later famous as the author of *Cubists and Post-Impressionism* [1914]), became Rodin's first American sitter.[12]

During the 1890s a number of American artists were in personal contact with Rodin. George Grey Barnard received encouragement and advice from

17
Auguste Rodin
(France, 1840–1917)
THE BURGHERS OF CALAIS
1884–88, bronze, 82½ x 94 x 75 in. (209.6 x 238.8 x 191 cm),
The Metropolitan Museum of Art, gift of Iris and B. Gerald Cantor, 1989

18
Auguste Rodin
(France, 1840–1917)
THE KISS
1888–98, marble, 72¼ x 43½ x 46⅝ in. (183.6 x 110.5 x 118.3 cm), Museé Rodin, Paris, s.1002

25

19
George Grey Barnard
(United States, 1863–1938)
STRUGGLE OF THE TWO
NATURES IN MAN
1889–94, marble, 101 x 102 x
48 in. (256.5 x 259.1 x 121.9 cm),
The Metropolitan Museum
of Art, gift of Alfred Corning
Clark, 1896

20
Edward Steichen
(United States, 1879–1973)
BALZAC, MIDNIGHT
1908 (printed later), gelatin
silver print, 11 x 14 in. (27.9 x
35.6 cm), Los Angeles County
Museum of Art, gift of B.
Gerald Cantor Art Foundation

the master when he exhibited *Struggle of the Two Natures in Man* (plate 19) at the Société Nationale des Beaux-Arts salon in 1894. Borglum, whom sculpture historian Chandler Post ranked as "the most pronounced and…gifted American exponent of the style of Rodin,"[13] considered his association with Rodin as the most significant episode of his Paris years and said it was not a new experience but "rather a feeling of coming home."[14] Of the American sculptors Borglum had perhaps the first close relationship with Rodin: he claimed they were on intimate terms, and while Borglum tended toward self-aggrandizement, their friendship did last for years beyond his Paris residence.[15]

Rodin was the French artist Americans preferred, according to Arsène Alexandre, a French art critic, who in 1898 lamented that the sculptor was still far better understood and admired abroad than in his own country.[16] In the first years of this century a number of Americans—among them Borglum, Brownell, and Cortissoz—wrote articles and appreciations that expanded even further the American awareness of Rodin's stature.[17] These publications were largely in response to the success of the special exhibition Rodin held at the Pavillon de l'Alma during the Exposition Universelle of 1900. In comparison with the few sculptures he displayed in the official exposition, the Rodin pavilion presented an enormous retrospective of the artist's career: 165 sculptures and drawings, including most of his best-known works.[18] Visitors seemed most interested in *Balzac* (plate 20) and the marbles of sensual lovers, although *The Gates of Hell* and *The Tower of Labor* (1898–1906) were also on view. The pavilion did not attract immense crowds but was significant for the number of artists and writers who visited; among the Americans were Isadora Duncan and

sculptors Lorado Taft, Meta Warrick, and Sarah Whitney (1877–1968).[19]

Taft claimed not to have heard of Rodin when he was a student in France during the 1880s, yet he was favorably impressed with Rodin's art at the Chicago fair, so much so that he began writing articles about Rodin and traveled to France in 1895 specifically for the installation of *The Burghers of Calais*.[20] At the 1900 Rodin pavilion Taft became thoroughly convinced that Rodin was "the most fertile, skillful and imaginative of modern sculptors."[21] It was only after this in-depth exposure that Taft experimented in his own sculpture and teachings with themes, approaches to surface and mass, and overall conception that diverged from conservative American practices. Taft, who ranked *The Burghers of Calais* as Rodin's highest achievement, would utilize Rodin's new type of monument as the conceptual basis for several of his major sculptures as well as for class projects he assigned his students at the School of the Art Institute of Chicago.

During the next fifteen years Americans were increasingly able to examine Rodin's art first-hand in displays throughout their own country. Loïe Fuller organized the first substantial showing in the United States at the National Arts Club in New York City in May 1903.[22] Fuller had become a close friend of Rodin, bought and promoted his work while living in Paris, and introduced him to at least two Americans who would early on amass extensive Rodin collections on the West Coast: Alma de Bretteville Spreckels in San Francisco and Samuel Hill in Portland. In 1904 Rodin contributed a mechanically enlarged version of *The Thinker* (plate 21) to the Louisiana Purchase Exposition in St. Louis and after the fair presented it to the Metropolitan Museum of Art.[23] The following year

Bostonians had the opportunity to examine eleven of Rodin's works on view at the Copley Society.[24] From 1907 to 1910 Alfred Stieglitz devoted three special exhibitions in his New York City gallery to Rodin: two to his drawings and one to Edward Steichen's tonalist photographs of the monument to Balzac. At the Armory Show in New York City in 1913 and two years later at the Panama-Pacific International Exposition in San Francisco Rodin continued to be well represented.[25] In addition, several large American museums featured substantial displays of Rodin's art as part of their permanent collections: in 1912 the Metropolitan Museum of Art became the first American institution to open a gallery devoted to Rodin's art, the collection amassed largely through the munificence of financier Thomas Ryan. By 1917 the Cleveland Museum of Art could also boast of owning seven of his sculptures and the Museum of Fine Arts, Boston, ten.[26]

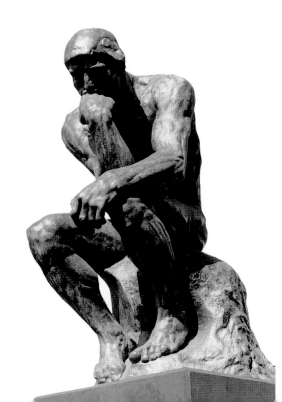

21

Auguste Rodin
(France, 1840–1917)
THE THINKER
1880, bronze, 79 x 38 x 59 in.
(200.7 x 96.5 x 149.9 cm), the
Norton Simon Art Foundation,
Pasadena

Many Americans journeyed to France specifically to meet Rodin, and visitors would continue to flock to see him and his studio until his death in 1917.[27] In both his Paris and Meudon studios (plate 22), visitors were allowed to examine his drawings and sculptures in different stages of completion; some also had the opportunity of watching him at work.

One of the earliest to make this pilgrimage was young Bessie Potter, who in the summer of 1895 traveled to Europe in the company of Taft, with whom she had studied. "[Rodin] was my idol at the time," she explained, "and to meet him was an event so tremendous in my uneventful life that I went to it trembling."[28] Such tremulous insecurity was surely shared by many of the callow compatriots who were to follow her path to Rodin's studio door. She found the visit rewarding nevertheless, later recalling, "Rodin's…encouraging words stimulated me to renewed effort, and I feel that I owe much to him."[29]

Rodin generously gave of his time to look at young sculptors' sketches and offer criticism. He had originally opened his studio every Saturday in the hope of attracting customers, but the barrage of aspiring sculptors so overwhelmed him that he was eventually forced to stop his open-house policy. He continued on a more selective basis, however, to give access to artists whom he felt had potential, and when their sculptures were too large to carry, he offered to visit them. He also suggested a course of study that included examining the historical sculpture collections at the Louvre. As a result Malvina Hoffman copied Egyptian statuary and the art of Michelangelo, and Eugenie Shonnard recalled his extolling the fourteenth-century reliefs of Antonio Pisanello.[30]

A few young Americans, among them Hoffman and Shonnard, went to Paris specifically hoping to study with the master. In 1900 Rodin joined with Antoine Bourdelle (1861–1929) and Jules Desbois (1851–1935), fellow sculptors who at times also worked as his practitioners, to establish the Académie Rodin in response to the growing demand, especially among foreigners, for his services as a teacher. Following the pedagogical practices of most Parisian art schools, the three artists visited the branches (there were separate classes for men and women) regularly about twice a week to examine the progress of each student and give advice. Rodin soon found, however, that even this was too disruptive for his own busy career and was obliged to have Bourdelle take over.[31] Among American art students only Harriet Frishmuth is definitely known to have been a pupil at the short-lived school, studying there for three months.[32] Notwithstanding others' claims to have been pupils of Rodin, most were not official students but met him

22
Auguste Rodin's studio in Meudon
Photograph in Malvina Hoffman papers, Resource Collections, Getty Center, Santa Monica

informally and irregularly to have him review their
advancement.

It is quite interesting that twelve of the
American students whose work Rodin critiqued
were women. The French artist Camille Claudel
(1864–1943) is now his best-known female student,
but he had a number of others. Rodin was a notori-
ous womanizer, and perhaps he often agreed to
advise them because he so enjoyed their company.
Of the Americans, Enid Yandell may have been the
first Rodin supervised (mid-1890s). Around the turn
of the century he advised Anne Marie Valentien
(1862–1947), Frishmuth, Anna Coleman Ladd
(1878–1939), Warrick, and Sarah Whitney.[33] The
attention his special pavilion had received in 1900
surely stimulated their interest. A decade later
three other American women received Rodin's
encouragement: Hoffman from 1910 to 1911 and
again during the summers of 1912 and 1914, Gertrude
Whitney in 1911, and Shonnard, sometime between
late 1911 and 1914. Hoffman was probably on the
most intimate terms with Rodin (plate 23), for he
asked her to supervise the installation of his 1914
London exhibition and shortly before the outbreak
of World War I to assist him in cataloguing his
drawings and installing his works in the Hôtel Biron
(now the Musée Rodin).[34]

The American women had come to France to
continue their training, and some were enrolled
in various Parisian art academies or were pupils of
other sculptors around the time they received
criticism from Rodin.[35] All, except Frishmuth (who
denied knowing anything about specific artists
before moving to Paris), were originally attracted to
the French capital by Rodin's fame.[36] Most were
young and insecure, and Rodin may have signified
a father figure for these women, several of whom

23

Auguste Rodin with Malvina
Hoffman (center), Rose Beuret,
Mme. Paul Vivier, and an
unidentified woman, Châtelet-
en-Brie, France, 1914
Photograph in Malvina
Hoffman papers, Resource
Collections, Getty Center,
Santa Monica

had lost their own male parent. Surely that was
the case with Hoffman, whose father had died only
the year before, for she described her first meeting
with Rodin as a rebirth: "I felt I was discovered."[37]
Even Gertrude Whitney, who had already estab-
lished a career and received critical attention,
expressed trepidation over the prospect of Rodin's
examining her work.[38]

In the decade before his death in 1917,
the cult of Rodin continued unabated among
Americans in Paris, their enthusiasm spread by
friendships within various artistic circles. Borglum
furnished Hoffman, Haig Patigian (1876–1950),
and Frederick Roth (1872–1944) letters of intro-
duction, and Paul W. Bartlett did the same for
Chester Beach. Around 1910 Rodin often tutored
Henry Clews, and it was probably the latter who
introduced the painter Robert MacCameron
(1866–1912). Shortly thereafter Claire de Choiseul,
the American-born duchess who was both Rodin's
mistress and business manager, asked MacCameron
to write an article announcing the Metropolitan
Museum's plan to form a Rodin gallery.[39] Among
Gertrude Whitney's associates who knew Rodin

29

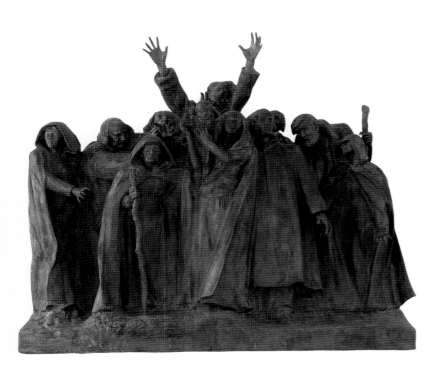

24

Lorado Taft

(United States, 1860–1936)

THE BLIND

1907–8, bronze, 108 x 126 x 72
in. (274.3 x 320 x 182.9 cm),
Krannert Art Museum,
University of Illinois, Urbana-
Champaign

personally or fell under his spell were Michael Brenner (1885–1969), Jo Davidson, Andrew O'Connor (1874–1941), and Morgan Russell (1886–1953).[40] John Storrs received criticism from Rodin beginning around 1912, became a close friend, and no doubt encouraged Richard Recchia to turn his attention to Rodin when the two were students at the Académie Julian.[41]

During the first two decades of this century some of the many sculptors who demonstrated Rodinesque tendencies in their art never met the master. Rodin's students became missionaries spreading his aesthetic: for example, in late 1900 Sarah Whitney, while in San Francisco on a brief break from her studies with Rodin to visit her family, probably introduced Arthur Putnam to Rodin's art.[42] Several of Rodin's American disciples became teachers or ran large studios, in which they employed artisans as helpers, thereby inculcating

the next generation with Rodin's ideals. Barnard and Gutzon Borglum taught at the Art Students League in New York City, Solon Borglum at the Beaux-Arts Institute of Design and at his own school there, Grafly at the Pennsylvania Academy of the Fine Arts in Philadelphia, and Taft at the School of the Art Institute of Chicago. Sometimes the ultimate source became confused in the mind of the student, as was the case with Paul Manship. Although trained under both Borglums and Grafly and having undergone an early Rodinesque phase, Manship was disappointed with Rodin's sculpture when he saw it firsthand, believing it to be an imitation of Gutzon Borglum's![43]

Foreign sculptors active in the United States in the 1910s also served as a conduit to Rodin, as demonstrated by the work of two immigrants: Onorio Ruotolo and Robert Baker. In New York City Ruotolo became known as the "Rodin of Little Italy,"[44] although his immediate source may have been the Italian Medardo Rosso (1858–1928), himself one of Rodin's most significant disciples. In such multifigural groupings inspired by World War I as *The Wishing Squad* (1916) and *Buried Alive* (plate 15) Ruotolo combined Rosso's humanitarian themes with Rodin's composition and surface treatment. *Buried Alive*, a model for a never-realized monument, reflects the innovative type of public sculpture established by Rodin in *The Burghers of Calais*: Ruotolo expressed the isolation and confusion suffered by the blind and did so by following Rodin's design approach to group sculpture, whereby the individuals relate compositionally as a cohesive ensemble (whether attached or freestanding) but remain psychologically separate. Ruotolo's adoption of Rodin's compositional approach to group sculpture may have been strengthened by

the public attention accorded Taft's *The Blind* (plate 24).[45]

Critics also referred to Rodin's art when writing of the imaginative sculptures Baker created in Boston.[46] Although this Englishman was not directly influenced by the French master, similarities in their work arose from common aesthetics. Baker was a proponent of the New Sculpture movement as promoted by Alfred Gilbert in Great Britain and demonstrated one of its tenets, a concern for the expressive potential of the heroic human form. He often worked in relief, perhaps because of his strong decorative-arts training, and in his twelve-foot multi-figural composition *The Soul's Struggle* (1916–17, destroyed) he echoed *The Gates of Hell* not only in the use of high relief but also in the repetition of sim-ilarly posed figures, muscular body types, and theme.

The first three decades of the twentieth century witnessed the widening sphere of Rodin's impact in America as demonstrated by the art of Recchia in Boston, Max Kalish in Cleveland, and Robert Aitken (1878–1949), Gertrude Boyle Kanno (1878–1937), Putnam, and Ralph Stackpole (1885–1973) in San Francisco. Many young sculptors who began their careers in the 1910s experienced a Rodin period as if it were an obligatory rite of passage. John Gregory, best known for his classical figures, listed as his training, "Then Paris and Rodin and the naturalistic school swallowed me, but I was not digested and I returned to New York still wondering what it was all about."[47] Aaron Goodelman modeled *Exhaustion* in 1919, and a decade later a critic wrote that this quiet figure with its sketchy handling and contorted anatomy was not a "slavish adherence" to Rodin but rather "the working over of his principles and techniques" as part of one stage in a young artist's development.[48]

DURING THE EARLY twentieth century the sculp-tures with which Rodin was most often identified were *The Gates of Hell* and sensuous marble carvings of female nudes and lovers. Likewise, American crit-ics when commenting on the Rodinesque character of works by American sculptors, usually referred to poetic and somewhat romantic interpretations of nudes sculpted in white marble. Rodin's oeuvre was much more varied than these references suggest, however, and his consequent impact on Americans more multifarious than was generally acknowledged at the time. His art exemplified the means of reject-ing sculpture's traditional role as allegory and narra-tive. His belief that sculpture was an interpretative art form for expressive purpose altered the American concept of figurative sculpture and consequently determined the themes, approach to the nude, and techniques that American sculptors chose to use.

Rodin's search for an expressive figure type led to his study and admiration of Michelangelo's art. Barnard, more than any of the other Americans, shared Rodin's appreciation. In their sculptures all three artists demonstrated strong affinities: powerful modeling, muscular bodies, construction of a figure with limbs and torso contorted obliquely, and a tendency to leave passages of the stone rough and looking unfinished.[49] In fact, the Michelangelo connection between the two sculptors may account for Barnard's repeated assertion that Rodin never influenced him, for in Barnard's mind his ultimate source was the Italian master not the French. Qualities of each master were strongest in Barnard's early sculptures done in Paris, such as the crouch-ing figure *Boy* (1887) and *Struggle of the Two Natures in Man*.

These elements were evident in the work of other Americans. Yandell, who, upon receiving the

important commission for the public fountain in memory of Carrie Brown in Providence, Rhode Island, returned to Paris in 1899 to seek Rodin's advice, borrowed athletic types, poised in contrapposto stances for the fountain's figures, and may have derived its circular arrangement of figures beneath a basin from Rodin's early, large-rimmed *Vase of the Titans* (c. 1879–80). The circular composition and gentle turn of the figures in Taft's *The Solitude of the Soul* (plate 25) and Gertrude Whitney's later bronzes for Washington's Arlington Hotel fountain were probably based on similar sources.

From his first major sculptures, like *The Walking Man* (1877–78), Rodin evinced a recurrent fascination with the body in motion. Many of his early figures are either in stride, bending, or twisting to emphasize movable parts of human anatomy, while several of his figures from the 1890s on seem to fly through the air. Around 1900 the free-form dance of Duncan and Fuller and the exotic repertoire of Southeast Asian traveling troupes proved alluring to Rodin; this interest culminated about 1910 in a series of terra-cottas of wiry dancers caught in various dance movements. Rodin ignored academic principles about presenting the figure in plumb, that is, with the supporting foot below the head, and often underscored the angularity of the limbs in juxtaposition to the body's torso through the pose and clean outline of the figure. Visitors commented on Rodin's tendency to sketch models in motion.

He told Frishmuth: "First, always look at the silhouette of a subject and be guided by it; second, remember that movement is the transition from one attitude to another. It is a bit of what was and a bit of what is to be."[50] She incorporated these ideas, even employing dancers as models. Although it may be difficult to see Rodin's influence in her characteristic

bronzes of female nudes, the more muscular *A Slavonic Dancer* (plate 26) with its arrangement of sharp angles harks back to such Rodin nudes in action as *Iris, Messenger of the Gods* (plate 27).

Hoffman also demonstrated a strong interest in modern dance, modeling her first work on that theme while under Rodin's tutelage. Putnam must have also known of Rodin's figures in motion, for his *Flying Messenger* (plate 28) suggests the floating figures in *The Gates of Hell*, in particular the swirling couple later known as the independent work *Fugit Amor* (1881–87?). Much later Gaston Lachaise contorted his female nudes in poses that owe a debt to Rodin's images of active, naked women.

Academic training extolled the classical ideal of perfection in the human form. Rodin rejected idealization, insisting on the importance of working from nature, whether it be elegant or ugly. This was heresy, and consequently, when he exhibited his male nudes in the late 1870s, their vigorous modeling and somewhat unattractive bodies precipitated criticism. Although Rodin's realism appealed far less to Americans than did his more romantic, emotive sculpture, his belief in the role of nature did affect the field of portraiture. Notwithstanding Taft's alignment of Barnard's statue of Lincoln (1917) with Rodin's *Balzac*,[51] it was in the work of Gutzon Borglum and Hoffman that Rodin's powerful realism found its most receptive disciples. Borglum so admired Rodin's *Balzac* that he repeatedly attempted to acquire a small version of the head. The American characterized the Frenchman's art as "intensely modern, therefore very real—so close to Nature" and claimed that Rodin had urged him when "making a bust you must create what you see, not what your model wishes you to see."[52] Borglum sculpted many portraits but is best known for Mount

25

Lorado Taft
(United States, 1860–1936)
THE SOLITUDE OF
THE SOUL
1901, bronze, 29 x 15 x 12 in.
(73.7 x 38.1 x 30.5 cm),
Los Angeles County Museum
of Art, purchased with funds
provided by the American Art
Council, Dr. and Mrs. Robert
Carroll, Mr. and Mrs. John
M. Liebes, Luppe H. and Kate
Luppen in honor of Donald
Reed, Brenda, Gary, and
Harrison Ruttenberg, and Mr.
and Mrs. William Lippman

26

Harriet Frishmuth
(United States, 1880–1980)
A SLAVONIC DANCER
1921, bronze, 13¼ x 6¾ x 5 in.
(32.4 x 17.2 x 12.7 cm),
Wadsworth Atheneum,
Hartford, purchased through
the gift of Henry and Walter
Keney

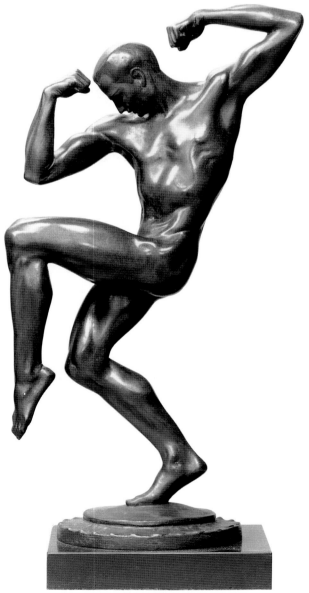

Rushmore National Memorial (plate 29). A monumental relief of the heads of four United States presidents carved out of a mountainside in the Black Hills of South Dakota, it exemplifies aspects of Rodin's art on a heroic scale: Borglum strongly modeled each head, leaving passages of the cliff rough to appear unfinished.

Traditionally the nude was presented in sculpture in allegorical terms or allied with standard attributes that would enable the viewer to identify the figures as specific personalities from mythology, history, or literature. Rodin broke with convention when he exhibited *The Age of Bronze* (1875–76), a full-length nude devoid of accoutrement. Exact subject matter was no longer inherently important to him, but rather the expressive potential of the human form became paramount. Rodin's attitude was revolutionary and brought the demise of the academic figure and traditional allegory as source material for progressive sculptors.[53]

Literature, by contrast, did play a significant role in enabling Rodin to liberate figurative sculpture from its previous narrative office to a more abstract realm. Rodin was well versed in the classics, both ancient and modern, but was more in sympathy with the French romantics, especially Charles Baudelaire, and with late nineteenth-century symbolists.[54] Unlike other French sculptors of the time, he was not interested in depicting specific characters or scenes from poems and plays. Instead, like the poet Stéphane Mallarmé and other symbolist writers, Rodin rejected nineteenth-century rationalism and materialism. To them literature and sculpture were emotive art forms. Stories and poems became mere sources of inspiration for the expression of universal concepts and private emotional experiences.

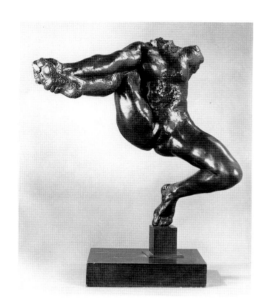

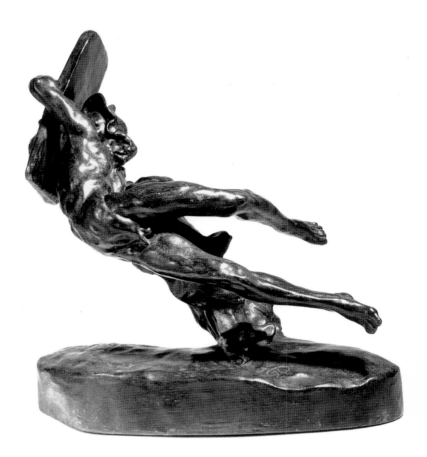

Americans likewise were inspired by contemporary literature, especially French and symbolist examples. In some instances, they borrowed their subjects directly from specific stories, remaining more faithful to their written sources than Rodin would have. Barnard exhibited *Struggle of the Two Natures in Man* with a title that referred to a Victor Hugo poem, Warrick based one of her 1902 sculptures on the central character of Hugo's novel *The Laughing Man*, while Taft borrowed the idea for *The Blind* from a symbolist play by Maurice Maeterlinck. Later Hoffman derived *Offrande* (1920) from a Paul Verlaine poem, and O'Connor found inspiration for *Tristan and Iseult* (plate 30) in Richard Wagner's opera.

Americans more often used their own imaginations to create a personal symbolism that would express philosophical ideas about humankind. Rodin shared with symbolist writers the desire to convey man's conscious and unconscious states, and by the late 1890s he, like them, was selecting themes concerning the human soul, dream states, and

27
Auguste Rodin
(France, 1840–1917)
IRIS, MESSENGER OF
THE GODS
1890–91, bronze, 37⅜ x 34¼ x
15¾ in. (94.9 x 87 x 40 cm),
Los Angeles County Museum
of Art, gift of B. Gerald Cantor
Art Foundation

28
Arthur Putnam
(United States, 1873–1930)
FLYING MESSENGER
1904, bronze, 15½ x 7¾ x 15½
in. (39.4 x 19.7 x 39.4 cm),
The Fine Arts Museums of
San Francisco, gift of Alma
de Bretteville Spreckels

35

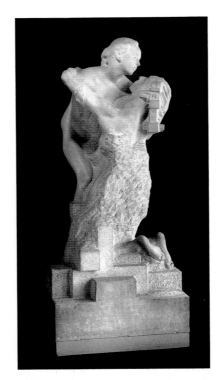

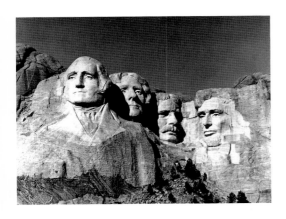

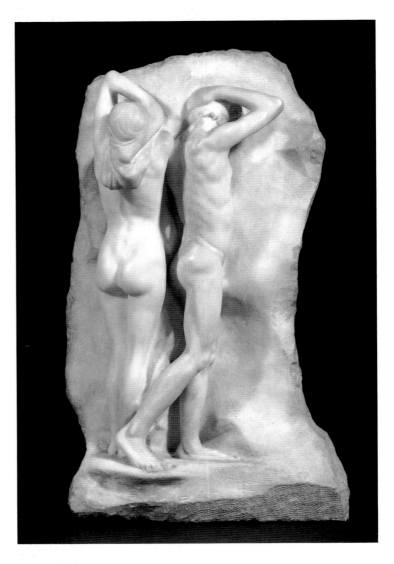

29
Gutzon Borglum
(United States, 1867–1941)
MOUNT RUSHMORE
NATIONAL MEMORIAL
1927–41, Black Hills, South
Dakota

30
Andrew O'Connor
(United States, 1874–1941)
TRISTAN AND ISEULT
1928, limestone, 76⅜ x 33⅞ x
34⅝ in. (194 x 86 x 88 cm),
The Brooklyn Museum,
Dick S. Ramsay Fund

31
George Grey Barnard
(United States, 1863–1938)
SOLITUDE
c. 1905–6, marble, 21¾ x 12 x
7½ in. (55.3 x 30.5 x 19.1 cm),
Frances Lehman Loeb Art
Center, Vassar College,
Poughkeepsie, gift of Mrs.
William Reed Thompson
(Mary Thaw, class of 1877)

moods of despair and ecstasy. Such themes were new to American sculpture. Katharine Metcalf Roof wrote of Barnard, "In his greatest work the idea is supreme, and one is conscious of no insistence upon the individual human form, because form has been transcended and become the abstraction of humanity."[55] Barnard devoted his most ambitious project, the capitol sculpture at Harrisburg, Pennsylvania, to the themes of Love and Labor, first presenting them in a marble funerary vessel, *Urn of Life* (c. 1898–1900). *Solitude* (plate 31) is one of several carved marble reliefs Barnard based on the mystical beings decorating the urn. According to his elaborate iconographic program, the nude man and woman in *Solitude* represent a couple in love, their spirits united. Nevertheless they remain apart, the man's back toward the woman, because they are distinct souls despite their love.[56]

Fascination with the state of man's soul was paramount in the art of Taft as well as Barnard. He created his first mature symbolic sculpture, *The Solitude of the Soul*, soon after his revelation at the Rodin pavilion, and such metaphysical explorations would also become the theme of his most significant late public monuments in Chicago, *The Fountain of Time* (1909–22) and *The Fountain of Creation* (begun in 1910 but never completed). As with Rodin, both Americans usually employed expressive poses and gestures of the nude to convey the condition of humankind. In the early years of the century before his time was completely consumed with larger public memorials of a historical character, Gutzon Borglum was also drawn to "the regions of mystic shadows," creating imaginative marble sculptures, often on themes relating to creation or birth, which he nicknamed "pipe dreams" (plate 32).[57]

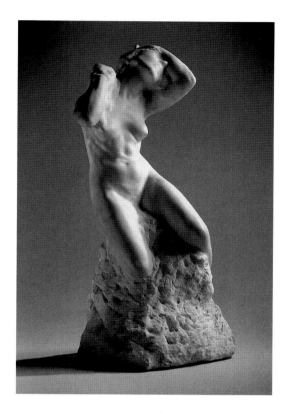

32
Gutzon Borglum
(United States, 1867–1941)
THE AWAKENING
c. 1902–14, marble, 34¼ x 15¼ x 15 in. (87 x 38.7 x 38.1 cm), San Diego Museum of Art, gift of Mr. and Mrs. Archer M. Huntington

Dante's *The Divine Comedy* provided the pretext for Rodin to comment in *The Gates of Hell* on the condition of society. Only a few of the groupings were borrowed directly from the poem, for Rodin preferred to use its figures, whom he contorted, entangled, and caught in a never-ending purgatory of suffering (plate 33), to express his concern for humanity and his pessimism about man's ability to solve his most basic problems.[58] Anguish and introspection were not typical of American art, yet such negative or quiet, inward states of mind did find a few powerful expressions. An early writer characterized Barnard's subjects as expressing "man's painful evolution, his struggles with the forces of nature, with sin and darkness—the tragedy of the ages repeating itself through all time."[59] Such a description echoes *The Gates of Hell* and applies to most

37

of Barnard's major sculptures. Inspired by Oscar Wilde's *The Ballad of Reading Gaol*, Hoffman expressed the poignancy of death in *Morte Exquise* (c. 1913–15). However, it was Warrick who in several works projected a sense of futility and despair equal to Rodin's. With the exhibition of *The Wretched* (plate 34) in Paris in 1903[60] she became known as the "sculptor of horrors." *The Wretched* demonstrates "no glint of hope," for six of the figures suffer from physical and mental diseases and debilitating social conditions, while the seventh, a philosopher, realizes he is powerless to effect change.[61] Warrick is the only black American known to have been influenced by Rodin, and her fascination with the macabre during her Paris years has often been explained as a personal response to racial prejudices

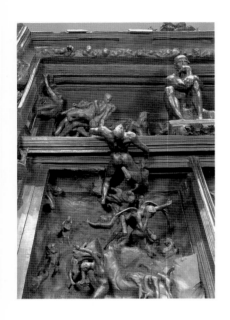

33
Auguste Rodin
(France, 1840–1917)
THE GATES OF HELL *(detail)*
1880–c. 1900, bronze, Stanford
University Museum of Art,
gift of B. Gerald Cantor Art
Foundation

34
Meta Warrick Fuller
(United States, 1877–1968)
THE WRETCHED
c. 1901, bronze, 17 x 21 x 15 in.
(43.2 x 53.3 x 38.1 cm),
Maryhill Museum of Art,
Goldendale, Washington

she experienced. There can be no doubt, however, that it was Rodin who demonstrated to her the potential of such themes. Warrick distinguished herself from other Americans by sharing with Rodin an interest in exploring the psychological range of human emotions rather than avoiding abhorrent sentiments and themes.

The image of a contemplative male figure, seated or reclining, but above all engrossed in thought and oblivious to his surroundings became perhaps the single most popular subject among Americans in the early decades of this century. Such imagery owed its existence to Rodin's *The Thinker*, which had been conceived to command the center of the lintel above the doors of *The Gates of Hell* but became famous as an independent work.[62] Young sculptors often adopted it for the motif of their early and sometimes only attempts at Rodinesque themes. In 1903 Putnam created *Il Penseroso*, a nude slouched on a rock, while four years later Gertrude Whitney borrowed the iconography for *Monument to a Sculptor* (1907), a fitting appropriation since *The Thinker* has at times been interpreted as a self-portrait and a symbol of a poet and his creativity. Ladd in *The Slave* (plate 35) accentuated the brooding attitude, so that her figure expressed a mood of futility comparable with that conveyed by Rodin's *Despair* (1890). In *Tired Out* (plate 36) Mahonri Young invested Rodin's *The Thinker* with a theme particularly relevant to contemporary labor issues by suggesting that its pose was expressive not of contemplation but of the exhaustion of an ordinary manual laborer. *Tired Out* was to be an essential figure in Young's unrealized monument to labor (plate 81), its placement as the central, crowning element of an ensemble consisting of architectural components and figures

35
Anna Coleman Ladd
(United States, 1878–1939)
THE SLAVE
1911, bronze, 4 x 5½ x 2¾ in.
(10.2 x 14 x 7 cm), Museum
of Fine Arts, Boston, gift of
Emily W. McKibbin

36
Mahonri Young
(United States, 1877–1957)
TIRED OUT
(also known as FATIGUE*)*
1903, bronze, 9 x 5¾ x 7 in.
(22.9 x 14.6 x 17.8 cm),
Los Angeles County Museum
of Art, Mr. and Mrs. Allan C.
Balch Collection

37
Hugo Robus
(United States, 1885–1964)
SUMMER AFTERNOON
1925, silver, 7 x 32 x 13 in.
(17.8 x 81.3 x 33 cm), estate
of Marjorie Content

in the round echoed that of *The Thinker* in *The Gates of Hell*. Rodin's powerful figures demonstrating basic human emotions continued to influence sculpture decades later, as evident in the art of Hugo Robus. His *Despair* (1927) and other figures (plate 37) were conceptually grounded in Rodin's art; by distorting human anatomy through abstraction in a manner analogous to Rodin's manipulation of the individual figures in *The Gates of Hell*, Robus underscored the potency of the human form as a conveyor of emotions.

The dream state also appealed to Americans. Baker, whose art was sometimes complex and enigmatic in the vein of Barnard's, was referred to as a "cosmic dreamer" who "though doomed to exist upon this little planet projects his mind continually upon others."[63] *Sanctuary of Dreams* (plate 38) is formally similar to Rodin's poetic handling but

thematically much more mysterious. A figure, perhaps two, floats in a cloud, bent arms and legs clearly emerging from a soft, misty cloak, while head and torso are only suggested. Such intangibility is definitely the "stuff as dreams are made on," while the undulating form, contrast of smooth and more rugged surfaces, and flickering light create a strong, sensuous quality.

Beach, Gutzon Borglum, O'Connor, and other Americans delved into states of reverie in carvings of partial heads, not fully delineated and often with their eyes closed as if asleep. Clyde du Vernet Hunt (1861–1941) varied the motif in his bust *Nirvana* (c. 1921), the gesture of a beautiful young woman stretching her head and neck upward symbolizing the beatific state of spiritual goodness. Rodin created similar portrait and figure studies of women as well as portraits of intellectual and creative men

of his day. The obsession with the mind and the cult of the intellect were central to symbolist ideology. Americans differed from Rodin in creating meditative heads that were only of women. This was possibly due to male perception of the female in turn-of-the-century American culture as a beautiful, yet docile object or to the even older belief that the female sex was more prone to imagination and flights of fancy.

The Kiss was Rodin's first marble to be officially commissioned, and in 1898 it was reproduced in a large commercial edition.[64] Even though it was the example of Rodin's carved lovers most readily accessible to the general public and therefore his best-known lovers group, it was only one of many. The French sculptor depicted nude couples seated, kneeling, straining, embracing, caressing, or kissing, sometimes their bodies melting together and merging with the surrounding stone. Other sculptors depicted lovers, but it was Rodin who excelled in emphasizing the aspect of sexual longing, transforming the hard, cold block of pure white marble into a sensuous material that appears to be soft and to shimmer with the life and passion of the flesh. During the last two decades of his life Rodin had many of his earlier plasters of lovers set in marble and also created new images of mythological and literary paramours; these were especially significant to Americans during the years immediately preceding World War I. Couples in the act of making love became one of the most oft-repeated motifs among American sculptors, both men and women. Gertrude Whitney's early marbles, such as the lovers in *Paganism Immortel* (c. 1907), share Rodin's strong romanticism and sensuous surfaces. But it was Beach who responded most enthusiastically to Rodin's marble lovers, creating for more than a

38
Robert Baker
(England, 1886–1940)
SANCTUARY OF DREAMS
c. 1919, bronze on marble base,
19½ x 10 x 11¾ in. (49.4 x
25.4 x 29.7 cm), National
Museum of American Art,
Smithsonian Institution, gift
of Bryant Baker

39
Malvina Hoffman
(United States, 1885–1966)
COLUMN OF LIFE
1912/17, bronze, 26 x 7 x 7 in.
(66.2 x 17.8 x 17.8 cm),
Los Angeles County Museum
of Art, gift of B. Gerald Cantor
Art Foundation

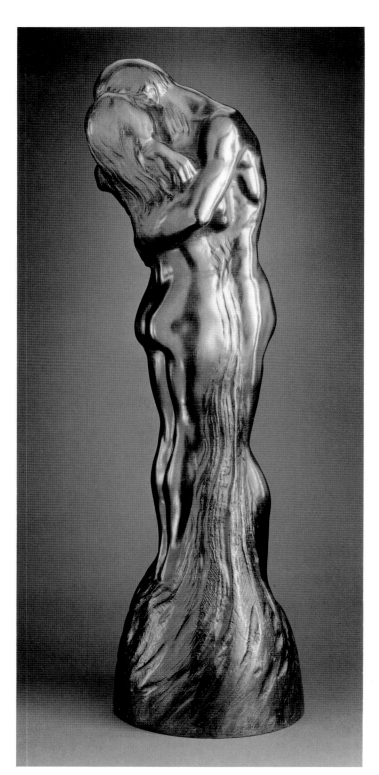

decade poetical couples caressing, clinging, and intertwined, usually as allegories of the forces of nature. Hoffman, while a student of Rodin, carried his idea of sexual union even further in *Column of Life* (plate 39), in which a man and a woman stand clutching each other, their bodies literally fused into one by the act of lovemaking.

Rodin offered Americans a means of focusing on the physicality of sensual pleasures without symbolic trappings, thereby liberating them from the rigid moral proscriptions of Victorian society. Propriety could be maintained, while a romantic sensualism was suggested. This sense of respectability was crucial for women sculptors, given the existence of double gender standards. The numerous romantic tales that Gertrude Whitney wrote expressed her sexual frustrations due to a neglectful husband, but these stories and her extramarital affairs were not satisfying enough; sculpture was perhaps the most creative means for her to enjoy vicariously the pleasures of the nude while retaining a public image of respectability.[65]

Since Americans were generally less flexible than the French in matters of decorum, it is understandable that sculptors in the United States differed from Rodin in their rejection of strong eroticism and the darker side of sex, insisting that love be presented in its ideal, sinless state. Guy Pène du Bois wisely acknowledged this difference when discussing the art of Beach and attributed it to the Puritan spirit of America.[66] Beach expressed the ecstasy of passion while simultaneously emphasizing a sense of purity. Eroticism rarely dominates his marble couples, *The River's Return to the Sea* (plate 40) being an exception that can be explained by its early date, created while Beach was still in Paris and close to his source.[67] Hoffman's *Column of Life*, despite

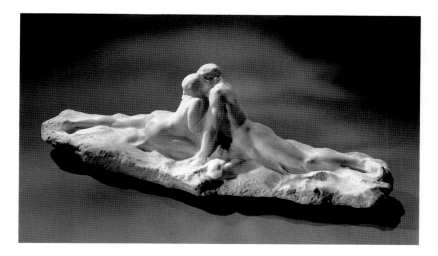

the physical union of the man and woman, is also about love idealized. Unlike the French symbolists, who delighted in exploring the dark side of the female soul, Americans never demonstrated much interest in the image of woman as seductress. Recchia's *Echo* (plate 41) is a rare exception, her crouching pose and art nouveau curves suggesting the alluring sound of her impassioned voice. To most Americans women remained perennial virgins; and lovers, a heterosexual pair. Yet Rodin, as so many late nineteenth-century French artists and writers, was fascinated by lesbian love and sometimes presented it in his art.

Perhaps the art of Solon Borglum best exemplifies how Rodin's ideas affected the American approach to subject matter and consequently modernized the conceptualization of sculpture. Borglum established his reputation as a delineator of western subjects, but *The Blizzard* (plate 42) is not just about a cowboy and his horse in a storm. It concerns the union of man and animal and their experience in battling the eternal forces of nature. It is difficult to determine where cowboy ends and horse begins, and this treatment is in complete

40
Chester Beach
(United States, 1881–1956)
THE RIVER'S RETURN
TO THE SEA
1906, marble, 14 x 45½ x 15 in.
(35.6 x 115.6 x 38.1 cm),
Dr. James D. Zidell

43

41
Richard Recchia
(United States, 1888–1983)
ECHO *(also known as* SIREN*)*
1914, bronze, 14 x 9⅛ x 15¼ in.
(35.5 x 23.2 x 38.7 cm),
Museum of Fine Arts, Boston,
bequest of Richard H. Recchia

42
Solon Borglum
(United States, 1868–1922)
THE BLIZZARD
c. 1900, bronze, 5¾ x 9⅞ x
6⅛ in. (14.6 x 25.1 x 15.6 cm),
collection of The Newark
Museum, gift of Mrs. J. G.
Phelps Stokes, 1977

contrast to the minute descriptive details that characterized most western bronzes. One of Borglum's students explained how his teacher's understanding of Rodin's art enabled him to abandon nostalgic western themes in search of the soul of western life. *In his later works Borglum shows more and more interest in the abstract.... For instances the "Balzac" and "Hand of God" of Rodin are what he termed abstract works.... He visited the Salon, and one of the first works he saw was this same "Balzac." ... He said that Balzac himself seemed there before him in his monolith of a figure with his defiant head. That was what he considered abstract work. The truth, the soul of the subject were there and complete without the insistence upon detail and petty fact.*[68]

In his handling of surfaces Rodin has been referred to as an impressionist. Working in bronze, he went beyond the fluidity and flickering passages of light and dark characteristic of beaux-arts aesthetics. Rather than smooth his surfaces, he often retained traces of gouging and kneading of the clay, evidence of the artist's hand. Americans also followed his example, although they did not depart so radically from traditional practice: such surface treatment is characteristic of Bessie Potter Vonnoh's domestic figures and Young's early laborers. Not surprisingly Rodin praised Ladd for her modeling of *The Slave*, which has a "molten" surface and summary treatment that resulted in distortion of the figure's anatomy.[69] Unfortunately the impressionist approach was easy to adopt, and artists sometimes generalized their surfaces for expediency without understanding the true significance of such handling.[70] So popular did the practice become that as late as the 1920s critics were still accusing sculptors, such as Kalish, of being derivative in their modeling.[71] Davidson above all others understood

Rodin's willingness to leave bits of clay as remnants of the modeling process and traces of the artist's manipulation. He approached the vigor of Rodin's handling in *Male Torso* (plate 43) and would long retain this tendency in his portraiture.

In the mid-1880s Rodin began using marble. He often varied the surface treatment, polishing some parts (usually the figures) to suggest a soft surface while leaving other passages (the background or base) uncut or chiseled to suggest the rough texture of an incomplete carving (*non finito*). Light on the smooth, white stone caused the flesh to appear supple and the surface to dissolve, thereby obscuring

43
*Jo Davidson
(United States, 1883–1952)*
MALE TORSO
*c. 1910, bronze and stone, 22 x
10 x 12 in. (55.9 x 25.4 x 30.5
cm), estate of Jo Davidson,
courtesy, Conner-Rosenkranz,
New York City*

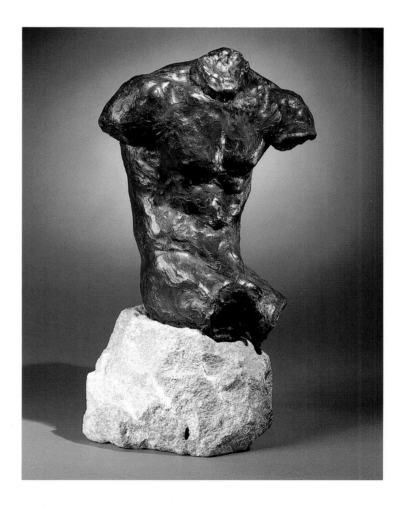

the figures' contours as if they were swathed in a mysterious veil. This emphasis on suggestion rather than delineation, on the subjective rather than objective was at the core of symbolist doctrine. Rodin used such handling most often in his sculptures of women and lovers, intensifying the suggestive and sexual nature of his themes.

His sensuous handling and incorporation of the unhewn block were enthusiastically adopted by his American disciples. However, early on critics debated the merits of *non finito* carving. Despite a few French writers criticizing Barnard for his rough passages and urging him "to leave this…mannerism to those who possess less talent," Taft believed, "judiciously used the rough-hewn background is an effective foil to the carefully modelled surface…. There is created a singular psychological impression of force and mastery where the steps of the works are boldly recorded."[72] Barnard was the first to demonstrate a fondness for Rodin's approach to stone carving: two athletic male figures in somewhat contorted poses with their faces hidden from the viewer emerge from the stone in *Brotherly Love* (1886–87; also known as *Friendship*). Chandler Post viewed Barnard's tendency to hide the bodies in marble and leave sections unhewn as having mystical as well as technical intent.[73] The American thereby successfully married form and content, as had Rodin.

Beach more than other Americans excelled in the use of roughened, unfinished passages of marble for evocative effect. By skillfully interpreting Rodin's poetic mode, he became known during the first decade of this century as a leader of the "new movement" of modernists.[74] Recchia was familiar with examples of Rodin's marble caryatids from the late 1880s, at least the one Samuel Isham gave to the Museum of Fine Arts in Boston in 1917; this source explains Recchia's unusual treatment of the hair of *Echo* as a bulky form exactly like the burdens of stone carried by Rodin's nude bearer figures.[75] Perhaps the final development of this tendency was *Tristan and Iseult*, in which O'Connor left so much of the stone untouched that the figures appear similar to an unfinished architectural block, although the unhewn passages actually indicate the armature the artist originally used in building up his clay model.[76]

Despite the degree of imitation Rodin inspired, his approach to stone was significant in the revival of direct carving.[77] The frequent exhibition of his marbles established a new appreciation for the inherent qualities of stone, and their partially hewn state inspired an admiration for the actual process of carving.[78] Rather than do the manual labor themselves, most nineteenth-century artists had hired technicians to carve their marble sculptures. In the early years of the twentieth century attitudes changed as artists began to deem the physical labor involved in chiseling a block of stone or wood a crucial factor in the act of creation. Materials and process became essential elements in the conceptualization of a modern sculpture. As a result, during the 1910s and 1920s an American sculptor was considered avant-garde if he were a direct carver.[79] Although non-Western art was a strong determinant in the popularity of direct carving in both Europe and the United States, Rodin began the interest. Consequently, John Flannagan, Robert Laurent, William Zorach, and a host of lesser-known American direct carvers ultimately owed a debt to the French master. Laurent developed Rodin's glorification of the suggestive surface to the extreme, finding in alabaster the perfect material for the evocation of sensuality and delight in translucent light.

Probably Rodin's most significant legacy to twentieth-century sculpture was the partial figure and the belief in its validity as a complete work of art.[80] Even though his appreciation of the fragmented body derived from ancient sculpture (which he collected), the partial figure became an integral element of Rodin's sculptural conception of the human body and of his working methodology. The French master would retain small plaster models of limbs, torsos, and heads, often cutting them from whole figures and then reassembling them to vary gestures as part of his exploration of the emotive potentials of the human body (plate 44). Hoffman sometimes assisted Rodin in the process of dismembering plaster figures.[81] Rodin first exhibited his figurative fragments publicly in 1889, but his largest presentation of them did not occur until 1900, and from then until 1914 they were, along with portraits, almost all he exhibited at the annual salons.[82] These partial figures received often adverse commentary. While Americans were not as harsh as the French, their opinions were mixed, few comprehending Rodin's intention and the consequence for future sculptural developments.[83]

Rodin's exploitation of the partial figure had its greatest impact on younger European sculptors, in particular Constantin Brancusi (1876–1957) and Henri Matisse (1869–1954), assisting in their development from naturalism to abstraction. Fewer Americans explored it. Some, such as Gutzon Borglum, made tentative attempts by cropping diagonal sections off heads. Clews was more extreme in his reductive treatment, cutting off the back of a woman's head so that her skull is more a flat mask with only the lower half of the face and neck remaining (plate 45). Incorporating other Rodin features — a firmly modeled, undulating physiognomy that

44
Auguste Rodin
(France, 1840–1917)
HEADLESS FEMALE TORSO
SEATED
c. 1889–90, plaster, 5¼ x
3¹⁵⁄₁₆ x 3¹⁵⁄₁₆ in. (13.3 x 10 x
10 cm), The Fine Arts Museums
of San Francisco, gift of
Adolph B. Spreckels, Jr.

45
Henry Clews
(United States, 1876–1937)
UNTITLED (PARTIAL FACE)
1911, bronze, 12½ x 7 x 8½ in.
(31.8 x 17.8 x 21.6 cm),
collection of Mr. and Mrs.
Lawrence Goichman

46
*Gutzon Borglum
(United States, 1867–1941)*
NUDE (ANGNA ENTERS)
*1916, bronze, 9⅛ x 6½ x 2⅜ in.
(23.2 x 16.5 x 6 cm), Yale
University Art Gallery, New
Haven, gift of Mr. and Mrs.
Jason Berger*

captures strong patterns of light and dark, dreamy closed eyes, and arching neck—Clews created a potent image that is simultaneously highly suggestive and mystifying. In a leaping nude (plate 46) Borglum combined Rodin's fascination with movement with his belief in the expressive potential of amputated figures to create a dancer who conveys an unbridled sense of energy despite her missing limbs. The fragment type Americans employed most often was the torso. Davidson's *Male Torso* recalls Rodin's early powerfully modeled figures, while later on direct carvers, such as Zorach, presented a simplified and idealized approach to form that suggested their ultimate source in antiquity (plate 47). Alexander Archipenko's *Torso in Space* (plate 6) and other examples of amputated and headless figures that he created after his move to the United States (1923) fostered the reconceptualization of the human body in abbreviated form by other sculptors.

Lachaise utilized the idea of the partial figure more frequently than any other artist in the United

States in the 1920s and 1930s, developing its abstract potential to the extreme. Inspired not only by Rodin but by Brancusi and Matisse as well, he created a group of anatomical fragments—torsos, breasts, backs, buttocks, and knees—that substantiate Rodin's belief that a complete body was not necessary to convey physical movement and emotional states. Rodin had daringly ignored social propriety in his creation of images of active naked women, even reveling in the female crotch;[84] Lachaise was the only American to explore the female body as sexual anatomy. By exploding the size of her breasts and prominently displaying her genitals, Lachaise went beyond Rodin's romantic sensuality to create a personal erotic imagery. Yet *Torso* (plates 48A–B) demonstrates that despite his frank sexuality Lachaise's sculptures were also an exploration of pure formal elements of mass, surface, and shape.

Rodin's impact on modern American sculpture culminated in the life-size reliefs Saul Baizerman hammered out of thin sheets of copper beginning in the 1930s. Much nineteenth-century sculpture had been based on narrative relief until Rodin rejected using a sequential presentation of story in *The Gates of Hell*.[85] The American response to this innovative aspect of his art was quite limited prior to Baizerman. In his copper reliefs he focused on the female nude, presenting whole and truncated figures, often in complex arrangements of overlapping or crowded groups. Baizerman also believed, contrary to most Americans of the early decades of this century, that Rodin's greatness stemmed from his bronzes rather than his marbles.[86] His manipulation of the copper sheets reveals his indebtedness: using a repoussé technique to model the figures, Baizerman created a textured surface that suggests the sensuousity of flesh while creating flickering

47
William Zorach
(Russia, 1889–1966)
TORSO
1925, sandstone, 13½ x 7¼ x
7¼ in. (34.3 x 18.4 x 18.4 cm),
Lyman Allyn Art Museum,
New London, Connecticut

48A
Gaston Lachaise
(France, 1882–1935)
TORSO *(front)*
1933, marble, 11¾ x 12 x 9 in.
(29.8 x 30.5 x 22.9 cm),
Smith College Museum of Art,
Northampton, given
anonymously

48B
Gaston Lachaise
TORSO *(rear)*

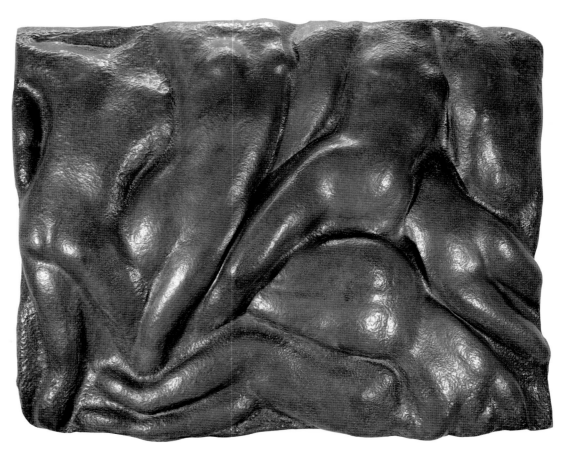

49

Saul Baizerman
(Russia, 1889–1957)
EXUBERANCE
c. 1933–49, hammered copper,
63 x 79 x 8 in. (160 x 200.7 x
20.3 cm), University of New
Mexico Art Museum,
Albuquerque, purchase through
the Julius L. Rolshoven
Memorial Fund

patterns of light that allude to the figures' move-
ments. The anatomy of the nudes is almost lost in
the rhythmic ebb and flow of the beaten surfaces.
Rodin's ideas about motion were central to
Exuberance (plate 49) and the other reliefs in his
Sculptural Symphonies series,[87] and enabled
Baizerman to go beyond Rodin in synthesizing sur-
face and form to create sculpture unencumbered
by representation.

 Many Rodin disciples were criticized during
the first decades of this century for being derivative,
but the art of Baizerman, Lachaise, Laurent, and
Robus was never thus faulted. Indeed, during their
lifetimes their names were rarely associated with
that of the French master. This is surprising, since
it is in their sculpture that is found the logical
conclusion and ultimate importance of Rodin's art
to American modernist sculpture.

Notes

1 Gutzon Borglum to Auguste Rodin, 20 January 1909, in archive, Musée Rodin, Paris. Translation by the author, who thanks Kenneth Wayne for his assistance in examining and transcribing Rodin's correspondence with Americans in the archive.

2 Royal Cortissoz, *Art and Common Sense* (New York: Scribner's, 1913), p. 375.

3 Rodin made a practice of showing plaster, bronze, and marble versions of the same piece at the Salon. The earlier, single-figure sculptures were usually first shown in plaster because of the expense of casting them in more permanent materials; however, when he began receiving large, complex public commissions, he also made it his practice to exhibit maquettes, models, and sketches in plaster of individual figures as well as entire compositions.

4 Dorothy Grafly, "Sculptor's Clay," typescript of an undated biography, pp. 77, 83, in Charles Grafly papers, archive, Pennsylvania Academy of the Fine Arts (also on microfilm, reel 3658, Archives of American Art).

5 Truman H. Bartlett, "Auguste Rodin, Sculptor," *American Architect and Building News* 25 (January–May 1889); reprinted in Albert Elsen, ed., *Auguste Rodin: Readings on His Life and Work* (Englewood Cliffs, N.J.: Prentice-Hall, 1965), pp. 13–109.

6 Ruth Butler, "Rodin and His American Collectors," in *The Documented Image: Visions in Art History*, ed. Gabriel P. Weisberg and Laurinda S. Dixon (Syracuse: Syracuse University Press, 1987), p. 89; and Ruth Butler, *Rodin: The Shape of Genius* (New Haven: Yale University Press, 1993), pp. 398–99.

7 William C. Brownell, "Auguste Rodin," *Scribner's Magazine* 29 (January 1901): 88. This article was later incorporated into Brownell's extended study *French Art: Classic and Contemporary Painting and Sculpture*, rev. ed. (New York: Scribner's, 1901).

8 Two sculptures had earlier been purchased by an American, the dealer George A. Lucas, 1887 and 1888.

9 *Fine Arts*, part 10 of *World's Columbian Exposition Official Catalogue* (Chicago: Gonkey, 1893), p. 95, exhibits 132–33. *Cupid and Psyche* was considered pornographic and consequently not permitted in the public galleries but relegated to a private room that required special permission for admittance (Butler, "Rodin and His American Collectors," pp. 92, 94).

10 Peter Selz, "Postscript: Rodin and America," in Albert E. Elsen, *Rodin* (New York: Museum of Modern Art, 1963), p. 191.

11 Auguste Rodin to Charles T. Yerkes, 13 July 1894; reprinted in Alain Beausire and Hélène Pinet, comp., *Correspondance de Rodin: I (1860–1899)* (Paris: Musée Rodin, 1985), pp. 143–44; and Rodin-Yerkes correspondence, in Charles T. Yerkes papers, Drake Memorial Library, State University of New York at Brockport, discussed and quoted in Frederic V. Grunfeld, *Rodin: A Biography* (New York: Holt, 1987), p. 343.

12 Grunfeld, *Rodin*, pp. 395–96.

13 Chandler Rathfon Post, *A History of European and American Sculpture from the Early Christian Period to the Present Day* (Cambridge: Harvard University Press, 1921), 2:260.

14 Robert J. Casey and Mary Borglum, *Give the Man Room: The Story of Gutzon Borglum* (Indianapolis: Bobbs-Merrill, 1952), p. 47.

15 Sources on Gutzon Borglum disagree over the date of his first encounter with Rodin. Although most claim Borglum met Rodin as early as 1890–91, perhaps taken to Rodin's studio by one of his teachers, Borglum may not have met Rodin until 1900 at the Pavillon de l'Alma. The Musée Rodin owns a substantial correspondence from Borglum to Rodin; since the earliest letter in this collection is dated 6 June 1901, it is likely that Borglum did not meet Rodin until 1900.

16 Arsène Alexandre, "Croquis d'après Rodin," in *Le Figaro*, 21 July 1899, 1.

17 For example, Gutzon Borglum, "Auguste Rodin," *The Artist* (New York) 32 (1902): 190–96.

18 *Exposition Rodin* (Paris: Société d'Edition Artistique, 1900), with prefaces by Albert Besnard, Eugene Carrière, Jean-Paul Laurens, and Claude Monet.

19 Sarah Whitney along with a Scottish sculpture student, Ottilie McLaren (b. 1875), helped Rodin hang his drawings and addressed invitations for the opening reception.

20 Lorado Taft, "Paris Letters: Rodin," *Chicago Record*, 8 July 1895; quoted in Lewis W. Williams II, "Lorado Taft: American Sculptor and Art Missionary," Ph.D. diss., University of Chicago, 1958, p. 159.

21 Lorado Taft, "Paris Letters: Sculpture at the Exposition," *Chicago Record Herald*, 8 August 1900; quoted in Williams, "Taft," pp. 172–73.

22 *Sculptures by Rodin, Roche, and Rivière, Belonging to Miss Lois [sic] Fuller*, cited in "Annotated List of National Arts Club Exhibitions, 1899–1960 and Undated," in Catherine Stover, *Inventory of the Records of the National Arts Club, 1898–1960* (Washington, D.C.: Archives of American Art, Smithsonian Institution, 1990), p. 34.

23 *Art*, unnumbered part of *Official Catalogue of Exhibitors* (St. Louis: Louisiana Purchase Exposition, 1904), p. 163, exhibit 1120; and Claire Vincent, "Rodin at the Metropolitan Museum of Art: A History of the Collection," *Metropolitan Museum of Art Bulletin* 38 (spring 1981): 15.

24 Selz, "Postscript," p. 192.

25 Of the twelve works exhibited at the San Francisco fair, Alma Spreckels bought five, including *The Age of Bronze* and *The Thinker*. These would later become the foundation of the world-famous Rodin collection at the California Palace of the Legion of Honor.

26 "Modern Sculpture at the Museum," *Bulletin of the Cleveland Museum of Art* 4 (August 1917): 108–9; and Butler, *Rodin*, p. 404.

27 Popular interest in Rodin was so great that in 1912 an account of Ellen Key's visit to Meudon and chat with the sculptor was a feature article in the February 11 issue of the *New York Sun*.

28 Bessie Potter Vonnoh, "Tears and Laughter Caught in Bronze: A Great Woman Sculptor Recalls Her Trials and Triumphs," *The Delineator* 107 (October 1925): 9.

29 Bessie Potter quoted in Alice Severance, "Talks by Successful Women: Miss Bessie Potter, Sculptress," *Godey's Magazine* 133 (October 1896): 358.

30 Malvina Hoffman, *Heads and Tales* (New York: Scribner's, 1936), pp. 41, 97; and Eugenie Shonnard, interview with Sylvia Loomis, 1964, Oral History Project, Archives of American Art, p. 4.

31 Grunfeld, *Rodin*, pp. 405–6.

32 Frishmuth explained her enrollment in Rodin's school as a matter of expediency, in one account stating the school was located near her home, in another that it was the only class for women sculptors she could find.

33 Little is known of Sarah Whitney's life and career. She seems not to have worked in sculpture much after her tutelage with Rodin. This is partly due to her marriage in 1903 to the painter and muralist Boardman Robinson. She did occasionally exhibit sculpture thereafter, presenting three portraits at the annual exhibition of the Whitney Studio Club in 1922.

34 Hoffman, *Heads and Tales*, pp. 46–48.

35 Frishmuth was the sole woman not to have had previous schooling, and it might be for this reason that she was the only one to express a negative sentiment about Rodin's teaching, stating that "perhaps he was not the best instructor for beginners" (quoted in "Rare Quality of Work of Modern Sculptress Ascribed to Her Love of Outdoor Life," *Waterbury [Connecticut] American*, 6 October 1926, p. 16).

36 "Rare Quality," p. 16; and [Ruth Talcott], "Harriet Whitney Frishmuth, American Sculptor," *The Courier* (Syracuse University Library Associates) 9 (October 1971): 22.

37 Malvina Hoffman diary, 8 June 1910, in Malvina Hoffman papers, Resource Collections, Getty Center, Santa Monica.

38 In an unfinished sketch of Rodin, Whitney wrote that the thought of his forthcoming visit was "pleasant…though terrifying…fearful and thrilling" ("A Narrow Escape," manuscript, in Gertrude Vanderbilt Whitney papers, Whitney Museum of American Art [also on microfilm, reel 2372, Archives of American Art]).

39 Lewis H. Van Dusen III, "Henry Clews, Jr.: The Life and Works of the Sculptor," senior thesis, Princeton University, 1962, p. 61 (also on microfilm, reel N70–39, Archives of American Art); and Ilene Susan Fort, "Robert Lee MacCameron's *Portrait of Rodin* and the Formation of the Metropolitan Museum of Art's Rodin Collection," manuscript, 1983.

40 Whitney was also friends with Robert Chandler and seems to have known of MacCameron when all three were in Paris. Russell and Brenner received financial support from Whitney, while Davidson and O'Connor were her close friends; the latter also served as her artistic advisor. In 1908 Russell studied at the Académie Matisse in the Hôtel Biron, where one of Rodin's studios was located.

41 The John Storrs papers in the Archives of American Art include several manuscripts about Rodin, one written shortly after his death when Storrs was asked by the family to draw a portrait of him. Various handwritten and typed letters and lists in the Storrs papers give contradictory dating, 1912 and 1913, for Storrs's initial studies with Rodin.

42 The literature on Putnam is silent about Sarah Whitney. He surely knew her, however, since Whitney's fiancé, Boardman Robinson, followed her to San Francisco and became an intimate of Putnam. The two men even formed a short-lived school. The date of Whitney and Robinson's visit to San Francisco is given in the Robinson literature as 1901, but a circular for the ill-fated school was dated November 1900.

43 John Manship, *Paul Manship* (New York: Abbeville, 1989), p. 26.

44 "New York as the World's Art Capital, Sculptor's Aim," *New York Evening Journal* [February 1919], clipping in Onorio Ruotolo papers (on microfilm, reel 2526), Archives of American Art.

45 Allen Weller, *Lorado Taft: The Blind* (Urbana-Champaign: Krannert Art Museum, University of Illinois, 1988), pp. 4–6.

46 W. H. de B. Nelson, "In a Boston Studio," *International Studio* 62 (October 1917): lxxxvi. Baker was annoyed by the comparison and felt that he had been "much victimized by such men as Rodin and Michelangelo, who happened to precede him."

47 "John Gregory, Sculptor," *Arts and Decoration* 12 (15 November 1919): 8.

48 Dorothy Goel, "The Unique Work of Some Jewish Artists," *Brooklyn Examiner*, 7 June 1929, clipping in Aaron Goodelman scrapbook (on microfilm, no reel numbers), Archives of American Art.

49 Both Rodin and Barnard studied Michelangelo early on. Contemporary critics repeatedly referred to each as a modern-day Michelangelo. Historian Charles H. Caffin, writing in 1903, attributed much of Barnard's development to the influence of Michelangelo, going so far as to state that as a student Barnard "shunned the influence of modern Paris, drawing nutriment in the museums from Phidias and Michelangelo" (*American Masters of Sculpture* [New York: Doubleday, Page, 1903], pp. 25–26, 29).

50 Quoted in "Frishmuth, American Sculptor," p. 22.

51 Lorado Taft, *Modern Tendencies in Sculpture*, Scammon Lectures for 1917 (Chicago: University of Chicago Press for Art Institute of Chicago, 1921), p. 129.

52 Borglum, "Rodin," 194–96; and Willadene Price, *Gutzon Borglum: Artist and Patriot* (Chicago: Rand, McNally, 1961), p. 35.

53 Peter Fusco, "Allegorical Sculpture," in *The Romantics to Rodin: French Nineteenth-Century Sculpture from North American Collections*, ed. Fusco and H. W. Janson, exh. cat. (Los Angeles: Los Angeles County Museum of Art, 1980), p. 68.

54 Ruth Butler, "The Literary Aspects in the Work of Auguste Rodin," master's thesis, New York University, 1957, pp. 12, 26, 57, 63.

55 Katharine Metcalf Roof, "George Gray [sic] Barnard: The Spirit of the New World in Sculpture," *The Craftsman* 15 (December 1908): 278.

56 Barnard's lengthy explanation of the symbolism is reprinted in the catalogue entry on his *Urn of Life* in Diana Strazdes, *American Paintings and Sculpture to 1945 in the Carnegie Museum of Art* (Pittsburgh: Carnegie Museum of Art, 1992), p. 56.

57 George Luks, "Preface," in *Exhibition of Sculpture by Gutzon Borglum*, exh. cat. (New York: Avery Library, Columbia University, 1914), p. 3; and Casey and Borglum, *Give the Man Room*, pp. 82–83.

58 Albert E. Elsen, *Rodin's Gates of Hell* (Minneapolis: University of Minnesota Press, 1960), pp. 12–15, 63.

59 Laura Carroll Dennis, "A Great American Sculptor," *Review of Reviews* 19 (January 1899): 49.

60 According to contemporary sources, *The Wretched* attracted attention when it was shown at the 1903 Paris Salon. The sculpture is not listed, however, in catalogues for either the salon of the Société des Artistes Françaises or that of the Société Nationale des Beaux-Arts. It was supposedly shown with *The Impenitent Thief*, which was catalogued at the Société Nationale des Beaux-Arts; perhaps *The Wretched* was accepted too late for publication.

61 Meta Vaux Warwick Fuller to C. R. Dolph (Maryhill Museum of Art), 13 February 1949, in Alma Spreckels correspondence, archive, Maryhill Museum of Art, Goldendale, Washington. The author thanks Colleen Schafroth, curator, for bringing this letter to her attention.

62 Small-scale (27 in.) casts of *The Thinker* as an independent sculpture were issued in the 1890s for collectors. Around 1902 Rodin enlarged it to over life-size. Examples were widely exhibited during Rodin's lifetime in both France and the United States, appearing at the National Arts Club, New York City (1903); at the Louisiana Purchase Exposition, St. Louis (1904); at the Copley Society, Boston (1905); again in New York City at 291 (1910); and in San Francisco at the Panama-Pacific International Exposition (1915).

63 Nelson, "Boston Studio," p. lxxxiv.

64 Daniel Rosenfeld, "Rodin's Carved Sculpture," in *Rodin Rediscovered*, ed. Albert Elsen, exh. cat. (Washington, D.C.: National Gallery of Art, 1981), p. 82. The Leblanc-Barbedienne Foundry produced 319 bronzes of *The Kiss* in varying sizes. Rodin's practice of having certain of his sculptures produced in large editions is discussed in Jacques de Caso and Patricia B. Sanders, *Rodin's Sculptures: A Critical Study of the Spreckels Collection, California Palace of the Legion of Honor* (San Francisco: Fine Arts Museums of San Francisco, 1977), pp. 30, 34.

[65] Numerous excerpts from Whitney's stories and love letters are published in B. H. Friedman and Flora Miller Irving, *Gertrude Vanderbilt Whitney: A Biography* (Garden City, New York: Doubleday, 1978). Avis Berman discusses the connection between Whitney's love life and art in *Rebels on Eighth Street: Juliana Force and the Whitney Museum of American Art* (New York: Atheneum, 1990), pp. 55–56.

[66] Guy Pène du Bois, "The Art of Chester Beach," in *Marbles and Bronzes by Chester Beach*, exh. cat. (New York: Macbeth Gallery, 1912), n.p.

[67] Several sources state that this carving was done before Beach went to Paris. It seems highly unlikely, however, that Beach would have created such a major work that was so similar to Rodin's without first-hand exposure to Rodin's art.

[68] Robert Alexander Horwood, "Gutzon [sic] Borglum— A Sculptor of the West," unidentified newspaper clipping, 2 April 1922, in Borglum family papers, private collection (also on microfilm, reel 1054, frame 103, Archives of American Art). The author's confusion of Gutzon for Solon Borglum was a common error of the period.

[69] Anna C. Ladd to Leila Mechlin, 18 May 1911, in archive, Philadelphia Museum of Art, quoted in Paula M. Kozol, "Anna Coleman Ladd," in *American Figurative Sculpture in the Museum of Fine Arts, Boston* (Boston: Museum of Fine Arts, 1986), p. 370.

[70] Frishmuth realized this: "[Rodin's] work often has the appearance of an unfinished sentence, but beneath it was the finest and most thorough finish. Many of his imitators have not understood this, and as a result their work is really unfinished. But beneath Rodin's work lies the real truth, and it cannot be mistaken" (quoted in "Rare Quality," p. 16).

[71] "Letters and Art: The American Worker Glorified in Bronze," *Literary Digest* 91 (18 December 1926): 26.

[72] Lorado Taft, *The History of American Sculpture*, rev. ed. (New York: Macmillan, 1930), pp. 359–60.

[73] Post, *History of European and American Sculpture*, 2:256.

[74] Mary L. Alexander, "Sculpture to Be Shown Here," in unidentified Cincinnati newspaper clipping, 1910, in Chester Beach scrapbook, private collection (also on microfilm, reel N727, frame 293, Archives of American Art).

[75] Paula M. Kozol, "Richard Recchia," in *American Figurative Sculpture*, p. 424.

[76] William Henry Fox, "Two Important Works by American Sculptors," *Brooklyn Museum Quarterly* 17 (July 1930): 82.

[77] Rodin conceived his sculptures in terms of modeling. The degree to which he did his own carving has been much debated. Early on he seems to have hired studio assistants and outside technicians (*practiciens*) to do the physical work; Truman H. Bartlett wrote that it was not feasible, in terms of time and labor, for Rodin to do it himself. Hoffman, however, witnessed Rodin carving, all the while explaining to her how he achieved certain effects. He probably did do the finishing touches on major works. Despite his practice, sculpture historian Adeline Adams suggested, "Perhaps we owe to Rodin this modern return from plastic to glyptic" (*The Spirit of American Sculpture* [New York: National Sculpture Society, 1923; rev. ed. 1929], p. 128).

[78] Rosenfeld, "Rodin's Carved Sculpture," p. 81.

[79] Roberta K. Tarbell, "Direct Carving," in Joan M. Marter et al., *Vanguard American Sculpture, 1913–1939*, exh. cat. (New Brunswick: Rutgers University Art Gallery, 1979), p. 45.

[80] Albert E. Elsen, *The Partial Figure in Modern Sculpture from Rodin to 1969*, exh. cat. (Baltimore: Baltimore Museum of Art, 1969), pp. 11, 16.

[81] Hoffman, *Heads and Tales*, p. 43.

[82] Elsen, *Partial Figure*, pp. 18, 22, 25; and idem., "When the Sculptures Were White: Rodin's Work in Plaster," in *Rodin Rediscovered*, p. 149.

[83] American writers usually discussed the fragments in the context of *The Gates of Hell*, questioning whether Rodin had enough design sensibility to complete the elaborate ensemble. Brownell and Kenyon Cox did understand that he was more interested in the individual elements, which Cox referred to as "the bits." Only Gutzon Borglum believed that Rodin's unfinished productions should be considered a serious and deliberate side of his art.

[84] Elsen, "When the Sculptures Were White," p. 144.

[85] Rosalind E. Krauss, *Passages in Modern Sculpture* (New York: Viking, 1977), pp. 9–23.

[86] Saul Baizerman, "Book on Art," manuscript, p. 67, in Saul Baizerman papers (on microfilm, reel N61–2, frame 592), Archives of American Art.

[87] Ibid., p. 88 (reel N61–2, frame 613).

MARLENE PARK

"Sculpture Has Never Been Thought

THE WOMEN WHO BEGAN *studying sculpture in the 1880s and 1890s were very different from the first generation of American women sculptors.*[1] *The earlier group, the neoclassicists, studied in traditional ateliers and beginning in the 1850s worked primarily in Rome. The themes of their figurative sculptures, like those of other neoclassical sculptors, were poetical, historical, or sentimental. Because marriage and a career were thought to be incompatible, they rarely married. Though they sometimes expressed feminist sentiments either personally by wearing practical clothing or professionally in their subject matter, they were not politically active. Critics wondered that there were any women sculptors at all, because sculpture, though actually executed largely by Italian workmen or sometimes by German founders, was traditionally considered a very physical and thus masculine activity.*

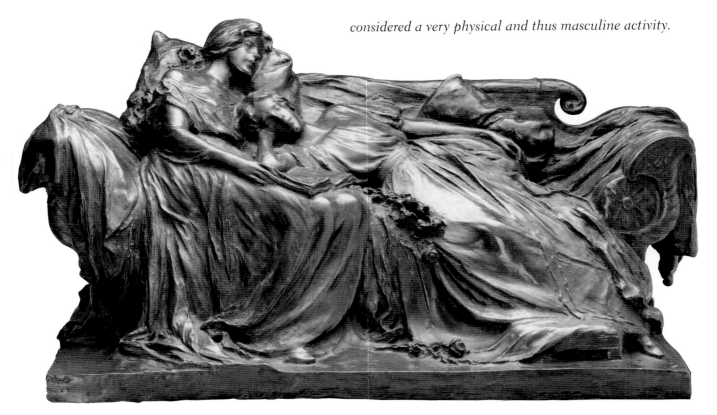

a Medium Particularly Feminine"

The diversified economies and secular, bourgeois societies that developed in the nineteenth century gradually came to favor the training of large numbers of women sculptors. In order to be professional sculptors these women had to live beyond the subsistence level; they had to have access to special training; they had to be able to function freely as individuals in the public sphere; and they had to have a market for their work. Because conditions in the United States were favorable, American women sculptors at the turn of the century were twice as numerous as women sculptors of other nationalities.[2] By the end of the century the arts, as part of "culture," were more and more associated with leisure and with the aesthetic rather than the practical side of human nature, and in the logic of that century with the feminine rather than the masculine. Women were associated with creativity if not with "genius" (a masculine and very singular noun). Critics now wondered not why there were any women sculptors but why there were so many, and the sculptor Adelaide Johnson (1859–1955) was the first to ask why were there no great women artists.[3]

The crucial decade for changing attitudes toward women sculptors, to judge by Enid Yandell's writings, seems to have been the 1890s. At the beginning of the decade Yandell, Laura Hayes, and Jean Loughborough published a fictionalized account, entitled *Three Girls in a Flat* (1892), about their experiences working on the architectural sculpture for the Woman's Building at the World's Columbian Exposition (1893) in Chicago. Mrs. Grant, the president's widow, was in Chicago for the dedication of the *Ulysses S. Grant Memorial* (1891), and when "Miss Wendell" was introduced to Mrs. Grant, she met the kind of disapproval that must have been quite common. Mrs. Grant said she didn't "approve of women sculptors as a rule," because she thought "every woman is better off at home taking care of husband and children. The battle with the world hardens a woman and makes her unwomanly." When Miss Wendell asked about an unmarried woman, Mrs. Grant said to get a husband. When Miss Wendell argued that some women needed to work to help support their families, the first lady conceded that under those circumstances that women "ought to go into the world."[4] By the end of the decade the situation was different. Yandell wrote a brief essay for a book entitled *What Women Can Earn* (1898), part of the new literature encouraging women to work outside the home. She began by noting that "there is only one reason why women with a talent for sculpture should not reach the same pre-eminence in this art as in others, and that is they do not all have the muscular strength and physical endurance which sculpture in its largest form calls for." But she then dismissed that caveat, citing the well-known success of women sculptors.[5]

By the 1890s sculpture had changed considerably. Paris rather than Rome was the center of the new style, and bronze rather than marble was the new medium. Sculpture, still figurative, lacked literary inspiration and was often allegorical. The training of sculptors was more formalized, centered in art schools, particularly in New York City and Chicago, and almost always required at least a trip to Paris. There women, who were excluded until the end of the century from the most prestigious school, the École des Beaux-Arts, studied independently with leading male sculptors or at other academies. There was a growing American market for small-scale sculpture for the home as well as for monumental works for public spaces. Both markets were actively promoted by the newly founded

50
Bessie Potter Vonnoh
(United States, 1872–1955)
DAYDREAMS
1899, bronze, 10 x 20 x 12 in.
(25.4 x 50.8 x 30.5 cm), Louise
and Alan Sellars Collection

National Sculpture Society, and a mark of the growing recognition of women sculptors was their early election to that society. A few women were notably successful in monumental commissions, but most succeeded in small-scale work, specializing in sculpture of women and children, of animals, in garden and fountain sculpture, or sometimes in portraiture or architectural sculpture. Like their male contemporaries, they enjoyed doing a variety of work but found that specialization was profitable.

There were some factors, however, which were unfavorable to women sculptors. Though certain collectors, despite changing tastes in art, have always bought fine bronzes, including those by women, it is probably correct to say that until the 1960s more women than men disappeared, so to speak, from art history. One might explain the fact partially by saying that male sculptors until the last few decades received more monumental commissions and that in spite of the influence of avant-garde and antiestablishment artists and critics in the twentieth century the values of monumentality, permanence, and forcefulness have survived and often favored the reputations of male artists, whose physical efforts have been seen as a kind of heroism in the face of physically and technically intransigent materials.

Additionally, women were perceived as amateurs rather than professionals. Anna Lea Merritt (1844–1930), a painter, complained in 1900 that there were too many women amateur artists,[6] and indeed women students attended art schools out of all proportion to the number who became professional artists. Women more than men were perceived as creating sculpture that was derivative or dependent on their teachers and at the other extreme have until recently less often been accorded the status of old master. Augustus Saint-Gaudens

(1848–1907) and Lorado Taft (1860–1936), the two male sculptors who taught and employed as assistants the most female sculptors, both had mixed feelings about the competitiveness of their female students as professional sculptors. Saint-Gaudens complained that women were copyists and not original like his male students.[7] Taft wrote that women could not do a male figure but qualified the statement in a later edition of his book *The History of American Sculpture* and indeed became in his writings an influential promoter of women sculptors.[8]

Given that there were hundreds of women sculptors by the early twentieth century, how successful were they? Success is measured in terms of both sales and reputation—what is written—during and after an artist's lifetime. By that standard women sculptors at the turn of the century were quite successful, because they not only sold their work but also received a great deal of coverage in popular and professional newspapers and magazines as "women sculptors." Writers sometimes praised their work as "feminine" or went to the other extreme and claimed that it was "virile." Both male and female critics used terms such as "delicate" and "graceful," but male writers were more apt to note the diminutive attributes of the sculptors themselves.[9] Critics sometimes saw feminine qualities in their works. Writing about Bessie Potter in 1897, Arthur Hoeber thought that a woman could be more successful than a man in sculpting female figures: "Her statuettes are purely and obviously the work of a woman. The feeling, the sentiment, and the delicacy are thoroughly feminine, but they are feminine from the psychological side entirely, for there are no traces of that weakness of artistic conception and that technical inefficiency which, it must be admitted, are frequent attributes of woman's plastic

efforts."[10] African American women received special attention, but it was often either racist or racial. American as well as French writers were very impressed with Meta Vaux Warrick Fuller's work. Early twentieth-century critics took her work as "living proof of the high capabilities of her race" but, similar to paintings by Henry Ossawa Tanner (1859–1937), characterized by "a wild, romantic spirit that reflects the life of the African jungle."[11] In the African American press, particularly during the Harlem Renaissance, her work spoke of "the very tragedy of the Negro race."[12] Though many turn-of-the-century artists objected to being classified as "women artists," they enjoyed more press coverage than did later women who were classified as "sculptors."

The literature in the early years of this century seems to have been motivated not just by the novelty of great numbers of women in what was assumed to be a male field but also by a number of other factors. Among those was a chauvinistic pride that America as a nation could produce women sculptors, though many writers noted the difficulties of succeeding in a country where both the government and the public were indifferent to art. Other factors were their competitiveness in a particular and new market for small bronzes; their success abroad; their connections to prominent male sculptors; the importance of such professional women writers as Adeline Adams, who singled them out; the influence of Taft, the author of the then-standard history of American sculpture, their limited but publicized commissions for monumental works; and most important the recognition of the quality of their work as measured, for instance, by the fact that in 1906 the Metropolitan Museum of Art in New York on the advice of Daniel Chester French started acquiring these small bronzes.[13]

Other themes or sculptural metaphors in this early literature have particular resonance when critics discuss the work of women. One is the creation or re-creation myth, in which sculpture is lifeless matter seeking to be imbued with life by the sculptor. This idea is a variant of an older metaphor, the marble resurrection, in which the sculpture, after having been "born" in clay, is reborn in stone. In writings about women sculptors, they, like mothers, have the power to bring to life dead materials such as marble and bronze. Their works, then, are like children, but rather than being creations of flesh, they are eternal and spiritual. In this creative process the sculptor discerns and then reveals what is essential, often taking unchanged and unspoiled people—French peasants or Native Americans—as their subjects because members of those groups were assumed to be closer to an essential and enduring nature and to have retained a spiritual dimension as part of their culture.

A less obvious but more intriguing sculptural metaphor is the silence of figurative sculpture: the need to make it "speak" and the unresolved question of whose voice it has. One often feels when reading interviews with the earlier women sculptors that they knew they had no voice—no public power as women—but that their works, especially those whose subjects were women, spoke for them. Fuller, like Harriet Hosmer (1830–1908) before her, sculpted Medusa, whose gaze had the power to turn men who dared look upon her to stone. Men thus became sculptures but, perhaps unlike good sculptures, were powerless and silent. Both Fuller and Nancy Prophet did sculptures about silence, and it is tempting to relate that theme to the double difficulty they faced in the United States. In a 1923 issue of the *Messenger* devoted to the problems of African

51

*Abastenia St. Leger Eberle
(United States, 1878–1942)*
WHITE SLAVE
*1913, bronze, 19¾ x 17 x 10¼ in.
(50.2 x 43.2 x 26 cm), Gloria
and Larry Silver*

American women, Ruth Whitehead Whaley wrote, "In the Negro world there is one figure [who is] the victim of a two-fold segregation and discrimination— the New Negro Woman…. She has been…taught that she, like children, must be seen and not heard…. But remember her closed doors are the thickness of two—she is first a woman, then a Negro."[14] Augusta Savage was one of the last African American women sculptors to suffer overt discrimination, but she did not have to suffer in silence. In 1923, after completing her studies at Cooper Union, she applied to study at Fontainebleau but discovered that she was denied the scholarship because two Southern women objected to her presence. When she decided to publicize the incident, it received wide coverage in every part of the press. The incident was no longer perceived as isolated, unfortunate, or socially acceptable, but as a racist pattern intended to deny equal access. As Savage wrote, "For how am I to compete with other American artists if I am not to be given the same opportunity?"[15]

The literature and criticism about "women artists" disappeared for half a century and did not reappear until the 1970s. Since then women artists past and present have received ever-increasing recognition. In both instances feminist activism inspired the recognition and was particularly beneficial to women sculptors. Indeed, there was a sense of growing liberation in the work of many women in the earlier twentieth century. In 1917 Ada Rainey noted the new athleticism and energy of much of their work and related it to the growing liberation of women.

As surely as the old shackles are being cast off, a new creativeness is to be discerned in their artistic work…. A joyous exuberance is the dominating quality…. The outcome of woman's mental emancipation is expressed

in figures dancing with joy in new-found freedom....
Women are...reaching forward to...worlds of exhilar-
ating atmosphere...that comes not from sheltered
protection, but from a vigorous spirit that has dared
venture forth into the unknown, and has conquered by
its own strength.[16]

Because many women sculptors began to
teach, younger sculptors had the benefit of advice
and help from more established ones. Several
sculptors—particularly Abastenia Eberle, Janet
Scudder (1869–1940), and Alice Morgan Wright—
were active in suffragist parades and exhibits.
Several turned to social themes, for instance,
Eberle's *White Slave* (plate 51), a protest against
prostitution, or to themes embodying their African
American heritage.[17] Most ventured to marry,
happily or not, many to other artists. Some actually
or virtually gave up their careers in favor of their
artist-spouses; others had supportive or very compet-
itive relationships with their artist-spouses; and a
few divorced.

IF WE EXAMINE figurative sculpture, we also find
gendered attitudes. In monumental public sculpture
the male is a historical figure of worldly achieve-
ment; the female is allegorical, representing some
abstract idea. We need only cite the most famous—
and since its conservation and regilding (1989–91)
most visible—example, Saint-Gaudens's *Sherman
Monument* (plate 52) in New York City, in which
the victorious general astride his horse, both figures
modeled with astounding realism, is led by a more
classically modeled Nike or Victory (whose features
incidentally were modeled upon those of the artist's
mistress). After the demise of that allegorical tradi-
tion, however, women disappeared from outdoor
sculpture except as symbolic pioneer mothers or,

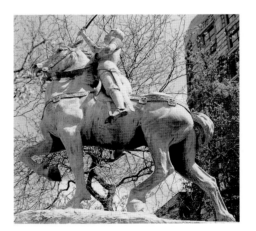

52
Augustus Saint-Gaudens
(United States, 1848–1907)
SHERMAN MONUMENT
1892–1903, gilded bronze,
168 x 172 x 72 in. (426.7 x 442 x
182.9 cm), collection of the
City of New York

53
Anna Hyatt Huntington
(United States, 1876–1973)
JOAN OF ARC
1915, bronze, 132 x 48 x 114 in.
(335.3 x 121.9 x 289.6 cm),
collection of the City of
New York

exceptionally, historic personages such as Sacajawea
or Joan of Arc (plate 53).[18] Scudder objected to the
preponderance of male subjects: "I won't add to
this obsession of male egotism that is ruining every
city in the United States with rows of hideous stat-
ues of men—men—men—each one uglier than the
other—standing, sitting, riding horseback—every
one of them pompously convinced that he is deco-
rating the landscape!"[19] If male figures reigned out-
side, however, females dominated inside, whether
in murals or small sculptures, because interior space
was a metaphor for domesticity and for inner ideas
and feelings, both feminine realms.

59

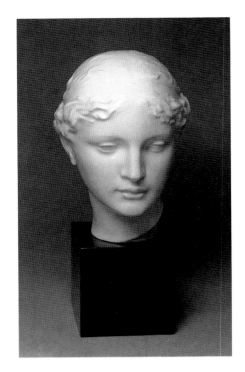

54
C. Paul Jennewein
(Germany, 1890–1978)
MEMORY
1928, glazed porcelain, 9¾ x
9 x 6½ in. (24.8 x 22.9 x 16.5
cm), Pennsylvania Academy
of the Fine Arts, Philadelphia,
Joseph E. Temple Fund

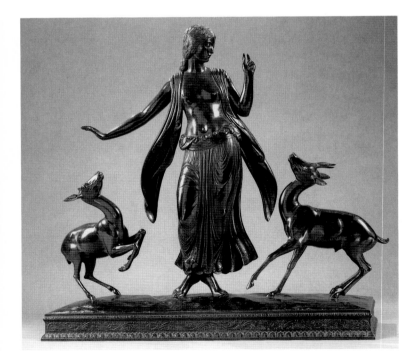

55
Paul Manship
(United States, 1885–1966)
DANCER AND GAZELLES
1916, bronze, 32½ x 34¾ x 11¼
in. (82.6 x 88.3 x 28.6 cm),
National Gallery of Art,
Washington, D.C., gift of
Mrs. Houghton P. Metcalf

As for the use of the female figure in small sculptures, such as those by male sculptors in this exhibition, we find some sculptors relied upon ancient traditions, while others were influenced by more recent ideas of sexuality. C. Paul Jennewein's *Memory* (plate 54) continues the allegorical tradition of the American Renaissance.[20] Others used the female as symbols of love, beauty, and both human and earthly fertility, embodied in Aphrodites, Dianas, and Ceres, as in John Flannagan's groups of mothers and their children. Again, corresponding to a long sculptural tradition, the female was associated with rhythm, the dance, and natural grace, as in Paul Manship's *Dancer and Gazelles* (plate 55) or Jennewein's *Greek Dance* (plates 3–4). Manship's *Centaur and Dryad* (1913) or Waylande Gregory's *Europa* (plate 56), who was carried off by Zeus in the guise of a white bull, embody in their classical subjects ideas of male desire.

As the older sculptural traditions were replaced by a modernist aesthetic, the traditional distinctions between the male figure embodying "masculinity" and the female "femininity" were exaggerated to embody opposing rather than complementary forces. Beginning with the late nineteenth-century symbolists and continuing with the cubists and other modernists before World War I, the female was identified with nature, the male with culture. As Mark Antliff has noted, "By associating the female reproductive processes with [Henry] Bergson's concept of the *élan vital*, these artists defined feminine creative capacities as synonymous with those found in nature, thereby denying women the power to realize that creative potential in spheres of cultural production, such as art."[21] Though we do not find such ideas articulated in the literature of American sculpture, we do see

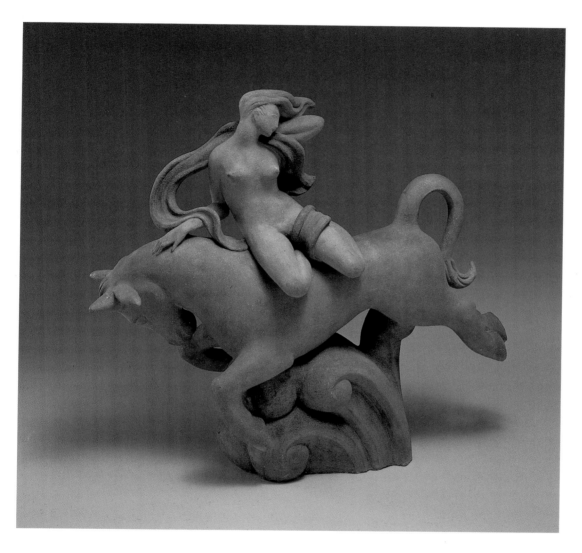

56
Waylande Gregory
(United States, 1905–71)
EUROPA
1938, unglazed earthenware,
23¾ x 27 x 9½ in. (60.3 x 68.6 x
24.1 cm), Everson Museum of
Art, Syracuse

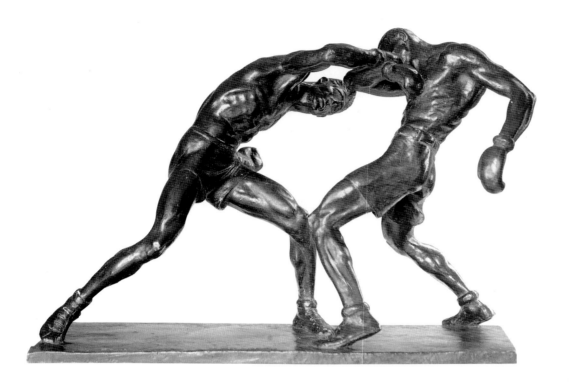

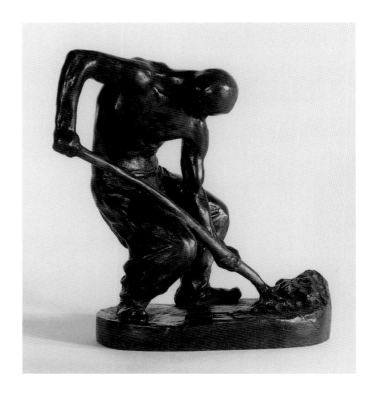

57
Mahonri Young
(United States, 1877–1957)
RIGHT TO THE JAW
c. 1926–27, bronze, 14⅛ x
19¹¹⁄₁₆ x 8 in. (35.9 x 50 x 20.3
cm), The Brooklyn Museum,
Robert B. Woodward Memorial
Fund

58
Mahonri Young
(United States, 1877–1957)
LABORER *(also known as*
THE SHOVELER III)
1903, bronze, 10¼ x 9 x 7 in.
(26 x 22.9 x 17.8 cm), Sheldon
Memorial Art Gallery,
University of Nebraska,
Lincoln, F. M. Hall Collection

the female figure associated with nature and the male with culture in sculpture as well as in painting. For instance, the female nude in the work of Gaston Lachaise is a mountain, strong and curvaceous; in Robert Laurent, a wave, surging forward; in José de Creeft, a cloud, soft, mysterious, and unpredictable. The male expresses the ideal of rugged and aggressive masculinity, as in Mahonri Young's boxers, *Right to the Jaw* (plate 57). At the turn of the century a European tradition of social realism, in which realistically modeled, posed, and clothed male figures symbolize labor—and often its exploitation—took root in America. Young's *Tired Out* and *Laborer* (plates 36, 58) and Max Kalish's *Steel into the Sky* (plate 59) represent this tradition. Male figures are used in all pointedly political works, for instance, Robert Cronbach's *Exploitation* (plate 110).

There is a further consideration: the freedom male artists felt in taking liberties and experimenting with the female figure. Beginning with neoclassical sculpture, such as Hiram Powers's *The Greek Slave* (plate 60), modeled in the 1840s, male sculptors perceived the female nude not just as an important subject for ideal sculpture but a field upon which they could inscribe their fantasies of desire, dismemberment, and power. Rodin's works in the nineteenth century popularized the dismembered or partial figure, which resembled antique fragments and allowed sculptors to concentrate on the sensuous and sexual female torso with its sculptural bumps and hollows, as in Arthur Lee's *Volupté* (plate 61).[22] Alexander Archipenko made a partial figure the subject of weightless elegance in *Torso in Space* (plate 6); in Lachaise's *Torso* (plate 48B) the buttocks become an almost frightening if somewhat humorous fetish. Beyond the sensuous

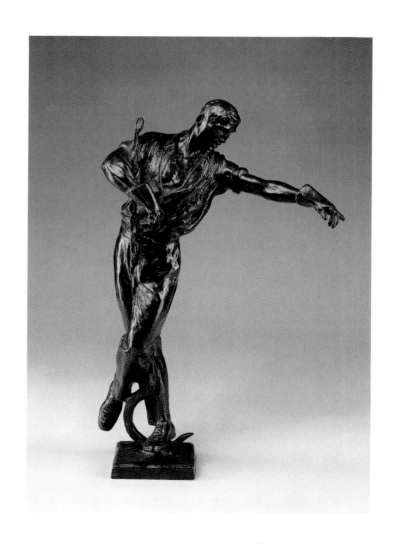

59
Max Kalish
(Russia, 1891[?]–1945)
STEEL INTO THE SKY
1932, bronze, 18¾ x 11 x 4½ in.
(47.6 x 27.9 x 11.4 cm),
The Cleveland Museum of Art,
gift of friends of the artist

63

60

Hiram Powers

(United States, 1805–73)

THE GREEK SLAVE

c. 1843, marble, 65¼ x 21 x

18¼ in. (165.7 x 53.3 x 46.4 cm),

Yale University Art Gallery,

New Haven, Olive Louise

Dann Fund

61

Arthur Lee

(Norway, 1881–1961)

VOLUPTÉ

1915, marble, 38⅜ x 15 x 10 in.

(97.5 x 38.1 x 25.4 cm), The

Metropolitan Museum of Art,

given anonymously, 1924

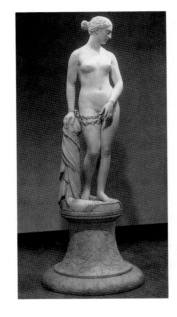

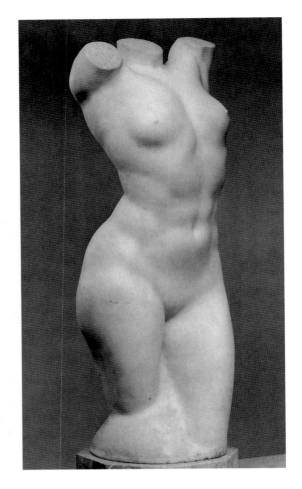

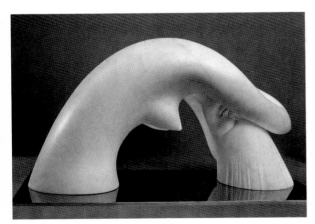

62

Hugo Robus

(United States, 1885–1964)

GIRL WASHING HER HAIR

1940, marble and glass mirror,

17 x 28⅜ x 12¾ in. (43.2 x

72.7 x 32.4 cm), The Museum

of Modern Art, Abby Aldrich

Rockefeller Fund

associations of female nudes, we also notice that it is the female figure that offers great freedom to experiment, whether humorously as in Hugo Robus's *Girl Washing Her Hair* (plate 62) or in cubist experiments, such as Boris Blai's *Triangle Girl* (plate 63), or in more abstract forms, such as Noguchi's *Leda* (plate 64). One might argue that these gendered visions gave male sculptors the freedom to experiment with modernist idioms and to produce, at least in the case of Archipenko and Noguchi, their strongest work.

Did women sculptors choose different subjects or treat their subjects differently? Neoclassical women sculptors tended not to use the female nude for their ideal works, though they sometimes used the male nude, as Hosmer did in her *The Sleeping Faun* (plate 65). Women sculptors at the turn of the century used both the partial and full-length female nude. Yandell's *Kiss Tankard* (plate 66), which is consciously sensuous and salable, is an example of

the latter. Several women sculptors in the twentieth century used the female nude, particularly adolescent figures (and often children) in sometimes coy poses, particularly for fountains, but several successful sculptors used the figures for the expression of physical and artistic prowess and even physical and psychological liberation. Malvina Hoffman was obsessed with Anna Pavlova, but her sculptures, such as *Russian Dancers* (plate 67) with Pavlova and Mikhail Mordkin, were about the physical and artistic achievements of a great modern dancer as well as about her obsession. Harriet Frishmuth

63
Boris Blai
(Russia, 1890 or 1898–1985)
TRIANGLE GIRL
c. 1928, mahogany, 12¾ x 8½ x
9¼ in. (32.4 x 21.6 x 23.5 cm),
The Metropolitan Museum of
Art, Hugo Kastor Fund, 1983

64
Isamu Noguchi
(United States, 1904–88)
LEDA
1928 (reconstructed, 1985),
brass on plastic base, 23⅜ x
14¼ x 11 in. (59.4 x 36.2 x
27.9 cm), The Isamu Noguchi
Foundation, Inc., New York City

65
Harriet Hosmer
(United States, 1830–1908)
THE SLEEPING FAUN
After 1865, marble, 34½ x 41 x
16½ in. (87.6 x 104.1 x 41.9 cm),
Museum of Fine Arts, Boston,
gift of Mrs. Lucien Carr

66
Enid Yandell
(United States, 1870–1934)
KISS TANKARD
c. 1899, bronze, 11½ x 7 x
5½ in. (29.2 x 17.8 x 14 cm)
Museum of Art, Rhode Island
School of Design, Providence,
gift of Miss Elizabeth Hazard

used well-developed dancers, usually female but sometimes male. The females are often posed in upward-reaching or stretching postures, expressing ecstatic emotions in what can be interpreted as images of liberation, such as *The Vine* (plate 68), but her male dancers, such as *A Slavonic Dancer* (plate 26), are posed in more stylized and earth-bound poses.

Again in the nineteenth century, beginning with Hosmer's *Beatrice Cenci* (1856) and *Zenobia in Chains* (plate 69), representing, respectively, sexual abuse and captivity, women sculptors were more apt to sculpt clothed female figures.[23] After the World's Columbian Exposition Potter made a successful career sculpting women, but her best-selling bronzes wore rather Grecian contemporary costumes and embodied acceptable notions of

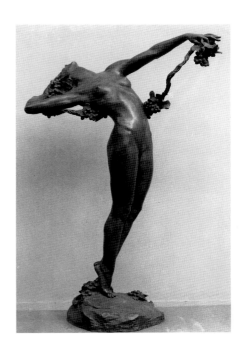

67
Malvina Hoffman
(United States, 1885–1966)
RUSSIAN DANCERS
1910, bronze, height: 10½ in.
(26.7 cm), private collection

68
Harriet Frishmuth
(United States, 1880–1980)
THE VINE
1923, bronze, 83½ x 49⅝ x
28½ in. (212.1 x 126.1 x 72.4 cm),
The Metropolitan Museum of
Art, Rogers Fund, 1927

69
Harriet Hosmer
(United States, 1830–1908)
ZENOBIA IN CHAINS
1859, marble, height: 49 in.
(124.5 cm), Wadsworth
Atheneum, Hartford, gift of
Mrs. Josephine M. J. Dodge

femininity. In *Daydreams* (plate 50; modeled 1899, the year she married and began exhibiting as Bessie Potter Vonnoh) the subject, whether about female fantasies, the socially acceptable physical closeness of women, or the leisurely life of middle-class women, depended on popular late nineteenth-century paintings by male artists. Except for her nude protest about prostitution, Eberle clothed her women in contemporary dress in her genre sculptures. Ethel Myers had a short career modeling humorous statuettes of women in exaggerated contemporary fashions. She said of her work, "The shams in American life are proclaimed by women nowadays."[24]

There are other, more subtle differences. When women sculptors did traditional subjects, their emphasis was often altered. For instance, Eberle's *Girls Dancing* (plate 70) is an image of street children in awkward, even raucous motion, lacking the natural grace that dancers typically

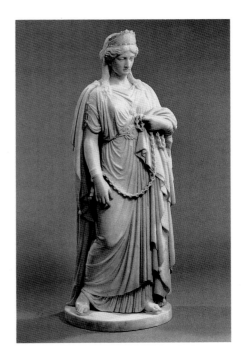

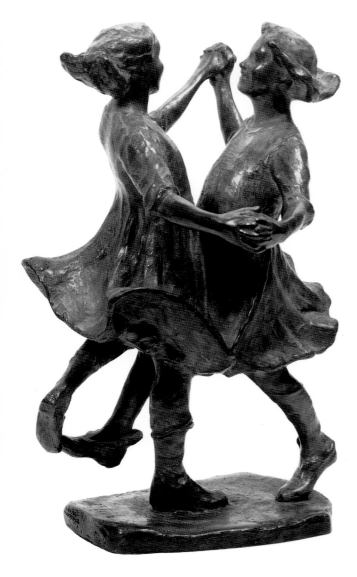

70

Abastenia St. Leger Eberle
(United States, 1878–1942)
GIRLS DANCING
1907, bronze, 11¼ x 7 x 7½ in.
(28.6 x 17.8 x 19.1 cm), in the
collection of The Corcoran
Gallery of Art, Washington,
D.C., bequest of the artist

personify. Fuller's early sculptures are unusual in their sculptural complexity and psychological pessimism. As she described *The Wretched* (plate 34),

There is the woman who suffers from loss—her child or a loved one, she reaches out over a space in a vain attempt to regain it. There is the man who hides his face in shame. The old man ready to die in poverty in his old age. The youth who realizes the task before him, he can never complete. The child suffers from some hereditary malady and the woman of some distress of mind. Topping them all is the philosopher who suffers through his understanding and sympathy; so you see there is no glint of hope in any of these.[25]

Her later work is in keeping with the ideals of the Harlem Renaissance, and indeed *The Awakening of Ethiopia* (plate 71) seems to be one of the earliest manifestations of that movement. The African American women differed from other female sculptors in several ways. They faced greater difficulties as sculptors in the United States; they valued the freer atmosphere of Paris even more; and beginning in the 1910s they had the active and enthusiastic support of Harlem Renaissance leaders, writers, patrons, and organizations. They became part of a broad social movement that valued and publicized their work, whether racial or not, as a distinctive cultural contribution.

IN THE 1920S, as before, many sculptors chose ethnic themes. Eugenie Shonnard, Hoffman, and Prophet depicted Native Americans and Africans, emphasizing their subjects' reserve and inwardness and by underscoring their passivity, conveying the ability of these races to endure. Rather than attempting to identify with tribal cultures by imitating or adapting indigenous arts the way Paul Gauguin (1848–1903) had, the women seem to have

sympathized with but respected the uniqueness of the individuals and cultures they modeled. Their intentions, however, differed. Shonnard, in the tradition of earlier sculptures of Native Americans, was a preservationist. She was encouraged by Edgar L. Hewett, the director of the Archaeological Institute of America at the School of American Research in Santa Fe, who was apprehensive that "this native American culture, which in so many ways has been without equal in the world and in all time, is destined to be lost." He thought she could preserve it "in its purity in the life."[26] To Hoffman successful sculpture was putting "one fragment of humanity into the universal language of art...that is bigger than states or nations or races."[27] Prophet thought that racial values were too limiting for great sculpture. A writer in *The Crisis*, the magazine of the National Association for the Advancement of Colored People, still took her as a model: "She stands today as one of the most promising figures in American sculpture without regard to color or race, and as such she should be an inspiration to every American artist, who handicapped by color, is turned aside by poverty and prejudice."[28]

In the decades under consideration there were two very different generations of sculptors. Turn-of-the-century sculptors such as Vonnoh, Eberle, and Myers specialized in small sculptures for a middle-class market, bronzes they began by model-ing in clay or wax and ended by sending to be cast in foundries. Sometimes, as in the case of Fuller, they actually succeeded in exhibiting and selling works in Paris. The 1920s were the time of transi-tion in sculpture, when older sculptors, such as Frishmuth, continued successfully to sell their ele-gant bronzes, but younger sculptors began working

directly, carving wood or stone. Unlike Chaim Gross, who preferred the hardest wood, lignum vitae, they did not delight in the resistance of the materials but rather in the color and texture. In addition to crafting their works themselves, they sold them in a more general market for "contemporary" or "modern" sculpture and generally received only brief notices in group or solo exhibitions. In this transition to a modern idiom women sculptors were not conservatives, for the truly conservative sculptors between the wars were the men who, having studied at the American Academy in Rome, produced archaizing academic work such as the pediments for the Philadelphia Museum of Art. Only Hoffman received this kind of commission— at Bush House in London.

After the suffrage amendment was passed in 1920, women's organizations continued to press for equal rights, but the years between the wars were, in the words of Lois Scharf and Joan M. Jensen, the "decades of discontent."[29] Though it became increasingly acceptable for unmarried women to work, the only clear artistic voice for feminism was Georgia O'Keeffe's. In 1930 O'Keeffe debated Mike Gold, the champion of proletarian literature, and O'Keeffe probably spoke for many women. Gold declared that "the struggles of the working class... [are] the only possible subject" for great art. O'Keeffe asked, "When you name the oppressed, do you include women?" Gold thought that the rights of bourgeois women were irrelevant and replied that the "class struggle includes and engulfs both sexes." O'Keeffe said she was "interested in the oppression of women of all classes" and that her "social con-sciousness, social struggle" consisted in "trying with all my skill to do painting that is all of a woman, as well as all of me."[30]

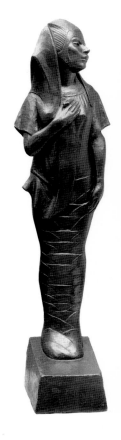

71
*Meta Warrick Fuller
(United States, 1877–1968)*
THE AWAKENING OF
ETHIOPIA
*1914, bronze, 67 x 16 x 20 in.
(170.2 x 40.6 x 50.8 cm),
Schomburg Center for Research
in Black Culture, New York
Public Library*

Because of the decline in the private art market, radical politics, and government patronage of the arts, the 1930s were quite different. The monument and the small bronze, both expensive and at variance with the aesthetics of modernity, virtually ceased to exist and with them many sales or commissions. The leftist politics of the period favored working-class subjects, and a few women made distinctive contributions to social realism. Emma Lu Davis, who first experimented with simplification while working in Buckminster Fuller's Dymaxion Factory, in 1935 went to the Soviet Union to observe art under communism. From Russia in 1936 she traveled to China, where she presumably carved and exhibited *Chinese Red Army Soldier* (plate 147). The walnut head is a unique statement of political sympathies. Severed at the neck but rough and colorful, her work is very unlike Constantin Brancusi's elegant female heads, such as his famous *Sleeping Muse* (plate 72).

72
Constantin Brancusi
(Romania, 1876–1957)
SLEEPING MUSE
1910, bronze, 6¾ x 9½ x 6 in.
(17.2 x 24.1 x 15.2 cm), The
Metropolitan Museum of Art,
the Alfred Steiglitz Collection,
1949

73
Berta Margoulies
(Poland, b. 1907)
MINE DISASTER
1942, bronze, 22¾ x 29⅛ x
12¼ in. (57.8 x 74 x 31.1 cm),
Whitney Museum of American
Art, purchase

74
Eugenie Gershoy
(Russia, 1901–86)
THE WEIGHT LIFTER
1940, polychromed plaster
and wire, 17½ x 13¾ x 11½ in.
(44.5 x 34.9 x 29.2 cm),
collection of Mrs. Daniel
Cowin

Berta Margoulies was a social realist, choosing the theme of anxious women waiting behind a gate for news of a mine disaster (plate 73). The women are in their own sphere, cut off from the male world of the mine, which was a more popular subject in paintings by men.

The federal art projects favored murals over sculpture, because they were far less expensive but still offered important opportunities to younger sculptors. Married women were not allowed to apply for work on the WPA/Federal Art Project, the largest of all the art projects, but they got around that regulation by using their own names. Women sculptors were particularly imaginative in creating pieces that were inexpensive, colorful, and attractive to the public for whom the works were intended. Eugenie Gershoy's painted papier mâché and plaster figures were sometimes intended to accompany murals in children's libraries decorated by the WPA/FAP. Her weight lifter (plate 74) is light, playful, and colorful. When compared with Alexander Calder's visual pun on weight and weightlessness in his wire sculpture, we note that however playfully or realistically Calder's "Atlas" in the Whitney Museum's *The Brass Family* (1927) supports a pyramid of circus acrobats, it remains a patriarchal image. Gershoy noted that "the chaos in the economic and social world in which we live has emphasized in art the fantastic, the satirical, and the humorous."[31]

An outgrowth of artists' militancy and federal patronage in the 1930s was the increasing number of artists' organizations. Unlike earlier periods women were numerous and important founding members of groups that promoted modernist work. A member of the American Abstract Artists, Gertrude Greene (1901–56) was one of the first Americans to experiment with the painted relief that was such an important part of abstraction from the mid-1930s to the mid-1940s. Many women joined in the first exhibition in 1938 of the Sculptors Guild, dominated by direct carvers.[32]

The work of the younger women in the 1930s is of unusual interest, often exhibiting strong personal tastes and inclinations as well as social ideas. Marion Walton's work is serious and psychological but has an elegant sculptural quality that is often lacking in rough carvings of porous stone. In sculpting *Alone* (plate 75), the artist recalls she felt very alone while at the Brearley School, particularly because her older sister did not approve of her desire to be an artist.[33] *Alone* is an interesting matriarchal figure that includes self-criticism in the form of barking dogs rather than the children one might expect. It might also be interpreted as a statement of a modern sculptor who feels the barking dogs of tradition at her feet. Anita Weschler, who also did pointedly social work, echoed a modernist aesthetic

75
Marion Walton
(United States, b. 1899)
ALONE
1932, stained mahogany, 32⅞ x
9 x 8 in. (83.5 x 22.9 x 20.3 cm),
the Mitchell Wolfson, Jr.,
collection, courtesy, the
Wolfsonian Foundation,
Miami Beach, Florida, and
Genoa, Italy

of "less is more" when she wrote of her work,
the basis of all art and living is in selection, or to put it
conversely, elimination.... My thought in executing
groups is to suppress all detail, all extraneous material,
to reduce the forms to their lowest terms. The eye can
grasp only so much at a time and the impact is greater if
the essentials are not disturbed by dissenting shapes, if
the planes are clean-cut and their edges clearly defined.[34]

While earlier generations of women sculptors succeeded for the first time in large numbers, later generations made the transition to a modern idiom as sculptors rather than as women sculptors. The next chapter in the history of American women sculptors began in the late 1940s. New York School artists were inspired by surrealism rather than realism. Abstraction replaced figuration, and direct metal replaced direct carving. Though some women, particularly those associated with the Sculptors Guild, worked in direct metal, they lacked the engineering background of Calder or the industrial experience, which along with Pablo Picasso (1881–1973) and Julio Gonzalez (1876–1942), had inspired David Smith. Louise Nevelson (1899–1988) in her early work consciously avoided metal as a masculine, warlike, and industrial material. She and Louise Bourgeois (b. 1911) were both artistically active in the 1930s; beginning in the late 1940s their wooden constructions had an originality that provided an alternative to the industrial metal sculptures of their male colleagues and opened a new and different chapter in the history of women sculptors. Previously women, like most successful sculptors, had made distinctive and individual contributions to styles that had been pioneered by a few male sculptors, but Nevelson and Bourgeois prepared the way for a distinctively feminist sculpture that was apparent in the 1960s and received widespread recognition in the 1970s.

Notes

The title of this essay comes from a statement by Ada Rainey: "Sculpture has never been thought a medium particularly feminine; that so many women should recently have chosen it for their own is significant.... It now seems that the vital changes that are taking place in ideals, in thought, and in mode of living are being reflected in the quality of work accomplished by women" ("American Women in Sculpture," *Century Illustrated Monthly Magazine* 93 [January 1917]: 432).

1 For a recent, complete history see Charlotte Streifer Rubinstein, *American Women Sculptors: A History of Women Working in Three Dimensions* (Boston: Hall, 1990).

2 Lisa Wizenberg and I counted the entries in Chris Petteys et al., *Dictionary of Women Artists: An International Dictionary of Women Artists Born before 1900* (Boston: Hall, 1985), and found more than five hundred American and more than two hundred French women sculptors, followed in number by the English and then Germans.

3 Adelaide Johnson in an address to the International Council of Women (1904). She concluded that women had had as yet few years to evolve as artists. See Ann Lyman Henderson, "Adelaide Johnson: Issues of Professionalism for a Woman Artist," Ph.D. diss., George Washington University, 1981, p. 15. Compare the better-known essay by Linda Nochlin, "Why Have There Been No Great Women Artists?" in *Woman in Sexist Society: Studies in Power and Powerlessness*, ed. Vivian Gornick and Barbara K. Moran (New York: Basic, 1971), pp. 344–46.

4 Enid Yandell, [Jean Loughborough], and Laura Hayes, *Three Girls in a Flat: The Story of the Woman's Building* (Chicago: Knight, Leonard, 1892), pp. 104–5.

5 Enid Yandell, "Talent for Sculpture," in Grace H. Dodge et al., *What Women Can Earn: Occupations of Women and Their Compensation* (New York: Stokes, 1898), pp. 226–28.

6 Anna Lea Merritt, "A Letter to Artists, Especially Women Artists," *Lippincott's Monthly Magazine* 65 (March 1900): 463–69; reprinted in *Love Locked Out: The Memoirs of Anna Lea Merritt*, ed. Galina Gorokhoff (Boston: Museum of Fine Arts, 1982), pp. 233–38. She also said that women's virtues were their limitations and that they suffered from not having wives.

7 Homer Saint-Gaudens, *The Reminiscences of Augustus Saint-Gaudens* (New York: Century, 1913), 2:4: "I noticed what others have discovered before me, that unquestionably women learn more rapidly than men, but that subsequently men gain in strength and proceed, whereas women remain, making less progress. Men always seem to compose better than women, and are more creative. Women can more easily copy what is before them."

8 Lorado Taft, *The History of American Sculpture* (New York: Macmillan, 1903, 1924; reprinted, Arno, 1969), pp. 214, 490–91, speaking of Anne Whitney's *Samuel Adams* (1876, 1880) but adding of Theo Alice Ruggles Kitson's *Volunteer* (1902) that he was "almost compelled to qualify the somewhat sweeping assertion."

9 Articles appeared in three different markets: art, general interest, and women's magazines. Articles in art magazines were more critical of any sculpture. The more sexist articles appeared in general magazines; the more boosterish, in women's magazines.

10 Arthur Hoeber, "A New Note in American Sculpture: Statuettes by Bessie Potter," *Century Illustrated Monthly Magazine* 54 (September 1897): 735. He thought until he saw Potter's sculpture that women's work derived from men's.

11 "A Negress Sculptor's Gruesome Art," *Current Literature* 44 (January 1908): 55.

12 Benjamin Brawley, "Meta Warrick Fuller," *The Southern Workman* 47 (January 1918): 32.

13 Clarence Hoblitzell, "Collection of Bronzes in the Metropolitan Museum," *The Sketch Book* 6 (December 1906): 183–88. The women sculptors were Anna Vaughn Hyatt Huntington, Janet Scudder, and Bessie Potter Vonnoh.

14 Ruth Whitehead Whaley, "Closed Doors: A Study in Segregation," *Messenger* 7 (July 1923): 772; quoted in Ernest Allen, Jr., "The New Negro: Explorations in Identity and Social Consciousness, 1910–1922," in Adele Heller and Lois Rudnick, eds., *1915: The Cultural Moment* (New Brunswick: Rutgers University Press, 1991), p. 51.

15 "Augusta Savage on Negro Ideals," *New York World*, 20 May 1923; courtesy, Hope Finkelstein.

16 See Rainey, "American Women in Sculpture," pp. 432, 434.

17 Susan P. Casteras, "Abastenia St. Leger Eberle's *White Slave*," *Woman's Art Journal* 7 (spring–summer 1986): 32–36.

18 See, for instance, Marion E. Gridley, *America's Indian Statues* (Chicago: Amerindian, 1966). For the moment we cannot say how many monuments are dedicated to historic women. Save Outdoor Sculpture (SOS), a joint project of the Smithsonian Institution's National Museum of American Art (NMAA) and the National Institute for the Conservation of Cultural Property, is currently surveying all outdoor sculpture in the United States. The information has been added to the Inventory of American Sculpture, a database available through the NMAA, the Archives of American Art, and Internet.

19 Janet Scudder, *Modeling My Life* (New York: Harcourt, Brace, 1925), p. 155.

20 See Richard Guy Wilson, et al., *The American Renaissance, 1876–1917* (New York: Brooklyn Museum, 1979), an exhibition catalogue whose essays define the period in both the fine and decorative arts.

21 Mark Antliff, *Inventing Bergson: Cultural Politics and the Parisian Avant-Garde* (Princeton: Princeton University Press, 1993), p. 70; see pp. 94–100 for male athletes. The analogy was first noted by Sherry Ortner, "Is Female to Male as Nature Is to Culture?" in *Woman, Culture, and Society*, ed. Michelle Zimbalist Rosaldo and Louise Lamphere (Stanford: Stanford University Press, 1974), pp. 67–87. In America there was a cult of masculinity emanating from Robert Henri's teachings; see Marianne Doezema, *George Bellows and Urban America* (New Haven: Yale University Press, 1992), pp. 15–18, 75.

22 Albert E. Elsen, *The Partial Figure in Modern Sculpture from Rodin to 1969*, exh. cat. (Baltimore: Baltimore Museum of Art, 1969), with many examples of female figures.

23 See Dolly Sherwood, *Harriet Hosmer: American Sculptor, 1830–1908* (Columbia: University of Missouri Press, 1991), pp. 128–35, 231–32.

24 "Fifth Avenue Types Wrought in Bronze by Woman Sculptor," *New York Evening Sun*, 17 January 1913, photocopy in the files of Myers's grandson, Barry Downes (also in Ethel Myers scrapbook, Ethel Myers papers, on microfilm, reel N68–6, frame 642, Archives of American Art).

25 Meta Vaux Warrick Fuller to C. R. Dolph, 13 February 1949, in Alma Spreckels correspondence, archive, Maryhill Museum of Art, Goldendale, Washington.

26 Edgar L. Hewett to Eugenie Shonnard, 31 October 1931, in Eugenie Frederica Shonnard papers, historical manuscript collection, Museum of New Mexico, Santa Fe.

27 Mildred Adams, "Malvina Hoffman, Sculptor," *The Woman Citizen* 9 (18 April 1925): 9.

28 "Can I Become a Sculptor? The Story of Elizabeth Prophet," *Crisis* 23 (October 1932): 315.

29 Lois Scharf and Joan M. Jensen, eds., *Decades of Discontent: The Women's Movement, 1920–1940* (Boston: Northeastern University Press, 1987).

30 Georgia O'Keeffe, quoted in Gladys Oaks, "Radical Writer and Woman Artist Clash on Propaganda and Its Uses," *New York World*, 16 March 1930, women's sec., 1, 3; courtesy, Sarah Whitaker Peters.

31 Eugenie Gershoy, "Fantasy and Humor in Sculpture," in *Art for the Millions: Essays from the 1930s by Artists and Administrators of the WPA Federal Art Project*, ed. Francis V. O'Connor (Greenwich, Conn.: New York Graphic Society, 1973), pp. 92–93.

32 For a recent account, see Evelyn Berstein [sic], *The Coming of Age of American Sculpture: The First Decades of the Sculptors Guild, 1930s–1950s*, exh. cat. (Hempstead, N.Y.: Hofstra Museum, Hofstra University, 1990).

33 Marion Walton, interview with the author, 29 January 1992.

34 Anita Weschler, "A Sculptor's Summary," *Magazine of Art* 32 (January 1939): 27.

"Mere Beauty No Longer Suffices":
The Response of Genre Sculpture

WRITING IN THE SPIRIT OF WALT WHITMAN, *the midwestern realist Hamlin Garland*

encouraged his turn-of-the-century contemporaries to throw off the tyranny of the classics

in search of American themes.¹ He did not have long to wait. Genre art (the realistic depiction

of everyday life) emerged as a vanguard artistic expression in scenes of lower- and middle-

class New York City life that Robert Henri (1865–1929) and his Ashcan school colleagues

painted at the beginning of the twentieth century. Genre painting's three-dimensional

counterpart arose shortly thereafter, and its emergence marked the first significant break with

the type of imagery that traditionally had been considered appropriate subject matter.

Sculptural representation of daily life had experienced popular success during the second half of the nineteenth century in the work of John Rogers (1829–1904) (plate 77). From 1859 to 1893 he sold some eighty thousand small-scale, painted plaster reproductions, presenting in an easily understood narrative format images of middle-class Americans engaged in commonplace activities. Produced in an inexpensive material, the statuettes were affordable to the general public. Aside from the Rogers groups, however, genre depictions were sporadic, limited to an occasional bronze figurine of a craftsmen or athlete, often designed by a minor artist or artisan as a trophy.

Not until the first decades of this century did genre sculpture attract artists in large numbers as a means of expressing progressive ideas. The gentility and naivete of the middle class in the Victorian era was about to end as the United States entered the modern age. The first modern-day genre sculpture extended Rogers's perception of American

76
Isamu Noguchi
(United States, 1904–88)
DEATH (*also known as*
LYNCHED FIGURE; *detail*)
1934; Monel metal, wood, rope,
and steel armature; The Isamu
Noguchi Foundation, Inc.,
New York City

77

John Rogers
(United States, 1829–1904)
A MATTER OF OPINION
1884, painted plaster, 21 x 16½
x 12 in. (53.3 x 41.9 x 30.5 cm),
Los Angeles County Museum
of Art, gift of Pearl Field in
memory of Isidor Tumarkin

life—innocuous, bourgeois subject matter presented straightforwardly and sometimes with an overlay of romanticism—but during the period 1890 to 1945 the country experienced massive demographic, economic, technological, and consequently social changes, and genre sculpture mirroring current attitudes and activities soon reflected these transformations.

Early twentieth-century genre sculpture tended to a large extent to be created by a new breed of artists from outside the mainstream. The majority of sculptors had been white males from eastern backgrounds, whereas many of the genre specialists hailed from the midwestern and western states and often spent some, if not all, of their mature careers in cities far from the eastern seaboard. Moreover, several of the first were women, and women would constitute at least a third of the practitioners in the field throughout the decades. By the 1910s genre sculptors had also emerged from ethnic, religious, and racial groups not previously notably represented. About half were immigrants or children of immigrants, and some were poor.

These new sculptors brought with them life experiences and attitudes different from those of their predecessors. They perceived their predecessors' idealized subject matter as elitist and quickly rejected it. Their sculpture not only reflected their cultural heritage and social class but also projected their dreams for a better future. Consequently, in their hands genre became a tool for social commentary and even change.[2] It was specifically because these women, westerners, African Americans, and immigrants were outside mainstream art circles or at best on their fringes that they were less inhibited than their established counterparts and could more readily break with tradition. As a whole, genre sculpture came to represent twentieth-century America; and the sculptors, democracy's emergent constituency.

HISTORIANS HAVE traditionally dated modern genre sculpture to the first twenty-five years of the century. Genre was actually a potent force in American sculpture much longer, however, not disappearing until World War II. Interest did diminish during the mid-1920s but was fully revived with the emergence of the American scene aesthetic and the populist ideology promoted by the federal art projects of the Great Depression. The development of genre sculpture thus falls into two principal periods separated by a brief interlude. Certain themes—labor, the role of women in society, urban life, entertainment, and war—continued to concern sculptors throughout the decades; differences in sculptures from these two eras are chiefly a matter of interpretation.

At the turn of the century most American sculptors strove to achieve success by winning commissions for large public monuments of a commemorative nature. Three who initiated a departure from such pursuits, preferring to establish their

reputations with small-scale genre sculpture, were women: Abastenia Eberle, Ethel Myers, and Bessie Potter Vonnoh. The realistic bronzes of all three represented the activities of women. Both Myers and Vonnoh expressed a personal view of upper- and middle-class life. The latter attended to its intimate, domestic side; the former, to its public face. Vonnoh came from a comfortable midwestern family, and her figurines (plate 50), usually of young, attractive, and well-attired women, are the sculptural counterparts of those in contemporary paintings by Thomas Dewing (1851–1938) and the Boston school. Like Vonnoh, whose childhood was sheltered due to illness, they exist in a domestic world untouched by harsh realities. They have the financial freedom to relax and enjoy the company of their children, and in their emphasis on grace and refinement they remain within the boundaries of late nineteenth-century, upper-class gentility.

After 1903 Vonnoh increasingly dressed her ladies in long, simple gowns suggestive of Grecian tunics. Such costumes had been adopted by dancers such as Isadora Duncan and represented a reform movement aimed at freeing American women from the constrictions of traditional dress.[3] The realist novelist William Dean Howells remarked of Vonnoh, "Her work, while it is Greek as the Tanagra figurines, is utterly and inalienably American…and perfectly modern…. It gets into sculpture the thing I am striving to get into fiction."[4] As Vonnoh explained, "I was a radical in art…. What I wanted was to look for beauty in the every-day world, to catch the joy and swing of modern American life."[5]

Myers was likewise alert to fashion, portraying society ladies dressed in up-to-date finery. Whereas Vonnoh's portrayal was sympathetic, a woman artist at ease with her gender and class, Myers adopted

a satirical stance, poking fun at her gender's slavish devotion to modish attire (plate 78). Such humor would only sporadically appear in genre sculpture.

Despite the interests of these two artists, the majority of American genre sculpture was devoted to the lower social strata. Eberle pioneered in this field with images of the poor of New York City. She had experienced financial hardship herself and therefore felt a bond with the urban poor. A follower of Jane Addams, founder of Hull House in Chicago, Eberle embraced the political ideals

78
Ethel Myers
(United States, 1881–1960)
FIFTH AVENUE GIRL
(also known as PORTRAIT
IMPRESSION OF MRS.
ADOLPH LEWISOHN)
1912, bronze, 8¾ x 2⁹⁄₁₆ x
2⁹⁄₁₆ in. (22.2 x 6.4 x 6.4 cm),
Gary and Brenda Ruttenberg

of the Progressive movement.[6] In her view art had to be rooted in life; the artist, the watchful eye of society: "Ugliness, as well as beauty, is in the eyes of the beholder—and the present isn't ugly at all, but full of a wonderful interest, as a few of us are beginning to find out."[7] In bronzes from 1906 to 1920 Eberle depicted street urchins (plate 70), the pleasures of the seashore, and women occupied with domestic and maternal chores, using as models the immigrant Italians of Greenwich Village and the Jews around Manhattan Bridge.

Despite the social disparities between their subjects, both Eberle and Vonnoh concentrated on the activities of women and children and presented them in a light and innocent mood. Unlike Vonnoh, however, Eberle also created some of the first social-protest sculpture. An ardent supporter of women's rights, Eberle contributed to the purity campaigns to eliminate the abduction of young women for prostitution with her graphic interpretation of that particular social ill, *White Slave* (plate 51).[8] Although the same theme was the basis for one of the most famous nineteenth-century ideal American sculptures, Hiram Powers's *The Greek Slave* (plate 60), Eberle brought it into the present realm by adding the figure of the male auctioneer in contemporary attire. Some art critics and moralists condemned the piece when it was exhibited at the Armory Show, finding it too realistic a portrayal of greed and lust; the seamy side of life was still deemed by them inappropriate for sculpture.

FOR MORE THAN four decades labor was the most common theme in American genre sculpture. Labor issues were constantly in the news, and many artists responded to them. The period witnessed drastic transformations in the situation of the working class, beginning with the immigration of an inexpensive work force, aggravating the effects of the economic depression of the 1890s on native-born workers. Exploitation was rampant and brutal, especially in the textile, mining, and steel industries, where masses of unskilled foreigners, including children, worked long hours in cramped, unventilated conditions with dangerous machinery. Employers attempted to block fast-spreading unionism, but workers resisted. In 1902 the situation erupted in the greatest strike in the nation's history as coal miners shut down production nationwide, winning a nine-hour workday. Progressive reformers during the first two decades of the twentieth century realized the need for further improvement in working conditions and wages and consequently encouraged the enactment of legislation to alleviate exploitation. Through a series of hostile job actions and sympathetic legal reforms unionism gathered strength as the century continued.

Most of the sculptors who depicted labor during the first of genre's two periods of activity were men who, despite their gender, shared few of the other defining characteristics of the social elite. Their places of origin and their religions cast them as outsiders. Max Kalish and Mahonri Young came from the Midwest and West, respectively, and Charles Haag and Saul Baizerman were foreign born. In addition, Kalish and Baizerman were Jews, and Young was the grandson of Mormon leader Brigham Young.[9] Haag and Young turned to the theme around the same time.[10] Young achieved recognition in 1903, when he exhibited plaster models of the companion pieces *Tired Out* and *Laborer*, elements of a planned monument to labor (plates 79–81), in Paris at the exhibition of the American Art Association, but he did not show his

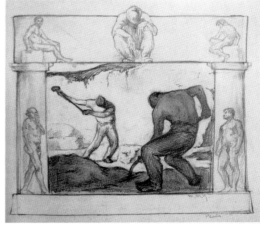

79
Mahonri Young
(United States, 1877–1957)
TIRED OUT
(also known as FATIGUE*)*
1903, bronze, 9 x 5¾ x 7 in.
(22.9 x 14.6 x 17.8 cm),
Los Angeles County Museum
of Art, Mr. and Mrs. Allan C.
Balch Collection

81
Mahonri Young
(United States, 1877–1957)
MONUMENT TO LABOR
c. 1902–3, graphite on paper,
7⅜ x 8¼ in. (18.7 x 21 cm),
archives, Harold B. Lee
Library, Brigham Young
University, Provo

80
Mahonri Young
(United States, 1877–1957)
LABORER *(also known as*
THE SHOVELER III)
1903, bronze, 10¼ x 9 x 7 in.
(26 x 22.9 x 17.8 cm), Sheldon
Memorial Art Gallery,
University of Nebraska,
Lincoln, F. M. Hall Collection

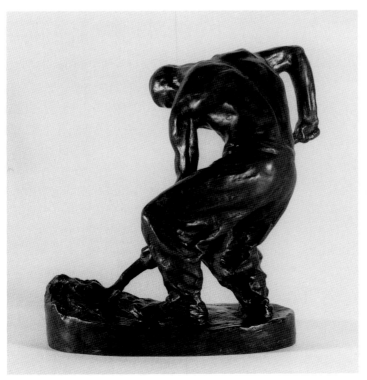

82

Aimé-Jules Dalou
(France, 1838–1902)
THE PEASANT
c. 1897–99, bronze, 16⅞ x 6¼ x
6¼ in. (42.9 x 15.9 x 15.9 cm),
Los Angeles County Museum
of Art, gift of Iris and B. Gerald
Cantor

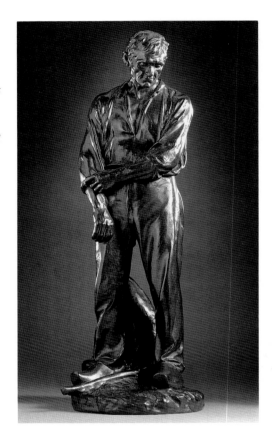

most famous works in the United States until the following decade, after his return.[11] Haag showed his bronzes of laborers in 1906 at his first solo exhibition in this country and produced most of his toilers prior to World War I.

Despite the association of genre sculpture with realism and contemporary life, labor iconography initially revealed remnants of nineteenth-century romanticism and stereotyping by gender. Male workers were mythologized: Young's and Kalish's figures are bare-chested in readiness for the day's labor, yet their robust physiques are godlike in classical perfection. Kalish's even seem to dance effortlessly through their chores (plate 59). Such idealization served as a reference to the pride of the working class.[12]

In the late nineteenth century the French sculptor Jules Dalou and the Belgian Constantin Meunier established the modern sculptural conception of the laborer by infusing a greater element of realism into their depictions; they did so by dressing their workers in contemporary garb (plate 82). By avoiding any suggestion of exertion or pain, they elevated the worker to humanity's new hero. The art of both Dalou and Meunier was known in the United States through frequent exhibitions and published accounts. Indeed, in 1913–14, during the period of Haag's and Young's greatest fame, a large Meunier exhibition circulated throughout the East and Midwest to much critical attention.[13] It is not surprising that similarities between the European and American interpretations of workers appear from the romanticized conceptions to the details of the poses. Working-class women were less frequently depicted in both European and American genre sculpture despite their active role in the social-ist labor movement. This was typical of socialist

iconography in general, for a paradoxical disparity existed between the ideology of the movement, which promoted equality of the sexes, and the artistic depictions that reinforced a division of labor.[14] Meunier presented the female proletarian in the symbolic role of silent sufferer, sometimes swathed in a shawl that simultaneously hid her emaciation and desexualized her body.[15] J. P. Frey, writing on Haag's art, reflected this bias: "The woman laborer is not an inspiring object to contemplate. The labor of the home may be wearing, but it is home, her home, and the labor is for herself.... But the woman laborer in industries.... means little but unremitting toil and the hardening of those tender and womanly qualities which elevate her to that plane where she becomes an inspiration to mankind."[16]

Despite the European sources and backgrounds of some of the sculptors active in the United States, the laborers they depicted were increasingly identified as native. Since agriculture no longer symbolized the American economy, sculptors rarely delineated farmers, focusing instead on the new city population.[17] Nearly 40 percent of the population lived in cities by 1900, and twenty years later 51 percent were urban dwellers; this was even truer of Eastern European immigrants, who constituted a majority of the industrial work force. This narrower selection of urban types would become characteristic of American genre sculpture in general throughout the decades.

Young's toilers, although not identified as American, exemplified the democratic spirit and hard work that was necessary to build a modern nation. Kalish's and Baizerman's portrayals were specifically American. Kalish felt that the future of this country's art would be in the expression of the Industrial Age because it typified the American

way.[18] Having grown up in working-class Cleveland, he portrayed the people of his milieu as heroes, describing the men at factories and railyards that he visited as "fine, sturdy men, ever alert, independent, forceful, and proud of their work, quite in contrast to so many types seen in Europe where the laborer's position is negligible.... [The American workman] is the maker of this great industrial age and to him should go part of the glory."[19] Kalish's figures, despite their classical grace, evince an intensity the artist perceived as typically American. His laborer was "a worker who thinks, who aspires... has feeling and depth."[20] The American spirit of his art led Kalish to be dubbed the "Walt Whitman of Sculpture."[21]

Kalish and Baizerman created most of their genre figures during the 1920s and early 1930s, when the United States experienced great building expansion in its two largest urban centers, New York City and Chicago. Baizerman diverged from the traditional, realistic interpretations of Young and Kalish by abstracting the laborer into condensed, geometric forms (plates 83–87) with flattened surfaces. The human element of the new technological age was thereby reconceptualized by Baizerman into terms analogous to the machine and skyscraper. The angular shapes of his Machine Age figures were reminiscent of the robotic movements of the dancers in John Alden Carpenter's ballet *Skyscrapers*, first performed in New York in 1926. This cubic, faceted interpretation of workmen was adopted in the next decade by Aaron Goodelman (plate 88). Throughout his career Goodelman depended on manual labor for a living, and critics attributed the brute strength and heroism of his figures to his stint as a dock walloper on the New York waterfront.[22] Through their formal simplifications both

81

Saul Baizerman
(Russia, 1889–1957)
From THE CITY AND THE
PEOPLE *series*
Bronze
Left to right:

83
ORGAN GRINDER
1922, 4⅛ x 2¾ x 2⅝ in. (10.3 x
7 x 6.5 cm)

84
CEMENT MAN
1924, 5½ x 3¼ x 2⅜ in. (14 x
8.3 x 6 cm)

85
TWO MEN LIFTING
1922, 3¾ x 6½ x 2½ in. (9.5 x
16.5 x 6.4 cm)

Hirshhorn Museum and
Sculpture Garden,
Smithsonian Institution, gift
of Mrs. Saul Baizerman, New
York, 1979

86
ROLLER SKATER
c. 1924–31, 4¹⁵⁄₁₆ x 4⅞ x 2 in.
(12.5 x 12.4 x 5.1 cm)

87
MAN WITH A SHOVEL
c. 1924–31, 3⅝ x 2 x 3 in. (9.2 x
5.1 x 7.6 cm)

Gary and Brenda Ruttenberg

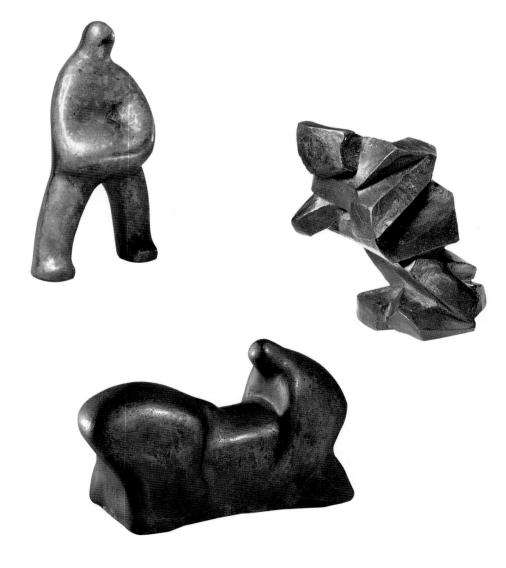

Baizerman and Goodelman removed specific references to the real world, details Kalish retained. The writer Karl Schwarz distinguished between the two conceptions in his discussion of their depiction of men drilling: Kalish, he said, "portrayed" a real man "at work, in his existence," while Goodelman symbolized "dynamic power."[23]

Among the first generation of labor specialists, only Haag devoted part of his oeuvre to the labor movement. A youthful follower of August Palm, the Danish apostle of Social Democracy, Haag believed in the necessity of organized labor and its right to strike and had participated in several strikes and boycotts in Sweden and Germany.[24] The multifigural groupings that he began to sculpt around 1905 demonstrate the power of masses who unite; in *Labor Union* (plate 89), for example, three muscular figures grasp a sledgehammer. Although

Haag did not use iconography that was strident, he depicted a proletariat that was determined. In spirit he was similar to Meunier, who among all European genre sculptors was closest to the socialist cause. As John Spargo (himself an immigrant dedicated to the welfare of the downtrodden) explained, Haag differed from the Belgian in his depiction of "labor in revolt. [Haag] glories in labor's struggle and believes firmly in it. Almost all his work aims to be a protest against the degradation and exploitation of the proletariat."[25]

So compelling were the struggles of the working class in Europe during the closing decades of the nineteenth century that even the Vatican recognized the right of workers to organize.[26] Dalou, Meunier, and Auguste Rodin, each of whom had proposed an elaborate memorial to labor during this period, were thus responding to contemporary events. Young's proposed monument incorporates figures into a composition based substantially on Rodin's *The Gates of Hell* (plate 16).[27]

88
Aaron Goodelman
(Russia, 1890–1978)
THE DRILLERS *(also known*
as MEN LIFTING*)*
1933, bronze, 12½ x 9 x 11 in.
(31.8 x 22.9 x 27.9 cm), collec-
tion of Hebrew Union College
Skirball Museum, Los Angeles

89

Charles Haag
(Sweden, 1867–1933)
LABOR UNION *(also known*
as IN UNION THERE IS
STRENGTH)
c. 1905, plaster, 6½ x 2½ x 4⅝
in. (16.5 x 6.4 x 11.8 cm),
Augustana College Art
Collection, Sofia Haag Trust,
Rock Island, Illinois

Historians generally consider Young to have been politically detached, his proposed monument notwithstanding;[28] it surely was not coincidental, however, that, like Haag, he devoted his sculpture almost exclusively to the working class at a time of labor unrest and union organization. Baizerman and Kalish also adopted the theme of the worker at another propitious moment in labor history, not long after unions had instituted in 1919 a series of strikes in the steel and coal industries to protest low postwar wages.

Haag's sculpture was extolled by organized labor, several articles appearing in trade union journals.[29] Despite union support and patronage from people of similar political persuasion, Haag rarely sold his art.[30] As one contemporary writer realized, "Those who usually buy works of art are precisely those who do not wish to be reminded of the substructure of distorted and unsightly humanity."[31] Even twenty years later, when art and politics would

be closely related and the common man lionized in federal art project ideology, the situation concerning private patronage would remain the same, which a critic writing in the Communist *Daily Worker* about Goodelman's sculpture deplored: "[American artists] must make a living, somehow, by selling to the wealthy enemies of the workers…. Why can't some of our big American unions become art patrons, thus performing a historic and necessary act in American culture? Why must art remain the monopoly of the parasites?"[32] The upper classes, the only people who could afford small bronze sculpture during the first decades of this century, preferred the inoffensive subject matter of much Victorian art: pretty, sweet, or patriotic but above all clean and positive. This situation explains why Vonnoh and Kalish were able to sell their work on a regular basis, but so many of the other genre artists were not and, therefore, are virtually unknown today.

HAAG WAS AMAZED that no one in this melting pot of a country had devoted a sculpture to the people who passed through Ellis Island. Consequently, around 1905 he created *The Immigrants* (plate 90), a group of six huddled adults trudging determinedly toward a new home. An admirer of Whitman, Haag, like the poet, wanted to create a genuinely American art. The theme of *The Immigrants* was considered evidence of "a new Americanism" that linked the wave of turn-of-the-century refugees from Europe to the Puritans of centuries before.[33]

The emergence of genre sculpture as a modern idiom coincided with the largest wave of immigration the nation had ever experienced. The flood of foreigners not only increased the country's population dramatically but changed the nature of its culture as

well. The new arrivals brought with them their own traditions. The degree to which they were to be encouraged or even forced to assimilate was hotly debated for much of the first three decades of the century. Ethnic diversity was often viewed as threatening to general harmony and leading to labor unrest. So progressive reformers and organizations such as the National Americanization Committee in New York advocated that foreigners abandon their distinctive customs and languages as part of the naturalization process, thereby ensuring that the American citizenry would remain culturally integrated.

In the summer of 1915 Gertrude Whitney joined forces with the National Americanization Committee in sponsoring a competition and exhibition on the theme of the immigrant in America. Its aim was "to inspire both native and foreign-born citizens with a better mutual understanding by setting forth the ideals of a unified America."[34] More than four hundred artists submitted works, among them Meta Vaux Warrick Fuller, who contributed *Mother America* comforting her refugee children, a theme inspired by the poetry of Emma Lazarus and Robert Haven Schauffler.[35] The young Italian immigrant Beniamino Bufano won first prize with a sculptural grouping of thirty figures that was an indictment of the exploitation of aliens.[36]

Two years later Walter A. Dyer, writing for *International Studio*, explored the potential of the immigrants' contribution to American art. Noting that American civilization was assimilative by nature, he believed the recent foreigners brought with them fresh ideas. As he explained, the immigrants often had to struggle and therefore were serious by nature and had a "type of understanding which differs from that of the Anglo-Saxon.... Our American art needs just what these Slavs and

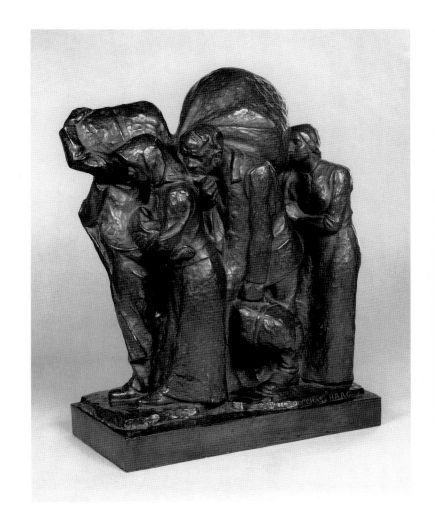

90
Charles Haag
(Sweden, 1867–1933)
THE IMMIGRANTS
c. 1905, bronze, 19 x 10 x 15 in.
(48 x 25.5 x 38 cm), American
Swedish Historical Museum,
Philadelphia

Jews and Orientals and immigrants from warm southern Europe can contribute. They can give us depth of thought and feeling, vividness, sympathy, mysticism, and emotion and a fresh conception of the human soul as expressed in the human form and face."[37]

Genre more than any other field of figurative sculpture appealed to immigrant artists, probably because it was so intricately tied to contemporary circumstances. In the 1910s Onorio Ruotolo, a Catholic from Italy, and Adolf Wolff, a Jew from Belgium who had studied with Meunier, devoted their sculpture to social issues. Their marginalized status as poor immigrants may have encouraged their rejection of the prescribed value system and also made them more sympathetic to the plight of the less fortunate, some of whom were relatives and neighbors. Both sculptors were also attracted to anarchism—the favored doctrine of the literary and artistic avant-garde in the United States between 1890 and 1920—and were closely involved with radical journals.[38]

Wolff's belief in an individual's freedom of expression led him to pursue an aesthetic as radical as his politics. Between 1914 and 1919 he was one of the few Americans to create cubist sculpture, the style of his figures thereby underscoring the progressive nature of their themes. In 1916 at the Modern Gallery in New York City he exhibited *Struggle* and *Revolt* (both c. 1912–16).[39] Some of his small works, such as *The Suppliant* (plate 91), were intended as models for large public sculpture.[40] The visionary quality of *Temple of Solidarity* (1914), a design for a meeting hall based on the shape of a crowd of

91
Adolf Wolff
(Belgium, 1883–1944)
THE SUPPLIANT
1914, plaster, 12 x 20 x 8 in.
(30.5 x 50.8 x 20.3 cm),
Francis M. Naumann

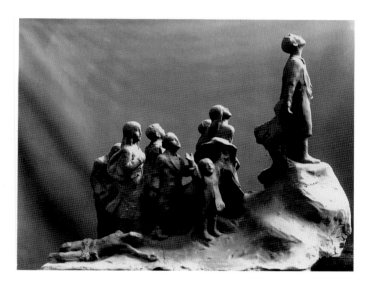

92
Onorio Ruotolo
(Italy, 1888–1966)
DOOMED
1917, plaster, approx. 29 x 9 in.
(73.7 x 22.9 cm), Lucio Ruotolo

93
Onorio Ruotolo
(Italy, 1888–1966)
THE WISHING SQUAD
1916, painted plaster, 21½ x 28 x
16¼ in. (54.6 x 71.1 x 41.3 cm),
Lucio Ruotolo

figures standing shoulder to shoulder, suggests that he aimed at creating sculpture expressive of the social order he hoped would arise.

Ruotolo utilized his art for similar purposes but in a more traditional, representational style; a straightforward realism dominates his single figures and heads, and a romantic spirit pervades his elaborate, multifigural projects. Altruistic, he demonstrated a great compassion for humanity, depicting with equal sympathy murderers, drunks, and persecuted blacks. He hoped to improve existing conditions by appealing to man's sense of decency. *Doomed* (plate 92) arose from his belief that the United States should abolish capital punishment just as his native country had. Visiting Sing Sing prison to capture the mental state of the condemned, he wanted "to give an object lesson in despair and show the good people who never entered a prison… what it really means to be deprived of hope."[41]

Ruotolo's belief in universal brotherhood resulted in a series of evocative war sculptures. In *The Wishing Squad* (plate 93) and *Buried Alive* (plate 15) he expressed despair over war's deaths,

mutilation, and destruction. By presenting refugees standing erect and dignified, he retained an element of hope for the future of humankind. His rejection of ugliness in favor of the traditional notion of beauty suggests the pervasiveness of a nineteenth-century romantic sensibility even in the treatment of the horrors of modern warfare.[42] In this respect Ruotolo's art differs from the strident antiwar statements of the late 1930s made by other sculptors.[43]

While World War I marked the last important era of commemorative war memorials, it inspired the first use of battle-related themes for reportorial sculpture.[44] The famous *Doughboy* (c. 1919) of Avard Fairbanks (1897–1987) was still within the tradition of the soldier monument as exemplified by Daniel Chester French's *The Minute Man* (1874), but Whitney's bronze soldiers broke with the mythology of the invincible hero.[45] She did retain the romantic view of the soldier as courageous (plate 94) but concentrated on battlefield tableaux, even depicting the soldier wounded and in need of a nurse's assistance. Her interpretation of the valiant

ILENE SUSAN FORT

94
Gertrude Vanderbilt Whitney
(United States, 1875–1942)
HOME AGAIN
c. 1918, bronze, 16¼ x 9 x
5½ in. (41.3 x 22.9 x 14 cm),
collection of Mr. and Mrs.
Whitney Tower

95
John Storrs
(United States, 1885–1956)
MAN WITH THE CRUTCH
c. 1919, stone, 9¾ x 5¾ in. (24.8
x 14.6 cm), location unknown

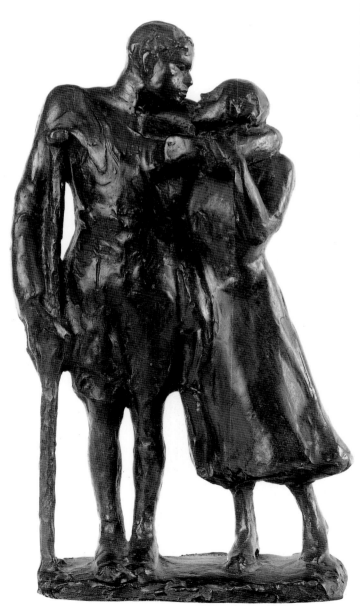

work of Red Cross nurses was exceptional, given the secondary, passive role females usually played in genre sculpture of the time. John Storrs, like Whitney, had worked in a field hospital in France and likewise created sculpture of the wounded on crutches (plate 95). However, Storrs, a socialist, intended his work as an antiwar statement.[46]

THE WAR INTENSIFIED ethnic tensions in the United States. The xenophobia that had emerged at the turn of the century now increased to a degree not previously experienced. In addition, relations between black and white Americans took a turn for the worse. Fuller's art was a reflection of this situation. Among Americans she was the earliest to depict the deplorable circumstances of the poor, when as a student in Paris she presented without sentimentality the miserable lives of the under-class in *Silent Sorrow* (1901) and *The Wretched* (plate 34).[47] *The Wretched* offers only despair to those ravaged by hunger and disease.[48] Even though these sculptures were not of African Americans per se, later critics have attributed the suffering she visualized to the black experience.[49] It was just such graphic representations of social conditions that made her sculpture unsalable to white collectors back home.

In the United States during the 1910s Fuller devoted her art to more specific social causes, such as racial harmony, the disenfranchisement of black Americans, women's suffrage, and peace. The lynching in Georgia of eight blacks falsely accused of murdering a white landowner in August 1918 inspired one of her most moving critical sculptures, *Memorial to Mary Turner: A Silent Protest against Mob Violence* (plate 162). Nineteen nineteen marked the nadir of race relations in America, as

the highest number of lynchings in eleven years occurred and six cities experienced riots. Fuller's was the first sculpture devoted to lynching, a subject that would increasingly haunt artists in the 1930s, when race problems again escalated. She infused the figure of Turner, the wife of one of the men lynched, with dignity, showing her cradling the unborn child her murderers had cut from her body before burning her. Three years earlier Ruotolo had likewise been inspired by race riots to model the head of a bewildered slave (1916), using him as a mute appeal for enlightenment among the races. Ruotolo's pro-black position was typical of Italian radicals, who, unlike other leftist immigrants, consistently expressed horror at the persecution of blacks.[50]

Fuller had introduced the black American as powerful subject matter, and during the postwar era black historians and white patrons encouraged other African American artists to turn to their heritage for inspiration. As a result, a talented, well-trained generation known as the Harlem Renaissance emerged. An interest in different races and cultures was awakened in white artists simulta-neously. Sculptors representing many ethnic groups increasingly exhibited busts and full-length figures of African Americans as well as Hispanics, Native Americans, and Asians. These were iconic in character, glorifying beauty and dignity rather than depicting the quotidian incidents of life. White sculptors were so enamored by their "discovery" that they never delved beneath these idealizations. Yet even black artists preferred types to individuals; Sargent Johnson, who was orphaned at ten, extolled black motherhood (plate 96), while William Edmondson conveyed the importance of religion to his race through his characterization of a preacher **89**

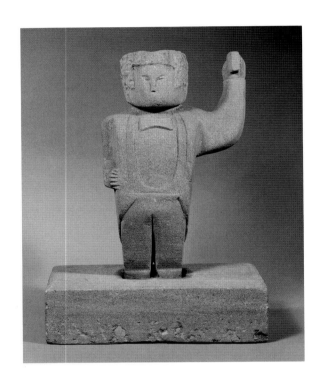

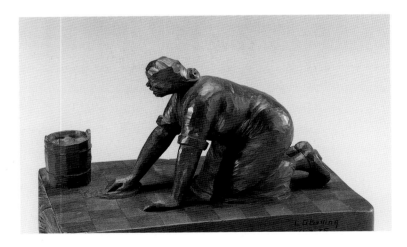

96
Sargent Johnson
(United States, 1887–1967)
FOREVER FREE
1933, wood with lacquer on
cloth, 36 x 11½ x 9½ in. (91.5 x
29.2 x 24.2 cm), San Francisco
Museum of Modern Art, gift of
Mrs. E. D. Lederman

97
William Edmondson
(United States, 1882–1951)
PREACHER
c. 1931–40s, limestone, 17¼ x
10⅜ x 5 in. (43.8 x 26.4 x
12.7 cm), collection of The
Newark Museum, Edmund L.
Fuller, Jr., bequest, 1985

98
Leslie Bolling
(United States, 1898–1955)
COUSIN-ON-FRIDAY
1935, maple, 6¾ x 5¾ x 9¼ in.
(17.2 x 14.6 x 23.5 cm), Virginia
Museum of Fine Arts,
Richmond, gift of the Hon. and
Mrs. Alexander W. Weddell

(plate 97). Richmond Barthé depicted a black stevedore, but it was Leslie Bolling who became the specialist of black genre. In 1937 he exhibited a series of seven carvings, each delineating a domestic chore associated with a day of the week (plate 98).

OTHER DEVELOPMENTS in postwar American life expanded the genre sculptor's thematic repertoire. Both middle- and lower-class Americans now had some time and money for leisurely activity, and businesses catering to entertainment prospered. The diversion of spectator sports became the principal genre theme during the 1920s, a decade that witnessed a decrease in the popularity of genre sculpture. Even Young was inspired to depict boxers (plate 57), and prizefighters became the specialty of Cecil Howard (1888–1956). As early as 1910 Malvina Hoffman had been entranced by the performances of the Ballets Russes, and a few years later modern dance bewitched Harriet Frishmuth (plate 26) and Alice Morgan Wright (plate 12). It was Elie Nadelman, however, who best conveyed the sophistication of contemporary performers in his polychromed wooden figures of singers, musicians, and dancers (plate 99).

The circus was a favored new subject. Alexander Calder and Chaim Gross captured the skill of acrobats (plates 100–101); and Carl Walters, the humorous quality of the fat lady and the weight lifter (plates 102–3). Later Eugenie Gershoy portrayed the strong man and other circus performers in highly exaggerated polychromed plasters (plate 74). Although seemingly lighthearted and innocuous, such subject matter reflected the sense of disillusionment with the technological orientation of society that pervaded the postwar age. American folk art, conveying a nostalgic sense of the innocence

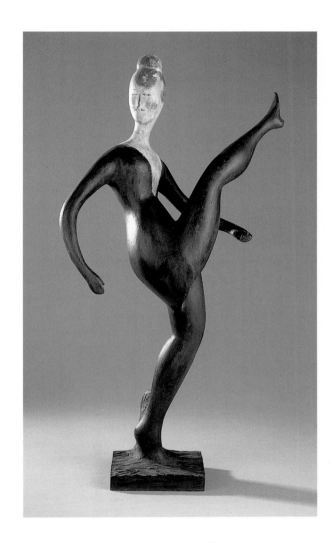

99
Elie Nadelman
(Russia, 1882–1946)
DANCER *(also known as*
HIGH KICKER)
c. 1918–19, painted and gessoed
cherry wood, 29½ x 26¾ x 13 in.
(74.9 x 68 x 33 cm), private
collection

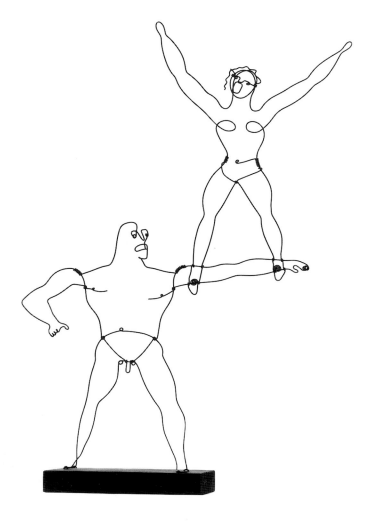

100

Alexander Calder
(United States, 1898–1976)
TWO ACROBATS
1928, brass wire on wood base,
37 ¹¹⁄₁₆ x 27 x 6 ⅛ in. (95.7 x
68.6 x 15.6 cm), Honolulu
Academy of Arts, gift of
Mrs. Theodore A. Cooke,
Mrs. Philip E. Spalding, and
Mrs. Walter F. Dillingham, 1937

101

Chaim Gross
(Austria-Hungary, 1904–91)
CIRCUS ACROBATS
1935, lignum vitae, 34 ½ x 11 ½ x
12 in. (87.6 x 29.2 x 30.5 cm),
Mimi Gross

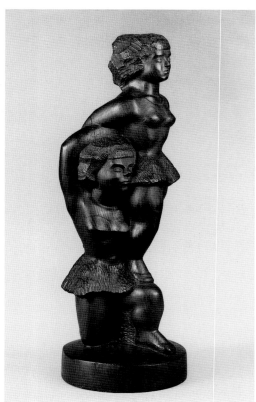

92

of a bygone era, had inspired Nadelman's perform-
ers, and entertainment imagery in general reflected
an escapist mentality, a search for another time,
place, or condition. In fact, the circus had a long
tradition as a haven for people dissatisfied with or
unable to fit into common modes of working and
living. Given the hardships of the Depression and
the need for relief from the stress of daily existence,
it is understandable that such seemingly light
themes continued to be so appealing. Hannah
Small's *The Picnic* (plate 104) therefore becomes not
only a charming idyll but a symbol of America's
former ingenuousness.

DURING THE 1930S genre sculpture reemerged
to experience its greatest flowering, encouraged to
a large extent by the various federal art projects,
which promoted the image of the common citizen.
(Most of the sculpture commissioned by the pro-
jects was architectural and therefore outside the
domain of this essay.) Those artists who were associ-
ated with the projects, as well as those who were
not, did present a variety of attitudes. Some depicted
contemporary life in straightforward terms as serious
realism, while others portrayed it with humor,
satire, or expressionist pathos. Although the uncriti-
cal, formal approach of abstraction also remained,
the use of sculpture for sharp condemnation grew
in importance. It was as if the troubled economic
and political situation compelled artistic expression.
Sculptors continued to explore the themes that had
dominated the initial period of genre sculpture—
the role of women, labor, and war—but the
increased political activism of many during the
Depression resulted in new interpretations. Some
sculptors continued to perceive contemporary
situations in positive terms, while others began to

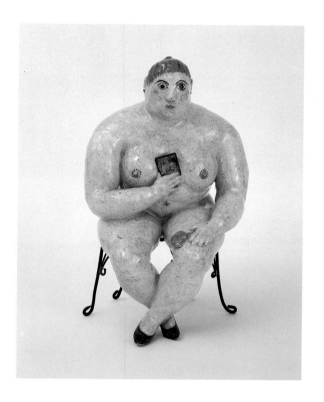 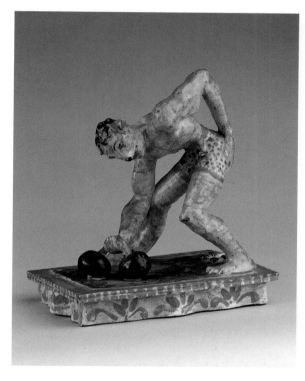

express their dissatisfaction through their art with the result that old subjects took on critical connotations. For instance, although the image of African Americans appeared in the 1910s as a reflection of escalating racism, the condition of this minority did not become a celebrated cause in art until the 1930s; in fact, lynchings became a recurrent theme in genre sculpture during the decade. Heightened activism was also responsible for the infusion of socialist sentiment in labor and urban iconography: the heroic worker of the first decades was transformed into a protesting striker. Ambivalence toward militarism after World War I gave way with the growth of fascism to strident antimilitarism. By the time war broke out again, genre sculpture had assumed a greater potency as a tool for criticism.

102
Carl Walters
(United States, 1883–1955)
ELLA
1927, ceramic and metal chair,
16¾ x 10¼ x 9⅜ in. (42.5 x
26.1 x 23.9 cm), The Museum
of Modern Art, purchase, 1941

103
Carl Walters
(United States, 1883–1955)
WEIGHT LIFTER
1927, ceramic, 9 x 8 x 5½ in.
(22.9 x 20.3 x 14 cm), The Renee
& Chaim Gross Foundation,
New York City

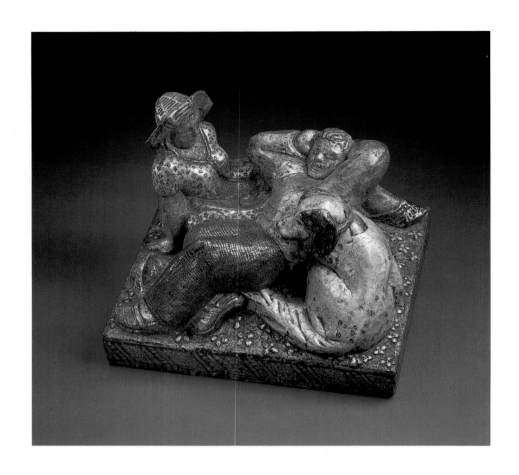

104
Hannah Small
(United States, 1903–92)
with Eugene Ludins
(United States, b. 1904)
THE PICNIC
c. 1935, wood with gold and
silver leaf applied by Ludins,
8½ x 10½ x 9 in. (21.6 x 26.7 x
22.9 cm), private collection,
courtesy, Guggenheim, Asher
Associates, Inc., New York City

105
Robert Cronbach
(United States, b. 1908)
CITY GIRL *(also known as*
PILLAR OF SOCIETY)
1939, bronze, height: 18 in.
(45.7 cm), formerly collection
of Hudson D. Walker

Genre painting of the period has been sepa-
rated by historians into two categories: American
scene and the more critically oriented social real-
ism. Genre sculpture can be similarly classified.
American scene sculpture continued the tradition
of charming vignettes of middle- and lower-class
life. At the end of the 1920s Gross depicted office
girls he observed on the streets of New York City;
later Robert Cronbach placed urban dwellers within
architectural settings, beneath the tracks of the
New York City "el," for instance (plate 105), sug-
gesting the city's claustrophobic environment.

Women became a notable element of
American scene and social realist iconography,
frequently appearing in murals and easel paintings.
They were featured less often in sculpture. Although
their eternal roles as wife and mother continued to
be exploited, the image of women as wage earners
also became widespread. As early as the turn of
the century middle-class women had entered the
work force as secretary/typists. Simultaneously

women of the working class were hired in factories and sweatshops. By 1930 the number of married women employed constituted 17.5 percent of factory labor.[51] Like her painted counterpart, the sculpted female was usually a healthy and happy laborer, whether side-by-side with a male coworker, as in Cronbach's *Industry* (1938), or as part of a group of women performing such repetitive tasks as sewing and ironing, as in John Hovannes's *Laundry Workers* (plate 106). These sculptures reflect the positive, propagandistic spirit of most American scene representations.

Compared with American scene sculpture, social realism appears negative, but its existence indicates that its creators believed art could affect social change positively. In this respect, sculptors were no different from painters, for during the Depression many American artists became highly politicized for the first time.

In 1933 the John Reed Club organized its first art exhibition specifically to "inspire and encourage artists to express their reactions to economic turmoil."[52] Whether they were affiliated with the Communist party, unaffiliated sympathizers, or simply concerned citizens, sculptors concentrated on the problems of the working class. The alleged greed and hypocrisy of businessmen and financiers and the evils of capitalism were implicit in sculpture of the common man, not the subject of separate works. The principal exception was Cronbach's satirical series (c. 1936–38), in which he spoofed such well-known capitalists as William Randolph Hearst, shown with Alfred Landon (plate 107), whom the artist considered Hearst's puppet candidate for the presidency, and Father Timothy J. Coughlin, riding a pig on his right-wing crusade for social justice.[53] Specific events inspired sculptors who were

106
John Hovannes
(United States, 1900–1972)
LAUNDRY WORKERS
1939, cherry wood, 40½ x 20 x
6¾ in. (102.9 x 50.8 x 17.2 cm),
collection of John P. Axelrod,
Boston

usually apolitical, some even employing seemingly neutral abstraction for their commentary. Gross carved *The Lindbergh Family* (plate 108) in response to the abduction and murder of Charles and Ann Morrow Lindbergh's son, and this sculpture, consisting of two totemlike poles, ranks among the most abstract and symbolic genre sculptures created in America. Isamu Noguchi was also searching "to find a way of sculpture that was humanly meaningful without being realistic, at once abstract and socially relevant."[54]

The genre sculptors who most frequently used their art for commentary were Cronbach, Goodelman, and Lipton. Cronbach believed that an individual artist could make a difference.[55] Both he and Goodelman were Marxists, active members of the John Reed Club, the Artists' Union, and the American Artists' Congress, and participated in protest demonstrations and workers' parades.[56] Goodelman was so ardent that he would only sell his work to people who shared his political persuasion.

107

Robert Cronbach
(United States, b. 1908)
WILLIAM RANDOLPH
HEARST AND ALFRED
LANDON
c. 1936–38, Plasticine, location
unknown

108

Chaim Gross
(Austria-Hungary, 1904–91)
THE LINDBERGH FAMILY
1932; golden streak ipil wood;
Charles Lindbergh (left): 66 x
11 x 6⅝ in. (167.6 x 27.9 x
16.8 cm); Ann Lindbergh: 64½ x
6⅞ x 5½ in. (162.6 x 17.5 x
14 cm); Mimi Gross/The Renee
& Chaim Gross Foundation,
New York City

He was active in many Yiddish organizations,
including the Jewish Art Center, the art section
of Yiddisher Kultur Farband (World alliance for
Yiddish culture), a Popular Front organization pro-
moted by the Communists. Even though Lipton
was not active politically, he did express sympathy
with the masses, one critic even asserting that
Lipton understood the psychology of the people
"with the deep social understanding of the
Marxist."[57] Lipton believed that his work should
be a comment on good and evil in the world:
"A work of art, in addition to being a creation by an
individual…is also a social concretion. I am not
referring to narrow schematic social ends as didac-
tically served by propaganda art, but ultimate
deep-seated social ends such as freedom, spiritual
cohesiveness and justice."[58] All three sculptors were
Jewish—Cronbach and Lipton had been raised in
middle-class, assimilated families—and their shared
religious background was one that encouraged
ethical behavior and would have contributed to
their humanitarian stances.

Despite delineation of the plights of both urban
dwellers and their rural counterparts by American
painters of the 1930s, sculptors did not differentiate
between them. They considered the problems of all
Americans to be poverty, inhumane labor conditions,
and racism. Poverty was most searingly portrayed
through the themes of hunger and homelessness.
In the period after the Civil War the homeless
population grew dramatically in response to the
unregulated transition from an agricultural to an
industrial economy. Vagrancy was basically an
urban issue and by the late nineteenth century was
perceived by native-born, Protestant writers to be
caused by indolent outsiders, that is, immigrants.[59]
Depressed food prices during the 1920s and the
prolonged drought in the Midwest during the 1930s
placed farmers in a similar predicament as they
increasingly lost their lands and moved to the cities.
The group most sympathetic to the displaced at
the turn of the century had been foreign refugees,
Italians and Eastern European Jews in particular.[60]
So it is not surprising that the sculptors who most
often depicted the impoverished in the 1930s were
from these ethnic and religious groups. Prior to this,
in the late 1920s, Kalish had commented on the
plight of the urban poor. Described as "an indict-
ment of society," *The Bread Line* (c. 1925) consisted
of types—a hobo, an exhausted mother with a baby,
an elderly couple, a drug addict, and a crippled
war veteran—who were actually derived from the
standard iconography of the downtrodden, as were
the tired, starving figures huddling for warmth that
Goodelman later depicted in several sculptures,
including *Homeless* (1934).[61]

Lipton completely departed from the mythology
of the American scene by creating the most gut-
wrenching sculptures about the urban poor through

the distortion of the human body. He wanted the viewer to be upset by the suffering he saw, so he did not sentimentalize the destitute. We cringe at the walking skeletons of *Subway Beggars* (1936) and shiver with a man hunched over from the cold (plate 109). Lipton's abstracted wood carvings of the 1930s and early 1940s were as penetrating and forceful as the sculpture of Ernst Barlach and other German expressionists, which he admired.

The condition of labor remained a favored theme. With fifteen million people out of work at the height of the Depression, the laborer was characterized by the social realists as unemployed, a discard of society, or a striker and ardent unionist. Kalish portrayed the unemployed in several sculptures, now lost, but it was Cronbach who powerfully summarized the victimization of labor in his *Exploitation* (plate 110), where a figure, constrained in a vice, is literally crushed, the vice a metaphor for the power of the capitalist system. *Exploitation* was Cronbach's harshest statement and one of the most upsetting sculptural condemnations of labor conditions created during the Depression.

In the hands of the social realist the worker was more often transformed into the proletarian, according to Marxist ideology. During the 1930s organized labor experienced an unprecedented increase in membership and activity. A major development was the formation in 1935 of the Committee for Industrial Organizations (CIO) to represent the unskilled who manned the production lines in the steel, automobile, and rubber industries. In 1933 Franklin D. Roosevelt had signed the National Industrial Recovery Act, which gave employees the right to bargain collectively. Pickets and strikes became more effective bargaining tools than ever before. Between 1932 and 1934 more than one

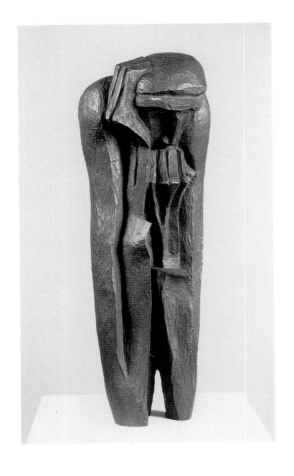

million went on strike, and with each succeeding victory labor became more powerful.[62] As a result, labor was portrayed in sculpture as defiant, undaunted in its united front, and the proletarian became the protagonist of a just cause, a modern-day hero. During the mid- and late 1930s Goodelman, Lipton, Nat Werner (1910–91), and Wolff exhibited picketers, strikers, and May Day celebrations in the spirit of Haag's workers but devoid of the idealization that characterized previous sculpture.[63] The cubist idiom of Goodelman's *On the Picket Line* (plate 111) indicates both literally and figuratively

109
Seymour Lipton
(United States, 1903–86)
COLD MAN
1938, mahogany, 23 x 7 1/2 x
8 1/2 in. (58.4 x 19.1 x 21.6 cm),
courtesy, Maxwell Davidson
Gallery, New York City

110
Robert Cronbach
(United States, b. 1908)
EXPLOITATION
1935, cast stone, 14 3/4 x 18 x
12 in. (37.5 x 45.7 x 30.5 cm),
Berman-Daferner Gallery,
New York City

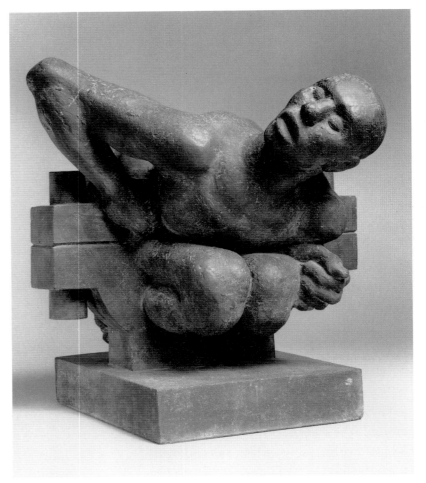

the constraints workers experience in a capitalist society and the power of the masses, for the figures and their placards are bent and compressed into solid, cubic shapes.

Social realist sculptors rarely identified strikers with individual trades or industries, for specificity was not as important to them as broad humanitarian causes. The depiction of miners is a good example. Toiling below the surface of the earth has always been a precarious employment, and during the 1920s and first years of the 1930s the fears of miners were confirmed by the frequency of disasters, including the worst since 1913 when nearly two hundred people were killed at Mather, Pennsylvania, in 1928. Only Wolff's defiant *Coal Miner on Strike* (1931) portrayed union activism in this particular profession. Instead, the plight of miners' families was conveyed. Two immigrant Jewish women, Minna Harkavay (1895–1987) and Berta Margoulies, compassionately explored the effects of poverty and emotional trauma: Harkavay in her *An American Miner's Family* (1931) etched the grim reality of their poverty on their gaunt faces, while Margoulies presented the miners' wives, mothers, and sisters anxiously waiting behind a fence for news of their loved ones in *Mine Disaster* (plate 73). Both sculptors used the torso as the synecdoche for the whole body, possibly suggesting that the miners and their families led partial, unfulfilled lives that were often cut off in their prime.

Women waiting was to be Margoulies's recurrent theme. Although inspired by the English motion picture *The Stars Look Down* about Welsh miners, she created in *Mine Disaster* a universal statement using the socialist iconography of the suffering woman.[64] Her introduction to the cause of labor came through her marriage to writer Eugene O'Hare,

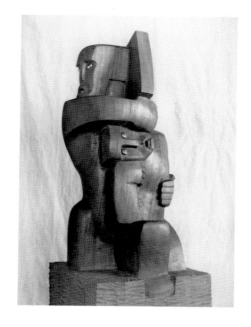

111
Aaron Goodelman
(Russia, 1890–1978)
ON THE PICKET LINE
(also known as UNDAUNTED
and UNITY)
1938, mahogany, 33 x 12½ x
12½ in. (83.8 x 31.8 x 31.8 cm),
collection of Dr. Connie
Weinstock

whose mother was the well-known labor and peace activist Kate Richards O'Hare; but Margoulies would have sympathized with suffering women in any case, for as a child during World War I she had lost most of her family.

PERHAPS AFRICAN AMERICANS suffered the most, the depressed economy exacerbating their already precarious existence. Even though Wolff presented a defiant woman with clenched fists in *Arise Oppressed of the World* (1931), most sculptors viewed the American black as victim. The Negro ranked among the "super-exploited" of the workers, and for that reason Cronbach made his figure in *Exploitation* "vaguely black," despite his intention to refer to all workers.[65]

Blacks often became scapegoats for the problems of the economy, and as a result the incidence of lynching, mainly in the South, increased dramatically beginning in 1930. Over the decades legislation to make such crimes a federal offense

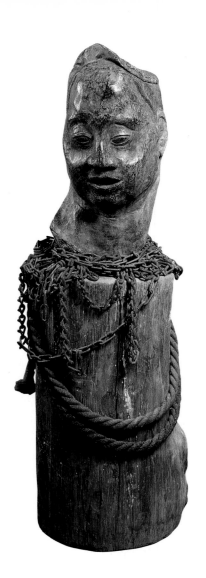

112

Isamu Noguchi
(United States, 1904–88)
DEATH *(also known as*
LYNCHED FIGURE*)*
1934; Monel metal, wood, rope,
and steel armature; figure:
36 x 17 x 33½ in. (91.4 x 43.2 x
85.1 cm); armature: 88¼ x 44 x
33½ in. (214 x 111.8 x 85.1 cm);
The Isamu Noguchi Founda-
tion, Inc., New York City

113

José de Creeft
(Spain, 1884–1982)
ESCLAVE
1936, beaten lead, wood, rope,
and metal chains, 42 x 12 x
12 in. (106.7 x 30.5 x 30.5 cm),
Childs Gallery, Ltd., Boston

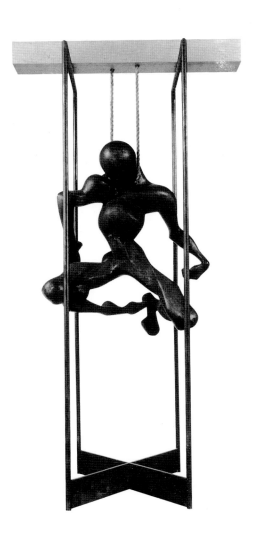

had repeatedly failed, but in 1933 mob violence so escalated that Walter White of the National Association for the Advancement of Colored People (NAACP) campaigned again for such legislation, with the result that the Costigan-Wagner antilynching bill was proposed in Congress. During the lobbying for passage of the bill, White decided to organize an exhibition to publicize the Negro cause. *An Art Commentary on Lynching,* sponsored by the NAACP and the New York liberal establishment, opened at the Arthur U. Newton Galleries in February 1935. Two weeks later *The Struggle for Negro Rights* opened nearby at the A.C.A. Gallery.[66] The second exhibition was sponsored by the John Reed Club on behalf of the American Communist party, which had been campaigning aggressively for the rights of African Americans since the late 1920s. The Communists viewed the NAACP as too conservative and an instrument of the white ruling class, consequently they supported different antilynching legislation and

held their own exhibition. To these and other exhibitions promoting the rights of African Americans, artists contributed some of the most potent, definitely the harshest critical statements in sculptural form.

During the 1930s and early 1940s Goodelman was the only one to devote several sculptures to the lynching theme, although Lipton, Noguchi, and others created individual works of a similarly propagandistic character. Unlike the other sculptors, Goodelman sometimes portrayed his figures standing upright and proud, awaiting their fates with dignity. The sculptures Goodelman and Noguchi contributed to the exhibition at the Newton Galleries were inspired by actual events.[67] *The Necklace* (1933) was Goodelman's protest against the injustice of the trial of the Scottsboro Boys (1931), a cause célèbre in which nine black boys and men from Alabama were framed for raping two white women.[68] Noguchi based *Death* (plates 76, 112) on a photograph published in the *Labor Defender,* the official organ of the International Labor Defense, of a 1930 incident in Sherman, Texas, in which a white crowd burned the body of George Hughes, the local courthouse, and black businesses. Lipton in *Lynched* (plate 133) and Noguchi considered the treatment of the victim as if a worthless thing, the latter's figure contorted by pain into almost unidentifiable body parts. Although not specifically about the murderous act but definitely related was José de Creeft's primitive-looking *Esclave* (plate 113): the head appears to be a straightforward representation, but its placement on a rough tree trunk with heavy chains around the neck gives the image a harrowing, surreal quality.

The lynched figure assumed universal significance. Goodelman used a Yiddish word for the title of one of his figures, *Kultur* (Culture, plate 114), thereby suggesting that the Jews slaughtered by

114
Aaron Goodelman
(Russia, 1890–1978)
KULTUR
Exhibited 1940, pearwood and
metal chain, 66½ x 12½ x
10¾ in. (168.8 x 31.8 x 27.3 cm),
National Museum of American
Art, Smithsonian Institution,
gift of Mrs. Sarah Goodelman

115

Octavio Medellin

(Mexico, b. 1907)

THE SPIRIT OF THE

REVOLUTION

1932, Texas limestone, 32 x 16 x

20 in. (81.3 x 40.6 x 50.8 cm),

collection of Mrs. Octavio

Medellin

the Nazis were suffering a similar fate.[69] Octavio Medellin also depicted men bound and hanged. Although based on his Hispanic heritage and his own experiences, Medellin's sculptures were about the universal concepts of slavery and freedom, life and death, and were intended to refer to all humankind (plate 115).[70] Lipton likewise did not limit his lynched figure to one persecuted group, explaining, "My heart did not bleed for the Negro, but for all the downtrodden, for anyone in pain."[71] These sculptors reflected the late 1930s trend among Americans, especially intellectuals, that allied antilynching forces with antifascist sympathies in the belief that all forms of racism needed to be eradicated.[72]

ALTHOUGH IN DECEMBER 1933 the John Reed Club organized an exhibition entitled *Hunger, Fascism, War,* it was not until later in the decade that American artists began to devote substantial attention to international politics. By 1939 one-third of the objects shown in the United American Sculptors annual exhibition were genre, and many of these were commentaries on dictatorship, burgeoning militarization worldwide, and human and material destruction. Unlike painters among their contemporaries, sculptors rarely criticized specific fascist leaders. Viktor Schreckengost was the exception. After residing in Vienna (1929–32), he realized the need to warn Americans of the specter of fascism and did so by creating an unforgettable satire, *The Dictator* (plate 116). Locating the source of contemporary dictatorships in Roman civilization, he presented the emperor Nero seated with cherub heads of Hitler, Mussolini, Stalin, and Hirohito clinging like barnacles to the sides of his throne.[73] The garish colors of the glazed ceramic contribute to its outrageous character.

The sense of foreboding that pervaded easel painting of the period also appeared in sculpture. With the memory of World War I still fresh, the idea of soldiers ready for battle could no longer be glorified as a symbol of patriotism. Instead, the military became the target of condemnation. Schreckengost devoted his largest antiwar piece, aptly entitled *Apocalypse '42* (plate 117), to the officers who led in battle, basing it on the Four Horsemen of the Apocalypse. Lipton and Anita Weschler explored the life of the typical soldier, from patriotic parades to battle wounds. In *Drafted* (1937) Weschler presented six robotic infantrymen, our sense of their individuality lost in their mechanistic anatomical forms and the rhythmic unison of their march.

The devastation pervaded even the civilian populations, and their agony made headlines. Among the many sculptors who responded by depicting the emotional trauma of air raids, displacement, and death were Hovannes, Lipton, Waldemar Raemisch (1888–1955), John Rood (1902–74), and Weschler. The traditional iconography of mother and child and of the suffering woman seemed especially appropriate for the times and was used in the late 1930s by Harkavay, Margoulies, and others in sculptures about refugees.

It was Weschler more than any other American sculptor who devoted her art to antiwar themes. Distressed by the Spanish Civil War and the possibility that militarism could spread, she created two series, *Martial Music* (1936–37) and *Martial Law* (1938). She preferred to simplify and exaggerate the figures into abstracted, often cubic masses, presenting them as groups in tight clusters and lines, rather than as individuals. These groups symbolized both negative and positive forces, the blind obedience of the masses as well as their will to survive.

Weschler's series *Ecclesiastes* (mid-1940s) formed a hopeful closing statement to her war-related sculpture; she followed the same formal approach but adopted "antithetical couplets" from the Book of Ecclesiastes, such as *A Time to Plant* (plate 118) and *A Time to Pluck Up That Which Is Planted* (plate 119). By casting some of the pieces in aluminum, she demonstrated that war material could be used for constructive purposes. She also conveyed a positive note through gender. It is fitting that the gardeners be female, since women give birth; by doing so, Weschler broke with the traditional representation of the suffering woman. No longer passive, her women represent an active force, heralding a new era of creation.

The distance that modern American genre sculpture had come since the turn of the century is demonstrated by a comparison of the work of Vonnoh and Weschler. Four decades after Vonnoh

116
Viktor Schreckengost
(United States, b. 1906)
THE DICTATOR
1939, glazed earthenware,
13 x 12½ x 10½ in. (33 x 31.8 x
26.7 cm), Everson Museum of
Art, Syracuse, gift of the artist

103

117
Viktor Schreckengost
(United States, b. 1906)
APOCALYPSE '42
1942, glazed ceramic, 15 ⅜ x
20 ⅜ x 8 ⅛ in. (39.1 x 51.8 x
20.6 cm), National Museum
of American Art, Smithsonian
Institution, gift of the artist

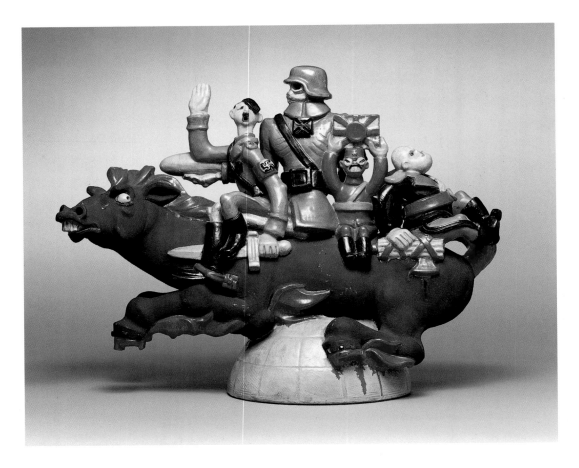

initiated the field with benign depictions of pampered females, Weschler transformed the iconography of women into pleas about the fate of humanity. Ironically, just at the moment when genre sculpture reached its greatest potency, it became outdated. Its demise lay in its definition: although at times it strove for universal application, genre represented first and foremost a particular time, place, and people. Abstract expressionism, with its formalism and universality, eventually replaced figuration as the most celebrated aesthetic among progressive American sculptors.

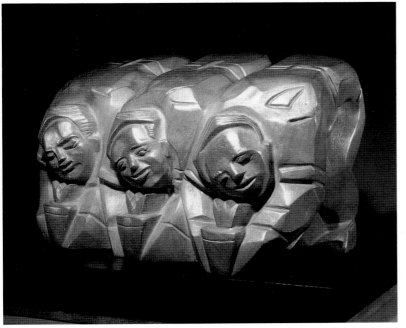

118
Anita Weschler
(United States, b. 1903)
From the ECCLESIASTES
series
A TIME TO PLANT
1945, cast aluminum, 9 x 16 x
12 in. (22.9 x 40.6 x 30.5 cm),
Berman-Daferner Gallery,
New York City

119
Anita Weschler
(United States, b. 1903)
From the ECCLESIASTES
series
A TIME TO PLUCK UP THAT
WHICH IS PLANTED
1945, cast aluminum, 17½ x
19 x 6 in. (44.5 x 48.3 x 15.2 cm),
collection of the artist

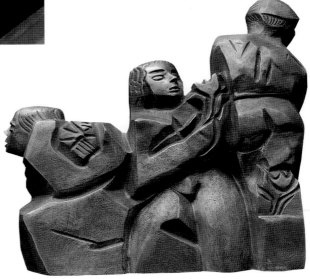

Notes

1. The quotation in the title of this essay is from Hamlin Garland's most famous writing, *Crumbling Idols* (Chicago: Stone and Kimball, 1894), a book devoted to contemporary issues in literature, drama, and art. In the essay "Local Color in Art" he discussed the new literary movement in Europe, urging Americans to follow Europe's example: "Everywhere all over the modern European world, men are writing novels.... Men who love the modern and who have not been educated to despise common things.... Mere beauty no longer suffices. Beauty is the world-old aristocrat who has taken for mate this mighty young plebeian Significance" (p. 59). His battle cry for local color was adopted by both writers and artists.

2. Sculpture authority Roberta K. Tarbell differs from this opinion: "American genre sculptors shared with Henri and Whitman the philosophy that 'life' was the primary motif for art—not political or social change, but commentary" ("Mahonri Young's Sculptures of Laboring Men, French and American Realism, and Walt Whitman's Poetics for Democracy," *Mickle Street Review* 12 [1990]: 114).

3. May Brawley Hill, *The Woman Sculptor: Malvina Hoffman and Her Contemporaries*, exh. cat. (New York: Berry-Hill Galleries, 1984), p. 12.

4. From a letter of introduction that Howells wrote to his brother-in-law, Larkin J. Mead, 1897, quoted in Bessie Potter Vonnoh, "Tears and Laughter Caught in Bronze: A Great Woman Sculptor Recalls Her Trials and Triumphs," *Delineator* 107 (October 1925): 78.

5. Ibid., p. 79.

6. Abastenia St. Leger Eberle to Beatrice Proske, 7 July 1937, in artist file, Brookgreen Gardens, South Carolina; and Louise R. Noun, *Abastenia St. Leger Eberle, Sculptor (1878–1942)*, exh. cat. (Des Moines: Des Moines Art Center, 1980), pp. 2, 5.

7. Christina Merriman, "New Bottles for New Wine: The Work of Abastenia St. Leger Eberle," *Survey* 30 (3 May 1913): 199.

8. The most extensive discussion of this sculpture and its reception is Susan P. Casteras, "Abastenia St. Leger Eberle's *White Slave*," *Women's Art Journal* 7 (spring–summer 1986): 32–36.

9. Mahonri M. Young, "Notes at the Beginning," in *Mahonri M. Young: Retrospective Exhibition*, exh. cat. (Andover, Mass.: Addison Gallery of American Art, Phillips Academy, 1940), p. 47; and Wayne Kendall Hinton, "A Biographical History of Mahonri M. Young: A Western American Artist," Ph.D. diss., Brigham Young University, 1974, pp. 27–28.

10. Historians usually consider Young among sculptors the first and most important exponent of the working man, even though Haag was accorded considerable critical praise during his career. The increasing time Haag spent in Chicago, beginning in 1909, diminished the attention paid to his art, a situation exacerbated perhaps by his foreign birth and strong political associations, since sculpture historians such as Adeline Adams and Lorado Taft represented established Protestant American families.

11. Tarbell incorrectly dates the exhibition of the companion pieces to 1902 ("Young's Sculptures," p. 118).

12. John M. Hunisak, "Images of Workers: From Genre Treatment and Heroic Nudity to the Monument of Labor," in *The Romantics to Rodin: French Nineteenth-Century Sculpture from North American Collections*, ed. Peter Fusco and H. W. Janson, exh. cat. (Los Angeles: Los Angeles County Museum of Art, 1980), pp. 52–53.

13. For example, "Mines, Misery and Meunier," *American Art News* 12 (31 January 1914): 3; and Royal Cortissoz, "Matters of Art," *New York Tribune*, 1 February 1914, sec. 5, 6.

14. Eric Hobsbawm, "Man and Woman in Socialist Iconography," *History Workshop* 6 (autumn 1978): 127.

15. Ibid., pp. 132–33.

16. J. P. Frey, "A Sculptor's Conception of Labor," *International Molders' Journal* 47 (June 1911): 425–26.

17. American sculptors such as Young did depict the rural worker but tended to do so primarily when they were young art students working abroad.

18. Alice Kalish, *Max Kalish As I Knew Him* (Los Angeles: privately printed, 1969), n.p.

19. Max Kalish, "Why I Take the Worker for a Model," *Survey* 59 (1 March 1928): 691.

20. Thomas Diederich, "Cleveland Sculptors and Their Work: Max Kalish," *Cleveland Musical Review* 1 (August 1926): 9.

21. "The American Workman Comes into His Own Art," newspaper clipping (perhaps *New York Post*, 1926), in Max Kalish file, library, Cleveland Museum of Art.

22. For example, Irene Kuhn, "Sculptor and His Art: Dock Walloper Turns Sculptor," *New York World-Telegram*, 29 November 1933, in Aaron Goodelman scrapbook, Aaron Goodelman papers (on microfilm, no reel numbers), Archives of American Art.

23. Karl Schwarz to Aaron Goodelman, 19 June 1952, in Aaron Goodelman papers, Archives of American Art. Schwarz had intended to write a book about Goodelman's art.

24. John Spargo, "Charles Haag—Sculptor of Toil—Kindred Spirit to Millet and Meunier," *Craftsman* 10 (July 1906): 435.

25. Ibid., p. 433.

26. Hunisak, "Images of Workers," p. 56.

27. Ilene Susan Fort and Michael Quick, "Mahonri Young," in *American Art: A Catalogue of the Los Angeles County Museum of Art Collection* (Los Angeles: Los Angeles County Museum of Art, 1991), pp. 403–4.

28. The most recent scholar being Tarbell ("Young's Sculptures," p. 117).

29. For example, Frey, "Sculptor's Conception," p. 424.

30. Through the assistance of John Spargo, a group of "unidentified gentlemen" bought Haag's *Accord* (1906) for the Metropolitan Museum of Art, New York.

31. Edward Yeomans, "Editorial Grist, City Springs," *Survey* 28 (4 May 1912): 187.

32. Mike Gold, "Change the World," *Daily Worker*, 7 February 1942, in Aaron Goodelman scrapbook, Aaron Goodelman papers (on microfilm, no reel numbers), Archives of American Art.

33. Edna I. Colley, "An Exhibition of Wood Carvings and Bronzes," *Fine Arts Journal* 34 (1 April 1916): 186.

34. "Patriotic Call to Artists," *New York Times*, 5 September 1915, sec. 2, 10.

35. Judith Nina Kerr, "God-Given Work: The Life and Times of Sculptor Meta Vaux Warrick Fuller, 1877–1968," Ph.D. diss., University of Massachusetts, 1986, pp. 236–38.

36. "Americanization of Immigrants," *Outlook* 111 (15 December 1915): 882.

37. Walter A. Dyer, "An East Side Art Movement," *International Studio* 63 (December 1917): l–li.

38. A dedicated revolutionist, Wolff not only contributed art reviews to the socialist *International* but attended rallies for the unemployed, strikers, and the peace movement. Ruotolo's involvement with anarchism may have been largely limited to Italian circles (Italians were among the most militant labor organizers), although his friends did include such non-Italians as Art Young, the well-known cartoonist and founding editor of the radical journal *The Masses*.

39. Because most of Wolff's early work is lost, this analysis is based on photographs, the few extant objects, and titles of exhibited works.

40. Andre Tridon, "Adolf Wolff: A Sculptor of To-Morrow," *International* 8 (March 1914): 86; and Alfred Kreymborg, "Adolf Wolff—Man of Ideas," *New York Morning Telegram*, 31 January 1915, magazine sec., 7.

41. Onorio Ruotolo, "Immortalizing the Doomed," *Chicago Sunday Herald*, 5 August 1917, sec. 5, 1.

42. Robert Baker conveyed the emotional trauma of death in similar terms in his now-destroyed war sculpture *Belgium* (1916; ill., *International Studio* 62 [October 1917]: lxxxiii, lxxxvi).

43. According to reviews of the day, a tone of revulsion pervaded the majority of the entries to a sculpture competition on the subject of war held at the Reinhardt Galleries in New York City in the spring of 1915. However, what was considered horrific in art at that time was quite tame compared with 1930s' standards.

Kalish is known to have sculpted at least two works in which he questioned the validity of war, as in *Was It Worth It?* (by 1916).

44 Ruotolo had hoped for an opportunity to transform some of his war sculpture into monuments; his dream was never realized.

45 Whitney's series of twenty-six tabletop figures had its origin in a monument. They were originally created as preparatory sketches for two relief panels commissioned for the Victory Arch in New York City, which was installed temporarily in 1919 to honor returning soldiers.

46 Noel Frackman, *John Storrs*, exh. cat. (New York: Whitney Museum of American Art, 1986), pp. 24–26.

47 William Francis O'Donnell, "Meta Vaux Warrick, Sculptor of Horrors," *World Today* 13 (November 1907): 1140.

48 The artist described her intent in a letter to C. R. Dolph, 13 February 1949, in Alma Spreckels correspondence, archive, Maryhill Museum of Art, Goldendale, Washington.

49 Velma J. Hoover, "Meta Warrick Fuller: Her Life and Art," *Negro History Bulletin* 60 (March–April 1977): 679.

50 Rudolph J. Vecoli, "'Free Country': The American Republic Viewed by the Italian Left, 1880–1920," in *In the Shadow of the Statue of Liberty: Immigrants, Workers and Citizens in the American Republic*, ed. Marianne Debouzy (St. Denis, France: Presses Universitaires de Vincennes, 1988), pp. 45–46.

51 Natalie Schuldt, "More than 'Pin Money'—Why Women Worked in the 1930s," in *Images of the American Worker, 1930–1940*, [ed., Lyndel King], exh. cat. (Minneapolis: University Gallery, University of Minnesota, 1983), pp. 16–18.

52 *Exhibition: Paintings, Sculpture, Drawings, Prints on the Theme of "Hunger, Fascism, War,"* exh. cat. (New York: John Reed Club Gallery, 1933–34), n.p.

53 Most of these have been lost and are known only through photographs. The author thanks the artist for bringing this series to her attention.

54 Isamu Noguchi, *A Sculptor's World* (New York: Harper & Row, 1968), p. 21.

55 Robert Cronbach, interview with the author, 23 October 1991.

56 Robert Cronbach, interview with the author, 19 October 1991; Dr. Connie Weinstock, interview with the author, 15 October 1991; and biographical entry, in Norman L. Kleeblatt and Susan Chevlowe, *Painting a Place in America: Jewish Artists in New York, 1900–1945*, exh. cat. (New York: Jewish Museum, 1991), pp. 171–72.

57 M. M., "Art Comment: S. A. Lipton's ACA Show Vigorous with Social Purpose," *Daily Worker*, 12 November 1938, in Seymour Lipton scrapbook, Seymour Lipton papers (on microfilm, reel N69–68, frame 399), Archives of American Art.

58 Seymour Lipton, "General Ideas of Values and Ideas of Esthetic Values—Social Elements in Esthetic Significance and Judgement," manuscript, 1942, in Seymour Lipton papers (on microfilm, reel D385, frame 49), Archives of American Art.

59 Kenneth L. Kusmer, "The Underclass in Historical Perspective: Tramps and Vagrants in Urban America, 1870–1930," in *On Being Homeless: Historical Perspectives*, ed. by Rick Beard, exh. cat. (New York: Museum of the City of New York, 1987), pp. 21–23.

60 Ibid., p. 30.

61 According to Alice Kalish, *The Bread Line* was created in Paris and based on the composition of Rodin's *The Burghers of Calais*. It was described as an indictment when illustrated in *Railway Clerk* 25 (January 1926): 20.

62 Mark Wilkowske, "On Strike: The Labor Movement in the 1930s," in *Images of the American Worker*, pp. 27–28.

63 Kalish, possibly inspired by a strike in a Paris foundry, created a bronze of a striker defiantly waving one arm (c. 1926). In the tradition of nineteenth-century bronzes, however, the striker's wife and children were depicted at his feet; their inclusion weakened the stridency of the composition.

64 Berta Margoulies lecture, Museum of Fine Arts, Boston, 24 May 1989, tape, Archives of American Art.

65 Cronbach interview, 19 October 1991.

66 The history of the antilynching movement and the two resulting 1935 art exhibitions are the focus of Marlene Park's "Lynching and Anti-lynching: Art and Politics in the 1930s," *Prospects: An Annual of American Cultural Studies* 18 (1993): 311–65. Park gives more attention to paintings and prints than to sculpture.

67 The little-known artists Samuel Becker and William Mosby also contributed sculptures of lynching victims to the Newton Galleries exhibition. Although Richmond Barthé was supposedly working on a sculpture devoted to the lynching theme for the NAACP exhibition, Mosby seems to have been the only black sculptor to exhibit at either 1935 showing. Barthé did exhibit in 1939 a sculpture of a mother mourning over the body of her son who had been hanged.

68 Goodelman had exhibited *The Necklace*, usually incorrectly dated 1934, in his 1933 one-man exhibition at the Eighth Street Gallery in New York City, the week before the Scottsboro Boys were to be retried in Alabama.

69 *Kultur* is identified as *German Millerism* [sic] in a photograph, in Aaron Goodelman papers, Archives of American Art. The artist referred to the association between blacks and Jews and the brotherhood of all men in another wood carving, *My Kin* (1939 or 1944).

70 Octavio Medellin, artist's statement, in *Americans 1942: 18 Artists from 9 States*, ed. Dorothy C. Miller, exh. cat. (New York: Museum of Modern Art), p. 102.

71 Seymour Lipton, interview with Roberta K. Tarbell, 5 July 1979, quoted in Tarbell, "Seymour Lipton's Carvings: A New Anthropology for Sculpture," *Arts Magazine* 54 (October 1979): 80. Lipton exhibited his dead figure as *Proletarian* in a 1933 John Reed Club exhibition.

72 Donald L. Grant, *The Anti-Lynching Movement, 1883–1932* (San Francisco: R. & E. Research Associates, 1975), p. 167.

73 Viktor Schreckengost, "Viktor Schreckengost of Ohio," *Studio Potter* 11 (December 1982): 77.

120

John Flannagan
(United States, 1895–1942)
NEGRO BOY *(also known as*
FIGURE OF A CHILD*)*
1929, sandstone, 28 x 11½ x
10 in. (71.1 x 29.2 x 25.4 cm),
The Regis Collection,
Minneapolis

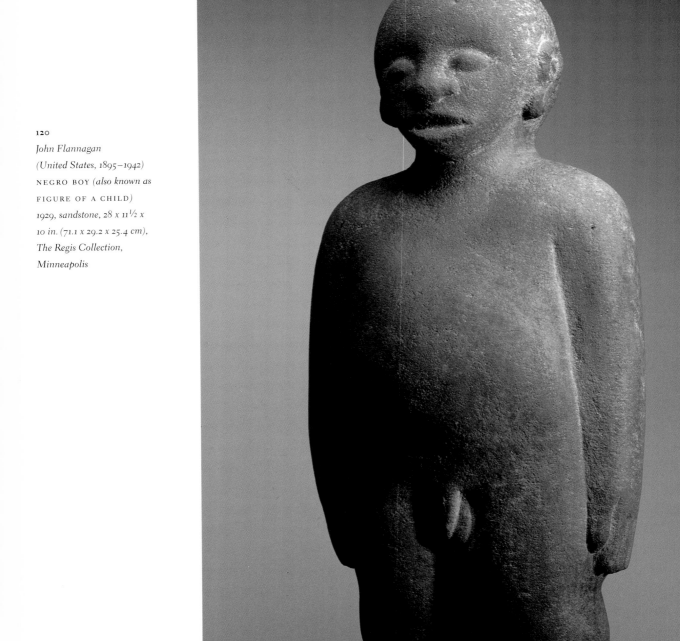

Primitivism,
Folk Art,
and the Exotic

ROBERTA K. TARBELL

THE FASCINATION OF *early twentieth-century American sculptors in racially, culturally, and aesthetically diverse tribal, folk, and exotic arts anticipated the crucial conflicts of the century. They could not have foreseen the Nazis or the civil rights movement, but as prescient thinkers they foreshadowed in their art the disintegration of the normative racial canon. When they rejected aspects of traditional, academic-classical arts and searched African, Asian, Latin and Native American, and folk cultures for palliatives to their unease, they were questioning their own identities. They discovered both the formalist and the evocative values that they believed were intuited by nontraditional, non-Western, nonacademic artists who lived in more natural societies.*

In contrast, artists who planned international expositions that took place in American cities in the decades following the centennial demonstrated racist attitudes. Historian Robert W. Rydell observed that fairs between 1876 and 1916 were organized to promote economic development that benefited white males more than other populations.[1] Women, unable to gain entrance to the École des Beaux-Arts in Paris and thus insufficiently trained, were either not represented or were there as assistants to the male mentors in whose studios they worked and learned.

Because Native American artists were considered inferior in intellect, social development, genetic potential, and artistic power by Americans with European ancestors, their works of art were relegated to the ethnographic pavilions. The same reasoning and division was the ongoing norm in Euro-American museums. In 1936, for example, the inaugural exhibition in the new building of the Dallas Museum of Fine Arts, its contribution to the

121

Allie Tennant
(United States, 1898–1971)
THE TEJAS WARRIOR
1936, gold leaf on bronze,
108 x 42 x 24 in. (274.3 x 106.7 x
61 cm), Hall of State, Fair Park,
City of Dallas

122

A. Stirling Calder
(United States, 1870–1945),
Frederick Roth
(United States, 1872–1944),
and Leo Lentelli
(Italy, 1879–1962)
THE NATIONS OF THE
ORIENT
1915, destroyed
Photograph from Juliet James,
Sculpture of the Exposition,
Palaces and Courts *(San*
Francisco: Crocker, 1915),
p. 11

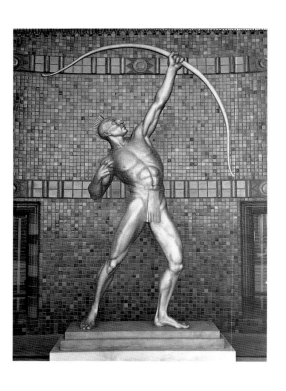

Texas Centennial Exposition, celebrated Texas regionalism. One-third of the exhibition was devoted to European art, and of the two-thirds allotted to Americans large sections were devoted to work by artists of Texas and the Southwest.[2] Objects created by Native and African Americans, excluded from these fine arts installations, were segregated into separate galleries. The eponymous Tejas Indians were conspicuously represented at the fair by a gilded-bronze personification, *The Tejas Warrior* (plate 121), by Allie Tennant (1898–1971), a Texas sculptor who had studied with Edward McCartan (1879–1947) at the Art Students League (1927–28). Some of McCartan's lean and angular figurative style is imposed on the nine-foot sculpture of a fictive native archer, whose likeness immediately became a symbol of the centennial, the fair, and the State of Texas itself. African Americans were prohibited from viewing the fine arts exhibition except for one evening a

week set aside for them, a discriminatory practice that continued in the South until the 1950s.[3]

Another dramatic example of such racism in sculpture was *The Nations of the Orient* (plate 122), modeled by A. Stirling Calder (1870–1945),[4] Leo Lentelli (1879–1962), and Frederick Roth for the Panama-Pacific International Exposition (1915) in San Francisco and described in its catalogue: *Atop the Arch of the Orient is the superb tableau representing the types of men that form the Orientals. From left to right—the Arab Sheik, the Negro Servitor, the Egyptian Warrior, the Arab Falconer, the Indian Prince and spirit of the East, the Lama, the Mohammedan Warrior...the Mongolian Warrior. On they come to join the Nations of the West in the great Court of the Universe.... It rises in its impressive pyramidal height to a climax in the Spirit of the East.*[5]

They portrayed ethnic diversity through white, racist eyes as stereotypes, employing the picturesque, exotic equipment inherited from French romantic artists. The sculptors lumped together Asian and African men as "Orientals." Women were ignored, unworthy of joining "the Nations of the West in the great Court of the Universe." As Rydell accurately perceived, science, religion, the arts, and architecture reinforced each other at the international expositions and offered Americans a "powerful and

highly visible, modern, evolutionary justification for long-standing racial and cultural prejudices" with profound and long-ranging consequences.[6]

For the catalogue *"Primitivism" in 20th Century Art*, which accompanied the exhibition at the Museum of Modern Art in 1984, William Rubin defined *"primitivism"* in formalist terms as the twentieth-century art-historical phenomenon involving the affinities between African and Oceanic arts and modernist works and the influence of tribal on modern art.[7] Ignoring the contexts and the cultures surrounding visually similar works, Rubin placed primitive aesthetics on a par with modernist aesthetics.[8] Marianna Torgovnick, in her penetrating analysis of five hundred years of ethnographic and formalist approaches to primitivism, concluded that the meanings of primitivism have varied widely and had more to do with the viewer than the subject.[9] Primitivism and tribal arts are subjective terms because they are always filtered through class, gender, racial, ethnic, national, and historical premises. The dictionary definition of *primitive* as prime and not derived is useful for the history of art; so much of the art of Europe and its colonies in America was secondary to and derived from other art. Twentieth-century Western artists were fascinated with objects created by indigenous people whose primary social unit was the tribe.

During the nineteenth century artists and collectors began to appreciate the differences between machined, mass-produced, contemporary consumer products and handcrafted arts executed with the loving care of individual artists. In America and Europe the rhetoric of the arts and crafts movement, with its emphasis on handcraftsmanship, organic materials, and the personal involvement of the craftsperson from inception to finished work,

prepared the way for modern artists to appreciate folk and tribal art. From 1905 to 1911 Hugo Robus, for example, lived and worked in an arts and crafts studio workshop in Cleveland, where he carved ivory jewelry and handcrafted metal objects. John Flannagan directly encountered arts and crafts philosophy during his discussions with one of its major advocates, Hervey White, at the Maverick in Woodstock, New York, in 1924. The value of Western vernacular arts arose in part because of a nostalgia for the apparently simpler rural life of a preindustrial past, lost to the millions who had moved to urban centers.[10] The exoticisms of distance and racial diversity, added to such a romanticized view of the past, also fostered new aesthetic interests in tribal arts.

Folk, tribal, and Mesoamerican sculptures were created by artists without the benefit of formal schools or awareness of the history of art, celebrating both their intrinsic individuality and their strong urge to create objects of art. The definition of folk art that Holger Cahill published in his catalogue for the exhibition of American folk art at the Newark Museum in 1931, remains a good one but also contributes to our understanding of tribal and Mesoamerican sculptures:

[Folk art] is an expression of the common people and not an expression of a small cultured class. Folk art usually has not to do with the fashionable art of its period. It is never the product of art movements, but comes out of the craft traditions, plus that personal something of the rare craftsman who is an artist by nature if not by training. This art is based not on measurements or calculations but on feeling, and it rarely fits in with the standards of realism. It goes straight to the fundamentals of art, rhythm, design, balance, proportion, which the folk artist feels instinctively.[11]

Distinctive characteristics of objects created by artists untrained in the academic tradition increase in proportion to the degree of isolation and "purity" of the society that produces them. Such arts flourish in uncomplicated cultures in which imagination is less acculturated than in more supposedly sophisticated societies. Modernist sculptors especially liked style characteristics in folk art, which they pursued in their own art: flat, patterned designs, often colorfully polychromed; reductive, almost geometric, three-dimensional shapes to describe human anatomy; clarity of contour line; and expressive description apparently unself-conscious of the rules of the Western academic tradition. Early twentieth-century American avant-garde artists recognized in folk, tribal, and Mesoamerican sculpture the qualities of abstraction, geometrization, and psychological intensity they sought for their own works of art.

Because tribal sculptures are usually cut from wood, they tend to stimulate direct carvings rather than sculptures modeled in clay. Tribal and folk artists throughout time whittled wood with simple cutting tools. What was innovative was the twentieth-century use of the technique by sculptors trained in academies where the hegemony of modeling clay for eventual casting in bronze or pointing to marble predominated. Direct carvers, inspired by the qualities inherent in the materials, "discovered" the subject as well as the form that emerged as they carved. A wide range of colors and grains intrinsic to wood and stone and the process itself were important determinants of iconography, composition, and surface treatment. Direct carving was the most pervasive of all the figurative sculptural techniques developed between 1910 and 1940, perhaps because it simultaneously encompassed so many of the aesthetic philosophies vital to the early modernists.[12]

Rubin wrote that modern primitivism began when Henri Matisse, André Derain (1880–1954), Maurice de Vlaminck (1876–1958), and Pablo Picasso discovered African and Oceanic tribal sculpture in 1906–7.[13] These modern artists delighted in the vigor and expressive force of the inventive and seemingly naive works devoid of traditional representation and illusionism. They believed that tribal societies might have the secrets to a serenity missing in stressful, discordant, misdirected, contemporary urban life. Somehow, by emulating the process of primitive, exotic, or naive artists, they might access the secrets of a simpler life. Early modernist artists were not, however, interested in documentation or in the iconography of individual non-Western works or in the specific cultures that produced the powerful carvings, nor were artists concerned with the myths, rituals, and legends. Fascination with cultural belief systems would only emerge strongly with the abstract expressionist generation. The Americans—all painters at that time—Hamilton Easter Field (1873–1922), Frank Burty Haviland (1886–1971), Robert Laurent, Maurice Sterne (1877–1957), and Max Weber discovered in Paris in the same years as the Europeans not only African art but also Asian art in the collections of the Musée Guimet and folk art still in use throughout the provinces.

Avant-garde sculptors who embraced tribal arts changed so that they were not only radical artistically but also socially and politically. Racial intolerance predominated internationally when a handful of artists acknowledged the aesthetic merits of the art of those uneducated in the classical tradition and of non-Western people. Frustrated with parts of the enfranchised world, a few modern artists celebrated the primitive in themselves and were happier for it.

As Patricia Leighten has so ably demonstrated, avant-garde artists understood that appropriating tribal art was not just a disinterested aesthetic consideration of formal characteristics but an attack on the forms of society itself.[14] They brought the marginal into the mainstream.

Many American and European modern sculptors—including Constantin Brancusi, Jacob Epstein (1880–1959), Flannagan, Chaim Gross, Laurent, Jacques Lipchitz (1891–1973), Matisse, Henry Moore (1898–1986), Picasso, Marguerite Thompson (1887–1968), and William Zorach— responded with zeal to the sculptural vigor of African objects and formed collections of them. Weber, who had studied African and Oceanic works at the Musée d'Ethnographie du Trocadero (now Musée de l'Homme) and in artists' collections in Paris, incorporated tribal sculptures in two still life paintings of 1910, *African Sculpture* (plate 123) and *Mexican Statuette*.[15] He became the first in America to create primitivist works, modeling between 1911 and 1915 a few sculptures linked with African, Oceanic, and pre-Columbian objects. Weber's own words best explain the primitivist distortions he chose for his paintings and sculptures: "Distortion is born of a poetic impulse, it is the very quintessence of the finest and most subtle discernment and preference. The local, the obvious, is thus subdued to the aesthetic and the personal.... A work may be ever so anatomically incorrect or 'distorted' and still be endowed with the miraculous and indescribable elements of beauty that thrill the discerning spectator."[16]

Weber introduced African sculpture to two people who would later become dealers, Joseph Brummer (1883–1947), the Hungarian sculptor, and Robert Coady (1881–1921), another American

123
Max Weber
(Russia, 1881–1961)
AFRICAN SCULPTURE
(also known as CONGO
STATUETTE*)*
1910, gouache on board,
13½ x 10½ in. (34.3 x 26.7 cm),
courtesy, Forum Gallery,
New York City

painter in Paris. They exhibited African sculpture in New York City between 1914 and 1917 at their Washington Square Gallery and from 1917 to 1919 at the Coady Gallery.[17] In 1914 Marius de Zayas and Agnes Ernst Meyer promoted the aesthetic value of wood sculptures from the Congo, Guinea, the Ivory Coast, and Nigeria with an exhibition at Alfred Stieglitz's Little Galleries of the Photo-Secession.[18] Art dealer Paul Guillaume selected the African works from his Paris gallery, de Zayas transported them to New York, where Edward Steichen installed them, placing large, colorful geometric shapes on the walls.[19] Zorach wrote that the sculptures in the exhibition "had almost unbelievable power, versatility and imagination."[20] De Zayas opened the Modern Gallery with an exhibition of African sculpture in 1915 and kept examples of African and Aztec sculpture on display; the following year he published his racist theories about primitivism in *African Negro Art: Its Influence on Modern Art*. In contrast, Coady

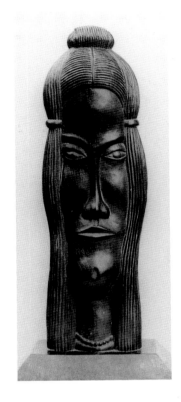

124
GOLI MASK: KPAN
Ivory Coast, Baule, 19th
century, wood with pigment,
15¾ x 8¼ x 9¼ in. (40 x 21 x
23.5 cm), Nelson-Atkins
Museum of Art, Kansas City,
Missouri, gift of Mr. and
Mrs. Morton I. Sosland

125
Robert Laurent
(France, 1890–1970)
MAYORKA
c. 1914, walnut, 16¾ x 4¾ x
3 in. (42.5 x 12.1 x 7.6 cm),
collection of John Laurent,
Ogunquit

insightfully attributed varieties of style in art to cultural, rather than racial, differences and advocated improving cultural conditions for blacks in America.[21]

Laurent was the first American sculptor to manifest his awareness of tribal art, European primitivist works, and French and American folk arts in his own sculpture. When he arrived in Paris in 1905, he was a painter, but he changed his métier to sculpture after seeing directly carved wood figures by Paul Gauguin, Aristide Maillol (1861–1944), and tribal artists.[22] Laurent's robustly carved walnut panel *Priestess* (exhibited in 1913 as *Negress*) marks the beginning of direct carving in America. Its bold forms, anatomical distortions, frontality, prominent, geometrized breasts, and schematized hair are based on African carvings (plate 124) and those by Gauguin that had so deeply impressed Laurent in Paris.[23] Two of Laurent's sculptures, *Mayorka* (plate 125) and *Widow of Toto* (1915), were inspired by Baule masks and those of other West African tribes shown at the Modern Gallery in 1915. Both the sash tied below the rotund belly, characteristic of relief carvings of

the pharaohs, and the title of another of Laurent's carvings, *Nile Maiden* (exhibited in 1915), indicate that Laurent, like Weber and Zorach, also studied the Egyptian collections at the Brooklyn Museum and Metropolitan Museum of Art.

Zorach had become aware of primitivism in Paris in 1911 and fostered his enthusiasm for tribal sculptures from exhibitions and artists in New York. He began to whittle wood sculptures in 1917, left off painting in oil in 1922, and devoted the last four decades of his career to directly carving sculpture and teaching its technique to hundreds of students. He wrote, "Primitive art…had an extraordinary magic and spiritual quality that is unequalled; it showed the spirit of man in all his terror and awe of the forces of the universe; it transcended the flesh."[24]

In 1917 the American precisionist Charles Sheeler (1883–1965) photographed twenty African sculptures at de Zayas's gallery and tipped copies of each into a small edition of an album with a preface by de Zayas; Weber and Zorach purchased two of them. Sheeler's photographs directed Zorach to carve primitivist, freestanding sculptures with compositions mimicking the African works.[25] Several of Zorach's wood sculptures are related to specific plates in Sheeler's album. The rigid symmetrical stance, frontality, single axis, exaggerated hips, blank eyes, segmental parts, and long torso of *Young Boy* (1921) and *Figure of a Child* (plate 126) can be found in the Fang figure (plate 127) there and in the Bambara figure in de Zayas's treatise.[26]

The appropriation of African artifacts by avant-garde artists was international in scope. The heads of Zorach's wood carvings are portraits of his children and therefore differ from the heads of the African sculptures. Although the Africanizing aspects are obvious, the statuettes also take on poses

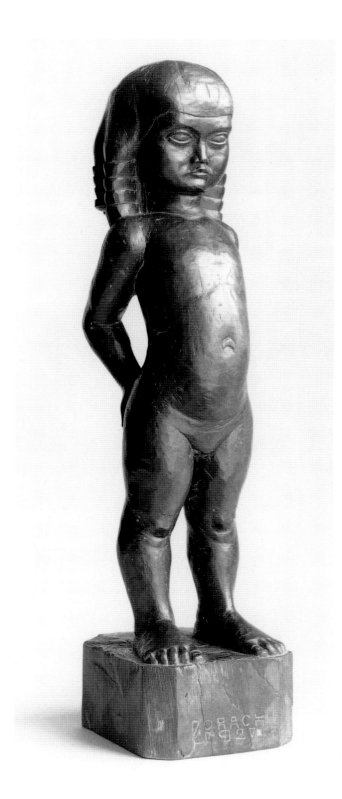

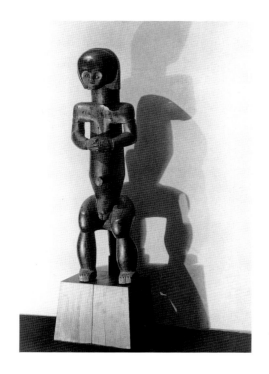

126

William Zorach
(Russia, 1889–1966)
FIGURE OF A CHILD
1921, mahogany, 23⅛ x 5¼ x
6½ in. (58.7 x 13.3 x 16.5 cm),
Whitney Museum of American
Art, gift of Dr. and Mrs.
Edward J. Kempf

127

Charles Sheeler
(United States, 1883–1965)
Untitled photograph of
reliquary figure, Gabon, Fang
c. 1918, gelatin silver print,
8⁵⁄₁₆ x 6⅛ in. (21.1 x 15.6 cm),
in Marius de Zayas and
Charles Sheeler, African Negro
Sculpture, Photographed by
Charles Sheeler *(New York:*
privately printed, c. 1918), 5

128
John Flannagan
(United States, 1895–1942)
BEDPOSTS
1923–24, polychromed wood,
approx. 19 x 3⅝ x 3¾ in.
(48.3 x 9.2 x 9.5 cm), formerly
collection of Jean Hall,
Westport

129
John Flannagan
(United States, 1895–1942)
EBON
1926, ebony, 35⅛ x 8½ in.
(89.2 x 21.6 cm), The Fogg Art
Museum, Harvard University,
Cambridge, gift of Lois Orswell

130
John Flannagan
(United States, 1895–1942)
ACROBATS
1926, mahogany, 19¾ x 3⅞ x
4 in. (50.2 x 9.8 x 10.2 cm),
collection of Gertrude Weyhe
Dennis

PRIMITIVISM, FOLK ART, AND THE EXOTIC

characteristic of their subjects. Naturalistic drawings of Zorach's son Tessim exist which are remarkably close to *Young Boy*. Defiance, an attitude reportedly typical of his daughter Dahlov, is clearly expressed in the thrust of the torso and the placement of the hands in *Figure of a Child*.[27] The compositions of the wood statuettes he whittled between 1917 and 1922 were controlled by the polelike qualities of the log, a signature characteristic of African tribal sculpture; he did not begin to break the leg from the cylinder or bend a knee in a tentative contrapposto on his standing figures until 1923. Zorach's art is based on a dialectic between naturalism, sources in art, his emotional connection with the content of his art, and his metaphysical orientation.

Zorach, like most of the early twentieth-century avant-garde sculptors, not only learned from Asian and African sources directly but also indirectly through European modernists, especially Brancusi, whose works were very influential in America. Brancusi combined in his art the aesthetics basic to orientalism, primitivism, formalism, folk art, and direct carving, goals the American carvers shared.

Flannagan first demonstrated his fascination with tribal art when he rudely carved four wood bedposts (plate 128).[28] These columnar, totemlike male figures are strikingly similar to African prototypes even to the integration of form and function. Flannagan as well as Brancusi, Gauguin, Laurent, and Zorach delighted in carving furniture and functional objects directly and crudely. Echoing the arts and crafts philosophy, Flannagan intended to market these or similar bedposts, a scheme that did not materialize.

Flannagan evoked Africa in his choice of resistant black ebony (a wood prized since ancient times) for two columnar, iconic sculptures,

Nocturne and *Ebon* (plate 129), exhibited at the Weyhe Gallery in January 1927. *Ebon*, a female figure with bulbous hips like the paleolithic *Venus of Willendorf*, is a symbol of fecundity. Flannagan acknowledged having been born of woman, but by the relative smallness of the breasts denied the nurturing qualities of the fertile female and more particularly the absence of nurture from his own mother.[29] In his oeuvre birth is an earthy, primitive process, which he intertwined dialectically with death. For *Acrobats* (plate 130) and other wood carvings of the mid-1920s he borrowed the composition of a small figure standing on the head of a larger figure from Baule ceremonial masks at the American Museum of Natural History.[30] In other works he communicated the elemental power and importance of life processes that he had discovered in tribal works.

Chaim Gross amassed more than one thousand African objects in wood and metal. He responded strongly to sculptures created by African tribesmen which like his are predominantly totemic, reductive, and axial. His two earliest carvings, *Girl with Animals* and *Mother and Child* (plate 131), both carved in Laurent's class at the Art Students League (1926), embrace the solid, compact, roughly hewn, loglike qualities of tribal sculptures. Their gouged, staccato surfaces declare the beginnings of his lifelong commitment to the technique and aesthetic philosophy of direct carving. He was inspired by the grain, the color, and the texture of the hardest—and thus the heaviest—woods: cocobolo, ebony, ipil wood, lignum vitae, mahogany, palo blanco, and walnut. Gross, like most of the American carvers, identified with the mystical content of tribal sculpture and equated such density of mass with the eternal qualities he sought in his works. He was inspired

ROBERTA K. TARBELL

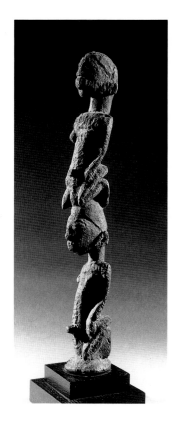

131

Chaim Gross
(Austria-Hungary, 1904–91)
MOTHER AND CHILD
1926, lignum vitae, 13¾ x 5½ x
4½ in. (34.9 x 14 x 11.4 cm),
The Renee & Chaim Gross
Foundation, New York City

132

MALE-FEMALE COLUMN
Mali, Dogon, 19th–20th
centuries, wood, 15 x 3 x 2¾ in.
(38.1 x 7.6 x 7.0 cm), estate of
Chaim Gross, New York City

to carve lignum vitae because the very old sculpture he saw at the Museum of Primitive Art looked like new.[31] Gross's primitivist intentions and his knowledge and love of tribal and anticlassical sources infused his work throughout his sixty-year career.

When Gross depicted circus acrobats, the principal subject of his oeuvre, he consciously emphasized the tribal qualities of the sculptures by stacking them totemlike three and four high. He named one six-foot lignum vitae carving *Circus Totem* (1946) and in his ebony *Family of Four* (1946) piled the square faces of three acrobats on top of each other like a totem pole. Similarly a male/female, columnar wood sculpture (plate 132) from his own collection of African objects vertically joined figures representing family members symbolic of spiritual ancestry or community survival. Gross evoked totemic, spiritual, and mystical powers when in *The Lindbergh Family* (plate 108) he chose totem poles to embody personalities in the news. The artist knew Charles and Ann Lindbergh, and when their small son, Charles A. Lindbergh, Jr., was kidnapped, Gross responded to their plight with a highly unusual, two-part sculpture. Gross chose abstracted forms to describe the situation of the aviator and his wife, incorporating into the column devoted to Col. Lindbergh a motif symbolizing his plane and into that of his wife a ladder representing the abduction. The spirit of the missing child appears at the top of both poles in the form of the family's tears. Gross was poignantly aware of the abrupt disruption of his own family when he was eleven. In his choice of the Lindbergh saga and the formal devices of a clan pole and masks (often used by shamans of Northwest Coast tribes in healing rites), he called attention to family values, creating the sculpture in the year of his marriage.[32] A product of two continents and a

serious collector of artifacts from a third, Gross epitomized the multicultural consciousness of artists throughout the century.

For his first wood carving, *Lynched* (plate 133), Seymour Lipton depicted an African American unjustly felled by mass violence and exhibited the sculpture at the John Reed Club. Lipton chose the expressionism of African tribal art to invoke the social disjunction of racism. The dramatic, zigzag figure looks like a "broken-necked" madonna, a source Lipton acknowledged, imposed upon a man who died from hanging. The anatomic distortion and segmentation are extreme and express the depth of the victim's suffering and Lipton's identification with it. In Lipton's carvings formalism, primitivism, and social consciousness coexist.

The major contributions of the self-taught sculptor's carvings are fusion of form and content and the unusual shapes he created to interpret human anatomy, both typical of tribal sculpture. From the beginning Lipton found neither non-objective nor realistic sculpture completely satisfying and invented a new human morphology, usually partial figures entwined with manmade objects in what the artist described as a new anthropology for sculpture.[33] The phrase is appropriate because Lipton's sculptural conclusions were drawn from his intense study of the origin and nature of humankind.

Lipton described *Spiritual* (plate 134) as "a contracted and imaginative body image in which focus and fusion relate to those parts of the body most directly involved with the mood" and explained that the arms emerged as if they originated in the cheekbones.[34] *Spiritual* and four carvings of similar date that deal with musical themes are partial figures (still uncommon in American sculpture at that time) with a dynamic use of voids, instead of the softly

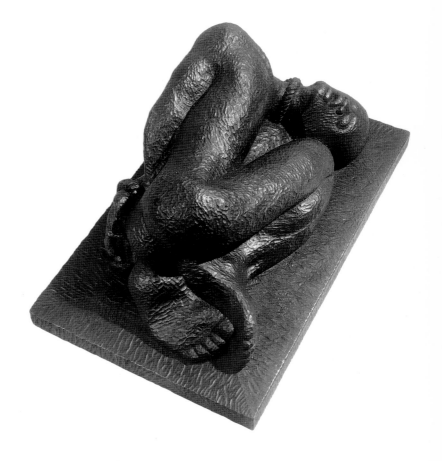

133
Seymour Lipton
(United States, 1903–86)
LYNCHED
1933, mahogany, length: 24 in.
(61 cm), collection of James
and Barbara Palmer

119

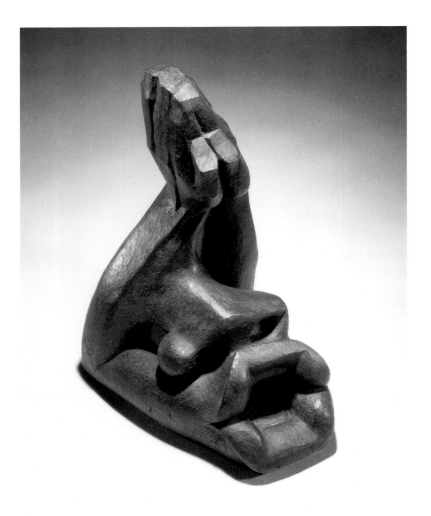

134
Seymour Lipton
(United States, 1903–86)
SPIRITUAL
1942, mahogany, 26 x 9¾ x
13⅛ in. (66 x 24.8 x 33.3 cm),
courtesy, Maxwell Davidson
Gallery, New York City

rounded, compact, closed forms favored by most direct carvers. He wrote that "the major influences of my early work stem from interest in primitive art—especially Northwest Indian and Oceanic. [Ernst] Barlach and [Wilhelm] Lehmbruck also interested me."[35]

EARLY IN THE CENTURY artists, collectors, and critics of the United States seized on folk art and architecture of the colonial era as the most American of products. When, in a time of chaos or of an indecisive value system, artists mimic folk artists, they are usually proselytizing for a return to their shared roots. In the aftermath of the United States centennial colonial artifacts became collectible, but interest in folk arts of the colonial and national periods did not proliferate until World War I. Such European-born American sculptors as Gross, Laurent, Elie Nadelman, and Zorach appreciated

the universal qualities of European and American folk arts and found that the latter affirmed some positive experience of arts or crafts from their childhoods. Gross, for example, had learned to love the sensuous qualities of wood at his father's sawmill in the forests of the Carpathian Mountains in Austrian Galicia.

In 1910, when Hamilton Field, accompanied by Laurent, traveled to Ogunquit, Maine, to establish an art school, he purchased folk artifacts, probably the first American to do so.[36] Field promoted their legitimacy by exhibiting them at his Ogunquit School of Art and at his Ardsley Studios in Brooklyn and by writing essays for the *Brooklyn Daily Eagle* and *The Arts*. Laurent's dependence on African sources decreased as he became more involved with abstraction inspired by French and American folk art and by the abstracted sculptures of Brancusi, Nadelman, and Adelheid Roosevelt (1878–1962).

In *Abstract Head* (plate 135) Laurent suppressed subject and primitivist crudeness for formalist considerations of contour, color, and surface finish. He eschewed the rough finish of African works executed with adzes and instead caressed and polished the rich grain of hard mahogany with more delicate tools, but *Abstract Head* remains connected with primitivism not only because it is directly carved but also because it is outside the Western classicizing tradition. Laurent, who had received little academic training, found in the vernacular abstraction and expressionism of folk and tribal arts more appealing anatomical canons.

Nadelman was so intrigued by European and American folk sculptures that he collected them (plate 136) and incorporated some of their characteristics into his own work. He displayed his extensive collection at Alderbrook, his home and studio at Riverdale-on-Hudson (which he sometimes called the Nadelman Museum of Folk Art), and in his New York City brownstone on East 93rd Street.[37] His fascination with these folk objects changed the direction of his work, evident especially in his polychromed cherry wood figures, which he began to cut in 1917. Lincoln Kirstein wrote that Nadelman "preferred the unredundant shapes from international folkfashioning which, however sophisticated in the true sense, have come to be called 'primitive,' but which are primal, irreducible, archetypical."[38] The witty, doll-like genre plaster figures that Nadelman translated to cherry wood were inspired not only by folk art but also by vaudeville, the circus, Georges Seurat's silhouettes,[39] and printed images from New York popular culture. These sleek, clothed figures, with their posturing and gesturing, exhibited in their plaster versions at Knoedler's in 1919, are some of the most memorable images of Nadelman's

135
Robert Laurent
(France, 1890–1970)
ABSTRACT HEAD
1915, mahogany, 15 x 8 x 6 in.
(38.1 x 20.3 x 15.2 cm), Amon
Carter Museum, Fort Worth

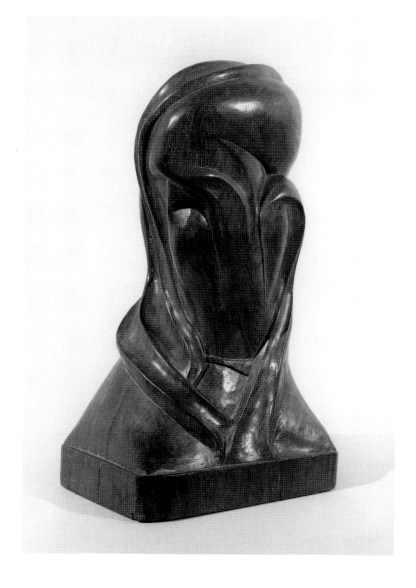

136
Unidentified artist
HARRY HOWARD
*c. 1857, polychromed wood,
over life size, collection of The
New-York Historical Society
(ex-collection, Elie Nadelman)*

137
*Unidentified artist
(possibly New York)*
LADY OF FASHION
*1870–90, polychromed wood,
68 x 11½ x 28 in. (172.2 x 29.2 x
71.1 cm), The Abby Aldrich
Rockefeller Folk Art Center,
Williamsburg (ex-collection,
William Zorach)*

oeuvre. Although he had carved and polished some of his earlier wood sculptures, the later wood figures, created between 1917 and 1922, were not directly carved. He conjured the character of his images as he drew them on paper, modeled them in clay, cast them in plaster, replicated them in wood by turning them on a lathe, thinly gessoed some of their surfaces, and washed them with diluted color. He captured different moods from the saucy (in *Dancer*, plate 99) to the soigné (in *Tango*, 1923–24). *Tango* embodies his search for a contemporary form of art that was at once abstract, symbolic of a specific culture, and yet as timeless and deeply satisfying as the classical art of antiquity and the folk art of all times. The polychromed, geometric solids, the combination of wrought iron, plaster, and wood, and the genre subjects of his cherry wood sculptures echo the vitality Nadelman found in the American folk sculptures he collected so avidly.

Because of Field's influence, Zorach ferreted out American folk sculpture (plate 137) beginning with his first trip to Maine in 1919. Like folk, tribal, and other modern sculptors, he carved many functional objects including figurative wood handles for a large fork and spoon and relief carvings on a mirror frame and clock case. A self-taught sculptor, he put aside his years of study in academic painting and emulated the immediacy of both African and American primitive carvings. He admonished his students to "study these early American carvings. There is an amazing directness of approach and an amazing simplicity of effort and intention."[40]

Some of the qualities of folk art that pervade Laurent's wood sculptures are the natural result of spending his early years among the fisherfolk of Brittany. In 1970, when I asked him about the influence of folk art on his sculpture, he laughed and said, "I am a peasant and create sculpture like one." During the early 1920s Eugenie Shonnard lived among the same gentle French people and carved their likenesses in stone. Because she had so ably captured the spirit of Breton peasants in her sculptures, Edgar L. Hewett, director of the School of American Research at the Archaeological Institute of America in Santa Fe, invited her to New Mexico in 1925 to capture in sculpture the fortitude and iconic power of Native Americans there. He was apprehensive that the native culture would be lost and believed that Shonnard's sculptures would preserve its special qualities. He later wrote to her:

*This great region, which is still so perfectly elemental in
its character, has profoundly influenced every race that
has come into it. The Indians who have lived here
through the ages are a part of it, as are the winds, clouds,
skies, rocks, trees and all other elements of its mesas,
canyons, and deserts.*

I marvel that you so quickly sensed all this; still more that you have so powerfully expressed it. You have interpreted the Indian with rare understanding. You have felt the forces that made this race what it is.[41]

Shonnard's monumental carving *Pueblo Indian Woman* (plate 138) is an abstracted but realistic interpretation of the physiognomy, anatomy, and traditional garb of a Pueblo woman. Its mass and density suggest the staying power of the sedentary agricultural tribes, whose prehistoric ancestors had given up hunting and gathering to settle in the area two thousand years earlier. The technique of directly carved wood with vertical axiality was a primitivist legacy of her Paris years.

By 1924, when the American painter Henry Schnakenberg (1892–1970) arranged an exhibition of folk art at the Whitney Studio Club, he borrowed examples owned by other American painters—Peggy Bacon (1895–1987), Alexander Brook (1898–1980), Charles Demuth (1883–1935), Yasuo Kuniyoshi (1893–1953), Sheeler, and Dorothy Varian (1895–1985)—suggesting the extent to which folk art fascinated modern artists.[42] The Whitney Museum of American Art continued its documentation and display through the 1980s.[43] Edith Gregor Halpert made her personal discovery of folk art in 1925, when she saw Laurent's Ogunquit collection, which he had inherited from Field. She sought out salable objects, which she collectively labeled primitives, and displayed them annually from 1932 to 1969 in a special section of her Downtown Gallery called the American Folk Art Gallery. Recognizing in folk art the voice of the people, Halpert took Cahill to Ogunquit in 1926. Cahill became the first scholar to write extensively on and organize exhibitions of folk art, the first at the Newark Museum (1930 and 1931) and then at the Museum of Modern Art (1932).[44]

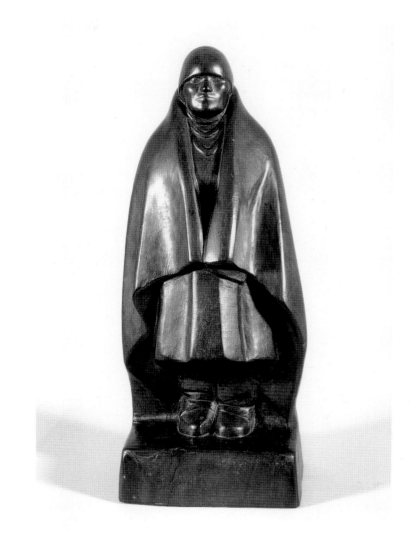

138
Eugenie Shonnard
(United States, 1886–1978)
PUEBLO INDIAN WOMAN
1926, hardwood (satina), 17¼ x
6½ x 5⅛ in. (43.8 x 16.5 x
13 cm), Taylor Museum for
Southwestern Studies of the
Colorado Springs Fine Arts
Center

123

139

*John Flannagan
(United States, 1895–1942)*
THE NEW ONE
*1935, bluestone, 6¼ x 11½ x
6¼ in. (15.9 x 29.2 x 15.9 cm),
The Minneapolis Institute
of Arts, the Ethel Morrison
Van Derlip Fund*

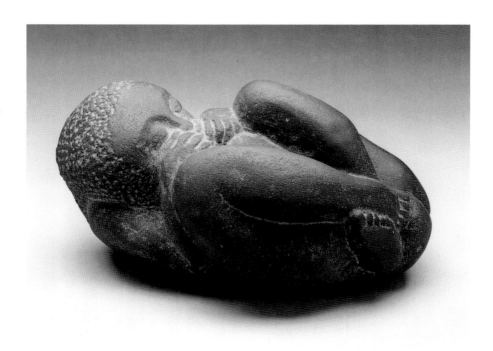

WHILE THE EARLY wood carvings of Flannagan, Gross, Laurent, and Zorach were strongly influenced by African and folk arts, by 1929 all had carved stone sculptures that demonstrated a comprehensive knowledge of pre-Columbian stone carvings. Zorach wrote:

The American continent produced an art of its own; an art of savagery, power and death; an art that included the austerity of a Chacmool and the mystic fear, savagery and decoration of the Coatlicue, as overwhelming and uncontrolled as the jungle which gave it birth. Pre-Columbian art is an art of power and lust and terror— man's attempt to equal the ferocity of nature and thus nullify its terrors.... [It] has a bold simplicity of design and a fierce emotional content, an education for death. Although basically abstract, we find among these, pieces of sculpture amazingly realistic in our Western sense of realism; a way of looking at nature not found in any other primitive art.[45]

Flannagan had "come to hate the sight of a woodblock" and instead cut stone blocks, usually of granite, limestone, and fieldstone, in an increasingly abstract style (plate 139).[46] Aztec prototypes in the collections he knew—the American Museum of Natural History and the Walter Arensbergs'—inform the childlike, androgynous figures that he carved between 1926 and 1930. Both his and the ancient Mexican figures are compact, seated or kneeling figures with arms pressed at their sides or clasping their knees. Flannagan's belief in the interrelationships of people, animals, and other natural forces was reinforced during two sojourns in Ireland. Most of his stone sculptures carved between 1930 and 1933, including those carved in Ireland, are of animals; several resemble tightly compressed Aztec figures. These have little to do with Irish art and a lot to do with the character of a place where time appears to stand still. His Irish stones are earthy, rough textured, and primordial.

Although Ahron Ben-Shmuel shared with the other American direct carvers their love of primitive, reductive carvings of the past, he was interested only in stone as a medium. He was a consummate craftsman, favoring the most resistant stones. If the density of his over-lifesize, black granite head, *Pugilist* (plate 140) is not convincing of the brutality of prizefighting, its broken nose, cut lips, and swollen eyes are. *Pugilist* has the vertical thrust of the giant Easter Island heads and resembles the plaster cast of one at the American Museum of Natural History, an institution Ben-Shmuel had haunted since his childhood.

The appearance of José de Creeft on the American art scene did much to popularize direct carving, and by the 1930s a second generation active on both coasts had proclaimed the virtues of stone as a carving material. Unlike Flannagan or Ben-Shmuel, de Creeft preferred less granular, more colorful stones, polished surfaces, and soft, fleshy figures (plate 141). As with *Pugilist* and some of Flannagan's carvings, the viewer senses the stone of Cleo Hartwig's *Child Asleep* (plate 142) before the subject. Typical of her works of the early 1930s, *Child Asleep* retains the geometry, rectangularity, mass, and texture of the limestone block of Aztec carvings (plate 143) and forces the sleeping child to conform to it. Both the primacy of material and the gross exaggeration of anatomy for expressive purposes are integral parts of primitivism. *Child Asleep* evokes the same elemental power as Ben-Shmuel's stone sculptures, though Hartwig chose a vulnerable, feminine, horizontal orienta- tion for her figure instead of the phallic verticality of Ben-Schmuel's boxer.

West Coast artists, such as Eugenia Everett and Donal Hord, found Mesoamerican sources especially

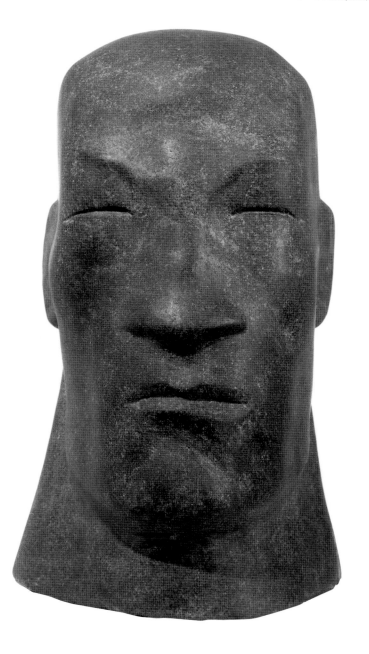

140
Ahron Ben-Shmuel
(United States, 1903–84)
PUGILIST
1929, granite, 21 x 13 x 12 in.
(53.3 x 33 x 30.5 cm), The
Museum of Modern Art, gift of
Nelson A. Rockefeller, 1934

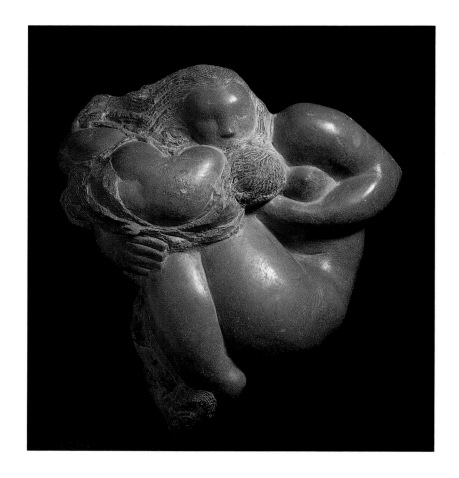

141

José de Creeft
(Spain, 1884–1982)
THE CLOUD
1939, greenstone, 16¾ x 12⅜ x
10 in. (42.6 x 31.4 x 25.4 cm),
Whitney Museum of American
Art, purchase

142

Cleo Hartwig
(United States, 1907–88)
CHILD ASLEEP
1937, Indiana limestone,
7 x 17½ x 6½ in. (17.8 x 44.5 x
16.5 cm), Albert Glinsky and
Linda Kobler Glinsky

143

CHACMOOL
Mexico, Patzxuaro, Tarrascan,
900–1520, volcanic tuff stone,
10¾ x 13½ x 6½ in. (27.3 x
34.3 x 16.5 cm), The American
Museum of Natural History,
New York City

appealing, for Mexico had historical and cultural ties with that region. Anthropological and art museums in Los Angeles, San Diego, and San Francisco had public collections devoted to Mesoamerica and the Southwest that were as good as, if not better than, museums in New York City. In addition, after moving permanently to Hollywood in 1927, the Arensbergs made their collection of pre-Columbian and modern art available to local and visiting artists.

When Laurent carved stone, his inspiration from non-Western sources was expressed more vaguely as exaggerations of anatomical form. Laurent preferred very soft stones and carved fifty blocks of alabaster between 1920 and 1970. He retained the flatness and ovoid shape characteristic of alabaster when he carved this quarried, gypseous stone into unpierced sculptures of youthful, nude female figures with stylized hair draped to fill the voids, exemplified by *Seated Nude* (plate 144). Unfinished alabaster is opaque with a dead-white, chalky crust that refracts light; Laurent coaxed out its gleaming surfaces and natural pink translucency by rubbing and polishing off the outer skin, allowing light to penetrate.

||

THE SCULPTORS WHO had created *The Nations of the Orient* appear to have been unaware of the tremendous debt Western artists owed to the East. Although Asian art and philosophy as motivating forces for modernist artists have been underestimated, their impact on the form and content of three-dimensional works was far-reaching from the eighteenth century to the present. Such sculptors as Beniamino Bufano, Allan Clark, Hord, and Jacques Schnier—all working on the West Coast— depicted Asians as exotic subjects, which emphasized their otherness. Both Bufano and Emma Lu

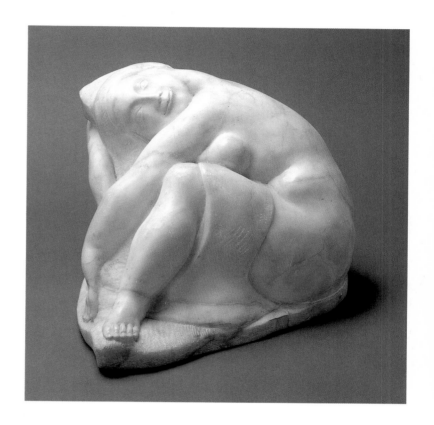

144
Robert Laurent
(France, 1890–1970)
SEATED NUDE
1930, *alabaster, 14¼ x 16 x 15*
in. (36.2 x 40.7 x 38.1 cm),
John P. Axelrod, Boston

Davis lived in China, where each concentrated on a single aspect of Chinese art: Bufano, its ceramic glazing techniques; Davis, its folk art. The serene, hieratic pose, color, and realism of Bufano's *Chinese Man and Woman* (plate 145) is both Chinese (plate 146) and modern. Glazed sculpture reached a high point in Ming dynasty China (1368–1644) but was rarely used in the United States. Just as Gross had collected African art and Nadelman American folk art, Bufano formed a large collection of ceramics and other objects during travels throughout Asia.

Directly carved hardwood was Davis's choice for *Chinese Red Army Soldier* (plate 147), an alignment of primitivism and radical politics that persisted during the first half of the twentieth century. Some of the abstraction, angularity, and apparent naivete also results from her discovery of Chinese folk art. She created this politically provocative head in China in 1936, a time when communist leaders Mao Zedong and Zhu De recruited a Red Army from the peasantry in order to oppose Chiang Kai-shek, who had declared himself president the year before. Although Davis was not herself a radical, her sculpture symbolizes the Red Army as the most militant threat to Chiang's power over China's 422 million people. Like Bufano's sculpture, Davis's sculpture is an example of the direct impact of Asian art and culture on American art. Davis personally made the transition between emulating the technique and rough appearance of tribal sculptures to the more scientific approach when, out of her interest in non-Western cultures, she earned a doctorate in anthropology (1964).

Clark's *The King's Temptress* (plate 148) was carved during his three-year Asian study tour. The massive temple city of Angkor in Cambodia with its extensive sculptural decorations fascinated him;

with their three-pointed jeweled diadems, the figures of celestial dancers seen throughout the temple complex surely served as inspiration for Clark's seductress (plate 149). However, he expended more energy depicting an archaeologically correct headdress than he did on capturing the characteristics of Southeast Asian people; the sculptured anatomy is little different from that of the ideal nudes he learned to create with Robert Aitken. Despite the sincerity of his quest and the knowledge of Asian art he had accumulated first hand, the title of Clark's sculpture and his attitude appear racist, sexist, and unknowing of the qualities of Asian art.

For sculptors like Flannagan, Robus, and Zorach, it was Asian philosophy that stimulated both their assimilation of eternal, metaphysical aspects into their figurative sculpture as well as their creation of sculpture as contemplative objects. Flannagan's earthy rocks, with their granular surfaces and primordial, embryonic shapes, proclaim the fervor of his spirituality, due in part to his continual exposure to the Buddhist art of India and its implicit attitude toward nature, which he learned from Ananda K. Coomaraswamy, curator of Indian and Islamic Arts at the Museum of Fine Arts, Boston. One of the first to study the art of India for its aesthetic merits, Coomaraswamy interacted with modernist artists in Boston, New York City, and New City, New York.[47] His ideas were disseminated by personal contacts, the publication of his many books, and the presentation of his lectures at the Sunwise Turn, a little-known but very important avant-garde bookshop and gallery in New York City.[48] The Sunwise Turn published Coomaraswamy's *Dance of Siva* (1918, 1924), a book of seminal importance, which Flannagan, Lachaise, Sterne, and Zorach owned and read. Flannagan, who shared

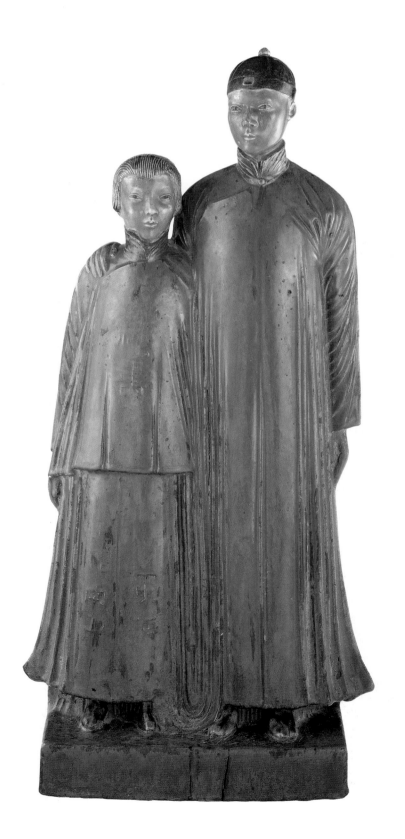

145
Beniamino Bufano
(Italy, c. 1898–1970)
CHINESE MAN AND WOMAN
1921, glazed stoneware, 31½ x
12½ x 7½ in. (80 x 31.8 x
19.1 cm), The Metropolitan
Museum of Art, gift of George
Blumenthal, 1924

146
THE HARMONY TWINS
China, late Qing dynasty,
c. 1821–1900, glazed ceramic,
9 x 6½ in. (22.9 x 16.5 cm),
the House of Benevolent
Learning, Guangzhou, China;
on temporary loan to
Louisiana State University,
Baton Rouge

ROBERTA K. TARBELL

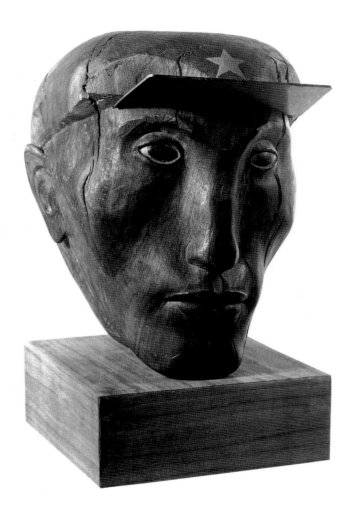

147
Emma Lu Davis
(United States, 1905–88)
CHINESE RED ARMY
SOLDIER
1936, polychromed walnut,
16½ x 8 x 9¾ in. (41.9 x 20.3 x
24.8 cm), The Museum of
Modern Art, Abby Aldrich
Rockefeller Fund, 1942

with many non-Western cultures an interest in the
concept of reanimation, of the interrelationship
of art and life, wrote, "To that instrument of the sub-
conscious, the hand of a sculptor, there exists an
image within every rock. The creative act of realiza-
tion merely frees it."[49] His carvings are pregnant
with the angst of his soul and the power of his
philosophical constructs. Many scholars and artists
responded to the efforts of Coomaraswamy and
others to inform Americans of the aesthetics and
symbolism of the art of Asia.

The interest of a few avant-garde artists in Paris
in the expressive power of the art of Africa expanded
through the twentieth century to the general accep-
tance of the concept that the art of the people of
any race, nationality, gender, class, or level of train-
ing has aesthetic merit. As we approach the twenty-
first century and a one-world culture, hierarchies,
assumed and entrenched in 1900, are being chal-
lenged and dismantled. During the 1920s and 1930s
in addition to the discovery, exhibition, and influ-
ence of tribal, folk, Mesoamerican, and Asian art,
sculptors expressed multicultural views in various
ways. Some created eclectic works mixing in a sin-
gle object features of diverse cultural groups. Others
focused on an anthropological recording of racial
and ethnic idiosyncracies.

The critic Mariquita Villard wrote that Zorach
had evolved a composite face with the high cheek-
bones of the Asiatic, the nose of the Semitic, the
"family resemblance" of archaic heads, and the
formal architectonic structure of the primitives.[50]
Zorach was typical of the many artists who deliber-
ately studied diverse anthropological artifacts, espe-
cially in Paris at the Trocadero and in New York
City at the American Museum of Natural History
and Metropolitan Museum of Art. Looking at the
illustrations and reading the text of *Zorach Explains*
Sculpture is a convincing demonstration of the wide
variety of cultures that inspired him and most direct
carvers of his generation.

During the 1920s sculptors and their patrons
were drawn to exotic cultures not only as sources for
design and expression but also to distinguish the
physiognomic features of various racial and ethnic
types. Malvina Hoffman was commissioned by
anthropologists to travel around the world to study
racial types and to create sculptural expressions of

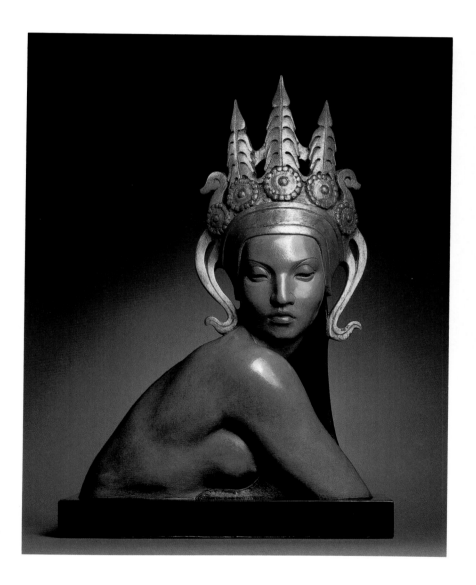

148
*Allan Clark
(United States, 1896–1950)*
THE KING'S TEMPTRESS
*c. 1926–27, polychromed
mahogany, 20½ x 13½ x 7¼ in.
(52.1 x 34.3 x 18.4 cm),
Russell P. Jaiser*

149
APSARAS (*Celestial dancer*)
*Cambodia, Angkor, 9th–13th
centuries, stone, 52⅜ x 16⅛ in.
(133 x 41 cm)*

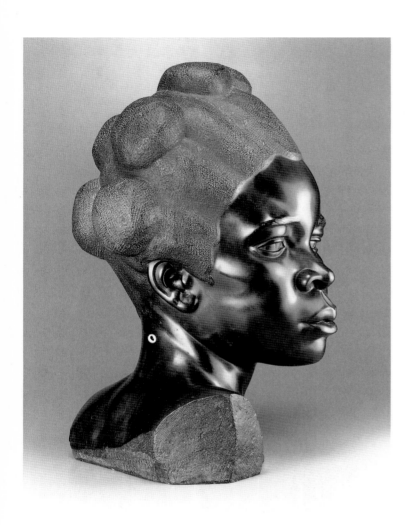

150

Malvina Hoffman
(United States, 1885–1966)
MARTINIQUE WOMAN
1927, Belgian marble, 20⅞ x
11⅜ x 15⅜ in. (53 x 28.9 x 39.1
cm), The Brooklyn Museum,
Dick S. Ramsay Fund

nonwhite, non-Western peoples. Her first journey to Africa and her experimentation with the distinct anatomies of different races preceded the commission from the Field Museum of Natural History to create sculptures portraying the races of humankind for display in Chicago at the Century of Progress Exposition in 1933. Although Martinique is one of the Windward Islands, a French Caribbean possession when Hoffman carved *Martinique Woman* (plate 150) in black Belgian marble, she recalled modeling the preliminary studies for it and *Senegalese Soldier* (1928) during a trip to North Africa in 1927. She was struck by the distinctive sculptural planes supported by high and prominent cheekbones, forehead, and jaw of what she called these "Senegalese types."[51] Similarly, in her *Congolais* (plate 156) Nancy Prophet carved the distinct and monumental anatomic structure of a man from the Belgian Congo (now Zaire) rather than emulate the traditional Fang statues from that area. Her choice of directly carving wood, however, especially in her roughly carved self-base, ultimately derives from African art.

Because Schnier's training in art followed his discovery of Asian and Polynesian sculptures during his two years in the Hawaiian Islands, his aesthetic assumptions are very different from those of artists trained in the academic tradition who later discovered primitivist sources. As a Californian he had been exposed to more Asian and Polynesian art than sculptors on the New York/Paris axis. The majority of his time on a world trip was spent in Asia, where he was enthralled by the cave sculpture and stone carvings in China, India, and Cambodia, particularly Angkor Wat. His preference for the "sensuous rhythmic quality" of their sculpture over the frontality and the forcefulness of African tribal

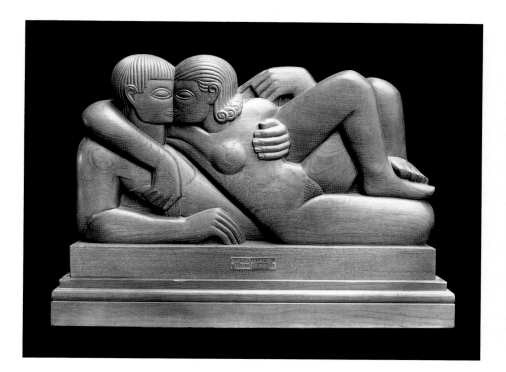

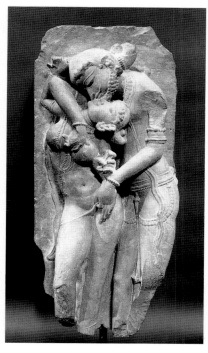

art can be seen in *The Kiss* (plate 151).⁵² This eclectic direct carving also recalls the blending of two heads into one seen in Brancusi's sculpture of the same name and the overt sexuality, if not the form and surface treatment, of Rodin's works. Other direct carvings of nude couples reclining and embracing include Zorach's *Youth* (1934–39) and Laurent's *Hero and Leander* (1943), but these American examples are later, larger (life-size), and less stylized stone sculptures. Precedents for carvings of heterosexual couples in sexual embrace can be found in African and Indian art (plate 152), but *The Kiss* does not reflect any specific work or culture but rather a synthesis and appreciation of several to some degree as well as his own contribution to an American art deco style. Teak, from which *The Kiss* is carved, is more plentiful on the West Coast than the East Coast of the United States

151
Jacques Schnier
(Russia, 1898–1988)
THE KISS
1933, teak, 26 x 20½ x 5 in.
(66 x 52.1 x 12.7 cm),
Mrs. Jacques Schnier

152
MITHUNA:
AMOROUS COUPLE
India, Madhya Pradesh,
Khajuraho style, 11th century,
sandstone, height: 29⅛ in.
(74 cm), The Cleveland
Museum of Art, 1994,
Leonard C. Hanna, Jr., Fund

153
Donal Hord
(United States, 1902–66)
THE CORN GODDESS
By 1942, lignum vitae, 39½ x
9½ x 7 in. (100.3 x 24.1 x
17.8 cm), Los Angeles County
Museum of Art, given
anonymously

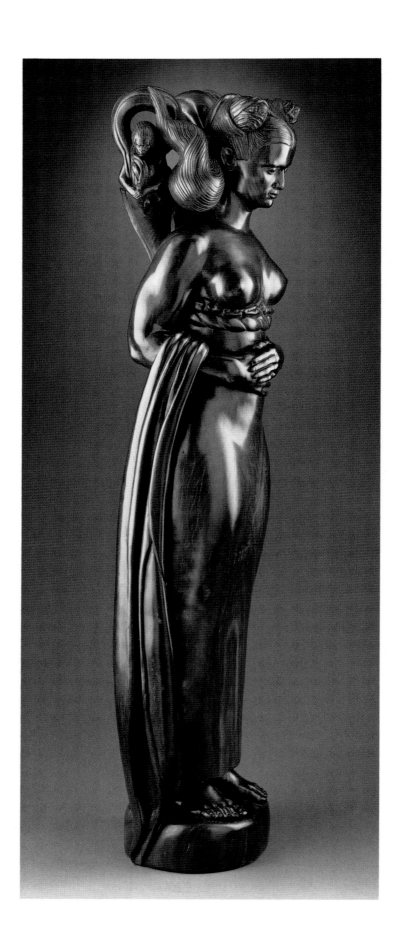

because it is native to India and Malaysia. Schnier may have preferred it at this time because of his recent travels.

Donal Hord, typical of these primitivist sculptors active in the 1930s who were serious students of many exotic cultures, focused on East Asian art during the 1910s, carved a sphinx in a sandstone cliff near Seattle in 1916, studied pre-Columbian, folk, and modern art during a fellowship year in Mexico (1928–29), and thereafter examined the indigenous culture of the Southwest in the guise of an amateur archaeologist.[53] His multicultural enthusiasms fueled his eclectic sculptural style. The sleekness of the slender figure in *The Corn Goddess* (plate 153) and the incised, parallel, sinuous striations of her coiffure are art deco. Hord's understanding of the importance of corn and its spiritual aspects to the Pueblo is acknowledged in this personification. He knew that the Pueblo not only depended on corn for sustenance but that they also placed the goddess high in their pantheon. In a notably original manner he incorporated ears of corn in the deity's hair and suggested husks in the shape of the material draped over her arm. Nevertheless, her complex headdress and strictly frontal pose with hands clasped tightly at the chest resemble Tang dynasty earthenware tomb figures of government officials (plate 154) more than sculptures created by the Pueblo. *The Corn Goddess* is carved from *lignum vitae*, or ironwood, a heavy Mesoamerican material favored by primitivist American sculptors. The literal translation of lignum vitae, "the tree of life," makes it especially appropriate for a goddess representing this staple crop. In his earlier carvings Hord retained the roughened finish typical of tribal sculptures, but in such later works as this he preferred the brilliant sheen he rubbed onto the surface.

FOLK CARVING not only inspired modern American sculptors but persisted during the modern era. Folklorists agree that William Edmondson's limestone carvings represent the religious fervor of African American charismatic religion, funeral rituals, and the tradition of folk gravestone carving.[54] The ardent, bareheaded clergyman of *Preacher* (plate 97) holds forth in white tie, stiff, bib-front shirt, and cutaway, extending his Bible as the unquestioned authority for his impassioned injunctions. Edmondson's cubic masses are often as simple as Brancusi's and as rough, granular, and primordial as Flannagan's.

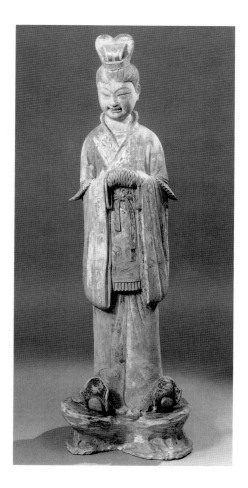

154

OFFICIAL
China, Tang dynasty, early 8th century, glazed earthenware, height: 45⅛ in. (114.5 cm), Royal Ontario Museum, Toronto

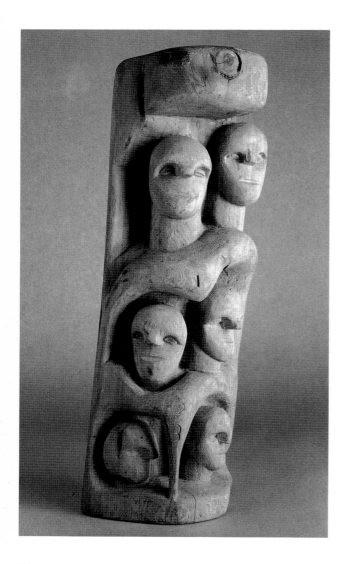

155

Patrociño Barela
(United States, c. 1902–64)
HEAVY THINKER
1930s–41, juniper, 19 x 6⅛ x
3 in. (48.4 x 15.6 x 7.5 cm),
The Harwood Foundation, Taos

Another folk artist, Patrociño Barela, a Hispanic carver of wooden *bultos* (busts) and other figures, like Edmondson, produced a large and cohesive body of powerful, idiosyncratic works. Barela expressed the weight of responsibility he felt in supporting his growing family in a multi-figural sculpture, *Heavy Thinker* (plate 155), and in this poem:

The sun and the moon
are in the knot
and it is in the sky
which is above us all
The six heads are all
one family
The father, the mother
and four children
The father has the care
of a large family
on his mind
"For I am thinking heavy
for everyone I have
to take care of"[55]

After visiting his studio in Taos in 1956 Lenore G. Marshall wrote:

The carvings, varying in size from a few inches to
a few feet, are religious, elemental, fatalistic, some
compassionate as a Rouault, some grotesque in pagan
humor, some looking as though they might have
come straight from the studio of an unlettered Henry
Moore: madonnas, angels, animals, family groups,
death-men aiming spears or arrows. His output is
prolific. He has little contact with the Anglo-American
group of artists in the neighborhood. He is the real
primitive.[56]

The spirit of Barela's works spans centuries and is universally intelligible.

SOME OF THE avant-garde artists who had learned traditional classicizing forms and subjects in academies of art in France and the United States perceived and incorporated into their own works the unusual, exciting qualities of tribal and folk arts. They understood that the more directly expressed emotions of non-Western figurative arts were closer to intrinsic human qualities than academic art based on extrinsic skills taught in schools. Early on artists appreciated both the reductive formal characteristics of the works and the powerful spiritual motivations of the nontraditional artists.

Early modern sculptors were dissatisfied with tradition for its own sake and more aware than academicians of a wide vocabulary of images of the past and present including American folk art and sculpture from Egypt, Japan, India, Africa, and Oceania. In seeming contradiction they sought a new signature style by examining non-Western and primitivist arts because they were seeking the spiritual motivation of the ancient or exotic artist as well as falling in love with some of their formal characteristics. They amalgamated the traditional subject of the human form with a modern consciousness of abstraction, expression, and originality to create a new morphology for figurative sculpture.

Notes

[1] Robert W. Rydell, *All the World's a Fair: Visions of Empire at American International Expositions, 1876–1916* (Chicago: University of Chicago Press, 1984), p. 235. See also Rydell's *World of Fairs: The Century-of-Progress Expositions* (Chicago: University of Chicago Press, 1993).

[2] Rick Stewart, "The Dallas Nine and the Texas Centennial," *Lone Star Regionalism: The Dallas Nine and Their Circle*, exh. cat. (Dallas: Dallas Museum of Art, 1985), pp. 41–76.

[3] The Dallas Museum of Art made restitution with a Museum of the Americas, inaugurated in September 1993 in its new Hamon Building. It now offers an innovative exhibition of Mesoamerican, North American, ancient American, and Spanish and English colonial art, which recognizes the diversity, unique contributions, and interrelationship of North American cultures.

[4] A. Stirling Calder recognized the power of the carvings of the Native Americans exhibited at the same fair. He wrote in *The American Architect* (8 December 1920) about "the charm of some of our aborigines. The totem poles and carved panels of our Alaskan Indians are vigorous, purposeful works of art, skillfully simple and complete, without a trace of that forced aestheticism that is the disease of art." Reprinted in *Thoughts of A. Stirling Calder* (New York: privately printed, 1947), p. 17.

[5] Juliet James, *Sculpture of the Exposition, Palaces and Courts* (San Francisco: Crocker, 1915), pp. 10, plate 11.

[6] Rydell, *All the World's a Fair*, p. 6.

[7] William Rubin, "Modernist Primitivism: An Introduction," in *"Primitivism" in 20th Century Art: Affinity of the Tribal and the Modern*, exh. cat. (New York: Museum of Modern Art, 1984), pp. 1–81. See also Gail Levin's essay, "American Art," pp. 452–73.

[8] Ivan Karp, "How Museums Define Other Cultures," *American Art 5* (winter–spring 1991): 13. Karp's thought-provoking essay was drawn from his contributions to Karp and Steven D. Lavine, eds., *Exhibiting Cultures: The Poetics and Politics of Museum Displays* (Washington, D.C.: Smithsonian Institution Press, 1991). In both, Karp distinguishes between two strategies used to represent other cultures: "Exoticizing showcases the differences between the cultural group being displayed and the cultural group doing the viewing, while assimilating highlights the similarities."

[9] Marianna Torgovnick, *Gone Primitive: Savage Intellects, Modern Lives* (Chicago: University of Chicago Press, 1990). Her chapter "William Rubin and the Dynamics of Primitivism" offers a solution to the dilemma of the inadequacies of both the formalist and the ethnographic approaches. See also Sally Price, *Primitive Arts in Civilized Places* (Chicago: University of Chicago Press, 1989); and Patricia Leighten, "The White Peril and *L'Art nègre*: Picasso, Primitivism, and Anticolonialism," *Art Bulletin 72* (December 1990): 609–30.

[10] Eugene W. Metcalf, Jr., and Claudine Weatherford, "Modernism, Edith Halpert, Holger Cahill, and the Fine Art Meaning of American Folk Art," in Jane S. Becker and Barbara Franco, eds., *Folk Roots, New Roots: Folklore in American Life* (Lexington, Mass.: Museum of Our National Heritage, 1989). Appreciation is extended to Diane Tepfer for bringing this article to my attention.

11 Holger Cahill, *American Folk Sculpture*, exh. cat. (Newark: Newark Museum, 1931), p. 5.

12 For a discussion of pertinent aesthetic theory, see Roberta K. Tarbell, "Direct Carving," in Joan M. Marter et al., *Vanguard American Sculpture, 1913–1939*, exh. cat. (New Brunswick: Rutgers University Art Gallery, 1979), ch. 5; and Judith K. Zilczer, "The Theory of Direct Carving in Modern Sculpture," *Oxford Art Journal* 4 (November 1981): 44–49. Although, as Zilczer points out, the English arts and crafts movement "nurtured the revival of direct carving" in England, tribal sculptures and the primitivist carved works of Paul Gauguin were more important in America.

13 Rubin, "Modernist Primitivism," pp. 2–3. See also Max Alfert, "Relationships between African Tribal Art and Modern Western Art," *College Art Journal* 31 (summer 1972): 387–96.

14 Patricia Leighten, *Re-Ordering the Universe: Picasso and Anarchism, 1897–1914* (Princeton: Princeton University Press, 1989).

15 Weber's poem celebrating an ancient Mexican sculpture, "Xochipilli," was published in *Camera Work* 33 (January 1911): 34.

16 *Max Weber* (New York: American Artists Group, 1945), n.p.

17 Judith K. Zilczer, "Robert J. Coady, Forgotten Spokesman for Avant-Garde Culture in America," *American Art Review* 2 (September–October 1975): 77–89. Coady also promoted primitive art in his magazine, *The Soil*; five issues were published from December 1916 to July 1917.

18 Eva E. Runk, "Marius de Zayas: The Early Years," master's thesis, University of Delaware, 1973, p. 27. For Meyer's dynamic role in organizing this exhibition and promoting avant-garde artists and publications, see Douglas Hyland, "Agnes Ernst Meyer and Modern Art in America," master's thesis, University of Delaware, 1976.

19 In his essay "From Africa" Jean-Louis Paudrat judged Paul Guillaume "to be the most prestigious African art collector and dealer in the period between the two world wars" (*"Primitivism,"* p. 152). Paudrat credits Guillaume with widening the split between the ethnographic and aesthetic approaches to African art. In his writings and his activities Guillaume elevated the finest African artifacts to the rank of masterpieces of world art.

20 William Zorach, *Art Is My Life: The Autobiography of William Zorach* (Cleveland and New York: World, 1967), p. 66.

21 Zilczer, "Coady," pp. 82–83. De Zayas and Coady mirrored the opposing views of Lucien Lévy-Bruhl, who promulgated racist, colonialist views in *La Mentalité primitive* (1910), and Franz Boas, who countered them in *The Mind of Primitive Man* (1911). See Torgovnick, *Gone Primitive*, especially ch. 1.

22 Robert Laurent to Roberta K. Tarbell, 15 February 1967. In an interview with the author (10 April 1970) Laurent reiterated that he had seen African art in Paris many times before he left in 1908.

23 Laurent also cited inspiration from a relief from Madagascar (which Field had purchased, probably from Martin Birnbaum or Frank Burty Haviland) described as "a board carved by Madagascar Savages early in the Nineteenth Century" in *Catalogue of an Exhibition of the Paintings by Hamilton Easter Field and of Wood Carvings by Robert Laurent*, exh. cat. (New York: Ardsley House, 1913), p. 4.

24 Zorach, *Art Is My Life*, p. 66.

25 *African Negro Sculpture, Photographed by Charles Sheeler* (New York: privately printed, c. 1918). Zorach's copy is in the library of the National Museum of American Art, Smithsonian Institution.

26 See Sidney Geist, "Brancusi," in *"Primitivism,"* pp. 344–67. Geist posited that this Bambara figure from Mali inspired Brancusi's full-length *First Step* (1913) and that it was illustrated on the cover of the Russian book *Iskusstvo Negrov* (The art of the Negroes, 1913). Brancusi and de Zayas knew each other in Paris.

27 When Edward J. Kempf, who had purchased *Young Girl* from Zorach in 1928, donated it to the Whitney Museum of American Art in 1970, he wrote (17 July) to John I. H. Baur, director: "It presents truly in most simple bodily form a characteristic attitude of an emotionally vigorous child."

28 Illustrated in Robert Forsyth, "The Early Flannagan and Carved Furniture," *Art Journal* 27 (fall 1967): 35, with very similar figures on an African chair from the Bajokwe tribe. See also Forsyth, "John B. Flannagan: His Life and Works," Ph.D. diss., University of Minnesota, 1965, pp. 116–18, 307, 316, and fig. nos. 15, 16.

29 Flannagan's father died in 1901. His mother placed her three sons in an orphanage in 1905, where they remained five years.

30 Forsyth, "Flannagan," p. 134.

31 Warren M. Robbins, founder and director emeritus of the Museum of African Art, Washington, D.C., studied Gross's incomparable collection for decades and was responsible for a traveling exhibition of seventy-two sculptures from it. See Arnold Rubin, *The Sculptor's Eye: The African Art Collection of Mr. and Mrs. Chaim Gross*, exh. cat. (Washington, D.C.: Museum of African Art, 1976). Gross was one of the founding trustees of the museum.

32 The title and date of this sculpture have long been problematic. At some point Gross seems to have revised his interpretation of the iconography, identifying the second pole as Bruno Hauptmann, the accused abductor of the Lindbergh child (see Roberta K. Tarbell, *Chaim Gross, Retrospective Exhibition: Sculpture, Paintings, Drawings, Prints*, exh. cat. [New York: Jewish Museum, 1977], p. 10). Renee Gross, the artist's widow, has recently confirmed that the poles were created simultaneously in 1932, the year of her wedding. Consequently, Gross could not have originally intended the second pole to be Hauptmann as he did not come under suspicion until the following year. (Ilene Susan Fort would like to thank April Paul, director, the Renee & Chaim Gross Foundation, for confirming this information with Mrs. Gross by telephone 4 October 1994.)

33 Roberta K. Tarbell, "Seymour Lipton's Carvings: A New Anthropology for Sculpture," *Arts Magazine* 54 (October 1979): 78–84.

34 Albert Elsen, *Seymour Lipton* (New York: Abrams [1974]), pp. 18–19.

35 Seymour Lipton, "The Sailor and the Flood," manuscript, 23 May 1979, in Lipton papers, Archives of American Art. This fusion of human forms with inanimate objects was an innovation of Alexander Archipenko, Henri Laurens, and Jacques Lipchitz (1915–17), part of the early developments of cubist sculpture, which echoed throughout the century.

36 See Doreen Bolger, "Hamilton Easter Field and His Contribution to American Modernism," *American Art Journal* 20 (summer 1988): 78–107.

37 On Nadelman's collection of folk art see Lincoln Kirstein, *Elie Nadelman* (New York: Eakins, 1973), pp. 29, 31, 215, 219, 224–26. A portion of the collection was sold by the artist to the New-York Historical Society, where it has remained.

38 Ibid., p. 23.

39 Ibid., pp. 168–69, 196, 220, 225. Kirstein emphasized the impact of Seurat on Nadelman, citing the large retrospective exhibitions of Seurat's paintings in Paris in March 1905 and in 1908–9, years Nadelman lived in Paris.

40 William Zorach, *Zorach Explains Sculpture: What It Means and How It Is Made* (New York: American Artists Group, 1947), p. 206. Zorach recalled that he had studied the American folk art collections at the New-York Historical Society.

41 Edgar L. Hewett to Eugenie F. Shonnard, 1 October 1925, in Eugenie Shonnard papers (on microfilm, reel 13, no frame numbers), Archives of American Art.

42 See Wanda M. Corn, "The Flowering of American Folk Art," *American Art Review* 1 (March–April 1974): 112–21.

43 See the various publications on American folk art written by Mary Black, Jean Lipman, Nina Fletcher Little, and Alice Winchester, most of them sponsored by Whitney Museum of American Art funds. Tom Armstrong documented connections between folk arts and more style-conscious sculpture in "The Innocent Eye: American Folk Sculpture," in *200 Years of American Sculpture*, exh. cat. (New York: Whitney Museum of American Art, 1976), 74–111.

44 Halpert's gallery was named Our Gallery (1926) and renamed the Downtown Gallery (1927); see Marjorie H., David A., and Margaret R. Schorsch, *American Folk Art: Selected Examples from the Private Collection of the Late Edith Gregor Halpert* (New York: Schorsch, 1994). See also Holger Cahill, *American Folk Art: The Art of the Common Man in America, 1750–1900* (New York: Museum of Modern Art, 1932), catalogue of an exhibition comprised of folk art in the collection of Abby Aldrich Rockefeller, who had begun to collect it during the late 1920s. Halpert and Cahill were two of Rockefeller's chief advisors, and a substantial number of her purchases were from Halpert's galleries.

[45] Zorach, *Zorach Explains Sculpture*, pp. 249–54.

[46] John B. Flannagan to Carl Zigrosser, 1929; published in *Letters of John B. Flannagan* (New York: Valentin, 1942), p. 21.

[47] During the 1920s Flannagan and Robus, painter and ceramist Henry Varnum Poor, textile designer Ruth Reeves, painters Morris Kantor, Wallace Putnam, and Martha Ryther, writers Harold Loeb, Bessie Poor, and Maxwell Anderson were gathered in the small artists' colony in New City, New York, established by Mary and John Mowbray-Clarke. Coomaraswamy was a frequent visitor. See Roberta K. Tarbell, *Hugo Robus (1885–1964)*, exh. cat. (Washington, D.C.: Smithsonian Institution Press, 1980), ch. 3.

[48] Coomaraswamy's books on religion and iconography—*The Mirror of Gesture* (1917), *Yaksas* (1928–31), *The Transformation of Nature in Art* (1934), and *Elements of Buddhist Iconography* (1935)—show numerous parallels of symbolism and content between Flannagan's work and Eastern art.

[49] John B. Flannagan, "The Image in the Rock," in *The Sculpture of John B. Flannagan*, exh. cat. (New York: Museum of Modern Art, 1942), p. 7.

[50] Mariquita Villard, "William Zorach and His Sculpture," *Parnassus* 6 (October 1934): 3–4.

[51] Malvina Hoffman, *Heads and Tales* (New York: Scribner's, 1936), p. 145.

[52] Jacques Schnier, interview with Jeffrey Wechsler, 18 November 1978; reported in Tarbell, "Direct Carving," p. 62; Wechsler wrote the section on Schnier.

[53] See Ilene Susan Fort, "Donal Hord," in Fort and Michael Quick, *American Art: A Catalogue of the Los Angeles County Museum of Art Collection* (Los Angeles: Los Angeles County Museum of Art, 1991), pp. 427–28.

[54] See John Michael Vlach, "From Gravestone to Miracle: Traditional Perspective and the Work of William Edmondson," and William H. Wiggins, Jr., "'Jesus Has Planted the Seed of Carvin' in Me': The Impact of Afro-American Folk Religion on the Limestone Sculpture of William Edmondson," in *William Edmondson: A Retrospective*, exh. cat. (Nashville: Tennessee State Museum, 1981), pp. 19–29.

[55] Quoted in Mildred Crews et al., *Patrocinio Barela, Taos Wood Carver* (Taos: Taos Recordings and Publications, 1962), 2d ed., p. 42.

[56] Lenore G. Marshall, "Patrocinio Barela," *Arts* 30 (August 1956): 24.

Creating the New Black Image

ACTIVE PARTICIPANTS IN MAINSTREAM TRADITIONS, *African American artists have also dealt with special issues in their art. Along with other American artists after the turn of the twentieth century, black artists explored new approaches to visual expression. They did so despite the discrimination that had always limited their opportunities for training, exhibition, and patronage. They also had to contend with a visual tradition that had been almost wholly constructed by Americans of European descent. Like their white counterparts, black artists experimented with modernism, but they also inflected their work with an African American voice concerned with social and racial issues. Their work created a new black image.*

MARY L. LENIHAN

Perhaps more than painting, sculpture reveals the full extent of the challenges involved in countering the traditional black image. The first three-dimensional images of American blacks were created in the post-Civil War era as part of numerous public monuments built to extol America's past and memorialize the war effort. Created by whites, who often infused their work with the perceptions of blacks prevailing among whites, these depictions usually presupposed blacks as inferior, objectified their status, and almost never showed persons of color in a context other than their relationship to whites. Paintings of black subjects certainly did the same, but sculptures, especially public monuments, took on added meaning, since by definition they were intended to "monumentalize" their subjects. Sculpture thus has its own politics.

All early twentieth-century African American artists not only had to establish a fully dimensional black image but also had to negate the prevailing view. Sculptors had a special challenge: that of

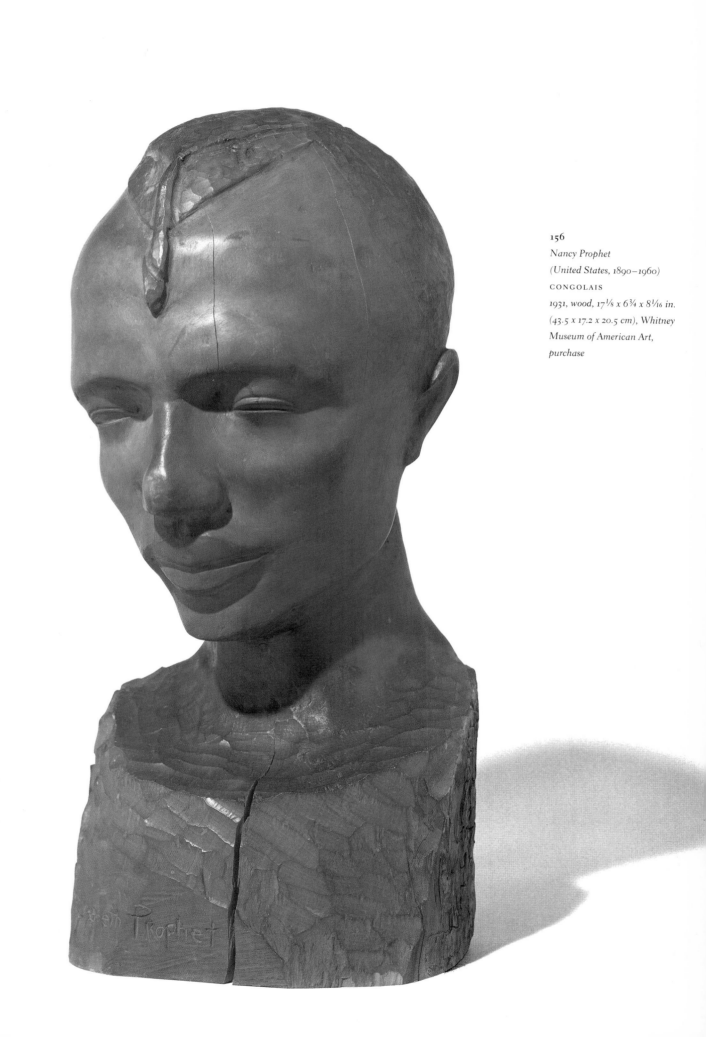

156
Nancy Prophet
(United States, 1890–1960)
CONGOLAIS
1931, wood, 17⅛ x 6¾ x 8¹/₁₆ in.
(43.5 x 17.2 x 20.5 cm), Whitney
Museum of American Art,
purchase

"remonumentalizing" the black image; in so doing, they contextualized it as well. Their willingness to use African American subjects in new modes of figurative expression invented a new American image, giving it a voice and a place. Their images had power, even as small genre pieces, which could not, and cannot, be ignored.

||

THE EARLIEST IMAGES of blacks are found in colonial paintings, in which they are portrayed as chattel, objects signifying white Americans' privileged status. In one of the oldest extant images, Justus Engelhardt Kühn's *Henry Darnall III*, (plate 157), a black servant, kneeling and wearing the silver collar marking his enslavement, is depicted as the material possession of a slave owner's son. These conventions—the kneeling posture and the bonds of slavery—were reiterated in two- and three-dimensional depictions thereafter.[1] Although most American art historians ignored these issues of racial power and difference until the 1970s, black art historians did not. The eminent African American

intellectual Alain Locke pointed out in *The Negro in Art* (1940) that it was "the colonial mind, particularly in America, where the spreading sway of chattel slavery and plantation bondage clamped on the Negro subject the stigma of inferiority."[2] Even paintings inspired by antislavery sentiment included visual reminders of blacks' subordinate status.

The sculptural renderings engendered by antislavery and Civil War sentiment were sympathetic to African Americans and presumably well-meaning but left intact an image that was becoming conventional. *The Freedman* (1863), a tabletop bronze by John Quincy Adams Ward (1830–1910), is one of the best examples. Inspired by the Emancipation Proclamation, Ward used a naturalistic rendering in his depiction of a newly freed slave. While the physiognomy is not caricatured and the subject's musculature imparts vigor, the underlying message is mixed: although the black man is not kneeling, he remains in a subordinate position, sitting; his shackles are broken but present nevertheless; and the figure is unprotected and unclothed. The bronze is remarkably free of the stereotypes and condescension prevailing at that time, but it still conveys a sense of its subject being "freed" but not free.

Post-Civil War monuments commemorating emancipation and Abraham Lincoln portrayed African Americans in a similar fashion. In many of these groupings a kneeling African American with a broken shackle looks up to Lincoln, whose outstretched arm is poised in benediction or a gesture of bestowal. The message is that the black man was freed only by the beneficence of the white and continues in a position subordinate to him. Thomas Ball's public monument *Emancipation Group* (plate 158), George Bissell's *Emancipation Group*

157
Justus Kühn
(Germany, d. 1717)
HENRY DARNALL III
c. 1710, oil on canvas, 54¼ x 44¼ in. (137.8 x 112.4 cm), collection of the Maryland Historical Society, Baltimore, bequest of Miss Ellen C. Daingerfield

(1893, Edinburgh), and Levi T. Scofield's *Emancipation Panel* (1894, Cleveland) are examples.

Even one of the best-known and most highly regarded of all Civil War monuments, Augustus Saint-Gaudens's *Robert Gould Shaw Memorial* (plate 159), shows the culturally embedded view of a racial hierarchy. The white Colonel Shaw was killed in action leading the first all-black volunteer regiment of the Civil War; the monument was made possible by the fund-raising efforts of Joshua Smith, a fugitive slave employed in the Shaw household, who later served in the Massachusetts state legislature. Remarkable for its time, it memorialized in monumental form the heroism of black fighting men in a way that surpasses the commonplace tribute.

In fact, two art historians of the era, one white and one black, who were among the first to focus on American sculpture, counted this as one of the most impressive monuments of their time.[3] There is an underlying message present, however. Compositionally the black subjects are still relegated to the subordinate position. Above the mounted Shaw and the marching black soldiers hovers a female figure,

guiding and protecting the men. Although a hovering protectress inspiring an army is not uncommon — François Rude's *The Departure of the Volunteers in 1792* (1833–36) on the southeast face of the Arc de Triomphe in Paris being perhaps the best known — the three levels of authority are conspicuous in the Saint-Gaudens: the floating female figure, the mounted white male, and at the lowest level the black soldiers.

Such compositions raise basic issues of pictorial language. Why can't blacks be visually equal in status to whites? Why can't a black figure hold his or her head as high as a white figure? Why can't the black subject be equal to the white in relation to Liberty or Peace or other divine inspiration? It is questions like these that early twentieth-century African American sculptors addressed and ultimately answered with their images.

Smaller figural sculptures of the post-Civil War era carry similar messages. The Boston sculptor John Rogers created small plaster genre groups, including several using the emancipation theme. These proved very popular and were sold in cities in

158

Thomas Ball
(United States, 1819–1911)
EMANCIPATION GROUP
1865, bronze, 32¼ x 20½ x
13¾ in. (81.9 x 52.1 x 34.9 cm),
*The Montclair Art Museum
Permanent Collection, gift of
Mrs. William Couper*

159

Augustus Saint-Gaudens
(United States, 1848–1907)
ROBERT GOULD SHAW
MEMORIAL, *fourth version*
1900, painted plaster, 132 x
168 in. (335.3 x 426.7 cm),
*Saint-Gaudens National
Historic Site, Cornish,
New Hampshire*

160
John Rogers
(United States, 1829–1904)
THE FUGITIVE'S STORY
1869, painted plaster, 21⅞ x
15¹⁵/₁₆ x 12 in. (55.5 x 40.5 x 30.5
cm), Cincinnati Art Museum,
museum appropriation

161
Edmonia Lewis
(United States, 1843/45–
after 1911)
FOREVER FREE
1867, marble, 41¼ x 11 x 7 in.
(104.8 x 27.9 x 17.8 cm),
The Howard University Gallery
of Art, Washington, D.C.,
permanent collection

the East and Midwest.[4] One of them, *The Fugitive's Story* (plate 160), shows a black mother recounting her story to three leading abolitionists: Henry Ward Beecher, William Lloyd Garrison, and John Greenleaf Whittier. While the fugitive is the title subject, it is the white men with their imposing presence who dominate the scene. Well-dressed and dignified, they are grouped around a desk, which separates them from the black woman, who, pleading her case, is clearly subordinate. The traditional separation between black and white and the social hierarchy of race and gender are thus preserved. Rogers's other small pieces, such as *Taking the Oath and Drawing Rations* (1865), also treat their subjects with sympathy but in a way that visually preserves white superiority.

Edmonia Lewis (1843/45–after 1911) was the only African American sculptor working at this time who was accorded critical recognition, and her work alludes to the challenges to the traditional black image that would come later. Her best-known sculpture, *Forever Free* (plate 161), broke with convention through its depiction of a freed male slave standing triumphantly, holding a broken shackle and stepping on a discarded ball and chain. The presence of a black woman adds a note of ambivalence, however. She kneels, gesturing gratefully, thus suggesting that blacks were not yet entirely free and that black women were oppressed because of both their race and gender. While that is a potent message, another reading might be that the sculpture stayed within the traditional canon.[5]

If the white-constructed black image presented challenges to African American sculptors of the early twentieth century, the social climate presented another set of hurdles. The advent of the twentieth century brought growing industrial prosperity for

the United States as a whole, but it ushered in an era of mixed blessings for African Americans. Economic conditions improved for those who left the rural South for factory jobs and other labor opportunities in the North, yet the new century also marked the end of post-Reconstruction advances made toward racial equality. By the year 1900 racial segregation was again the norm in the South, where improved mechanization eliminated agricultural jobs. African Americans left the Southern states in large numbers, with Chicago and New York the most popular destinations. From 1890 to 1910, for example, the black population of New York City tripled to nearly 100,000.[6] Harlem soon attracted black artists, writers, and other social and cultural leaders. By the time of its "discovery" by whites in the 1920s Harlem had a thriving subculture. Many of its residents had a growing awareness that it was at the vanguard of a developing sense of black pride.

At the same time that black ethnic pride was growing, there was a marked increase in race riots and lynchings. Riots in Wilmington, North Carolina (1898), Springfield, Illinois (1904), Statesboro, Georgia (1904), and Atlanta (1906) indicated that despite the improved status of some blacks, race relations were deteriorating.[7] Even worse, racist ideology was widely accepted in the United States and Europe. Charles Carroll's book *The Negro: Beast or in the Image of God* (1900), Thomas Dixon's *The Clansman* (1905), and William A. Dunning's *Reconstruction* (1907) all asserted that whites were genetically superior and that it was their moral responsibility to keep other races subjugated. Despite the cultural reawakening that became the Harlem Renaissance and the success of individual black artists and writers, many Americans continued to view African Americans as lower in status than whites.

Black and white leaders both added to this social and cultural stew. Without an organized agenda they offered differing and sometimes conflicting opinions regarding African American art and Western cultural traditions. Black leaders, especially W. E. B. DuBois, Locke, and later James Porter, saw excellence in the arts as visible proof that blacks were not inferior to whites. Further, all three advocated the use of African-inspired styles and black subject matter as a way for black Americans to develop self-esteem at this difficult time. White critics, writers, and philanthropists such as Albert Barnes, Robert Coady, Marius de Zayas, William Harmon, and Carl Van Vechten were supportive of black American efforts in the arts but for different reasons. Some subscribed to the notion of racial inferiority but supported black artistic achievement for its "primitivism"; others simply believed that black artists deserved the same opportunities for training and public recognition that were available to whites. Regardless of their diverse ideologies, these leaders exerted a powerful influence on black artists and intellectuals of the day.[8]

The turn of the century was thus a moment of potentiality for African American artists: the early stages of the Harlem Renaissance created a climate in which to challenge the entrenched black image. At the same time mainstream and avant-garde artists on both sides of the Atlantic became fascinated with non-Western cultures. The pursuit of African art championed by Henri Matisse, Pablo Picasso, and other European artists and by American collectors and critics like de Zayas and Coady helped spur American interest in nonwhite themes and subjects. Many American artists simultaneously began producing work utilizing exotic motifs.[9] Marsden Hartley drew upon Native American sources, and **145**

the establishment of art colonies in the American Southwest was further evidence that American artists shared the interest in non-European cultural influences. In addition, Asian themes as well as a new modernist interpretation of the archaic also surfaced. Paul Manship's archaism and Allan Clark's exoticism showed American sculptors' willingness to combine these new interests with figurative sculpture. Other artists also addressed these issues. By the 1930s the list of Americans to do so included Viktor Schreckengost, who created ceramic depictions of black musicians; Malvina Hoffman, who worked on a series of racial types; as well as other sculptors who produced heads of African, African American, and Native American subjects. Max Weber promoted the use of exotic themes both through his art work and his writing, and José de Creeft, John Storrs, and William Zorach mined non-Western and "primitive" cultures for inspiration. The perceived ingenuousness of non-Western cultures was considered to be less decadent and a more direct path to an honest means of visual expression.

Interest in primitivism and the exotic legitimized the African image in some ways, but the "noble savage" assumption was obviously racist and condescending. Furthermore, while primitivism led to interest in African art and tribal subjects, it did not necessarily lead to an increased interest in African American art and subjects. Within the social context of popular literature and public forms of visual representation, such as advertising, cartoons, and sheet music, the omnipresent caricatures and stereotypes of blacks prevailed. Black artists had an almost insurmountable task in overturning this image. As Locke noted, "The extreme popularity of these types held all the arts in so strong a grip that, after seventy or more years of vogue, it

was still difficult in the last two decades to break through this cotton-patch and cabin-quarters formula."[10]

This multifaceted social and cultural situation presented many challenges for American sculptors in the early twentieth century. Labor unrest, the women's suffrage movement, and the plight of immigrants inspired other artists to utilize the human figure in fresh and sometimes controversial depictions, using themes that had not been used before. Exoticism and new interpretations of classicism further widened the existing scope of sculptural form. Like others, black sculptors' innovations created a new visual image. They challenged the old tradition that DuBois, Locke, and others had identified, and as they grappled with issues of racial difference, social context, and cultural heritage, black sculptors also addressed problems of identity. Some, like Lewis, were of mixed African American and Native American heritage and confronted special problems.

Meta Warrick Fuller was one of the first and most important African American sculptors to counter the traditional black image. Born to a prosperous family in Philadelphia, she studied in Paris. She returned to America, married Dr. Solomon Fuller, and moved to the affluent Boston suburb of Framingham, where she created fresh and challenging work, which is hailed today as the first to embody the spirit of the Harlem Renaissance.[11]

Meta Warrick's years in Paris were crucial to her development. There she associated with a family friend, the notable black American painter Henry Ossawa Tanner, who resided in France, began a longtime friendship with DuBois, and was strongly influenced by Auguste Rodin, who agreed, after he had seen her work, to offer her regular

criticism. After three years in France (1899–1902), she returned home a celebrity.

Like Hoffman and other American sculptors who worked or studied with Rodin, Warrick used dramatic themes and fluid surface treatments. While sculptures such as *The Wretched* (plate 34) and *Man Eating Out His Heart* (1905–6) certainly show Rodin's influence, she recounted later that her horrific subjects were also inspired by the ghost tales and superstitions from African American folklore that her older brother had recited to her when they were children.[12] These early figures, while not ethnic in physiognomy, thus united universal themes of human suffering with African themes in a unique expression of African American identity.

The sculptor's later work (exhibited under her married name) more openly expressed the nascent black consciousness and her exploration of her own roots. *The Awakening of Ethiopia* (plate 71) is one such piece. In its original conception it was named *The Rise of Ethiopia* and was intended to celebrate Africa's emergence from colonial rule. By 1920, when Fuller submitted it for exhibition at the Making of America exposition in New York City, she had renamed it to recognize the emerging intellectual vitality of black America. As she wrote to the African American art historian Freeman Murray, she wanted the sculpture to symbolize the African American who was "awakening, gradually unwinding the bondage of his past and looking out on life again, expectant and unafraid."[13]

The Awakening of Ethiopia fused African and African American themes; Fuller's *Memorial to Mary Turner: A Silent Protest against Mob Violence* (plate 162) directly confronted the African American experience. The event that inspired the piece was an orgy of violence that took place in August 1918 in

162

Meta Warrick Fuller
(United States, 1877–1968)
MEMORIAL TO MARY
TURNER: A SILENT PROTEST
AGAINST MOB VIOLENCE
1919, painted plaster, 14 x 5¼ x
4½ in. (35.6 x 13.3 x 11.4 cm),
courtesy, Museum of Afro
American History, Boston

163

Meta Warrick Fuller
(United States, 1877–1968)
TALKING SKULL
1937, bronze, 28 x 40 x 15 in.
(71.1 x 101.6 x 38.1 cm),
courtesy, Museum of Afro
American History, Boston

Georgia. The fatal shooting of a white landowner sent a white mob on a rampage that resulted in the lynching of eight innocent blacks, including Mary Turner's husband. When Turner, who was pregnant, stated publicly that she wanted to bring her husband's murderers to justice, she too was seized by the mob, which burned her alive. Utterly incensed by the event, Fuller created a sculptural sketch of Turner protecting her baby. As she remembered in a 1964 letter, Fuller felt that the statue was better left in the sketch stage, and even so, it would surely not be appreciated; it would be too inflammatory for the Northern white audience of the time and, of course, could never be accepted in the South.[14]

Despite the fact that she knew a mostly white public would reject the piece, Fuller had created one of the first three-dimensional depictions of the theme of racial injustice as perceived by African Americans. Not only was this sculpture one of the first such treatments, it was one of the few pictorial representations by a black artist to deal with this subject. Fuller's own comments suggest that patronage played a part in the African American artists' unwillingness to address this topic. Another explanation is that black sculptors avoided producing images that portrayed blacks as victims. Whatever the reason, black sculptors of this era did not often

touch upon the subject, thus underscoring the uniqueness of Fuller's piece.

By the 1930s Fuller's work showed more naturalism, and her style celebrated African physiognomy and form. For *Talking Skull* (plate 163) her inspiration was an African folktale. The bronze sculpture, one of her best known, sensitively rendered the subject's features and paid homage to Fuller's ethnic heritage. Whether it depicted the physical beauty of Africans and African Americans, made reference to the rich African cultural heritage, or combined African and African American themes, her work helped recast the African American image past and present.

Fuller pioneered the use of African American themes at the same time that Sargent Johnson became the first black sculptor to utilize the formal properties of African art. Working in San Francisco, Johnson was employed as an assistant to Beniamino Bufano, one of the West Coast's best-known sculptors. Johnson's work reveals his teacher's predilections in terms of his interest in the exotic and a tendency toward solid, archaic forms. However, it is African American influences that are most apparent in Johnson's work.

A turning point for Johnson was his association beginning in 1925 with the Harmon Foundation. Started by William Harmon, a white philanthropist, the foundation sought to honor black achievements in the arts in order to further the cause of racial equality. Current scholarship hypothesizes that the foundation institutionalized white control of black artistic production, but seen in retrospect, it did enable many black artists of the 1920s and 1930s to achieve critical recognition as well as earn financial remuneration for their work.[15] Johnson's sculpture was shown in Harmon Foundation exhibitions from

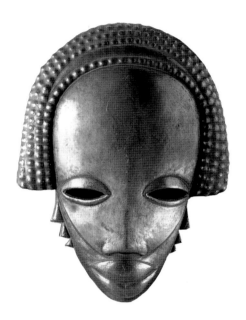

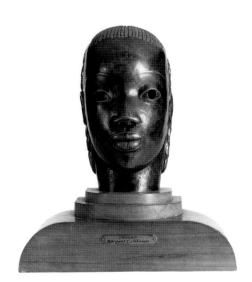

1926 through 1935. He won several awards, and that recognition, as well as his association with other African American artists, invigorated him. He turned from his approach of the 1920s—archaic and/or exotic portrait sculpture of friends and associates— to frankly African and African American themes.

Johnson was interested in pre-Columbian and African art. By 1930 he was experimenting with mask forms reminiscent of tribal art. The incised lines of *Mask* (plate 164) emphasize the subject's African features in a clear statement of racial difference. Johnson based another small sculpture, also entitled *Mask* (plate 165), on African styles but expressed through a modern American idiom. Around the same time, the early 1930s, he created a number of larger figures in lacquered wood. In these he united his depiction of African American physiognomy with an African-inspired cylindrical shape. *Forever Free* (1933), *Standing Woman* (1934), and *Negro Woman* (plate 166) have a monumental presence. These sculptures celebrate the dignity of African American people and capture the essence of West African sculpture, which often has a serene, regal character. Though understated, Johnson's figures engage the viewer on issues of racial representation.

In 1935 Johnson articulated his approach to art in an interview in the *San Francisco Chronicle*. "I aim at producing a strictly Negro art," he said. "Very few artists have gone into the history of the Negro in America.... I am...aiming to show the natural beauty and dignity in that characteristic lip, that characteristic hair, bearing, and manner. And I wish to show that beauty not so much to the white man as to the Negro himself. Unless I can interest my race, I am sunk."[16] Johnson continued by criticizing American artists, including black artists, who study in Europe and return to imitate European styles.

164
*Sargent Johnson
(United States, 1887–1967)*
MASK
*1933, copper, 10⅞ x 7⅞ x 2⅜ in.
(27.6 x 20 x 6 cm), San
Francisco Museum of Modern
Art, Albert M. Bender
Collection, gift of Albert M.
Bender*

165
*Sargent Johnson
(United States, 1887–1967)*
MASK
*c. 1930–35, copper on wood
base, 15½ x 13½ x 6 in. (39.4 x
34.3 x 15.2 cm), National
Museum of American Art,
Smithsonian Institution, gift
of International Business
Machines Corporation*

149

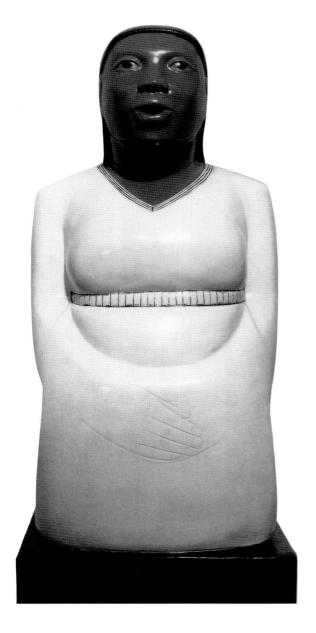

166

Sargent Johnson

(United States, 1887–1967)

NEGRO WOMAN

By 1936, wood with lacquer on
cloth, 32 x 13½ x 11¾ in. (81.3 x
34.3 x 29.9 cm), San Francisco
Museum of Modern Art,
Albert M. Bender Collection,
gift of Albert M. Bender

This tendency, he said, was reinforced by the public, which wanted to follow foreign trends. Johnson advocated that African American artists express the beauty of black Americans, using ethnic-inspired techniques, for a black audience.

Ironically, this advice ran contrary to the views of some leaders of the Harlem Renaissance. At the same time that they advocated the use of black themes, they also urged African American artists to excel in European techniques to show they were inferior to no one. Johnson pursued his own course, experimenting with the materials, techniques, and polychromy found in sculpture of several cultures: African, Greek, and Mesoamerican. His work of the 1930s clearly expressed his pride in his racial identity and challenged the public to appreciate both the beauty of the African American form and the legacy of African artistic traditions.

Other black sculptors produced figural works that brought to the American public a variety of African American depictions. Although their work was not as openly confrontational as some of Fuller's pieces nor as frankly indebted to African forms as Johnson's, they nevertheless helped create a new African American image through a variety of themes and techniques. William Artis, Richmond Barthé, Nancy Prophet, and Augusta Savage all were at the vanguard of inflecting figural sculpture with novel pictorial language.

Savage was an important figure in the Harlem Renaissance. A gifted artist, teacher, and spokesperson for the black cause, she directed one of the most successful of the WPA/Federal Art Project schools, the Harlem Community Art Center. She was one of the first black sculptors to use genre themes. Her use of African American subjects was quite a change from white, middle-class depictions,

although Savage's figures tended to represent types rather than true genre subjects. One of her best-known works, *Green Apples* (plate 167), shows a young boy suffering the effects of eating unripened fruit. Its frank use of racial physical features and sympathetic rendering challenged the prevailing minstrel stereotype. Her pupils, including Artis, followed her example and depicted African Americans from everyday life.

Prophet and Barthé also celebrated African American physical features in their work, but they tended to emphasize the inner lives of their subjects. Both also made reference to African influences. Much of Prophet's work has been lost, but in the extant sculpture, such as *Congolais* (plate 156), the stoicism of African Americans and their ancestors is clearly evident. *Congolais* was probably inspired by the Harlem Renaissance and its awakening of ethnic pride and is a wonderfully sensitive portrayal of a Masai warrior. There is an overwhelming meditative quality in this piece. Tellingly Prophet chose to make it a bust rather than a torso, which might have been heavily ornamented, distracting the viewer from the subject's inner spirit. This African warrior is no stereotypical noble savage but an individual whose depth of expression engages and quietly challenges the viewer. Barthé's *Head of a Woman* (plate 168) is a good example of the deeply spiritual quality of his work. Not unlike Prophet's heads, this representation shows the beauty of the black woman as well as the deeply contemplative and almost otherworldly air that symbolizes the fortitude needed to overcome the many hardships posed by African American life. Barthé's commissioned portrait busts provided much of his livelihood and were more conventional.

Prophet, of mixed racial heritage, at times denied being black. Some of her wood carvings,

167
Augusta Savage
(United States, 1892–1962)
GREEN APPLES
1928, bronze, 15¾ x 5½ x 6¾ in.
(40 x 14 x 17.2 cm), James
Weldon Johnson Memorial
Collection, Yale University
Collection of American
Literature, Bienecke Rare
Book and Manuscript Library,
New Haven

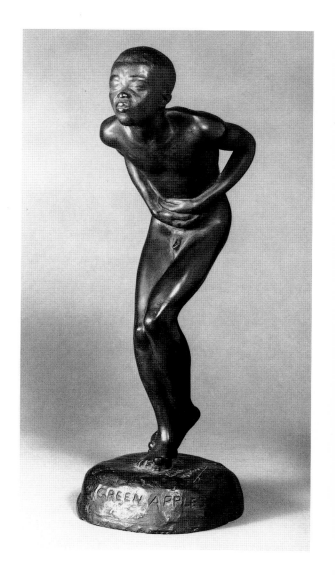

168

Richmond Barthé
(United States, 1901–89)
HEAD OF A WOMAN
c. 1933, plaster, 13½ x 6 x
5½ in. (34.3 x 15.2 x 14 cm),
permanent collection of Carl
Van Vechten Gallery of Fine
Arts, Fisk University, Nashville

169

Nancy Prophet
(United States, 1890–1960)
DISCONTENT
Before 1930, polychromed
wood, 14 x 6¾ x 9 in. (35.6 x
17.2 x 22.9 cm), Museum of Art,
Rhode Island School of
Design, Providence, gift of
Miss Eleanor Green and Miss
Ellen D. Sharpe

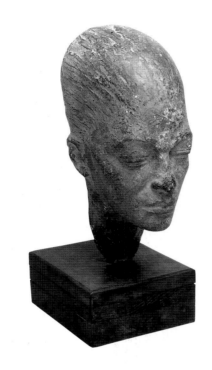

more inscrutable than resolute, suggest a struggle for identity through their inner tension. *Discontent* (plate 169), produced during her years in Paris, has an aura of impassivity that she might have felt as she grappled with her own racial identity.[17] Interestingly, she also produced lovely, sympathetically rendered marble heads of white subjects. That these subjects were depicted in white marble and her African American subjects often in wood (some, such as *Congolais*, with polychromy) was probably due to issues of patronage but serves as a not-so-ironic reminder of racial hierarchy and difference.

Unlike Prophet, who enjoyed only brief recognition, Barthé was the Harlem Renaissance era's most successful sculptor. His success sometimes generated criticism of catering too much to white taste, though the wide dissemination of his work contributed to the remaking of the black image. Focusing solely on the human figure, Barthé deliberately attempted to convey the beauty of the black figure. In a 1985 interview he recalled that "black is beautiful" was a slogan he firmly believed and

sought to express in the 1930s, long before the black power movement of the 1960s.[18]

Barthé often incorporated dance or music as subjects. *Blackberry Woman* (plate 170) is a rhythmic interpretation of an African subject. *African Dancer* (plate 171) is a visual metaphor celebrating African culture. *Inner Music* (1956) also uses the dance motif but in a more naturalistic interpretation that displays a reverence for the black male figure. The latter two subjects are unclothed, a reminder that, deprived of the tools and technology that Africans used to create much of the rich artistic tradition they left behind, the heritage of music and dance they carried within them became a means of cultural survival during slavery. Barthé's work thus underscores not just the physical beauty of the black body but honors the heritage of music and dance that both links American blacks to their ancestral roots and celebrates the unique culture that grew out of the African American experience.

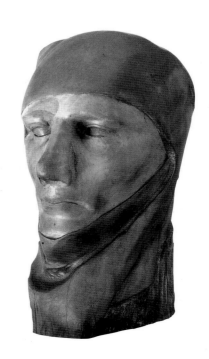

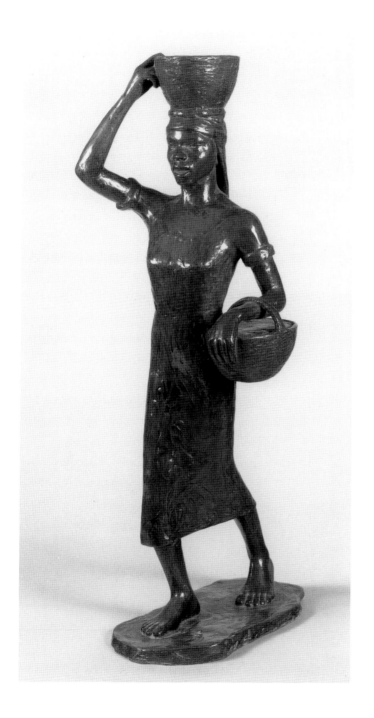

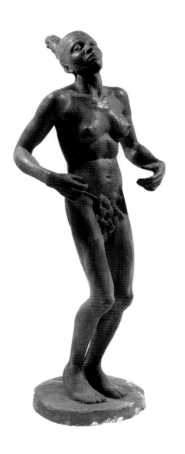

170
Richmond Barthé
(United States, 1901–89)
BLACKBERRY WOMAN
1932, bronze, 33⅞ x 14¼ x
12⅜ in. (86 x 36.2 x 31.4 cm),
Whitney Museum of American
Art, purchase

171
Richmond Barthé
(United States, 1901–89)
AFRICAN DANCER
1933, painted plaster, 43½ x
17¹/₁₆ x 14¹¹/₁₆ in. (110.5 x 43.3 x
37.3 cm), Whitney Museum
of American Art, purchase

172
William Artis
(United States, 1914–77)
HEAD OF A NEGRO BOY
1939, terra-cotta, 12 x 7 x 6 in.
(30.5 x 17.8 x 15.2 cm),
Dorothy B. Porter Collection

Artis followed the example of Savage and another gifted African American sculptor, Selma Burke (b. 1907), in celebrating ordinary people through sensitively rendered portrait busts and heads. A student of theirs in Harlem in the 1930s, he exhibited with the Harmon Foundation. Study with Robert Laurent, one of the masters of direct carving, helped him develop a style whereby he allowed his medium to help determine key qualities in his highly simplified works, which he created in terra-cotta. Like Barthé, Artis was not concerned with social commentary. Portraits such as *Head of a Negro Boy* (plate 172) both acclaim the beauty of the human form and, like Johnson's sculpture, celebrate black physiognomy with close attention to facial features. Artis's work during his Harlem days was instrumental in helping bring African American subjects to a wider audience.[19]

Most of the recognized African American sculptors from the early years of the twentieth century were formally trained, but notable artists emerged from the folk arts and "outsider" tradition. Leslie Bolling and William Edmondson were both untrained Southerners who gained fleeting recognition. Bolling, a wood carver, received critical notice in the 1930s for his genre pieces.[20] Other genre sculpture, including Abastenia Eberle's and Robert Cronbach's treatments of urban street life, were at times serious, at times self-conscious expressions of the inequities of modern life. Bolling's work was neither satirical nor overtly political, but his modernism was apparent in his depictions of everyday African American life.

Bolling's work focused on the black figure at work and at play. *Cousin-on-Friday* (plate 98) is part of a series showing domestic activities for each day of the week. These carvings were championed by

a Nashville writer, introduced his work. The Museum of Modern Art honored Edmondson with a one-man show in 1937, its first ever to feature the work of an African American.[21]

Carvings such as Edmondson's *Preacher* (plate 97) and *Crucifixion* (c. 1932–37), show his simple forms. Sometimes inspired by the Bible, Edmondson's "mirkels," as he called them, capture the artist's ability to translate spiritual intensity with a spare visual vocabulary. Edmondson's work can be read as a declaration of the deeply held religious faith that united many African Americans, but it also shared the monumentality and expressionistic distortion of other direct carvers of the time.

THE WORK OF many of these artists faded from the scene after 1940, when the Harlem Renaissance waned and the attention of the entire nation turned to World War II. When that conflict ended, black artists and intellectuals shifted their focus to the political arena and new aesthetic concerns. African American artists of the 1960s were more directly concerned with black power as a theme, but the African American sculptors of the 1920s and 1930s had all attempted in their own way to form a new visual representation of the African American image. These earlier artists' work and their motives were different, and each had as an influence his or her own search for racial pride and ethnic identity. Their achievements seem even greater when measured against the enormous difficulties posed by the American experience of the early twentieth century, including racial prejudice, the lack of patronage, limited exhibition opportunities, and an entrenched, white-created visual tradition. Yet they also participated in the larger work of experimentation with the human form. Whether their sculpture

173
Leslie Bolling
(United States, 1898–1955)
WOMAN'S HEAD
N.d., wood, 13½ x 7⅞ x 8⅝ in. (34.3 x 20 x 22 cm), Yale University Collection of American Literature, Beinecke Rare Book and Manuscript Library, New Haven

Van Vechten, who chronicled and promoted the Harlem Renaissance, and were exhibited by the Harmon Foundation. Good-humored but neither caricatured nor silly, Bollings's working-class black subjects were a unique contribution to the newly emerging representation of blacks. He also produced at least one carving of an abstract head (plate 173), which was more modern in formal terms than his other works.

Edmondson earned national recognition for his direct carvings in stone. A Nashville hospital janitor, he began carving tombstones and statues in 1932. Fresh in their simplicity and deeply spiritual, Edmondson's figures and animals emerged from limestone as naive and original forms. No doubt completely unaware of the direct-carving tradition revived by trained sculptors such as John Flannagan, Laurent, and Zorach earlier in the century, Edmondson astonished the important figures of the New York City art world, when Sidney Hirsch,

was African or exotic in formal vocabulary, modernist in its use of genre themes, daring in social content, or drawn from folk art traditions, they succeeded in widening the scope of American figurative sculpture.

One of their most important contributions was that they challenged the traditional black image and created a new one. African Americans were unique among American immigrants because they were brought to a hostile country against their will. African American artists throughout American history have had to contend with singular problems of cultural identity. While other sculptors of the early twentieth century grappled with similar issues of visual representation and self-expression, black artists had to find a voice and a place amid a mostly stereotypical tradition they did not create. The true black identity was invisible, layered both under caricature and the sometimes well-intentioned images created by Americans of earlier years. John Woodrow Wilson (b. 1922), a black artist who worked in the 1940s, commented in a 1992 interview that what he was trying to do in those years was "make the invisible man visible, to build into these images such power and impact that you couldn't ignore them."[22] The sculptors examined here did the same, and in so doing helped redefine, reclaim, and transform the African American image.

Notes

1 For a discussion of the black image in American art, see Guy McElroy, *Facing History: The Black Image in American Art 1710–1940*, exh. cat. (Washington, D.C.: Corcoran Gallery of Art, 1989).

2 Alain Locke, *The Negro in Art* (Washington, D.C.: Associates in Negro Folk Education, 1940; New York: Hacker, repr., 1969), p. 139.

3 Lorado Taft, *The History of American Sculpture* (New York: Macmillan, 1903), p. 302; and Freeman Murray, *Emancipation and the Freed in American Sculpture* (Washington, D.C.: self-published, 1916), p. 165.

4 Taft, *History of American Sculpture*, pp. 180–86.

5 Freeman Murray clearly grasped the statue's political implications, noting that by 1867, when Lewis created the piece, "re-enslavement" had set in as whites attempted to negate the progress toward racial equality achieved during the Civil War (*Emancipation and the Freed*, pp. 20–23). Albert Boime discussed the idea that Lewis stayed, in part, within the prevailing mode of black representation in *The Art of Exclusion* (Washington, D.C.: Smithsonian Institution Press, 1990), pp. 162–72.

6 United States Department of Commerce, Bureau of the Census, 1918.

7 Cary Wintz, *Black Culture and the Harlem Renaissance* (Houston: Rice University Press, 1988), pp. 8–9.

8 The views of each of these men are found in numerous publications of the time as well in more recent articles. DuBois's views are summarized in "Criteria of Negro Art," *Crisis* 32 (October 1926): 290–97; Locke's in *The New Negro* (New York: Bodoni, 1925); and Porter's in "The Negro Artist and Racial Bias," *Art Front* 3 (June–July 1937): 8–9. Much of de Zayas's view is presented in an article he worked on intermittently from 1916 through the early 1950s; "How, When, and Why Modern Art Came to New York," ed. and annot., Francis M. Naumann, *Arts Magazine* 54 (April 1980): 96–126. For an account of Coady, see Judith K. Zilczer, "Robert J. Coady, Forgotten Spokesman for Avant-Garde Culture in America," *American Art Review* 2 (September–October 1975): 77–89.

9 There have been several exhibitions in the past decade that investigated the influence of African and other non-European art on Western art of this era. Two of the best known were *Black Art: Ancestral Legacy* (Dallas Museum of Art, 1989) and *"Primitivism" in 20th Century Art: Affinity of the Tribal and the Modern* (Museum of Modern Art, New York, 1984).

10 Locke, *The Negro in Art*, p. 139.

11 For extensive information on Meta Fuller, see Judith Nina Kerr, "God-Given Work: The Life and Times of Sculptor Meta Vaux Warrick Fuller, 1877–1968," Ph.D. diss., University of Massachusetts, 1986. For a view of Fuller's anticipation of themes followed by Harlem Renaissance artists of the 1920s and 1930s, see David Driskell et al., *Harlem Renaissance: Art of Black America*, exh. cat. (New York: Studio Museum in Harlem, 1987).

12 Kerr, "God-Given Work," p. 17.

13 Meta Fuller to Freeman Murray, 9 January 1915, in Freeman Murray papers, Howard University Library, Washington, D.C.

14 Meta Fuller to Sylvia Dannett, 15 April 1964; quoted in Kerr, "God-Given Work," p. 254.

15 For a somewhat critical look at the Harmon Foundation, see Erma M. Malloy, "African-American Artists and the Harmon Foundation," Ed.D. diss., Columbia University Teachers College, 1991.

16 "San Francisco Artists," *San Francisco Chronicle*, 6 October 1935, sec. d., 3.

17 Blossom Kirschenbaum, "Nancy Prophet, Sculptor," *Sage* 4 (spring 1987): 48–52.

18 Bert Hammond, "A Conversation with Richmond Barthé," *International Review of African-American Art* 6, no. 1 (1985): 9.

19 Source material for Artis tends to be about his later career.

20 "Richmond Academy Accords Show by Negro," *Art Digest* 9 (15 February 1935): 23, is an example of the mainstream recognition Bolling received.

21 Edmondson's New York exhibition was reviewed in *Time*, 1 November 1937, 52; *Newsweek*, 25 October 1937, 22; and *Life*, 1 November 1937, 79.

22 The quotation is from William Grimes, "Art of Black Printmakers: Making Life Real," *New York Times*, 21 December 1992, sec. b., 1.

Avant-Garde or Kitsch?
Modern and *Modernistic* in American Sculpture

SUSAN RATHER

between the Wars

DURING THE 1910S, 1920S, AND 1930S *a vogue for stylization refigured American sculpture. From the small-scale, decorative works in sleek, gleaming materials which today we might label "art deco" to the rugged, monumental public sculptures intended to communicate national vigor and purpose, stylization reigned, supplanting the aesthetics of the ideal or the natural preferred by an earlier generation of sculptors. Depending on one's point of view, such stylization might appear truly modern or merely modernistic. For those squarely aligned with the avant-garde, however, it could only be kitsch.*

When critics tried to determine responsibility (they only rarely granted credit) for initiating this approach, they often looked to the American Academy in Rome, a conservative institution dedicated to the defense and preservation of a classicism under siege. Some identified a single academician, Paul Manship, as the culprit. A fellow at the academy between 1909 and 1912, Manship had attracted widespread attention on the occasion of his New York professional debut in February 1913, an event that coincided with the notorious Armory Show, long considered the decisive blow to the dominance of the artistic academy. But academic sculpture, and figurative sculpture more generally, did not immediately yield; and Manship, rather than any representative of the vanguard, ranked as the most visible and sought-after sculptor in America between the wars.

Manship's success owed much to the way his work negotiated the distance between tradition and modernity, a distinction arising essentially from his style (plate 175). Purged of the tactile naturalism familiar to a generation schooled in French ways,

174
Gaston Lachaise
(France, 1882–1935)
THE MOUNTAIN
1919, sandstone, 7¾ x 17½ x 5½ in. (19.7 x 44.5 x 14 cm),
The Metropolitan Museum of Art, bequest of Scofield Thayer, 1982

159

175
Paul Manship
(United States, 1885–1966)
CENTAUR AND DRYAD
1913, bronze, 28 x 21¾ x 12 in.
(71.1 x 55.3 x 30.5 cm), The
Metropolitan Museum of Art,
Amelia B. Lazarus Fund, 1914

176
ATHENA
(restored by Bertel Thorvaldsen,
Denmark, 1768–1844)
Greece, Aegina, Temple of
Aphaia, c. 510 B.C., marble,
height: 66 in. (167.6 cm),
Glyptothek, Munich

177
Leo Friedlander
(United States, 1890–1966)
VALOR
1915, bronze, 30¼ x 29 x
13½ in. (76.8 x 73.7 x 34.3 cm),
private collection

his sculpture featured crisply articulated forms, taut, polished surfaces, and rhythmic contours— characteristics that aligned his work visually with that of more patently modern sculptors who showed at the Armory, including Constantin Brancusi and Alexander Archipenko. To be sure, Manship's sculpted figures were anatomically more natural- istic, yet the artist contradicted that quality with stylized, linear incisions marking hair, drapery, and other details. The most obvious source for this treat- ment in Greek archaic art (plate 176) immediately earned for Manship's sculpture the label *archaistic,* a term in critical use for about a decade.[1]

Manship's standing as the most visible and successful exponent of archaism in America and the popularity of the style with his immediate succes- sors at the American Academy—including John Gregory, Leo Friedlander (1890–1966), and C. Paul Jennewein—account for the identification of archaism with that conservative institution. By the mid-1920s the association between archaism and the American Academy had become so strong that

Walker Hancock (b. 1901), a fellow from 1925 to 1928, recalled that Charles Grafly, his teacher (and formerly Manship's) at the Pennsylvania Academy of the Fine Arts, would not recommend him to the American Academy "because he was so afraid that [Hancock] would be infected by this stylization."[2] Hancock did not recall ever being urged "to work archaistically," but he conceded that "it was in the air to some extent and you felt a little more comfort- able if you were doing it."[3] Thus, "those renowned young playboys of the classic spirit"—fellows of the American Academy in Rome—became, in the popular view, the apostles of archaism.[4]

Friedlander's *Valor* (plate 177), an academy project in 1915, anticipated the appearance of large-scale public sculpture in this archaizing style. A brawny man, with the simplified head of an archaic warrior from Aegina, rides an enormous, muscular horse, while an Amazon with helmet and shield strides alongside. Comparison with Augustus Saint-Gaudens's similarly configured *Sherman Monument* (plate 52) highlights the distinctive

character of Friedlander's art and reveals significant changes in the style of monumental sculpture over the first quarter of the twentieth century. Sherman and his spirited mount, led by a personification of Victory, which sculptor and critic Lorado Taft called "the most ethereal of all sculpted figures," appear as if proud participants in a military parade, the general's cape fluttering like a flag in the breeze.[5] A lively silhouette contributes to the festive appearance of the group. Friedlander's figures, by contrast, are compact and herculean; their gestures are bold, their forms large and simplified, and their pace deliberate. Taft considered Friedlander's work too foreign to be acceptable as an American military monument (as the sculptor had proposed); he recoiled from the attempt "to crystallize patriotism into such alien forms as these," exclaiming, "For Germany or Austria yes, but for America not quite yet, please!"[6]

Taft's distaste for Friedlander's model for a monument, expressed in a lecture of 1917, undoubtedly reflected his dislike of anything evocative of Germany's militarism, yet he foresaw a time when

the archaism practiced by a rapidly growing corps of sculptors from the academy in Rome might come to dominate American sculpture. Indeed, by 1929, when Friedlander received a commission to translate his statuette into monumental form—as a nineteen-foot-high anchor for the Washington, D.C., end of Arlington Memorial Bridge—its appearance was anything but unusual.[7] This heroic, impersonal style had become the new official classicism.

More massive and muscular than the classical styles of the nineteenth century, this archaizing classicism married elements of stylistic archaism to the aesthetic of direct carving, a technical archaism important to modernist sculptors. These archaisms stripped the classical of its refined veneer, calling attention to and in effect reempowering the classicism that post-Renaissance ubiquity had rendered invisible. In referring to the foundations of classical art, archaism called forth the very roots of civilization. Such archaism, if superficial in a literal sense, was not an empty, formal exercise but an urgent affirmation of traditional values under siege.

Direct carving, widely practiced by the 1920s, made its mark in the glyptic mass and weightiness of the new classicism. The actual technique, however, could not practicably be used for monumental public sculpture executed by hired workers; indeed, in such a context direct carving would have forfeited its modernist significance as an approach that facilitated an artist's private exploration. Nevertheless the look of direct carving communicated stability and permanence, qualities desired both by newly established political regimes—Nazi, fascist, communist—and relatively older ones, such as America's democratic government.[8] As an official style, or a style employed for official projects, this archaizing classicism served competing ideologies equally well. **161**

178
Paul Manship
(United States, 1885–1966)
PROMETHEUS
1934, gilded bronze, height: 216
in. (548.6 cm), in Rockefeller
Center, New York City

179
Abner Dean
(United States, b. 1910)
"Let's tie up the rights for radi-
ator caps!"
In Rockefeller Center Weekly 1
(25 October 1934): 6

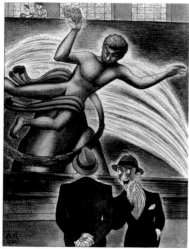

"Let's tie up the rights for radiator caps!"

Manship himself did not excel at monumental sculpture; his larger sculptures, as critic Royal Cortissoz observed, give the impression of "a statuette magnified."[9] Thus, there is a certain irony that Manship is best known today for his *Prometheus* (plate 178) for the main plaza of Rockefeller Center, a distinction undoubtedly attributable to its prominent location. Both artist and patron recognized the work's inadequacy. In the center's own organ, *Rockefeller Center Weekly*, Manship conceded that his sculpture was out of scale with its surroundings.[10] This miscalculation encouraged humor; the very first issue of the magazine reproduced a cartoon (plate 179) showing two men in front of the *Prometheus*, one saying conspiratorially to the other, "Let's tie up the rights for [automobile] radiator caps!" With its bright gilding, sleek lines, and unstable pose—a poor attempt to express the titan's flight to earth—Manship's *Prometheus* indeed resembles a gaudy hood ornament. Such an association hardly seems extraordinary taken in context with one of New York's most famous skyscrapers, the Chrysler Building (1930), and its ornament of sculpted automobile hubcaps, mudguards, radiator caps, and fins. But the joke on Manship's *Prometheus* required more than popularization of the automobile. It depended on the assimilation of the aesthetic of archaism to a commercial context—as the style known to posterity as art deco.

The term *art deco* was coined in the 1960s as a shorthand reference to the elaborately ornamental, eclectic French style that reached its apotheosis in the Exposition Internationale des Arts Décoratifs et Industriels Modernes, an impressive display of the latest consumer fashions held in Paris in 1925.[11] Arthur B. Davies (1862–1928), the principal organizer of the Armory Show twelve years earlier, somewhat

equivocally pronounced the exposition (in which the United States did not participate) "a great success for the modern movement in a sort of commercialized cubism—with restrictions toward archaism."[12] Although few of the displays could be called artistically revolutionary—they could not have been and still held the kind of commercial appeal that guided the event—modernity was the exposition's rallying cry.

The exposition in Paris created a popular image of modern design, and by the end of the decade French-inspired art deco had spread to the United States. Attention to surface, the use of exotic materials, textural variety, strong color contrasts, and a preference for simplified geometric or stylized forms identify 1920s art deco. Its promoters encouraged the coordination of architecture and interior design as critical to the effect, and sculpture too had an important role to play. As Roger Gilman, reporting on the Paris exposition for *Art Bulletin*, observed, "Sculpture seems to be everywhere."[13]

Not all champions of sculpture approved of the new developments. "You will not find as much sculptural modernism in the marketplace as in the boudoir," declared Adeline Adams, a frequent essayist on sculpture, in 1929; "the boudoir is the transient asylum for novelties." As Adams surely intended, a lady's private chamber (especially as called by its French name) evokes indecision, frivolousness, luxury, perhaps even a certain decadence—qualities far removed from the "masculine" intellectualism and seriousness of purpose that academic and vanguard sculptors alike claimed. By "sculptural modernism" Adams did not mean to invoke anything that her more radical contemporaries (or later writers) would have identified as modern in this period. Her essay makes this clear. "Modernism,

that ambiguous word of many meanings, is on every tongue, and on many pens. Open at random a sheaf of American publications [she mentions *House Beautiful*].... Modernism rustles from their leaves." Even the secretary of the Metropolitan Museum of Art, she wrote with evident dismay, "tells us of the modernism of the department store, as daily offered to the home-maker in her choice of furnishings." In Adams's formulation fashion and "the chicanery of modernism" go hand in hand.[14]

More than half a century later Reinhold Hohl disdainfully tagged the fashionable sculpture of this period (which he did not otherwise call modern) "*la haute sculpture*," a clever phrase calculated to evoke *haute culture* or *haute couture*; in other words, sculpture that is commercially desirable with pretensions to aesthetic superiority.[15] What did this sculpture look like? Hohl named Archipenko, Brancusi, and Elie Nadelman, reminding the reader that in 1912 Brancusi sold his *Maiastra* to couturier Paul Poiret, who placed it in the showroom, while cosmetics executive Helena Rubinstein bought out one of Nadelman's shows in 1911. Gilman, unspecific about artists, indicated that the sculptures he found so "entirely one with their surroundings" at the exposition were "simplified to the last degree, whether by polished surfaces or by archaic or even geometrical treatment of the detail," a characterization that applies to many of the works in the present exhibition.[16] Adams gives the reader only the fashionable consumer and her boudoir. Significantly she and Gilman—although differing in their estimation of "modern" sculpture—shared a reference point. Their formulations of the modern reveal a blurring of divisions between fine art and decorative or utilitarian objects and the assimilation of artistic modernism to the realm of popular culture.[17] By the **163**

late 1920s *modern* had become an important signifier of fashionability.

Modernistic emerged as the contemporary term of derision—"born out of the hysteria created by the Paris Exposition," in designer Donald Deskey's phrase—for the fashionable decorative and fine arts.[18] In an essay on the language of art criticism, published in 1930, art collector Duncan Phillips and Charles Law Watkins defined *modernistic* as "a critical term of reproach" and its practitioners as academically sanctioned imitators, popularizers, or "normalizers" of a modernist manner.[19] "*Modernistic…*," another brief essay on terminology concurred, "should apply to works which imitate superficially the forms of *modern* art, reducing them to decorative mannerism."[20] Similarly, Alfred Barr, director of the Museum of Modern Art, declared in 1932, "The modernistic has become merely another way of decorating surfaces."[21] In a literal sense, something modernistic is *superficially* modern.

By the 1920s many critics had come to view archaism in precisely this way. As one of the most prominent sculptors of the day and a consistent "stylist" (sculptor Charles Grafly's derisive term for Manship, elicited by his archaism),[22] Manship made an obvious target, one struck with no greater force or dispatch than by E. E. Cummings in an essay on Gaston Lachaise for *The Dial* of February 1920. Manship, Cummings declared, "is neither a sincere alternative to thinking, nor an appeal to the pure intelligence, but a very ingenious titillation of that well-known element, the highly sophisticated unintelligence."[23] Case closed. Curiously Cummings failed to mention that Lachaise served as Manship's principal assistant during the 1910s. We might explain the omission by noting that Cummings

shunned biographical detail in his essay (though he did not entirely exclude it) and that his comments on Manship deny the possibility of any benefit to Lachaise from the association (clearly he did not think it improved Manship). Certainly it seems unlikely that Cummings sought to contain the affront to Manship by avoiding direct comparison; that would require taking Manship more seriously than he intended to. Cummings, in short, had a point to make; it required him to introduce Manship as a type and then to isolate Lachaise from that type, an objective accomplished with considerable rhetorical skill. We may come to a better understanding of the exclusion of this type from the modernist arena if we examine the terms of artistic excellence that, for Cummings, Lachaise exemplified and so many others failed to meet. We should also consider Lachaise's work both during and immediately after the period of his employment with Manship. The evidence suggests a critical effort—not unique to Cummings—to draw a more decisive line between academic and modern than may, in fact, have existed.

Cummings met Lachaise through his Harvard classmate Edward Nagle, Lachaise's stepson, and a strong friendship soon developed between the sculptor and the young man, who at the time considered himself "primarily a painter."[24] That calling decisively informed Cummings's piece on Lachaise, his first published critical essay. The article opens with a passage from Willard Huntington Wright's *Modern Painting* (1915) which, in effect, proclaims the death of sculpture: Paul Cézanne (Cummings quotes Wright) "made us see that painting can present a more solid vision than that of any stone image. Against modern statues we can only bump our heads: in the contemplation of modern painting

we can exhaust our intelligences."[25] Cummings identified Manship as one of those sculptors whom Wright's words "wipe off the earth's face," but in Lachaise he found a sculptor-equivalent to Cézanne.

This comparison drives his essay. Just as Cézanne's "hate of contemporary facility and superficiality drove him to a recreation of nature which was at once new and fundamental," so too Lachaise, whose "two greatest hates are the hate of insincerity and the hate of superficiality," sought to express "the truths of nature as against the facts of existence." Cummings elaborated his point by analogy with "the child's vision," which he characterized in linguistic terms as the ability to depict things "not as nouns but as verbs….to liberate the actual crisp organic squirm—the IS." Unlike academic art—a mere "prepositional connective…between two nouns: an artist and a sitter" ("Mr. Sargent's portrait OF Some One")—the child's work "IS" itself, a site where self and subject converge.[26] The adult artist in a developed Western society may recover the intensity of immediate experience that belongs to the child (or the "primitive") only by abandoning the academy; Cézanne and Lachaise, for their parts, go "not beyond but under conventional art." Paradoxically this demands "an intelligent process of the highest order, namely the negation…by thinking, of thinking." Thus, "Cézanne became truly naif—not by superficially contemplating and admiring the art of primitive people, but by carefully misbelieving and violently disunderstanding a second-hand world." Lachaise, for his part, was at once "inherently naif, fearlessly intelligent, utterly sincere"—these are the first things Cummings tells us about Lachaise, and they flag both author and artist as modernists.

To the art of children, primitive peoples, and modern artists who succeed in expressing themselves "in spite of all schools," Cummings opposed the "self consciously attempted naivete" and "deliberate unthought" of the "would-be primitives." In this instance he singled out William Zorach, identifying him only as a painter and making no mention of his activity as a sculptor. Nor did Cummings offer any indication of the kind of work he had in mind when describing the dynamics of viewing Zorach's art. We learn only that "shapes" "imitate" or "duplicate the early simple compositions of mankind" and, by some mysterious "emotional appeal" (arising from a primitive formal configuration?), "numb" our minds "into inactivity." But the effect is short-lived: "The spell wears off, intelligence rushes in, the work is annihilated." The cheated viewer is left with nothing but a "'fakey' feeling." How can we not be confused when, after all this, Cummings tells us that Zorach is "unquestionably sincere"? For the practitioners of archaism, by contrast, there can be no shred of hope. Cummings stated at the outset that Manship failed even to present the "sincere alternative to thinking" that emotional appeal seemed to offer in Zorach's work. All the negative words in this essay—*sophisticated, superficial, second-hand, insincere, fakey, dead*—apply to Manship's art. Their positive counterparts (stated or implied)—*naive, searching, immediate, sincere, authentic, alive*—are the attributes of Lachaise as a modernist.

The modernist paradigm privileged directness and spontaneity, qualities more difficult to identify with the practice of sculpture than painting. Significantly Cummings did not frame his presentation of Lachaise in terms specific to sculpture; the persistent comparison is with Cézanne. References to touch at several points in the essay might equally serve a modernist painting: Lachaise's work "tactilises **165**

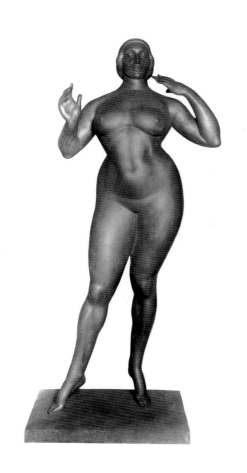

180
Gaston Lachaise
(France, 1882–1935)
ELEVATION — STANDING
WOMAN
1912–27, bronze, height: 70 in.
(177.8 cm), collection of the
Lachaise Foundation, Boston

181
Paul Manship
(United States, 1885–1966)
TABLET IN MEMORY OF
J. PIERPONT MORGAN
1915–20, limestone, 134 x 64 in.
(340.4 x 162.6 cm), The
Metropolitan Museum of Art

the beholder, as in the case of an electric machine which, being grasped, will not let the hand go"; *Elevation* (plate 180) is "a complete tactile self-orchestration." The sculptor's medium entered the discussion only on the final page of the essay when Cummings praised a stone edition of the voluptuous reclining female nude known as *The Mountain* (plate 174). The first version of this sculpture, of patinated plaster cast from a clay model, figured earlier as an example of "perfectly knit enormousness."[27] But for Cummings the stone *Mountain* alone "actualizes the original conception of its creator" and does so because Lachaise worked directly in his medium: "He has enjoyed it as his contemporaries to whom stone is not a tactile dream, but a disagreeable everyday nuisance to be handled by paid subordinates, can never enjoy it."

Cummings might have had any number of Lachaise's contemporaries in mind—though Zorach, a more dedicated direct carver than Lachaise, cannot have been among them. The remark, however, may be more pointed. In 1920, as Manship's "paid subordinate," Lachaise had nearly finished carving into limestone a massive memorial tablet to John Pierpont Morgan (plate 181) commissioned from Manship five years earlier by the Metropolitan Museum of Art. In written response to a question regarding his role in this work Lachaise told A. E. Gallatin that he not only executed the carving but also composed the ornamentation and allegorical figures, "Manship *introducing his manner in a final tracing* over same."[28] Though Gallatin did not exploit this intelligence in his book on Lachaise, published in 1924, it must surely have ended the regard he had earlier expressed for Manship.[29] Cummings, as an intimate of Lachaise, very likely had the same information. From a modernist point of view the evidence was damning. Lachaise's statement, if circulated, would have confirmed the worst that Manship's critics thought of him by exposing a (literally) graphic example of superficiality in Manship's art. The sculptor had conspired to "fling" over the foundation provided by another artist "an eclectic garment of style," and this act bespoke complete disassociation between self and work; as one writer charged, "the pieces are all outsides."[30] Lachaise, for his part, executed the job as Manship directed, and the resulting plaque appeared to one observer "an unintentional caricature....an anthology of all the styles with which Mr. Manship was familiar."[31]

Such chameleonlike ability in an assistant might be surprising, but Lachaise joined Manship's studio a far more experienced artist than his

employer. Indeed, when he arrived in America from Paris in 1906 (in pursuit of his muse and future wife, Isabel Nagle), Lachaise had a decade of training and work behind him. For fourteen more years, however, financial need bound him to the service of others. Lachaise's highly personal interpretation of the female form undoubtedly limited the market for his work, but the artist was less than aggressive in testing it. In modernist circles such hesitance (read as refusal) to engage commercial culture enhanced the artist's standing; as Cummings approvingly noted, "Lachaise's personality profoundly negates the possibility of self-advertising."[32] Manship exhibited no such restraint, and his commercial success undoubtedly stimulated Cummings's venom.

Neither Cummings's essay for *The Dial* nor his later piece on Lachaise for *Creative Art* mention that Lachaise also made works that might have been confused with the stylized productions of Manship and his academic colleagues.[33] The omission or marginalization of Lachaise's commercially viable and commissioned sculpture in this and other accounts—and insistent demonstration of the thick-headedness of critics ("The Dealers in Second-Hand Ideas") by Cummings—encourages the reader to regard Lachaise as a victim of commercial culture, compelled by economic need to prostitute his talents to an art of "easy aesthetic currency."[34] Cummings's essays were hardly comprehensive and certainly impressionistic; nevertheless they present a vision of the artist as nonconforming outsider, which cannot easily be reconciled with Lachaise's production of sculpture palatable to the consuming public. The *Dial* essay in particular was a rhetorical tour-de-force, a brilliant effort to establish a clear distinction between the modern and modernistic.

Some twenty years after Cummings's essay for *The Dial* another young spokesman for the avant-garde drove the decisive wedge between the modernist work of art and the product of commercial culture. The now landmark essay, "Avant-Garde and Kitsch," published in the fall 1939 issue of *Partisan Review,* launched the career of critic Clement Greenberg at the moment of Manship's decline and the eclipse of figurative sculpture generally.[35] Although Greenberg did not mention Manship, he might well have targeted the sculptor as a high priest of kitsch. Kitsch, he wrote, "draws its life blood" from the "reservoir of accumulated experience" of "a fully matured cultural tradition," resulting in "ersatz culture," market-bound art for a consumer society. Manship and his fellow archaists

drew from that reservoir both thematically and stylistically, and their art enjoyed considerable commercial and popular success. Greenberg identified kitsch with "vicarious experience and faked sensations," recalling Cummings's detection of something fakey in Manship's work and the dismay of other, less hostile critics over the seemingly indiscriminate combination of stylistic elements in archaizing sculptures.[36] Finally Greenberg defined kitsch as the culture of the masses and therefore as a tool for their manipulation by government. Here too his essay implicates a majority of sculptors in the present exhibition, who made accessible, marketable works and garnered numerous public commissions. In 1939, the year of Greenberg's essay, sculpture by many of these artists could be seen on prominent outdoor display at the New York World's Fair (despite its nominal claim to internationalism, a jingoistic set piece for American commerce). As damningly, they embraced an aesthetic that found echoes in the official art of Germany, Italy, and the Soviet Union (each of which Greenberg mentioned), an archaizing classicism that some believed Manship had inaugurated in America.

As the antithesis of kitsch the avant-garde belonged to a different, "superior" realm of culture. Unlike kitsch, which seemed "natural" and transparent, avant-garde art was for Greenberg emphatically artificial; it "imitates the processes of art" and is "the imitation of imitat*ing*." This idea is central to Greenberg's definition of the avant-garde, and he expanded it in "Towards a Newer Laocoon," an essay published in 1940.[37] The medium, Greenberg asserted, is the avant-garde artist's primary concern: the artist willingly accepts the limitations of a particular medium and "surrenders" to its resistance, while calling attention to the act of doing so.

Avant-garde art, accordingly, rejects narrative and all external referents to focus on expression. "Pure" modern poetry, freed from grammatical logic, offered an analogy; in a passage reminiscent of Cummings's insistence on the "IS" of Lachaise's sculpture, Greenberg stated, "The content of the poem is what it does to the reader, not what it communicates." The visual artist's medium has physical presence; "hence pure painting and pure sculpture seek above all else to affect the spectator physically." Cummings, who wrote that Lachaise's sculpture "tactilises the beholder," would certainly have agreed.

By 1940 figurative sculpture had by and large been relegated to the netherworld of kitsch, and archaism, "snatched from the charnel house of what was once alive," was dead again.[38] Such art had failed, some charged, to address the profound and disturbing aspects of human nature that events culminating in World War II threw into high relief. While this undoubtedly contains some truth, it remains unsatisfactory; we are left to wonder at the very least how abstract art came to be seen as a more direct form of address.[39] Perhaps instead we should ask why the stylized productions of Manship and his colleagues held up for as long as they did and why these sculptors persisted even longer. Witness Aline Saarinen's comments before the Architectural League of New York in 1954. She cautioned architects against working with sculptors who produced *art which substitutes stylization for style…the streamlined or slipcover stuff…. These are sculptures which sheer and shave that inevitable eagle to be as sleek as an automobile radiator cap or stylize the Macfadden musculature of a figure so that it looks like a streamlined version of those embarrassing photos of male models. These are sculptures that simply enlarge what would be unpretentiously acceptable at ash-tray scale.*[40]

This characterization immediately calls to mind Manship's *Prometheus*, but it might serve any number of modernistic sculptures executed between the wars. Reflecting on that period, Manship once said that he had possessed no great talent but had been "the right man at the right time."[41] He might have been speaking for any number of his colleagues who employed archaizing stylizations. To the many Americans who found themselves profoundly disturbed by artistic abstraction, archaism represented something of a compromise that demonstrated it was possible to create a modern style that bore recognizable ties to tradition. It seemed to tap the vital, but undisciplined forces of modernity and to temper them with the elements of a salvageable tradition.

In fact, the archaism of the interwar period was fundamentally conservative, but the veneer of stylish modernity appears to have satisfied most patrons perfectly well. They favored, and sculptors produced, an art that reached back into the past while seeming to look ahead to the future, combining stylistic and thematic references to the very roots of Western civilization with sleek forms associated with modern industrial design. The duality helped to locate contemporary culture on a historical continuum. In a world of flux and uncertainty the modernistic sculpture of Manship's generation offered reassurance, mediation, and synthesis.

Notes

1. For a complete treatment of archaism as both modernist and reactionary phenomenon (its form in this essay), see my *Archaism, Modernism, and the Art of Paul Manship* (Austin: University of Texas Press, 1993).

2. Walker Hancock, interview with author, 25 August 1984.

3. Ibid.

4. Herbert Adams, "The Debt of Modern Sculpture to Ancient Greece," *Art and Archaeology* 12 (November 1921): 220.

5. Lorado Taft, *Modern Tendencies in Sculpture* (Chicago: University of Chicago Press for the Art Institute of Chicago, 1921), p. 113.

6. Ibid., p. 145. Some identified the very beginnings of twentieth-century archaism with Germany. See Ada Rainey, "A New Note in Art: A Review of Modern Sculpture," *Century Magazine* 90 (June 1915): 195; Chandler Rathfon Post, *A History of European and American Sculpture* (Cambridge: Harvard University Press, 1921), 2:263; and Adams, "Debt of Modern Sculpture," p. 220.

7. Friedlander's *Valor* and its companion, *Sacrifice* (modeled 1929), were not completed and positioned on the bridge until 1951. Owing to the prohibitive expense of executing the works in stone, as originally planned, the sculptures were cast in bronze. See Joel Rosenkranz, *Sculpture on a Grand Scale: Works from the Studio of Leo Friedlander,* exh. cat. (Yonkers: Hudson River Museum, 1984), n.p.

8. For the most recent study of this subject, see Igor Golomshtock, *Totalitarian Art in the Soviet Union, the Third Reich, Fascist Italy, & the People's Republic of China* (New York: IconEditions, 1990). On sculpture made for United States government buildings during the 1930s, see George Gurney, *Sculpture and the Federal Triangle* (Washington, D.C.: Smithsonian Institution Press, 1985).

9. Royal Cortissoz, as quoted in "A Modern Primitive in Art," *Literary Digest* 52 (6 May 1916): 1279.

10. Kenneth Andrews, "What Paul Manship Thinks of Prometheus," *Rockefeller Center Weekly* 2 (17 January 1935): 5, 22–23.

11. The term *art deco* first appeared as the subtitle to the exhibition *Les Années 25* at the Musée des Arts Décoratifs in Paris in 1966. Two years later Bevis Hillier applied the term more broadly in *Art Deco of the Twenties and Thirties* (London: Studio Vista, 1968), and this usage became firmly established with the exhibition *The World of Art Deco* (New York: Dutton, 1971), which Hillier organized for the Minneapolis Institute of Arts in 1971. Since that time *art deco* has designated a modern design movement having roots early in the twentieth century and flourishing during the 1920s or, alternately, during the entire interwar period, notwithstanding the fact that a pronounced stylistic shift toward simplified, machine-reproducible forms marked passage into the 1930s. I use *art deco* in reference to design of the 1920s and 1930s as a matter of convenience only, without intent to endorse any particular position on its more specific chronological implications.

12 Arthur B. Davies to Virginia Meriwether Davies, 10 August [1925], as quoted in Brooks Wright, *The Artist and the Unicorn: The Lives of Arthur B. Davies (1862–1928)* (New City, N.Y.: Historical Society of Rockland County, 1978), p. 94 (where the date is given as 1927). Secretary of Commerce Herbert Hoover believed American designers could not meet the exposition's official requirement that submissions show "new inspiration and real originality" or avoid its strict prohibition on "reproductions, imitations, and counterfeits of ancient styles" (*Report of Commission Appointed by the Secretary of Commerce to Visit and Report upon the International Exposition of Modern Decorative and Industrial Art in Paris, 1925* [Washington, D.C.: Department of Commerce, 1926], pp. 17–18).

13 Roger Gilman, "The Paris Exposition: A Glimpse into the Future," *Art Bulletin* 8 (September 1925): 38.

14 Adeline Adams, *The Spirit of American Sculpture*, rev. ed. (New York: National Sculpture Society, 1929), pp. 166–68.

15 Reinhold Hohl, in Jean-Luc Daval et al., *Sculpture: The Adventure of Modern Sculpture in the Nineteenth and Twentieth Centuries* (New York: Rizzoli, 1986), p. 139.

16 Gilman, "Paris Exposition," p. 41. Cf. Henri Rapin, *La Sculpture décorative moderne*, 3 vols. ([Paris]: Moreau, [1925–29]).

17 For one study of the relationship of modernist aesthetics, consumer culture, and advertising, see James Sloan Allen, *The Romance of Commerce and Culture* (Chicago: University of Chicago Press, 1983), esp. pp. 3–17.

18 Donald Deskey, "The Rise of American Architecture and Design," *The Studio* (London) 105 (April 1933): 268. Use of the term *modernist* in a positive sense appeared earlier and more rarely; see Paul T. Frankl, *New Dimensions: The Decorative Arts of Today in Words and Pictures* (New York: Payson and Clarke, 1928), p. 28 ("sharp modernistic effects which are characteristic of our time"); and Leon V. Solon, "The Park Avenue Building, New York City," *Architectural Record* 63 (April 1928): 289–90. Recently Richard Striner revived the term in reference to the work of architects who were sympathetic to modernism but unwilling to abandon ornament, including William Van Alen and Raymond Hood ("Art Deco: Polemics and Synthesis," *Winterthur Portfolio* 25 [Spring 1990]: 27).

19 Duncan Phillips and Charles Law Watkins, "Terms We Use in Art Criticism," *Art and Understanding* 1 (March 1930): 165.

20 John McAndrew, "'Modernistic' and 'Streamlined,'" *Museum of Modern Art Bulletin* 5 (December 1938): 2.

21 Alfred Barr, *Modern Architecture: International Exhibition* (New York: Museum of Modern Art, 1932), p. 13.

22 Hancock, interview with author.

23 E. E. Cummings, "Gaston Lachaise," *The Dial* 68 (February 1920): 195.

24 E. E. Cummings, as quoted in Milton A. Cohen, *Poet and Painter: The Aesthetics of E. E. Cummings's Early Work* (Detroit: Wayne State University Press, 1987), p. 35.

25 Quotations in this and the next three paragraphs are from Cummings, "Lachaise," pp. 194–204. Cummings's artistic and theoretical debt to Cézanne forms a recurrent theme in Cohen, *Poet and Painter*.

26 Cummings's understanding of children's art may have been informed by Roger Fry, "Children's Drawings," *Burlington Magazine* 30 (June 1917): 225–31.

27 For the various versions of *The Mountain*, see Gerald Nordland, *Gaston Lachaise: The Man and His Work* (New York: Braziller, 1974), pp. 113–18.

28 Gaston Lachaise to A. E. Gallatin, 12 February 1924 (my emphasis), in Gaston Lachaise papers, Yale Collection of American Literature, Beinecke Rare Book and Manuscript Library, Yale University. Manship describes the labor that he and three assistants put into the Morgan memorial in "The Reminiscences of Paul Manship," 1958, Oral History Collection, Columbia University. Several photographs in the Peter A. Juley and Son Collection, National Museum of American Art, Smithsonian Institution, document changes in the design.

29 A. E. Gallatin, *Paul Manship: A Critical Essay on His Sculpture and an Iconography* (New York: Lane, 1917). Significantly, Gallatin emphasized the importance of direct carving to Lachaise's art in his *Gaston Lachaise* (New York: Dutton, 1924), pp. 10–11.

30 The clothing metaphor figures in an early, favorable review by Royal Cortissoz, *New York Tribune*, 23 November 1913, sec. 5, 6.; A. M. Rindge, *Sculpture* (New York: Payson and Clarke, 1929), p. 148.

31 Jerome Mellquist, *The Emergence of an American Art* (New York: Scribner's, 1942), p. 371.

32 Cummings, "Lachaise," p. 198.

33 Cummings's *Creative Art* essay of August 1928 is reprinted in Hilton Kramer et al., *The Sculpture of Gaston Lachaise* (New York: Eakins, 1967), pp. 25–26. In the biographical portion of his monograph on Lachaise, Nordland mentioned the artist's commercial works (*Lachaise*, pp. 25–29). He excluded them from consideration, however, in a separate, thematically organized section on the sculpture, which privileges "the body of work that is most deeply personal…[the] recurring themes to which [Lachaise] returned obsessively" (p. 59).

34 Cummings, "Lachaise," p. 196, cf. p. 204; and Nordland, *Lachaise*, p. 29. A former editor of *The Dial*, Gilbert Seldes explicitly noted, by contrast, that Lachaise's patrons represented conservative and vanguard extremes in "Profiles: Hewer of Stone," *New Yorker*, 4 April 1931, 30.

35 "Avant-Garde and Kitsch," reprinted in Clement Greenberg, *Perceptions and Judgments, 1939–1944*, vol. 1 of *The Collected Essays and Criticism*, ed. John O'Brian (Chicago: University of Chicago Press, 1986), pp. 5–22.

36 See, for example, Charles Caffin, "Certain Reflections Are Suggested by the Architectural League Exhibition," *New York American*, 8 February 1915, 9; and Joseph Bailey Ellis, *Chicago Tribune*, 21 August 1915.

37 "Towards a Newer Laocoon," reprinted in Greenberg, *Collected Essays*, 1:23–28.

38 Caffin (writing of "conventionalization" in Manship's work), "Certain Reflections," p. 9.

39 Of course, many advocates of abstract art thought that it was indeed an answer to the social and political realities of the 1940s; see, for example, Barnett Newman's statement in Emile de Antonio and Mitch Tuchman, *Painters Painting* (New York: Abbeville, 1984), pp. 41–44.

40 Aline B. Saarinen, "Art as Architectural Decoration," *Architectural Forum* 100 (June 1954): 132.

41 Manship, as quoted in Frederick D. Leach, "Paul Manship: Artist, Time and Place," in *Paul Howard Manship: An Intimate View*, exh. cat. (St. Paul: Minnesota Museum of Art, 1972), p. 2. Cf. John Manship, *Paul Manship* (New York: Abbeville, 1989), p. 203 n. 31.

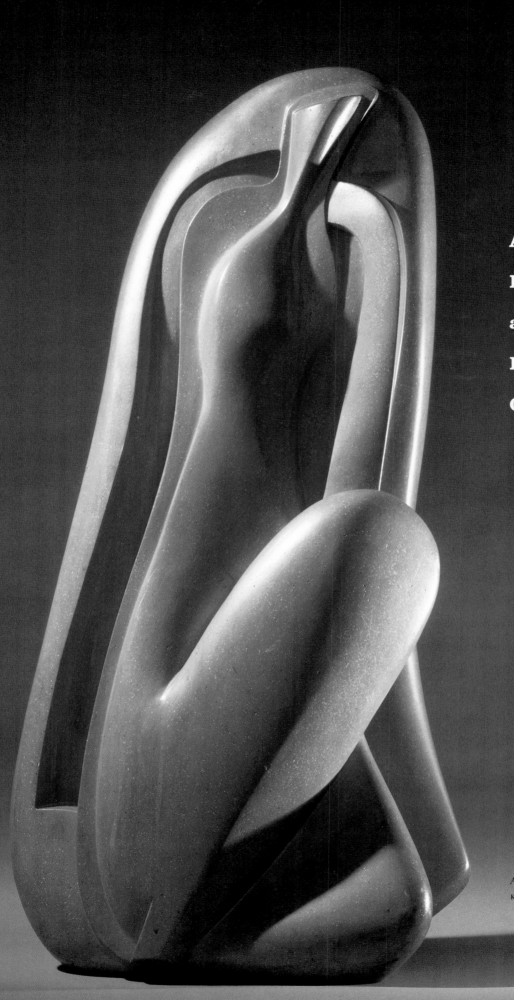

Artist

Biographies

and

Exhibition

Checklist

Alexander Archipenko,
KNEELING FIGURE

Alexander Archipenko

Born 1887 Kiev, Russia
Died 1964 New York City

Abbreviations

AAA Archives of American Art,
Smithsonian Institution,
Washington, D.C.

Conner and Rosenkranz Conner, Janis, and Joel
Rosenkranz. *Rediscoveries in
American Sculpture: Studio Works,
1893–1939.* Austin: University of
Texas Press, 1989.

GAR George Arents Research Library
for Special Collections, Syracuse
University.

OHC Oral History Collection, Archives
of American Art, Smithsonian
Institution, Washington, D.C.

Rubinstein Rubinstein, Charlotte Streifer.
*American Women Sculptors:
A History of Women Working in
Three Dimensions.* Boston: G. K.
Hall, 1990.

WPA/FAP Works Progress Administration/
Federal Art Project

KNEELING FIGURE
1935
Terra-cotta
26½ x 11½ x 6½ in. (67.3 x 29.2 x 16.5 cm)
Hughes and Sheila Potiker
Page 171

TORSO IN SPACE
1936
Bronze
8⅞ x 26⅞ x 6 in. (22.5 x 68.2 x 15.2 cm)
*The Museum of Fine Arts, Houston,
given in grateful memory of Alice Pratt Brown
by the Board of Governors of Rice University*
Plate 6

Achieving international fame during the
1910s for his innovative rendition of cubism,
Alexander Archipenko brought to America one
of the most advanced interpretations of non-
representational sculptural form and surface.

 Trained at the Kiev Art Institute (1902–5),
Archipenko lived and exhibited in Moscow
(1906–7) before establishing himself in Paris
(1908). In the French capital he became part
of the Passy group of cubists, which included
Fernand Léger (1881–1955) and Marcel
Duchamp (1887–1968), and subsequently
rejected his academic training. He exhibited
in the Salon des Indépendents (1910) and two
years later participated with other cubists in
the Section d'Or exhibition. By then he was
attracting critical notice for his application of
cubist aesthetics to three-dimensional form.
In 1913 he sent four works to the Armory Show.

William Artis

Born 1914 Washington, North Carolina
Died 1977 Northport, New York

In 1912 Archipenko blurred the distinction between painting and sculpture by creating "sculpto-paintings," reliefs constructed from carved and painted plaster. The dazzling colors and textured surfaces would become integral to his art. By 1914 he had begun interchanging concave and convex forms in his sculptures of the human figure and eventually invented sculpture with holes. Heads and other body parts were delineated as voids, thereby challenging the traditional concept of sculpture as a solid surrounded by space.

In 1921 Archipenko moved to Berlin. He had met Katherine Dreier through his friend Duchamp two years earlier, and she, having just established the Société Anonyme in New York City, gave Archipenko his first American solo exhibition at the association's galleries (1921). On Dreier's advice Archipenko immigrated to the United States (1923), supporting himself at first with portrait commissions. In 1927 he patented his invention, the Archipentura, an apparatus for displaying changeable pictures that he conceived as "the concrete union of painting with time and space."

Much of his energy for the next decade was taken up with lecturing and teaching, passing on his aesthetic theories to the uninitiated. Archipenko had established his first art school in Paris (1912) and had also taught in Nice and Berlin before giving classes in New York City and Woodstock during the mid-1920s; in the early 1930s he established the Guild School in New York City. A peripatetic personality, Archipenko would also teach throughout the country: at Mills College in Oakland (1933), the Chouinard Art Institute (1934) and his own school in Los Angeles (1935–37), the University of Washington in Seattle (1935–36), and in Chicago (1937). Ever the teacher, in 1960 he published his theories of art.

Archipenko did not develop any radically new ideas in his art during his American years. Rather he refined his interpretation of form, smoothing planes and shapes to create elongated and gently curving human figures of extreme simplicity. In California he worked primarily in terra-cotta and with color. His art helped promote the popularity of the partial figure (the female torso) and use of polychromy among American sculptors in the 1930s.

Sources

Archipenko, Alexander, papers, AAA.

Archipenko, Alexander. *Archipenko: Fifty Creative Years, 1908–1958*. New York: TEKHNE, 1960.

Karshan, Donald H., ed. *Archipenko: International Visionary.* Exh. cat. Washington, D.C.: Smithsonian Institution Press for the National Collection of Fine Arts, 1969.

———. *Archipenko: Sculpture, Drawings and Prints, 1908–1963*. Danville, Kentucky.: Centre College; Bloomington: Indiana University Press, 1985.

Michaelsen, Katherine Janszky, and Nehama Guralnik. *Alexander Archipenko: A Centennial Tribute*. Exh. cat. Washington, D.C.: National Gallery of Art, 1986.

HEAD OF A NEGRO BOY
1939
Terra-cotta
12 x 7 x 6 in. (30.5 x 17.8 x 15.2 cm)
Dorothy B. Porter Collection
Plate 172

During the 1930s William Ellisworth Artis was a prominent New York ceramic sculptor, who found beauty in straightforward portrayals of African Americans.

Moving from the rural South to New York City in 1927, Artis while still in high school enrolled in classes at the Harlem Community Art Center, where his teachers Selma Burke and Augusta Savage encouraged him to seek further training. Awarded a Harmon Foundation prize (1933) for sculpture made while working with Savage, Artis received a scholarship to the Art Students League. There he studied with Robert Laurent (1933–35). After high school Artis began teaching arts and crafts at the Harlem branch of the YMCA, remaining until 1941.

Artis's favorite medium was clay, because it enabled a broad range of expression in modeling. During the 1930s Artis used it to produce portrait heads and figural sculpture. His style relied on naturalism, although his simplified sculptures verged at times on an abstract use of geometric shapes. While he relied upon African American subjects almost exclusively, his work was not concerned with social commentary but rather with the universal beauty of the human form. He is best known for the terra-cotta portrait sculptures of children that he created during his early career.

Saul Baizerman

Born 1889 Vitebsk, Russia
Died 1957 New York City

In 1940 and again in 1946–47 Artis attended the New York State College of Ceramics in Alfred. Thereafter he changed his focus from the sculptural use of clay, working instead with functional objects, often decorating them with abstract motifs. Reentering school, he earned both B.F.A. (1950) and M.F.A. (1951) degrees at Syracuse University, where he studied with sculptor Ivan Mestrovic (1883–1962). Artis then spent the remainder of his life in academia, teaching ceramics at several midwestern institutions. He continued to win awards and fellowships and exhibited regularly.

Sources

Driskell, David C. *Paintings by Ellis Wilson; Ceramics and Sculpture by William E. Artis.* Exh. cat. Nashville: Carl Van Vechten Gallery of Fine Arts, Fisk University, 1971.

Pendergraft, Norman E. *Heralds of Life: Artis, Bearden, and Burke.* Exh. cat. Durham: North Carolina Central University, 1977.

Reynolds, Gary A., and Beryl J. Wright. *Against the Odds: African-American Artists and the Harmon Foundation.* Exh. cat. Newark: Newark Museum, 1989.

From THE CITY AND THE PEOPLE *series*
Bronze

a. ORGAN GRINDER
1922
4⅛ x 2¾ x 2⅝ in. (10.3 x 7 x 6.5 cm)

b. CEMENT MAN
1924
5½ x 3¼ x 2⅜ in. (14 x 8.3 x 6 cm)

c. TWO MEN LIFTING
1922
3¾ x 6½ x 2½ in. (9.5 x 16.5 x 6.4 cm)

Hirshhorn Museum and Sculpture Garden, Smithsonian Institution, gift of Mrs. Saul Baizerman, New York, 1979

d. ROLLER SKATER
c. 1924–31
4¹⁵⁄₁₆ x 4⅞ x 2 in. (12.5 x 12.4 x 5.1 cm)

e. MAN WITH A SHOVEL
c. 1924–31
3⅝ x 2 x 3 in. (9.2 x 5.1 x 7.6 cm)

Gary and Brenda Ruttenberg

Plates 83–87

EXUBERANCE
c. 1933–49
Hammered copper
63 x 79 x 8 in. (160 x 200.7 x 20.3 cm)
The University of New Mexico Art Museum, Albuquerque, purchase through the Julius L. Rolshoven Memorial Fund
Plate 49

In his genre figures and nudes Saul Baizerman demonstrated the modernist's urge to explore new sculptural themes and techniques.

Arrested as a youth for political activities during the Russian revolutionary unrest of 1905, Baizerman escaped Siberian imprisonment five years later, fleeing to the United States. He attended the National Academy of Design in New York City (1911) and became the first sculpture student at the Beaux-Arts Institute of Design (1916), studying there with Solon Borglum until 1920.

After witnessing the Armory Show, Baizerman resolved to revitalize figurative sculpture. In 1920 he began a series of small genre figures of urban dwellers, which came to be known as *The City and the People.* Depicting a street paver, construction worker, organ grinder, Italian mother, and rabbi among others, he worked on the project intermittently for more than thirty years. The modernity of his subject matter was reenforced by his technique; rather than finishing cast bronze figures with chasing, he hammered the soft metal to create figures composed of faceted, smooth planes. The people with their cubic shapes thereby became analogous to the new American skyscraper city they inhabited; Baizerman depicted such a metropolis in the only nonfigurative image of the series.

During a four-year stay abroad (1922–26) Baizerman learned the repoussé technique while living in Paris. Returning to New York, he used the technique to begin his mature work: large-scale figurative reliefs made from thin copper sheets. The artist stopped working for two years (1931–33) after a studio fire destroyed a significant number of *The City and the People* plasters. He resumed making sculpture with enthusiasm in 1933, and his compositions of individual figures and groups of nudes in motion and intertwined would constitute his oeuvre for the rest of his career. Baizerman

Robert Baker

Born 1886 London, England
Died 1940 Hyannis, Massachusetts

sometimes presented his repoussé figures as torsos to suggest the abstract nature of the forms rather than the literal meaning of the nudes. His method again complemented his subject matter: the surfaces of the metal sheets were so delicately hammered that they caught the light and seemed to shimmer, thereby enhancing the sensual nature of the figures.

Baizerman was an active exhibitor during the 1930s and 1940s. At his first New York solo exhibition (Eighth Street Gallery, 1933) he showed *The City and the People* (he had had an earlier solo exhibition at Dorien Leigh Galleries in London during his European sojourn); the first showing of his hammered-copper sculptures was held at the Artists Gallery, New York (1938). That year he also began showing with the Sculptors Guild. Not until 1953 was he accorded a retrospective exhibition, at the Walker Art Center in Minneapolis.

Sources

Baizerman, Saul, papers, AAA.

Debakis, Melissa. "The Sculpture of Saul Baizerman." Ph.D. diss., Boston University, 1987.

Goldstein, Carl. "The Sculpture of Saul Baizerman." *Arts* 51 (September 1976): 121–25.

Held, Julius. *Saul Baizerman.* Exh. cat. Minneapolis: Walker Art Center, 1953.

Salpeter, Harry. "The Man with the Hammer." *Coronet,* January 1939, 135–40.

SANCTUARY OF DREAMS
c. 1919
Bronze on marble base
19½ x 10 x 11¾ in. (49.4 x 25.4 x 29.7 cm)
National Museum of American Art,
Smithsonian Institution,
gift of Bryant Baker
Plate 38

Robert Peter Baker was an English-trained sculptor who worked in the symbolist style of August Rodin.

In London, where he was born into a family of sculptors and carvers, Baker, a child prodigy, attended the Lambeth School of Art, the City and Guilds of London Institute, and the Royal Academy of Arts. By 1907 he was assisting Adrian Jones (1845–1938) with the quadriga surmounting Inigo Jones's monumental arch in Hyde Park. His solid training in architectural sculpture led to many commissions for decorative carvings in newly restored gothic churches throughout England. Baker won a medal at the Royal Academy of Arts for a portrait bust (1909) and continued to exhibit there until 1915. He also participated in the activities of the Chelsea Club and seems to have studied in or at least visited France and Germany. Following the outbreak of World War I Baker, a pacifist, traveled with his friend James H. Worthington, an astronomer, to the United States to avoid military service. After visiting the Panama-Pacific International Exposition in San Francisco, they headed east and by the end of 1915 had settled in Boston. Baker established a studio and hired the young sculptor Donald De Lue (1897–1968) as his assistant. Although he continued to support himself with portrait and architectural commissions, such as decorations for the Princeton University chapel, Baker's primary interest was in imaginative figurative sculpture. He also expressed his preference for romantic themes in his illustrations for Worthington's *Sketches for Poetry, Prose, Paint and Pencil* (1917).

Though his contemporaries referred to him as a "conservative radical" and a "modern" and drew comparisons between his sculptures and those of Phidias and Michelangelo, Baker was probably most influenced by the philosophies and aesthetics of Worthington and Rodin. Called by writer W. H. de B. Nelson a "cosmic dreamer," Baker modeled romantic and poetic figures representing the spiritual history of humankind. He responded to the war with several works that demonstrated the futility of battle, but most of his sculptures were more idealized. His most elaborate was *The Soul's Struggle* (1916–17), an allegory of man's spiritual ascension from bestiality to a higher plane; in its theme and manner of presentation (with figures vaguely defined) *The Soul's Struggle* was reminiscent of Rodin's romantic symbolism.

A series of fantasy paintings suggests that Baker visited Bermuda in 1921. He also worked in Paris and New York City during the 1920s. By 1929 he had moved his studio to Woods Hole, Massachusetts. He participated in *Contemporary American Sculpture*, the major exhibition organized by the National Sculpture Society in 1929, but little is known of his activities thereafter. He seems to have led a wanton existence. Much of his sculpture was destroyed when his studio was flooded by a hurricane (1938).

Sources

Baker, Robert, files, art division, Boston Public Library; library, Metropolitan Museum of Art, New York City; and GAR.

Baker, Bryant, papers, AAA.

Howlett, D. Roger. *The Sculpture of Donald De Lue: Gods, Prophets, and Heroes.* Boston: Godine, 1990.

Nelson, W. H. de B. "In a Boston Studio." *International Studio* 62 (October 1917): 81–88.

Patrociño Barela

Born c. 1902 Bisbee, Arizona
Died 1964 Cañon, New Mexico

HEAVY THINKER
1930s–41
Juniper
19 x 6⅛ x 3 in. (48.4 x 15.6 x 7.5 cm)
The Harwood Foundation, Taos
Plate 155

In naively rendered wood carvings Patrociño Barela transformed the santos tradition of his Hispanic heritage into a modern, personal idiom.

Born to a poor family, Barela led a peripatetic existence during his early years, sometimes accompanying his father, an itinerant laborer and folk healer, around the Southwest. Eventually Barela moved to Cañon, New Mexico, near Taos. Self-taught, he started wood carving in 1931. Despite his wife's disapproval of his artistic endeavors, Barela continued to carve *santos* and other religious figures, and by the mid-1930s was attracting local attention. Employment with the WPA/FAP (1936–43) provided the only steady income he ever derived from his art.

Both *Time* and the *New York Times* commented favorably on Barela's carvings in the exhibition *New Horizons in American Art* (1936) at the Museum of Modern Art in New York City. Several of his pieces were also displayed at the New York World's Fair (1939). Despite a growing reputation, Barela declined gallery representation, preferring to sell his work himself whenever he needed money. He received commissions for decorative relief carvings, figures, and Spanish-style, ornamental wood furniture. When he perished in a studio fire, he was completing carvings commissioned for a Taos church.

Barela worked primarily with cedar, juniper, and pine. Most of his pieces were small, yet monumental in character. While his depiction of religious figures grew out of the *santos* tradition of northern New Mexico, he used subjects of personal interest—biblical characters, human figures expressing such universal themes as man's struggle to survive and support himself and his family, and some darkly humorous and morbid themes—as well. True to the direct-carving tradition, his art reflected a deep respect for the wood, with each sculpture's shape determined by the material's grain and other characteristics. Barela approached representation naively, and consequently his art was admired by avant-garde sculptors promoting primitivism.

Sources

Barela, Patrociño, interview with Sylvia Loomis, 1964, OHC.

Crews, Mildred, et al. *Patrocinio Barela, Taos Wood Carver.* Taos: Taos Recordings and Publications, 1962.

Greenwood, Phaedra. "The Mother, the Struggle, the Search, the Heart: The Story of Patrocinio Barela." *New Mexico Craft* 3, no. 1 (1980): 13–16.

Hunter, Vernon. "Concerning Patrocinio Barela." In *Art for the Millions: Essays from the 1930s by Artists and Administrators of the WPA Federal Art Project,* ed. Francis V. O'Connor, pp. 96–99. Greenwich, Connecticut: New York Graphic Society, 1973.

Marshall, Lenore. "Patrocinio Barela." *Arts* 30 (August 1956): 24–25.

George Grey Barnard

Born 1863 Bellefonte, Pennsylvania
Died 1938 New York City

SOLITUDE
c. 1905–6
Marble
21¾ x 12 x 7½ in. (55.3 x 30.5 x 19.1 cm)
Frances Lehman Loeb Art Center,
Vassar College, Poughkeepsie, gift of
Mrs. William Reed Thompson
(Mary Thaw, class of 1877)
Plate 31

The most creative disciple of Auguste Rodin in the United States, George Grey Barnard was hailed as a dreamer and genius.

Barnard began his artistic training in 1882 at the School of the Art Institute of Chicago but the following year left for France, residing there more than a decade. He studied at the traditional École des Beaux-Arts (1884–87) and at the atelier of Pierre Cavélier (1814–94). While Barnard repeatedly denied the influence of Rodin, emphasizing instead the inspiration of Michelangelo, his sculpture was decidedly akin to the symbolist art of the French master. Barnard used the nude to signify such broad themes as love and the relationship between nature and humankind, often imbuing them with personal and mystical interpretations. Working primarily in stone, he sometimes left parts of the block unfinished in the manner of Rodin, allowing his muscular figures to appear as if emerging from the hewn stone. At the salon of the Société Nationale des Beaux-Arts in 1894 Barnard exhibited *Struggle of the Two Natures in Man* (1889–94) to acclaim, including that of Rodin, yet shortly thereafter he returned to the United States, despite Rodin's urging him to remain in Paris, and settled in the Washington Heights section of New York City.

Barnard continued to exhibit successfully at international expositions, taught at the Art Students League (1900–1904), and undertook numerous portrait commissions. In 1902 he was awarded the commission to decorate the Pennsylvania State Capitol in Harrisburg, the

Richmond Barthé

Born 1901 Bay St. Louis, Mississippi
Died 1989 Pasadena, California

largest sculptural commission given to an American until that time. Representing the entire history of humankind, his design entailed more than sixty figures flanking the main entrance and staircase. The project took eight years to complete but ensured Barnard's fame. Its universal theme, elaborate conception, and the artist's difficulty with his patron made his Harrisburg project comparable with Rodin's major commissions.

Wide journalistic attention paid to the Harrisburg project and to Barnard's activities during the following fifteen years made him the best-known progressive sculptor of his time. He was also admired by his peers, and consequently in 1908 the Museum of Fine Arts, Boston, accorded him an extensive exhibition.

Thereafter Barnard divided his attention among three projects: amassing a collection of medieval art (later the basis of the Cloisters at the Metropolitan Museum of Art and a similar installation at the Philadelphia Museum of Art); completing a series of portrayals of Abraham Lincoln commissioned for various cities; and planning the *Rainbow Arch*, a grandiose antiwar sculptural project for his own estate, left uncompleted at his death. Thematically the Lincoln memorials and Rainbow Arch continued Barnard's earlier interest in symbolizing the course of humankind.

Sources

Barnard, George Grey, papers, AAA, Kankakee County Historical Society, Illinois, and Philadelphia Museum of Art.

Coburn, Frederick W. "The Sculptures of George Grey Barnard." *World Today* 16 (March 1909): 273–80.

Dickson, Harold E. "Barnard's Sculptures for the Pennsylvania Capitol." *Art Quarterly* 22 (summer 1959): 127–47.

———. *George Grey Barnard: 1863–1963, Centenary Exhibition.* Exh. cat. University Park: Pennsylvania State University Library, 1964.

Mørstad, Erik. "George Grey Barnard i Langesund: Noen aspekter ved vennskapet som motiv." *Kunst og kultur* 69, no. 4 (1986): 211–23. In Norwegian.

BLACKBERRY WOMAN
1932
Bronze
33⅞ x 14¼ x 12⅜ in. (86 x 36.2 x 31.4 cm)
Whitney Museum of American Art, purchase
Plate 170

Striving to capture the beauty he saw in African Americans, Richmond Barthé won acclaim during the 1930s and 1940s for his realistic depictions.

Barthé began studying painting at the School of the Art Institute of Chicago (1924), taking classes with the sculptor Albin Polasek (1879–1965). Charles Schroeder, who taught him anatomy, was the first to encourage Barthé to model in clay in order to improve his sense of three-dimensionality. The first two heads he created were well received when exhibited as part of Negro History Week (1927) in Chicago and won him portrait commissions. Rosenwald fellowships (1931, 1932) enabled Barthé to continue his training in New York City, but he studied only briefly at the Art Students League before following Jo Davidson's advice to become his own teacher. In 1934 he traveled to Europe to tour museums.

Born of mixed American Indian and African ancestry, Barthé in the late 1920s fell under the spell of African art. By 1931 this influence only remained in his tendency to delineate anatomy in terms of simplified, elongated forms, for throughout his career he retained his allegiance to realism and to bronze as a medium. It was during the 1930s that Barthé's figures attracted considerable attention. Although he would continue to do numerous portraits, often of celebrities, such as Katherine Cornell and Paul Robeson, Barthé also created allegorical and African American genre figures—stevedores, shoeshine boys, and boxers—but became known primarily for the African dancers that allowed him to demonstrate his mastery of the nude form. Barthé also received a significant

government commission to design panels for the Harlem River Housing Project (1937–38), sponsored by the Treasury Relief Art Project.

By participating as early as 1929 not only in the Harmon Foundation exhibitions but also in the Salons of America and Whitney Museum of American Art annuals, Barthé found ready acceptance with both black and white audiences. He was accorded several one-man shows during the 1930s, first at the Grand Rapids Art Gallery in 1930 and then in other cities, including New York at the Caz-Delbos Gallery (1931, 1933) and Arden Gallery (1939). He was also active in promoting sculpture through the Sculptors Guild. By 1939 Barthé was represented in two significant collections, the Allen Memorial Art Museum, Oberlin College, and Whitney Museum.

In 1941 Barthé won the first of two Guggenheim fellowships. He continued to obtain noteworthy commissions throughout the 1940s, including the portrait bust of Booker T. Washington for the Bronx Hall of Fame and religious figures for churches. He withdrew increasingly from exhibiting, however, as abstract expressionism superseded realism in critical appeal. Ill health caused Barthé to leave the United States, and in 1951 he settled in Jamaica, where he remained for two decades. He retired to Pasadena in the early 1970s.

Sources

Hammond, Bert D. "A Conversation: Richmond Barthé." *International Review of African American Art* 6, no. 1 (1985): 4–13.

Lewis, Samella. *Richmond Barthé, Richard Hunt: Two Sculptors, Two Eras.* Exh. cat. Los Angeles: Landau/Traveling Exhibitions, 1992.

Porter, James A. *Modern Negro Art.* New York: Dryden, 1943; repr. Arno, 1969.

"The Story of Barthé." *Art Digest* 13 (1 March 1939): 20.

Van Vechten, Carl, papers, Bienecke Rare Book and Manuscript Library, Yale University.

Chester Beach

Born 1881 San Francisco, California
Died 1956 Brewster, New York

THE RIVER'S RETURN TO THE SEA
1906
Marble
14 x 45½ x 15 in. (35.6 x 115.6 x 38.1 cm)
Dr. James D. Zidell
Plate 40

In the early years of the twentieth century Chester Beach was one of America's most progressive sculptors, creating sensuous marble figures inspired by the art of Auguste Rodin.

Beach studied modeling at the California School of Mechanical Arts (1899) and antique and life drawing at the Mark Hopkins Institute of Art (1900–1902), both in his native city. During these years he supported himself as a silver designer and modeler for the firm of Shreve and Company. He left San Francisco to study in Paris, enrolling at the École des Beaux-Arts in 1904. During his three-year stay he also studied at the Académie Julian with Charles Raoul Verlet (1857–1923) and exhibited at the salons. After establishing a studio in New York City, Beach returned to Europe (1911), spending two years in Rome.

Although in France Beach had come under the spell of Rodin's evocative symbolist sculpture and done at least one significant marble carving, *The River's Return to the Sea*, following his Parisian years he began modeling realistic genre figures in the vein of the bronzes of Abastenia Eberle and Mahonri Young. It was not until his stay in Rome that Beach devoted himself to stone carving and idealized themes. Classical antique sculpture as well as the impressionist works of Medardo Rosso no doubt inspired him. Abandoning the contemporary subject matter of his earlier sculpture, Beach created a series of allegorical nudes symbolizing natural phenomena and human emotions. Through the interplay of polished surfaces with roughly hewn passages, Beach exploited the sensuous nature of white marble, carving bodies that seem to flow out of the stone. Beach's carvings ranked among the most poetic sculpture created by an American during the first three decades of the century. Although his preferred material remained white marble, he occasionally polychromed terra-cotta and late in his career returned to bronze.

Beach taught modeling at Richmond Hill Settlement House (1910–22) and drawing at the Beaux-Arts Institute of Design (1934). Commissioned portraits were a significant source of income throughout his career, but beginning in the 1920s he also received numerous commissions for public monuments and private garden statuary and fountains. In 1929 his bronze figural *Fountain of the Waters* was placed near Rodin's *The Thinker* in the garden of the Cleveland Museum of Art.

Despite contemporary acknowledgement of his leadership in the modern movement, Beach was quite successful commercially. He sold works to the wealthiest private collectors, such as Andrew Carnegie and Gertrude Whitney, as early as 1907 and placed his first work in a museum collection in 1910, when the Rhode Island School of Design purchased *Swimming* (1907). Five of his sculptures were selected for the Armory Show. He was also accorded numerous solo exhibitions during his first years back in the United States: by Macbeth Gallery (1912, 1914) and Pratt Institute (1913), New York City; Cincinnati Art Museum (1916); John Herron Art Institute, Indianapolis (1916); and Memorial Art Gallery, Rochester (1917).

Sources

Beach, Chester, papers, collection of Mrs. Paul Fitchen, Brewster, New York (partially microfilmed, AAA).

"News of the Realm of Art." *New York Herald*, 20 October 1912, 7.

Porter, Beata Beach. "Chester Beach." *National Sculpture Review* 14 (fall 1965): 20, 24–25.

Rehn, Frank K. M., Jr. "Chester Beach: A Sculptor Who Works with the Stone." *Metropolitan* 39 (December 1913): 34–35.

"Subtle Studies of Human Emotions Shown in the Sculpture of Chester Beach." *Craftsman* 30 (July 1916): 350–55.

Ahron Ben-Shmuel

Born 1903 New York City
Died 1984 probably Jerusalem, Israel

PUGILIST
1929
Granite
21 x 13 x 12 in. (53.3 x 33 x 30.5 cm)
The Museum of Modern Art,
gift of Nelson A. Rockefeller, 1934
Plate 140

Ahron Ben-Shmuel established a reputation as a respected direct carver during the 1930s and 1940s.

Ben-Shmuel came to sculpture through the stone carving business. While in his teens he pursued a three-year apprenticeship with a stone cutter and then found employment carving monuments and reproducing preliminary models in stone for sculptors. He may have traveled through Europe and North Africa, using his trade to support himself. During these seminal years he frequently visited museums to study primitive, Egyptian, and archaic Greek sculpture.

By the late 1920s the artist was doing original carvings. Four of his sculptures were selected for inclusion in the Brooklyn Museum's important *Exhibition of Recent Work by Distinguished Sculptors* (1930), and thereafter he participated in exhibitions organized by the Whitney Museum of American Art, Pennsylvania Academy of the Fine Arts, and Sculptors Guild. Such was the regard of his colleagues that his carvings along with those of Chaim Gross were the subject of a joint exhibition the guild installed to inaugurate its gallery space (1935). Ben-Shmuel also participated in federal art projects with the WPA and Treasury Section.

Ben-Shmuel preferred hard stones and won the greatest acclaim for his direct carvings in granite. He focused on the human figure. The influence of the solidly massed stone sculptures of earlier ages which he saw in museums is evident in his carvings, which tend to be monolithic forms with details (both etched and carved) kept to a minimum. Like his better-known colleagues, John Flannagan and William Zorach, Ben-Shmuel disturbed the character of the stone as little as possible in his simplification and abstraction of anatomical forms. More interested in the medium and craftsmanship than in subject matter, he usually shunned literary and mythological themes. For him the material provided the sole beauty and meaning of art. Ben-Shmuel spent his career perfecting technique. As he explained in 1940, "Craftsmanship is the foundation in every art."

Sometime before 1940 the artist began living part of the time in Upper Black Eddy, Pennsylvania. During his later years he turned to painting.

Sources

Sculptors Guild papers, AAA.

Ben-Shmuel, Ahron. "Carving: A Sculptor's Creed." *Magazine of Art* 33 (September 1940): 502–9.

Cross, Louise. "Ahron Ben-Shmuel." *Arts Weekly* 1 (26 March 1932): 63.

Schack, William. "Four Vital Sculptors." *Parnassus* 9 (February 1937): 12–14, 40.

Boris Blai

Born 1890 or 1898 Rovno, Russia
Died 1985 Philadelphia, Pennsylvania

TRIANGLE GIRL
c. 1928
Mahogany
12¾ x 8½ x 9¼ in. (32.4 x 21.6 x 23.5 cm)
The Metropolitan Museum of Art,
Hugo Kastor Fund, 1983
Plate 63

Philadelphia sculptor Boris Blai demonstrated in his art and teachings that a traditional representational foundation was essential for the abstraction of the figure.

Blai pursued academic training in several countries before his arrival in the United States. He attended the Kiev Royal Academy, the Royal St. Petersburg Academy of Fine Arts, the Royal Academy of Fine Arts, Munich, and shortly before World War I the École des Beaux-Arts in Paris. In France he was also involved with more progressive artists and, according to tradition, was either an apprentice to or student of Rodin. At the urging of American sculptor R. Tait McKenzie (1867–1938), he immigrated to the United States (1917) and worked as McKenzie's assistant in Philadelphia for several years and also did portrait commissions.

Blai was accorded his first solo exhibition at Grand Central Art Galleries in New York City (1933). His display there of both modeled and carved figures ranged from representational to abstract and stylized and demonstrated his openness to experimentation. It was often in his sculptures of dancers, such as *The Dance of Mary Wigman* (1932), that he moved furthest from representation.

Blai also had a long and successful career as an educator, beginning in 1928, when he worked at the Oak Lawn Country Day School. He cofounded and directed the Stella Elkins Tyler School of Art of Temple University (1935) and served as its dean for twenty-five years. He founded the Long Beach Island Foundation of the Arts and Sciences (1949)

Alexander Blazys

Born 1894 Poniewiesz, Russia (Lithuania)
Died 1963 Cleveland, Ohio

in New Jersey. After his retirement from Tyler School, Blai established the Boris Blai College of Contemporary Arts (1966) in Forked River, New Jersey, and served as artist-in-residence at Glassboro State College (1972–76). He himself rejected reliance on art of the past and encouraged his students to experiment with materials and styles.

Sources

Blai, Boris, papers, Samuel S. Paley Library, Temple University.

Blai, Boris. "It's in Your Hands." *American Magazine* 129 (January 1940): 51–52, 103–4.

Butterweck, Joseph. *Exhibition of Sculpture by Boris Blai.* Exh. cat. New York: Grand Central Art Galleries, 1933.

BALALAIKA PLAYER
1925
Bronze
12½ x 7¾ x 3⅝ in. (31.6 x 19.7 x 9.2 cm)

RUSSIAN DANCER
1925
Bronze
10¼ x 11½ x 5 in. (26 x 29.2 x 12.5 cm)

*The Cleveland Museum of Art,
Hinman B. Hurlbut Collection*

Alexander Blazys was a leading sculptor in Cleveland during the late 1920s.

According to published sources, Alexander Blazys Blaziewitch, the son of a Russian officer, studied with Sergei Mikhailovich Volnuchin (1859–1921) and Sergei Vasilievich Beklemisheff (1870–1920) from around 1911 to 1918 at the Moscow School of Painting, Sculpture, and Architecture. However, Blazys was probably their student at the Royal St. Petersburg Academy of Fine Arts, since both instructors taught there in the years before the Russian Revolution. Later he himself taught at the academy. Around 1920 Blazys settled in Paris, where he studied sculpture. Two of his wood carvings were the sensation of the 1921 Salon des Indépendents.

In 1922 a cousin of Blazys brought him to Detroit, where he first exhibited in the United States. The following year the sculptor moved to New York City and immediately began exhibiting at the annuals there and in Philadelphia and Chicago. The dancer Nicholas Seminoff, a friend from Moscow and fellow refugee in Paris and New York, invited him to Cleveland, where Blazys settled in 1925. The following year he attracted considerable attention at the annual May Show of the Cleveland Museum of Art, winning first prize in sculpture. Demonstrating a cosmopolitan sophistication that was lacking among local artists, he found ready support and success.

In 1927 he was commissioned to enlarge and install near the entrance of the Cleveland Museum of Art his *City Fettering Nature*, and in 1929 the Eastman-Bolton Galleries gave him a solo exhibition. One critic described Blazys as neither a traditional nor a radical artist.

Blazys supported his family in part through portrait commissions, which were his most realistic work. His more imaginative sculpture included both religious and folk figures and demonstrated modernist tendencies. Blazys became known as the "sculptor of rhythms": during the 1920s he created a group of Russian dancers and musicians that were each dynamic arrangements of smooth and curved, intersecting planes and that reflected his familiarity with cubism and futurism. His versatility is apparent in the contrast between his direct carvings—he often conveyed a raw power by leaving the bark of the log showing—and his figures modeled in clay and later cast in bronze, which demonstrated the elegance of art deco.

The attention Blazys received at the 1926 May Show resulted in two important associations: Cowan Pottery Studio, a leading manufacturer of art ceramics, hired him as one of its designers, and the Cleveland School of Art asked him to join its faculty. Blazys was largely responsible for Cowan's introduction of purely decorative, free-standing ceramic figures, and at the May Show of 1927 seven of his ceramic designs were awarded first prize in the new category of ceramic sculpture. Although his association with the firm was not long lasting, the sculptor did continue producing ceramic sculpture in small quantity. Blazys remained at the Cleveland School of Art until 1938, serving as the head of its sculpture department. Blazys participated in the WPA/FAP, receiving a commission (1940) for statues for the Woodhill Homes housing project in Cleveland. The following year marked his last contribution

Leslie Bolling

Born 1898 Dendron, Virginia
Died 1955 New York City

COUSIN-ON-FRIDAY
1935
Maple
6¾ x 5¾ x 9¼ in. (17.2 x 14.6 x 23.5 cm)
Virginia Museum of Fine Arts,
Richmond, gift of the Hon. and Mrs.
Alexander W. Weddell
Plate 98

The folk sculptor Leslie Garland Bolling
brought a new dimension to genre sculpture
during the 1930s with his honest depictions
of African American life.

Bolling attended Hampton Institute and
Virginia Union University but had had no
formal art training when in 1928 he began carv-
ing soft poplar with a pocketknife. As a result
of showing at the annual of the Richmond
Academy of Arts (1933), he attracted the atten-
tion of the Harmon Foundation and subse-
quently participated in its group exhibitions
(1934–40).

Bolling participated in other Negro art
exhibitions during the 1930s, including a spe-
cial display at the Texas Centennial Exposition
(1936) in Dallas and regional annuals. He
became the first African American artist to be
honored by a solo exhibition at the Richmond
Academy of Arts (1935), and two years later
was given another one-man show at the
William D. Cox Gallery in New York City.
Bolling actively participated in the Richmond
arts community, lecturing and teaching. He
was esteemed by Thomas Hart Benton (1889–
1975) and Carl Van Vechten, who showed his
work to the artists in their circles of friends.

Bolling's first carvings were of female
nudes, but he soon began focusing on working-
class genre types: postmen, athletes, and laun-
dresses. His best-known sculptures were a
series representing domestic activities for each
day of the week; *Cousin-on-Friday* (plate 98)
is part of that series. Like the sculpture of
William Edmondson, Bolling's carvings were

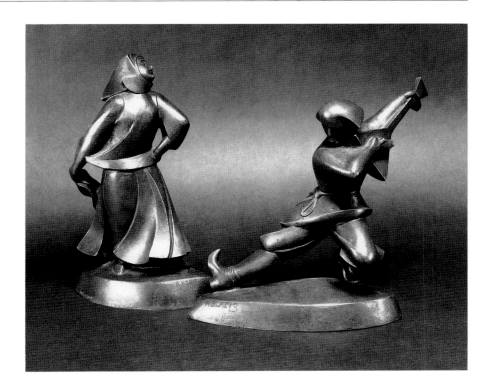

to the May annuals for more than a decade.
During his absence from competition Blazys
worked for several ceramic firms in New
Jersey, modeling figurines for reproduction
in molds. With his move from Cleveland,
Blazys's career as a significant sculptor ended.

Sources

Blazys, Alexander, file, library, Cleveland Museum of Art.

Cowan Pottery Museum. Rocky River, Ohio: Rocky River Public
Library, 1978.

Hawley, Henry. "Cowan Pottery and the Cleveland Museum of
Art." *Bulletin of the Cleveland Museum of Art* 76 (September
1989): 238–63.

Alexander Blazys, RUSSIAN
DANCER *and* BALALAIKA
PLAYER

Gutzon Borglum

Born 1867 near Bear Lake, Idaho
Died 1941 Chicago, Illinois

fresh and simple, but unlike the stone carver, he included a greater degree of descriptive detail. Above all, his figures typified African American life. Only occasionally did his simplification of line and form verge on abstraction. Little is known of his life after World War II.

Sources

Cederholm, Theresa. *Afro-American Artists: A Bio- and Bibliographical Directory.* Boston: Boston Public Library, 1973.

Reynolds, Gary A., and Beryl J. Wright. *Against the Odds: African-American Artists and the Harmon Foundation.* Exh. cat. Newark: Newark Museum, 1989.

"Richmond Academy Accords Show to Negro." *Art Digest* 9 (15 February 1935): 23.

Whittling Works of Leslie Garland Bolling. Exh. cat. New York: Cox, 1937.

THE AWAKENING
c. 1902–14
Marble
34¼ x 15¼ x 15 in. (87 x 38.7 x 38.1 cm)
San Diego Museum of Art, gift of
Mr. and Mrs. Archer M. Huntington
Plate 32

John Gutzon Mothe Borglum was one of the best-known American sculptors of the early twentieth century, largely due to his more than 170 public monuments and statues, especially Mount Rushmore in South Dakota.

Born to Danish immigrants, Borglum began drawing as a schoolboy in the Midwest. He accompanied his family on a brief move to Los Angeles, where he was apprenticed to a lithographer. When his family moved again, this time to Omaha (1886), he went instead to San Francisco, studying painting at the Art Association. Back in Los Angeles he set up a studio and with the help of famous patrons, General John and Jessie Frémont, started attracting portrait commissions.

Borglum went abroad, exhibiting both painting and sculpture at Paris salons in the early 1890s. Conflicting accounts date his first encounter with Auguste Rodin to the early 1890s or 1900; he would retain contact with Rodin until the latter's death. In 1893 he returned to the United States but stayed only two years, settling in England for much of the remainder of the decade. There he exhibited and received several mural commissions. Although he supported himself with his painting, he became increasingly involved with sculpture. He competed for commissions in the United States, and when he failed to win a competition for a monument to Ulysses S. Grant, he resolved to return to his homeland so that his work would become better known there.

Borglum first established a studio in New York City but worked increasingly in a studio he built at his house in Stamford, Connecticut (c. 1909). He completed several commissioned works, including a portrait bust of Abraham Lincoln for the Library of Congress, architectural sculpture for Princeton University, and statues for the Cathedral of St. John the Divine in New York City. By 1915, his reputation well established, he turned his attention to a major work, a monument to the Confederacy to be erected at Stone Mountain, Georgia. That project ended abruptly in a disagreement between Borglum and the sponsors, and he began plans for the Mount Rushmore monument, to which he devoted the rest of his life.

Mount Rushmore, Borglum's lasting triumph, overshadows his other work. As early as the first years of this century he also created and exhibited allegorical marble nudes. His noncommissioned sculptures demonstrate a fluent modeling and dramatic sense of immediacy characteristic of Rodin's work.

Sources

Borglum family papers, AAA and collection of George Borglum, Royal Oak, Michigan.

Borglum, Solon, papers, manuscript division, Library of Congress, Washington, D.C.

Borglum, Gutzon. "Art That Is Real and American." *World's Work* 28 (June 1909): 200–217.

Casey, Robert J., and Mary Borglum. *Give the Man Room: The Story of Gutzon Borglum.* Indianapolis: Bobbs-Merrill, 1952.

Luks, George. Preface. In *Exhibition of Sculpture by Gutzon Borglum.* Exh. cat. New York: Avery Library, Columbia University, 1914.

Mechlin, Leila. "Gutzon Borglum, Painter and Sculptor." *International Studio* 28 (April 1906): xxxv–xliii.

Solon Borglum

Born 1868 Ogden, Utah
Died 1922 Stamford, Connecticut

THE BLIZZARD

c. 1900

Bronze

5¾ x 9⅞ x 6⅛ in. (14.6 x 25.1 x 15.6 cm)

Collection of the Newark Museum,

gift of Mrs. J. G. Phelps Stokes, 1977

Plate 42

Solon Hannibal Borglum was one of the American sculptors who adopted Auguste Rodin's aesthetic, using it in bronzes of the American West.

Raised on a Nebraska ranch, Borglum turned to art with the encouragement of his older brother, Gutzon. He studied at the Cincinnati Art Academy (1895–97), and there Louis T. Rebisso (1837–99) recognized his talents as a sculptor and offered Borglum the use of his studio. A scholarship enabled him to travel to Paris, where he stayed for five years, working in the life class of Denys Puech (1854–1918) at the Académie Julian and receiving criticism from the famous French *animalier* Emmanuel Frémiet (1824–1901) and the American Augustus Saint-Gaudens. His sculptures of wild horses were accepted for the Paris salons (1898 and 1899). As a teenager Borglum had demonstrated a fascination with cowboys and horses, and despite his foreign education, it was life on the western plains that furnished subject matter for his sculpture throughout his career.

So that the sculptor could become familiar with Indian customs and attire, he and Emma Vignal, his bride, spent their honeymoon (1899) at Crow Creek, South Dakota, where the Sioux had been permitted to gather for tribal celebrations. The experience altered his opinion of the Native American, and as a result his approach to western subjects changed from the exuberant anecdotal tales of cowboy life to a more introspective look at the American Indian. Borglum had been spellbound by Rodin's monument to Balzac upon seeing the plaster at the salon of the Société Nationale des Beaux-Arts (1898). The impressionist surface treatment of Rodin's sculpture as well as the French modernist's use of humanistic themes served as an inspiration for Borglum. In his small-scale bronzes of a solitary Indian and his horse, Borglum conveyed the silent battle of the Native American with the hardships of nature and the settlers. When he won medals for these works at the Paris Exposition Universelle (1900), Borglum became known to the French as "the sculptor of the prairie."

Borglum and his family settled in New York City (1902), and the following year Keppel Gallery showed his small western bronzes. He received a commission for outdoor sculpture for the Louisiana Purchase Exposition, and the four monumental groups symbolic of westward expansion that he created marked a watershed in his career. Borglum continued to win commissions for monumental sculpture; his themes were well suited to equestrian statuary. His success in this field often brought him into competition with his brother.

Borglum's accomplishments enabled him to acquire a home and studio in rural Connecticut (1907), and his presence near Silvermine encouraged the development of an artists' colony there. Following World War I Borglum turned increasingly to teaching. He was involved in the innovative school that was established for soldiers in the suburbs of Paris immediately after the war, and upon his return home he established the School of American Sculpture (1919) in New York. Borglum had long been concerned with the teaching of art, and in 1923 his manual, *Sound Construction*, was published.

Sources

Borglum, Solon, papers, manuscript division, Library of Congress, Washington, D.C.

Borglum family papers, AAA and collection of George Borglum, Royal Oak, Michigan.

Armstrong, Selene Ayer. "Solon Borglum, Sculptor of American Life." *Craftsman* 12 (July 1907): 382–89.

Caffin, Charles. "Solon Borglum." In *American Masters of Sculpture*, pp. 149–62. New York: Doubleday, 1903.

Davies, A. Mervyn. *Solon Borglum: "A Man Who Stands Alone."* Chester, Conn.: Pequot, 1974.

The Solon H. Borglum Collection of Sculpture. New Britain, Conn.: New Britain Museum of American Art, 1974.

Beniamino Bufano

Born c. 1898 San Fele, Italy
Died 1970 San Francisco, California

CHINESE MAN AND WOMAN
1921
Glazed stoneware
31½ x 12½ x 7½ in. (80 x 31.8 x 19.1 cm)
The Metropolitan Museum of Art,
gift of George Blumenthal, 1924
Plate 145

San Francisco's best-known sculptor, Beniamino Bufano achieved national recognition early in life for his hauntingly beautiful ceramic figures. His experiments with glazes contributed substantially to the use of color in sculpture.

Bufano immigrated from Italy to New York City with his family in 1901 or 1902. He was awarded a scholarship to the Art Students League (1913), where he studied with Herbert Adams (1858–1945) and James Earl Fraser (1876–1953) for two years. As Paul Manship's assistant, Bufano was sent to San Francisco to execute the architectural figures that Manship had designed for the Panama-Pacific International Exposition. He won a national competition (1915), funded by Gertrude Whitney, on the theme of the immigrant in America. Afterward he decided to settle on the West Coast.

In San Francisco Bufano was soon attracted to the Asian community and eventually to its art. In 1918 he traveled to China, Japan, Korea, Thailand, and India. For about two years he studied Chinese ceramics, working at the famed pottery centers of Shiwan, near Canton, and Jingdezhen, south of Shanghai.

Returning to San Francisco, Bufano applied what he had learned about Chinese glazing techniques to ceramic figurative sculpture of local Chinese people and commissioned portraits. He experimented extensively with glazes, achieving a varied and brilliant palette, although most of his stoneware figures were colored a yellowish green approximating aged bronze, derivative of the colors of Tang figures. Bufano received critical acclaim with his first solo shows (1925), at the City of Paris art gallery, San Francisco, and Arden Gallery, New York. A year earlier the Metropolitan Museum of Art had purchased *Chinese Man and Woman*, thereby becoming the first institution to acquire his work.

After visiting Paris for an exhibition of his art (1926), Bufano started experimenting with new materials and conceiving figures on a monumental scale. One of the first American sculptors to utilize stainless steel and cast stone, he incorporated the metal and red granite into his best-known statue, the monumental Sun Yat-sen in St. Mary's Square, San Francisco, created under the WPA. In addition he created smaller animal and human figures, brightly colored and cast in stone. His art of the 1930s was characterized by stylized, geometric forms and polished surfaces. It was probably after World War II that Bufano began incorporating mosaics into his sculpture as he turned to religious imagery. St. Francis, the hand of peace, and the concept of a harmony among races dominated his late work.

His difficult personality brought Bufano into constant conflict with peers, patrons, and institutions. He taught at the California School of Fine Arts (1922–23), where Sargent Johnson was his student, but left because of a disagreement over art theory. He also taught briefly in the 1940s at the California College of Arts and Crafts in Oakland. His proposals to erect large sculptures with religious subjects throughout the region usually were fraught with controversy.

Sources

Bufano, Beniamino, interview with Mary McChesney, 1964, OHC.

Ackerman, Phyllis. "The East Meets the West." *International Studio* 80 (February 1925): 375–79.

Falk, Randolph. *Bufano*. Millbrae: Celestial Arts, 1975.

Miller, Henry, and Roger Fry. *Bufano*. Milan, 1956.

Wilkening, H., and Sonia Brown. *Bufano: An Intimate Biography*. Berkeley: Howell-North, 1972.

Alexander Calder

Born 1898 Philadelphia, Pennsylvania
Died 1976 New York City

HEAD OF CARL ZIGROSSER
c. 1928
Wire
20 x 10 x 12 in. (50.8 x 25.4 x 30.5 cm)
Philadelphia Museum of Art, purchased,
Lola Downin Peck Fund from the
Carl and Laura Zigrosser Collection
Shown in Los Angeles only
Plate 10

TWO ACROBATS
1928
Brass wire on wood base
37¹¹⁄₁₆ x 27 x 6⅛ in. (95.7 x 68.6 x 15.6 cm)
Honolulu Academy of Arts, gift of Mrs.
Theodore A. Cooke, Mrs. Philip E. Spalding,
and Mrs. Walter F. Dillingham, 1937
Plate 100

ACROBAT AND TRAPEZE
c. 1929
(trapeze is a reconstruction)
Steel wire and cloth
Acrobat: 6 x 4¾ x ¾ in.
(15.2 x 12.1 x 1.90 cm)
Trapeze: 21¾ x 13½ x 9 in.
(55.3 x 34.3 x 22.9 cm)
University Art Museum, University of
California, Berkeley, gift of Margaret
Calder Hayes, class of 1917
Shown in Los Angeles and Montgomery only
Plate 14

Known primarily for his abstract mobiles and large, brightly colored public sculptures, internationally acclaimed Alexander ("Sandy") Calder began his career creating innovative figural sculptures of wire.

Calder was a third-generation sculptor: his grandfather, Alexander Milne Calder (1846–1923), and father, Alexander Stirling Calder, were known for their public monuments. Although Calder was graduated (1919) from Stevens Institute of Technology, Hoboken, with a bachelor's degree in mechanical engineering, he soon became dissatisfied with the

profession. He enrolled in painting and drawing classes at the Art Students League, studying with John Sloan (1923–26). As a magazine and newspaper illustrator Calder spent two weeks on assignment sketching performers with the Ringling Brothers, Barnum and Bailey Circus (1925). That year he made his first wire sculpture, a rooster sundial. The following year his first illustrated book, *Animal Sketching*, was published.

Calder went to Paris to study at the Académie de la Grande Chaumière (1926), but his real education took place in the international avant-garde art circles of Paris. Inspired by their spirit of inventiveness, Calder made small-scale circus performers and animals out of wire, wood, and bits of cloth, so many that they constituted an entire circus. Beginning in the winter of 1927, he presented performances of this circus, accompanied by music. He soon began creating larger, full-length figures and portrait heads, the latter usually of close friends and celebrities: Josephine Baker and Marcel Duchamp, for example. For these he rejected the traditional media to create sculpture based on negative space. Consequently, the wire figures appear to be three-dimensional line drawings. Challenging conventional assumptions, they display an uncanny sense of balance, design, and proportion—elements that would characterize his later abstractions.

Inspired by the art of his friends Fernand Léger, Jean Arp (1887–1966), and Piet Mondrian (1872–1944), Calder abandoned representation (1930). Utilizing most of the same materials as before, he constructed sculpture that consisted entirely of abstract (wire) lines and geometric and amorphous shapes (of metal, wood, and later glass and found objects). Soon he strove to incorporate motion into the pieces, first by attaching motors to move parts of these constructions and eventually by allowing the wind to activate them. His mobiles (a term coined

by Léger) were either attached to bases or suspended from ceilings. He continued to elaborate on the number of parts, shapes, and colors of the individual cutouts, but by 1939 Calder had established the basic concepts of the mobiles and stabiles. Thereafter he became increasingly interested in transferring his sculptures to the large scale of public art.

Calder was honored by more than seventy solo exhibitions during his lifetime. His first museum retrospective was at the Museum of Modern Art in New York City (1943).

Sources

Calder, Alexander, papers, AAA.

Calder, Alexander. *Calder: An Autobiography with Pictures.* New York: Pantheon, 1966.

Marshall, Richard. *Alexander Calder: Sculpture of the Nineteen Thirties.* Exh. cat. New York: Whitney Museum of American Art, 1987.

Marter, Joan. *Alexander Calder.* Cambridge and New York: Cambridge University Press, 1991.

Sweeney, James. *Alexander Calder.* Exh. cat. New York: Museum of Modern Art, 1943.

Allan Clark

Born 1896 Missoula, Montana
Died 1950 near Delta, California

THE KING'S TEMPTRESS
c. 1926–27
Polychromed mahogany
20½ x 13½ x 7¼ in. (52.1 x 34.3 x 18.4 cm)
Russell P. Jaiser
Plate 148

Allan Clark was one of the foremost proponents of the exotic figure and one of the most daring masters of polychromy in American sculpture during the 1920s and 1930s.

Clark was raised in Washington state. He obtained a traditional academic training at the School of the Art Institute of Chicago with Albin Polasek, a fellow of the American Academy in Rome, and later studied with Robert Aitken most likely at the Art Students League (1920–21). By 1917 he was working independently, and in 1918 he was honored with his first solo exhibition, at the Los Angeles Museum of History, Science and Art. During the years following World War I Clark received commissions for garden statuary and a project to decorate the library of the University of Washington in Seattle with eighteen life-size figures. He also supported himself teaching at the Beaux-Arts Institute of Design. In his early figures he revealed a strong interest in dance, creating several figures of Ruth St. Denis, one of his first patrons, and a nascent fascination for the exotic.

Clark's early residence in the Pacific Northwest may have stimulated his interest in Far Eastern art. The sculptor traveled to Asia in 1924 to immerse himself in the art and techniques of Far Eastern cultures. He spent three years abroad, visiting Japan, China, India, Java, and other areas of Southeast Asia. In Japan he learned techniques of woodcarving and polychromy, and in Korea he studied Buddhist art. Desiring to study the cave chapels of Dunhuang (Tung Huang) and Wanfoxia, he joined the second Fogg Museum expedition in China

(1925), serving unofficially as its artist. Sculptures inspired by his Asian experiences were exhibited at the new Fogg Art Museum (1927), making Clark the first living artist to have a solo exhibition there. In this and a showing later that year at Wildenstein Galleries in New York City, Clark presented exotic heads and figures in bronze and wood to critical acclaim. He had made studies of Ichikawa Danjūrō X, the greatest actor in Japan, during live performances. His style was considered exotic, but very modern. He coifed and garbed his dancers and gods in traditional attire, emphasizing their exoticism through polychromy, gold, and lacquer, often using nonrealistic hues not customarily seen in Western sculpture. His Eastern dancers were the exotic cousins of Paul Manship's figures, for both artists elegantly stylized their figures by emphasizing line, silhouette, design, and rhythm.

In 1929 Clark moved to New Mexico, where he gained prominence in art circles, which numbered few sculptors. Transferring his interest in the exotic to the Southwest, he began sculpting images of Native Americans. Clark conceived these images as monumental and emphasized their form and solidity rather than outline, working primarily in wood and stone, often with gilding. He carved more heads than full figures and in them demonstrated a declining interest in surface detail. He included sculptures of Native Americans frequently in solo exhibitions (Wildenstein, 1930; Dalzell Hatfield, Los Angeles, 1931; Arden, 1934). Comprehensive exhibitions, including recent portraits, took place at the Art Gallery of the Museum of New Mexico (Santa Fe, 1940) and the Museum of Fine Arts (Houston, 1946).

Sources

Clark, Allan, file, Museum of Fine Arts, Museum of New Mexico, Santa Fe; and papers, Grand Central Art Galleries, New York City.

"Allan Clark's Small Bronzes." *Metal Arts* 1 (November 1928): 37–38.

Christensen, Erwin O. "An Exhibition of Sculpture by Allan Clark at the Fogg Museum, Harvard University." *Art and Archaeology* 24 (December 1927): 228–33.

Steele, John. "The Decorative Sculpture of Allan Clark." *International Studio* 89 (February 1928): 61–64.

Henry Clews

Born 1876 New York City
Died 1937 Lausanne, Switzerland

UNTITLED (PARTIAL FACE)
1911
Bronze
12½ x 7 x 8½ in. (31.8 x 17.8 x 21.6 cm)
Collection of Mr. and Mrs. Lawrence Goichman
Plate 45

Henry Clews, Jr., first developed his powerful modeling and penetrating insight of human character under the influence of Auguste Rodin but then transformed his figurative sculpture into a vehicle for a bizarre vision of humanity.

Clews was born into a wealthy and distinguished New York City family; his grandfather and great-uncle, James and Ralph Clews, had been well-known potters in Staffordshire. After graduation from Amherst College (1898), Clews embarked on a career as an artist, working as both a painter and sculptor. For about a decade until 1914 he divided his time among New York, Paris, and Newport. Without formal training, he initially became a society portraitist. His early paintings, with their dark palette and elegant air, were influenced by James Whistler; these Whistlerian canvases were praised by critics when exhibited at Gimpel and Wildenstein in New York (1910). Thereafter his palette became lighter and more impressionistic.

By 1907 or '08 Clews had begun to sculpt. In France he was a friend of Auguste Rodin, who encouraged his sketchy surfaces, incomplete forms, and desire to capture character and focus on types, such as an absinthe drinker. In 1909 Clews first showed his small, imaginative marble and bronze heads in New York. The artist also modeled realistic portrait busts, but so keen an observer of human nature was he that eventually Clews created caricatures to attack the materialism and pretensions of the rich. These were featured

Robert Cronbach

Born 1908 St. Louis, Missouri

in a solo exhibition of his paintings and sculptures that Gimpel and Wildenstein organized in 1913. While critics admired his technical skill, the mordant satire displeased them.

Clews settled permanently in France (1914), and five years later purchased a chateau at La Napoule, near Cannes. The restoration of the Romanesque structure involved recreating its extensive stone and wood carvings and decorations and occupied him for years. Clews spent the next two decades filling the columns, lintels, and panels with imaginative creatures not unlike the gargoyles of medieval cathedrals. He also completed a series of garden statues that were more conventional, but still grotesquely underscored the darker side of human nature. When the chateau was completed (1933), he returned to portrait sculpture. After the artist's death his widow established a foundation at the chateau to foster cultural relations between the United States and France.

Sources

Clews, Henry, papers, AAA.

Exhibition of Sculpture by Henry Clews, Jr. Exh. cat. New York: Metropolitan Museum of Art, 1939.

"Gods, Ogs, Wogs: Castle of Weird Images Becomes a Museum." *Life,* 15 October 1951, 119–24.

Proske, Beatrice Gilman. *Henry Clews, Jr., Sculptor.* Brookgreen, S.C.: Brookgreen Gardens, 1953.

Van Dusen III, Lewis H. "Henry Clews, Jr.: The Life and Works of the Sculptor." Senior thesis, Princeton University, 1962.

EXPLOITATION
1935
Cast stone
14¾ x 18 x 12 in. (37.5 x 45.7 x 30.5 cm)
Berman-Daferner Gallery, New York City
Plate 110

Robert Cronbach's political activism determined the spirit of his pre-World War II figurative sculpture.

The son of a prosperous businessman, Cronbach studied sculpture for a year at the St. Louis School of Fine Arts with Victor Holm and then moved to Philadelphia (1927) to continue his training with Charles Grafly and Albert Laessle (1877–1954) at the Pennsylvania Academy of the Fine Arts. Cresson scholarships enabled him to spend summers traveling in Europe (1929, 1930). Cronbach served as Paul Manship's assistant in his Paris and New York City studios (1930–31) and then returned to St. Louis, where he worked as an architectural sculptor.

At the height of the Great Depression Cronbach returned to New York and immediately became active in politically concerned artists' organizations. He was a member of the John Reed Club, American Artists' Congress, Artists' Union (serving on its executive committee), and United American Sculptors. He believed that government should support art, and accordingly he embraced the federal art projects enthusiastically. Cronbach participated in the WPA/FAP (1936–39) and won a commission from the Treasury Section (1940) for two heroic bronze figures to decorate the Social Security Building in Washington, D.C. His most significant FAP work was the concrete wall relief decorations for the Willert Park Housing Project in Buffalo, which he worked on jointly with Harold Ambellan (b. 1912).

Cronbach's techniques were essentially traditional: basically a modeler, he also carved, usually in plaster, and used cast stone. His modernity lay in his themes: Cronbach focused on the life of the working class. Since his art concerned city life, he often presented figures in conjunction with urban architectural forms, such as a girder from an elevated railway. Although he believed in the importance of ready comprehensibility in art, in his noncommissioned work Cronbach often distorted parts of the human body to suggest the stresses and demands of social and political conditions. Around 1938 he modeled a series of caricatures of such prominent personalities as William Hearst and Franklin Roosevelt; photographs of the figures were used as cover illustrations for *The New Masses.* Occasionally Cronbach's commentary was harsher, and he did create a trenchant condemnation of racism in *Exploitation.*

Cronbach actively participated in exhibitions of the Sculptors Guild, and Hudson D. Walker gave him his first solo exhibition (1940) in New York. That year his floating aluminum and plaster sculptures decorating the restaurant Cafe Society became the "talk of the town." After the war Cronbach abandoned the figure for many years.

Sources

Cronbach, Robert, papers, AAA.

Cronbach, Robert, interview with Ilene Susan Fort, 18 and 23 October 1989.

Cronbach, Robert. "The New Deal Sculpture Projects." In *The New Deal Art Projects: An Anthology of Memoirs,* ed. Francis V. O'Connor, pp. 133–52. Washington, D.C.: Smithsonian Institution Press, 1972.

Lane, James W. "Cronbach's Literal and Fantastic Sculpture," *Art News* 38 (20 January 1940): 11–12.

McCausland, Elizabeth. "Exhibitions in New York: Robert Cronbach." *Parnassus* 12 (January 1940): 25–26.

Jo Davidson

Born 1883 New York City
Died 1952 Tours, France

MALE TORSO
c. 1910
Bronze and stone
22 x 10 x 12 in. (55.9 x 25.4 x 30.5 cm)
Estate of Jo Davidson, courtesy,
Conner-Rosenkranz, New York City
Plate 43

Although the most famous portrait sculptor in the United States, Joseph ("Jo") Davidson also used the figure for purely emotive purposes.

Davidson attended drawing classes at the Educational Alliance in New York City, studied at the Art Students League (1901–5), and may have continued his studies at Yale University Art School. By 1903 he was employed in New York as a studio assistant to sculptor Hermon A. MacNeil (1866–1947). In 1905 Davidson completed his first commissioned sculpture and the following year exhibited publicly for the first time, at the National Academy of Design. In 1907 he moved to Paris. Although he briefly attended the École des Beaux-Arts and studied with Jean-Antoine Injalbert (1845–1933), Davidson soon rejected academic training. First a stipend from the Hallgarten Scholarship Fund, then beginning in 1909 the patronage of Gertrude Whitney, who eventually became his close friend, enabled him to work independently. He became a member of the circle of progressive Americans, frequented the salon of Gertrude Stein, and helped organize the New Society of American Artists in Paris. Davidson also fell under the spell of Auguste Rodin at this time. He began modeling idealized figures and figure fragments that concentrated on the nude, a subject he would never abandon completely. Many of these were figures depicted in action, physically straining. Like Rodin, Davidson conceived the figure as a conveyer of mood, writing in 1910, "Plastic art is a form of expression by which emotions can be made visible." Davidson returned to New York (1910), and after his first solo exhibition at the New York Cooperative Society, his work began attracting considerable attention. Before his participation in the Armory Show he exhibited widely and was accorded several more solo displays in New York and Chicago galleries. During World War I he turned his attention from nudes and imaginative themes to portraiture and subjects closer to reality. Consequently, his work became increasingly objective, as he depicted his subjects as specific people rather than as generic types or figures symbolizing specific emotions.

Davidson modeled a series of bronze busts of military and civic leaders (1918), creating what he called a "plastic history." Thereafter he modeled several series of prominent political leaders and other heroes of the twentieth century: in 1924 the heads of Soviet leaders, in 1938 the leaders of the Spanish Loyalists, in 1941 the leaders of the Pan-American Union, and at the end of his life, Israeli statesmen. Davidson also sculpted important American and English literary figures, many as a project for Doubleday, Doran and Company. By World War II Davidson had become the best-known portrait sculptor in the world.

Sources

Davidson, Jo, papers, manuscript division, Library of Congress, Washington, D.C.

Davidson, Jo. *Between Sittings: An Informal Autobiography of Jo Davidson.* New York: Dial, 1951.

Griffin, Henry F. G. "Jo Davidson, Sculptor." *World's Work* 22 (August 1911): 14746–55.

"Jo Davidson, an American Pupil of Rodin: An American Creator of the 'New Statuary.'" *Current Literature* 52 (January 1912): 99–101.

Wyer, Raymond. "A New Message in Sculpture: The Art of Jo Davidson." *Fine Arts Journal* 26 (April 1912): 262–70.

Emma Lu Davis

Born 1905 Indianapolis, Indiana
Died 1988 San Diego, California

CHINESE RED ARMY SOLDIER
1936
Polychromed walnut
16½ x 8 x 9¾ in. (41.9 x 20.3 x 24.8 cm)
The Museum of Modern Art,
Abby Aldrich Rockefeller Fund, 1942
Plate 147

The figurative sculptures Emma Lu Davis created during the 1930s exemplified her fascination with the lifestyles and naive art of different folk cultures.

After graduation from Vassar College (1927), Davis studied for three years at the Pennsylvania Academy of the Fine Arts with Charles Grafly and Albert Laessle. Thereafter her career as an artist was somewhat unorthodox. At the invitation of Buckminster Fuller (1895–1983), she went to work at his Dymaxion factory (1933) in Bridgeport, Connecticut. In this innovative design environment and under the influence of Fuller's colleague, engineer Starling Burgess, she made her first experiments with abstract sculpture. This association taught her the principles of good workmanship and knowledge of materials. Around this time Davis also began creating simplified and painted, carved wood and terra-cotta animals that suggest affinities with early American toys.

Davis had a large income that made her independent of exhibition and commercial demands. When she desired to learn how socialism affected artistic production, she traveled throughout the Soviet Union and China (1935–37). In Russia she met and married Robert MacGregor, an American teacher, and with him continued her exploration. While in China, she carved several wood heads of Chinese soldiers in a manner similar to her earlier animals. The Beijing Institute of Fine Arts honored her with her first solo exhibition (1937); upon her return to the United States several months later the Boyer Galleries in

José de Creeft

Born 1884 Guadalajara, Spain
Died 1982 New York City

New York City held her first American solo show. While she was away, the Whitney Museum of American Art had purchased two of her sculptures.

Davis's belief that art should be accessible to and enjoyed by all people corresponded with the philosophy of the federal art projects. Commissioned by the Public Works of Art Project, she did book illustrations for the Museum of Natural History in New York (1933–34) and received further commissions from the Treasury Section for architectural reliefs (1939, 1941).

Davis served as artist-in-residence at Reed College (1938–41). During her tenure there the Ceramic Studio in Portland held an exhibition of her sculptures and paintings (1940). Two years later she was one of the few sculptors selected for the Museum of Modern Art's important exhibition *Americans 1942: 18 Artists from 9 States*. In the years following her foreign travel Davis continued to depict animals in wood and terra-cotta (work in the latter medium made in response to her experience of Chinese art). Around 1940 she invented "handies," small, amorphous, carved wood sculptures that, like fetish figures of other cultures, could be examined by touch as well as by sight.

After leaving Portland, Davis studied lithography and engraving at Taller de Gráfica in Mexico City. Fascinated by Mesoamerican culture, she eventually abandoned art for anthropology. Much of Davis's sculpture was destroyed in a fire in the early 1960s.

Sources

Davis, Emma Lu, files, Pennsylvania Academy of the Fine Arts; Reed College.

Davis, Emma Lu. Artist's statement. In *Americans 1942: 18 Artists from 9 States*, ed. Dorothy C. Miller, pp. 43–50. Exh. cat. New York: Museum of Modern Art, 1942.

Davis, Emma Lu. "People Make Art." *Arts and Architecture* 62 (January 1945): 47–50.

HEAD OF GERTRUDE LAWRENCE
1931
Ceramic and shell
5½ x 3½ x 2⅝ in. (14.0 x 8.9 x 6.7 cm)
National Museum of American Art, Smithsonian Institution, museum purchase
Plate 1

ESCLAVE
1936
Beaten lead, wood, rope, and metal chains
42 x 12 x 12 in. (106.7 x 30.5 x 30.5 cm)
Childs Gallery, Ltd., Boston
Plate 113

THE CLOUD
1939
Greenstone
16¾ x 12⅜ x 10 in. (42.6 x 31.4 x 25.4 cm)
Whitney Museum of American Art, purchase
Plate 141

After having enjoyed a successful career as an innovator in Europe, José de Creeft assisted in promoting the direct-carving technique as the progressive mode of the period in the United States.

Moving from Barcelona to Madrid in 1900, de Creeft enrolled in the workshop of the academic sculptor Augustin Querol (1863–1909). He showed portraits of children in his first one-man exhibition (1903) at El Círculo de Bellas Artes. He settled in Paris (1905) and at Auguste Rodin's suggestion entered the Académie Julian. At Maison Gréber, a commercial firm that reproduced sculptors' models in stone, he learned the intricacies of stonecutting using pointing machines (1911–14). Despite his academic training de Creeft had become associated with Georges Braque (1882–1963), Pablo Picasso, and other modernists, and the year following his departure from Gréber, he began working independently, rejecting traditional techniques for the more personal direct-carving method. Although a commission he received in 1918 was for a traditional monument, in other works he explored primitivist approaches and themes, used cubist and expressive styles, experimented with a variety of materials, including beaten lead, and incorporated found objects in a Dadaist manner.

Marriage to an American brought him to the United States (1929). Because he already had a significant European reputation, de Creeft was immediately given solo exhibitions at the Art Institute of Seattle and the Ferargil Gallery in New York City. His robust figures, often with Eastern physiognomies, were carved in a variety of woods and stones; these were well received and helped contribute to the popularization of direct carving, a technique that John Flannagan and Robert Laurent had earlier introduced to the American art scene.

During his first decade in New York de Creeft quickly assumed a place among progressive artists. While he had exhibited in various European salons nearly every year from 1909 to 1930, after his move to the United States he showed primarily in his adopted country. De Creeft was also involved in American artists' organizations, both the Society of Independent Artists and the American Artists' Congress, the latter an antifascist group with views congenial to his own. He spread his influence further by teaching at the New School for Social Research (1932–48, 1957–60), Black Mountain College (summer 1944), and the Art Students League (1944–48).

Gleb Derujinsky

Born 1888 Smolensk, Russia
Died 1975 New York City

Sources

De Creeft, José, papers, AAA.

Breeskin, Adelyn D., and Virginia Mecklenburg. *José de Creeft*. Exh. cat. Washington, D.C.: National Museum of American Art, Smithsonian Institution, 1983.

Campos, Jules. *José de Creeft*. New York: Herrmann, 1945.

Davidson, Martha. "Recent Works by a Notable Sculptor: José de Creeft." *Art News* 37 (19 November 1938): 15.

Welty, Eudora. "José de Creeft." *Magazine of Art* 37 (February 1944): 42–47.

RAPE OF EUROPA
c. 1932
Marble with silver
15¹/₂ x 21¹/₂ x 8¹/₂ in. (39.4 x 54.6 x 21.6 cm)
*Collection of Robert Pincus-Witten and
Leon Hecht, New York City*
Shown in Los Angeles and New York City only
Plate 5

Gleb Derujinsky went beyond the boundaries of the academic figurative tradition, often infusing his sculpture with a spirituality and abstract sense of rhythmic, linear design.

A Russian aristocrat, Derujinsky had the means to study in Paris (1911) at the Académie Colarossi with Jean-Antoine Injalbert and also with Charles Raoul Verlet. He also received criticism from Auguste Rodin, returning to Russia (1913) to train at the Royal St. Petersburg Academy of Fine Arts for four years. The Russian revolution prohibited his accepting a Prix de Rome, and eventually he fled his native country, arriving in New York City in 1919.

Derujinsky found almost immediate success, receiving his first solo exhibition at the Milch Galleries (1921). Throughout the 1920s and early 1930s his frequent solo exhibitions at the Macbeth, Wildenstein, and other commercial galleries met with critical approval. Derujinsky created a significant number of sculptures of dancers, demonstrating his love of movement and fascination with modern dance, an interest he shared with other modernist sculptors of the period. However, the artist became best known and appreciated for his classical and religious figures.

Derujinsky worked in a variety of materials as both a modeler and carver, but it was his wood carvings that were considered the most progressive. Most direct carvers of the period demonstrated their modernity by rejecting tradition and looking toward non-Western art for inspiration. Derujinsky was no different, locating his sources within his own Eastern European and Russian heritage. By presenting his figures as thin forms, constantly in flux and similar to medieval wood carvings and Byzantine paintings, Derujinsky infused sculpture with a vitality that had been lost to the academic figurative tradition. His stylization also paralleled the angularity and elongation of art deco, then popular in the decorative arts. When he did depart from this medievalism, sometimes in his classical figures, Derujinsky always retained a sense of elegance and emphasis on the abstract nature of line, as in *Rape of Europa*, which was enlarged for an outdoor fountain at the New York World's Fair.

During the 1920s and 1930s Derujinsky supported himself largely through portrait commissions and teaching. Many of his friends were musicians, and his commissioned busts included Sergei Prokofiev and Sergei Rachmaninoff. He taught for years at the Beaux-Arts Institute of Design, beginning in 1926, and was an instructor at Sarah Lawrence College; along with Simka Simkhovitch he opened a school in New York to teach modern methods (1938). Derujinsky received two commissions from the federal art projects (1937, 1940) and made brief visits to California (c. 1937, 1941) in search of additional work on the federal projects. Thereafter he was primarily occupied with ecclesiastical commissions. His religious sculptures were the subject of a solo exhibition at St. Paul's Guild Gallery (1942) in New York.

Sources

Derujinsky, Gleb, papers, AAA and GAR.

Breese, Jessie Martin. "Some New Sculpture for Adorning the Country House." *Country Life* 41 (December 1921): 70–71.

Comstock, Helen. "Sculptures of Derujinsky." *International Studio* 81 (September 1925): 453–56.

Derujinsky, Glebe [sic]. "A Few Words about Woodcarving." *Architect* 14 (August 1930): 458–59.

Proske, Beatrice Gilman. "Gleb W. Derujinsky." In *Brookgreen Gardens Sculpture*, pp. 317–20. Rev. ed. Brookgreen, S.C.: Brookgreen Gardens, 1968.

Hunt Diederich

Born 1884 Szent-Grot, Austria-Hungary
Died 1953 Tappan, New York

Hunt Diederich, THE JOCKEY

THE JOCKEY
1924
Bronze
23 1/2 x 24 1/2 x 9 3/4 in. (59.7 x 62.2 x 24.8 cm)
Collection of the Newark Museum,
gift of Mr. and Mrs. Felix Fuld, 1927

In the late 1910s and 1920s William Hunt Diederich liberated figurative sculpture from academic tradition by using wrought iron to convey a modernist ornamental style inspired by folk art.

The son of a Prussian calvary officer and an American woman, Diederich was sent around 1900 to live in the house of his maternal grandfather, the noted Boston painter William Morris Hunt (1824–79). His training began at the School of the Museum of Fine Arts (1902) but was interrupted when he went to work as a cowboy in the Southwest and Wyoming. He continued his studies in 1906, spending two years at the Pennsylvania Academy of the Fine Arts, where he met Paul Manship. Together the two traveled to Spain. After extensive wandering in Europe and North Africa Diederich established a studio in Paris, where he continued his training with the animalier Emmanuel Frémiet. While there he became friends with Alexander Archipenko and Elie Nadelman, close associations that continued later in New York City. Diederich exhibited at the Paris salons (1910–11, 1913). He returned to the United States shortly after the commencement of the war.

During his first years in New York Diederich modeled lively bronze sculptures of dogs and horses as well as genre scenes in which he began to depart from academicism through the use of a sinuous, attenuated line. In 1917 he displayed at a Manhattan decorator's studio such utilitarian objects as andirons, fire screens, and weather vanes, all fashioned of wrought iron and designed with deer, hounds, and other animals and figures of polo players; the animals and sportsmen were delineated in essentially two dimensions with their silhouettes emphasized. Stylized elegance, spontaneity, and even humor came to characterize his brand of modernism. Folk art, a passion he shared with Nadelman, substantially determined his approach to the figure and design.

Diederich's first significant showing was held at the Kingore Galleries (1920). By the late 1920s his imaginative modernist interpretations were exhibited at the Whitney Studio Club. Although the artist enjoyed the comfortable life of a wealthy bon vivant, he exhibited seriously throughout the 1920s. An accident in 1928 severely diminished his productivity. While his later animal bronzes were often reinterpretations of earlier works, he continued to evince an elegance in his wrought-iron pieces. During the 1930s Diederich resided for extended periods in Germany, Spain, and Mexico. Returning to America (1941), he became more outspoken in his pro-German and anti-Semitic sentiments, and those views eventually destroyed his reputation.

Sources

Diederich, William Hunt, papers, AAA.

Armstrong, Richard. *Hunt Diederich.* Exh. cat. New York: Whitney Museum of American Art, 1991.

"William Hunt Diederich." In Conner and Rosenkranz, pp. 10–26.

Du Bois, Guy Pène. "Hunt Diederich: Decorator, Humorist, Stylist." *Arts and Decoration 7* (September 1917): 515–17.

Farmer, Lyn. "Interview: Diana Blake on William Hunt Diederich." *Journal of Decorative and Propaganda Arts 1875–1945* 9 (summer 1988): 108–21.

Abastenia St. Leger Eberle

Born 1878 Webster City, Iowa
Died 1942 New York City

GIRLS DANCING
1907
Bronze
11¼ x 7 x 7½ in. (28.6 x 17.8 x 19.1 cm)
In the collection of the Corcoran Gallery of Art,
Washington, D.C., bequest of the artist
Plate 70

WHITE SLAVE
1913
Bronze
19¾ x 17 x 10¼ in. (50.2 x 43.2 x 26 cm)
Gloria and Larry Silver
Plate 51

Mary Abastenia St. Leger Eberle was a pioneer artist of the Ashcan school, creating small bronzes of New York tenement life.

Eberle grew up in Canton, Ohio, and studied clay modeling there with Frank Vogan. In 1899 she moved to New York City, where she enrolled at the Art Students League, working with George Grey Barnard. After completing her schooling (1902), Eberle shared a studio with Anna Hyatt Huntington (1876–1973). The two collaborated until 1906 on animal and human figural groupings, receiving favorable notice. One such group earned a bronze medal at the Louisiana Purchase Exposition. Eberle began exhibiting regularly on her own (1906) at the National Academy of Design and the Pennsylvania Academy of the Fine Arts. That year she also became a member of the National Sculpture Society.

Eberle believed that an artist has a responsibility to show real life, and although she designed candle holders, tobacco jars, and other decorative household items to maintain a steady income, by 1907 it was her small figures of immigrant women and street urchins that consumed much of her time. Her work was the sculptural counterpart of the paintings of the Ashcan school, and like those painters she usually represented lower-class life in light-hearted terms, with few references to social problems. To ensure the authenticity of her depictions, she lived on the Lower East Side among her subjects, first at a settlement house. An ardent follower of Jane Addams, she considered her art a means to promote social reform. Eberle also promoted feminist causes, organizing an exhibition of women artists (1915) that raised money for the suffrage movement.

William Macbeth accorded Eberle her first solo exhibition (1907). The bronzes brought the sculptor almost immediate critical acceptance; in 1909 the Metropolitan Museum of Art purchased *Girl with Roller Skates* (1906), and the following year she was awarded the Barnett prize by the National Academy of Design for a similar subject. She exhibited two sculptures, including one of her rare critical pieces, *White Slave*, at the Armory Show. By World War I she had achieved national prominence; Macbeth honored her with another solo exhibition (1921), but already her output had diminished due to heart problems.

Sources

Eberle, Abastenia, papers, Kendall Young Library, Webster City, Iowa.

Macbeth Gallery papers, AAA.

Casteras, Susan P. "Abastenia St. Leger Eberle's White Slave," *Women's Art Journal* 7 (spring–summer 1986): 32–36.

"Abastenia St. Leger Eberle." In Conner and Rosenkranz, pp. 27–34.

Merriman, Christina. "New Bottles for New Wine: The Work of Abastenia St. Leger Eberle." *Survey* 30 (3 May 1913): 196–99.

Noun, Louise R. *Abastenia St. Leger Eberle, Sculptor (1878–1942)*. Exh. cat. Des Moines: Des Moines Art Center, 1980.

William Edmondson

Born 1882 Nashville, Tennessee
Died 1951 Nashville, Tennessee

PREACHER
c. 1931–40s
Limestone
17¼ x 10⅜ x 5 in. (43.8 x 26.4 x 12.7 cm)
Collection of the Newark Museum,
Edmund L. Fuller, Jr., bequest, 1985
Plate 97

The carvings of self-taught artist William Edmondson came to epitomize primitivism in the 1930s.

One of six children born to former slaves, Edmondson was employed at various jobs until 1907, when he was temporarily incapacitated in an accident. When he was able to work again a few months later, he found employment as a janitor and orderly at Woman's Hospital, Nashville. In 1932 the hospital was closed, and Edmondson found himself without a job. That year he experienced a religious vision urging him to carve tombstones and statues, and so at age fifty, with no formal training, he made his own tools and began to carve, using limestone from demolished buildings.

Edmondson's carvings were discovered by the Nashville Fugitives, a group of poets and writers who introduced him and his work to Louise Dahl-Wolfe, a New York City photographer and friend of Alfred Barr, director of the Museum of Modern Art. Barr and many of the trustees of the museum considered Edmondson's sculpture demonstrative of the modernist aesthetic of primitivism, which many trained direct carvers strove to achieve. As a result, MoMA organized a solo exhibition of Edmondson's work in 1937, the first time the museum showcased the work of an African American artist. He subsequently received two commissions from the WPA/FAP (1939–41). Unfortunately arthritis impeded his production thereafter.

Eugenia Everett

Born 1908 Loveland, Colorado

Edmondson's sculptures are stylistically similar to carvings by more sophisticated primitivist artists in that they tend to retain suggestions of the original shape of the stone block and to have only essential descriptive details indicated. Leaving the surfaces of his stone rough, Edmondson created blocky figures that have a genuine freshness and naivete. He differed, however, from trained artists somewhat in his choice of theme. His favorite subjects were human figures, often everyday types he knew (e.g., a preacher and a schoolteacher), angels, and animals. A deeply religious man, his Baptist faith was central to his art. He often depicted the Virgin Mary and Mary Magdalen as twins. He believed his birds were depictions of "God's creatures" and the embodiment of the angels who, he said, visited him regularly.

Sources

Edmondson, William, file, Tennessee State Museum, Nashville.

Fletcher, Georganne, ed. *William Edmondson: A Retrospective.* Exh. cat. Nashville: Tennessee State Museum, 1981.

Fuller, Edmund. *Visions in Stone: The Sculpture of William Edmondson.* Pittsburgh: University of Pittsburgh, 1973.

LeQuire, Louise. "Edmondson's Art Reflects His Faith, Strong and Pure." *Smithsonian,* May 1981, 51–55.

Will Edmondson's Mirkels. Exh. cat. Nashville: Tennessee Fine Arts Center at Cheekwood, 1964.

COOPERATION
c. 1933–34
Marble on mahogany base
19 x 33¾ x 10⅞ in. (48.3 x 85.7 x 27.6 cm)
Los Angeles Unified School District
Frontispiece

Eugenia Zink Everett was a Los Angeles direct carver who enjoyed regional recognition during the 1930s and early 1940s.

Raised in San Diego and Los Angeles, Everett attended Mount St. Mary's College and Otis Art Institute (1931–32), where she studied sculpture with Roger Nobel Burnham (1876–1962) and George Stanley (1903–77). She began participating in group exhibitions sponsored by local art organizations in 1931, immediately winning prizes. Considered one of the area's new talents, she was employed under the auspices of the federal projects, beginning with the earliest, the Public Works of Art Project (1933–34). While she created two statues specifically for Los Angeles public schools, usually she was allowed to work alone on her own ideas. In 1939 she participated in the Golden Gate International Exposition in San Francisco.

Everett focused on the human figure. She created both heads and full figures, interpreting the figure as a simplified, monumental form of a generalized character. Including few descriptive details, she only became specific with reference to physiognomy. Like so many American sculptors of the 1920s and 1930s, Everett often depicted exotic types, American Indians and Asians with broad faces and thick lips. She did not intend them to be particular individuals or even racial types but rather expressions of dignity, simplicity, and courage. While she occasionally modeled and cast, Everett preferred to carve directly in stone and wood. Typical of second-generation direct carvers was her tendency to polish her surfaces to a glossy finish, devoid of traces of the artistic process. She occasionally combined materials and at least once, under the influence of Beniamino Bufano's art, experimented with stainless steel and ebony.

In 1938 Everett moved north to Ojai, where she raised a family. Thereafter she sculpted and exhibited less frequently.

Sources

Everett, Eugenia, interview with Betty Hoag, 1964, OHC; papers, AAA; and scrapbook, collection of the artist, Sedona, Arizona.

Millier, Arthur. "Gifted Sculptress Prefers Life to Career." *Los Angeles Times,* 31 July 1938, sec. 3, 7.

John Flannagan

Born 1895 Fargo, North Dakota
Died 1942 New York City

ACROBATS
1926
Mahogany
19¾ x 3⅞ x 4 in. (50.2 x 9.8 x 10.2 cm)
Collection of Gertrude Weyhe Dennis
Plate 130

NEGRO BOY
(*also known as* FIGURE OF A CHILD)
1929
Sandstone
28 x 11½ x 10 in. (71.1 x 29.2 x 25.4 cm)
The Regis Collection, Minneapolis
Plate 120

THE NEW ONE
1935
Bluestone
6¼ x 11½ x 6¼ in. (15.9 x 29.2 x 15.9 cm)
*The Minneapolis Institute of Arts, the
Ethel Morrison Van Derlip Fund*
Plate 139

John Bernard Flannagan was one of America's
pioneering direct carvers, known principally
for his simple stone carvings.

Flannagan's success as an artist was
haunted by a childhood spent in poverty. He
was five when his father died and ten when his
mother placed him and two brothers in an
orphanage. The trauma of parental loss and
separation repeatedly influenced his art, and
he often turned to mother-and-child, birth,
and rebirth motifs, even cradling his animals
in womblike, ovoid shapes.

After briefly studying painting at the
Minneapolis School of Fine Arts and serving
in the U.S. merchant marines at the close of
World War I, Flannagan moved to New York
City. Arthur B. Davies gave the poor, young
artist refuge for a time at his upstate farm, and
it was Davies who encouraged Flannagan in
his creation of unusual wax paintings. He exhib-
ited with Davies and a group of more estab-
lished artists at the Montross Gallery (1923).

Flannagan turned to sculpture (c. 1924),
carving figures in wood, many of which
were religious in theme. Around the same
time, following several artists he first knew in
Minneapolis—among them Carl Walters—
he took up residence in the Maverick, the
most experimental of the artists' groups at
Woodstock. Attuned to the colony's philosophy
of a return to nature, Flannagan often worked
in Woodstock during the next twelve years.
His patron and lover, Florence Rollins, bought
land at New City on the Hudson (1925), and
this rural estate also offered Flannagan the
solace he needed. It was there that his fascina-
tion with stone began; by 1928 he was carving
almost exclusively in stone. Introduction to
Carl Zigrosser, director of Weyhe Gallery in
New York City, led to the first of many solo
exhibitions there (1927); an exclusive represen-
tation arrangement lasted almost a decade.
Weyhe financed Flannagan's first trip to
Ireland (1930), while a Guggenheim fellow-
ship underwrote a second residency (1932–33).

The Irish experience crystalized the
direction of Flannagan's mature stone sculp-
ture, although the effect of pre-Columbian
art is also apparent. In Ireland he was intrigued
by the fieldstone found in the countryside,
by the ever-present farm animals, and by what
he perceived to be the primitivism of Celtic
art and legend. In his figures of individual
humans and animals Flannagan conveyed
power through rough surfaces and the barest
of modeled form. In 1941 he wrote what would
become the credo of direct carvers, the essay
"The Image in the Rock," explaining that the
sculptor's creativity freed the images that exist
within the stone.

The early 1930s marked the high point
of Flannagan's career, while for him the end
of the decade was an emotional seesaw caused
by recurrent bouts with alcoholism. Shortly
after a solo exhibition at the Arts Club of
Chicago (1934), he suffered a nervous break-
down. While hospitalized, he experimented
with metal casting. He completed the
monument *The Gold Miner* (1938), commis-
sioned by the Fairmont Park Association in
Philadelphia, but the following year he
sustained head injuries in an automobile
accident. Despite four surgeries, he suffered
chronic head pain and was advised to give up
stone carving. He committed suicide in 1942.

Sources

Flannagan, Margherita, ed. *Letters of John B. Flannagan.*
New York: Valentin, 1942.

Forsyth, Robert Joseph. "John B. Flannagan: His Life and
Works." Ph.D. diss., University of Minnesota, 1965.

Gordon, Jennifer. "John Flannagan, a Maverick in Stone
and Wood." In *John Storrs & John Flannagan: Sculpture &
Works on Paper.* Exh. cat. Williamstown: Sterling and
Francine Clark Art Institute, Williams College, 1980.

Miller, Dorothy, and Carl Zigrosser. *The Sculpture of John B.
Flannagan.* Exh. cat. New York: Museum of Modern Art, 1942
(includes reprint of "The Image in the Rock").

Schack, William. "Four Vital Sculptors." *Parnassus* 9
(February 1937): 12–14, 40.

Harriet Frishmuth

Born 1880 Philadelphia, Pennsylvania
Died 1980 Southbury, Connecticut

A SLAVONIC DANCER
1921
Bronze
13¼ x 6¾ x 5 in. (32.4 x 17.2 x 12.7 cm)
Wadsworth Atheneum, Hartford, purchased through the gift of Henry and Walter Keney
Plate 26

Followings the teachings of Auguste Rodin, Harriet Whitney Frishmuth achieved wide fame for bronzes in which she interpreted the female body as a lyrical free spirit.

When she was very young, Frishmuth was taken by her mother to be raised in Europe. By chance in 1899 she met a Mrs. Hinton, possibly the American sculptor Clio Hinton Bracken (1870–1925), who encouraged her to begin modeling. She spent the next three years studying sculpture in Paris, at the Académie Rodin and also with Henri Desiré Gauquié (1858–1927) and Jean-Antoine Injalbert at the Académie Colarossi. She debuted publicly with a bust at the official Salon (1903). After two years in Berlin assisting Cuno von Uechtritz-Steinkirch (1856–1908) on monuments, she returned to the United States. Too shy to pursue a career independently, she enrolled at the Art Students League, studying with Hermon A. MacNeil and Gutzon Borglum until the latter encouraged her to go on her own (1908). For the next few years she made a modest living designing small, functional objects—bookends, ashtrays—issued in limited editions by Gorham Company.

It was in 1913 or 1914 that Frishmuth took a studio in Sniffen Court near that of Malvina Hoffman. There she lived more than twenty years, creating her most famous sculptures. Although she occasionally modeled portraits, she achieved popular acclaim with her female nudes, often of dancers. Remembering Rodin's encouragement to study the human body in motion, she became a master of depicting figures stretching, leaping, frolicking, and dancing with unbounded enthusiasm. A lyrical, fluid line dominates most of her mature sculpture, removing her nudes from the static poses of classicism. Dance was a frequent theme of many progressive artists, and Frishmuth became one of its foremost depicters, conveying the spirit of abandonment. She formed a close relationship with the dancer Desha Delteil, who eventually served as the model for her most important work.

During the 1920s Frishmuth was in demand as a designer of garden and fountain sculpture. *The Vine* (1921), so popular on a small scale, became even more successful when enlarged in 1923; this encouraged her to treat several other works conceived as small-scale bronzes similarly. Grand Central Art Galleries held her first solo exhibition (1928). She exhibited regularly and was a commercial success, even during the difficult years of the Depression, but by the 1930s Frishmuth was creating few new works. She moved to Philadelphia (1937) and devoted her remaining years to the promotion and sale of her work.

Sources

Frishmuth, Harriet, papers, GAR.

Aronson, Charles N. *Sculptured Hyacinths*. New York: Vantage Press, 1973.

"Harriet Whitney Frishmuth." In Conner and Rosenkranz, pp. 35–42.

"Rare Quality of Work of Modern Sculptress Ascribed to Her Love of Outdoor Life." *Waterbury American*, 6 October 1926, 16.

[Talcott, Ruth]. "Harriet Whitney Frishmuth, American Sculptor." *The Courier* (Syracuse University Library Associates) 9 (October 1971): 21–35.

Meta Warrick Fuller

Born 1877 Philadelphia, Pennsylvania
Died 1968 Framingham, Massachusetts

THE WRETCHED
c. 1901
Bronze
17 x 21 x 15 in. (43.2 x 53.3 x 38.1 cm)
Maryhill Museum of Art, Goldendale, Washington
Plate 34

Although her work is not well known today, Meta Vaux Warrick Fuller was one of the earliest significant African American sculptors and one of a select group of women to have studied with Auguste Rodin.

Born to prosperous parents in Philadelphia, Meta Warrick won a scholarship to attend the Pennsylvania Museum's School of Industrial Arts (1894), remaining there until she left for Paris (1899). She studied sculpture at the Académie Colarossi with Jean-Antoine Injalbert and also attracted the attention of Rodin, who invited her to his studio and encouraged her progress. Warrick at this time modeled macabre subject matter, not unlike some symbolist art of those years. The famous French dealer Samuel Bing gave her a showing (1902), and her work was selected for the Société Nationale des Beaux-Arts salon the following year.

Heartened by Rodin's praise and her Paris success, Warrick returned to Philadelphia a few months after her Paris solo exhibition but was disappointed by the lack of interest in her work. She studied modeling at the Pennsylvania Academy of the Fine Arts with Charles Grafly, however, and received some commissions. A fifteen-piece tableaux she completed for the Negro exhibit at the Jamestown tercentenary exposition (1907) won a gold medal and brought her national attention.

Karoly Fulop

Born 1893 Czabadka, Austria-Hungary
Died 1963 Los Angeles County, California

Warrick married the distinguished, Liberian-born physician Solomon C. Fuller, the first black psychiatrist in the United States (1909), and the couple moved to Framingham, Massachusetts. There she continued to produce sculpture. She abandoned her earlier motifs to symbolize the emergence of a new African American sensibility, anticipating by several years the ethnic pride that was the focus of the artists of the Harlem Renaissance. This theme persisted in her work throughout the 1920s and 1930s, and today her sculpture is recognized as among the earliest examples to reveal the social injustices of the times.

Starting in the late 1930s Fuller's work leaned toward religious preoccupations. She continued to receive commissions and awards and, never losing her social consciousness, at age eighty-seven opened a studio in south Boston to work with young students from the black community.

Sources

Dannett, Sylvia G. L. "Meta Vaux Warrick Fuller." In *Profiles of Negro Womanhood*, 2:30–46. Yonkers: Educational Heritage Press, 1966.

Driskell, David, et al. *Harlem Renaissance: Art of Black America.* Exh. cat. New York: Studio Museum in Harlem, 1987.

Kennedy, Harriet Forte. *An Independent Woman: The Life and Art of Meta Warrick Fuller (1877–1968).* Exh. cat. Framingham: Danforth Museum of Art, 1984.

Kerr, Judith Nina. "God-Given Work: The Life and Times of Sculptor Meta Vaux Warrick Fuller, 1877–1968." Ph.D. diss, University of Massachusetts, 1986.

O'Donnell, William F. "Meta Vaux Warrick, Sculptor of Horrors." *World Today* 13 (November 1907): 1139–45.

THIRST
c. 1936
Walnut and poplar
Statue: 21½ x 14½ x 13 in. (54.6 x 36.8 x 33 cm)
Relief: 39½ x 32¾ in. (100.3 x 83.2 cm)
Berman-Daferner Gallery and
Conner-Rosenkranz, New York City
Page 7

Inspired by both Byzantine and modernist influences, Karoly Fulop created formally stylized, spiritual sculpture in the 1920s and 1930s.

Little is known of this enigmatic man. Educated at a monastery school in Hungary, Fulop was surrounded by medieval art while growing up. He later studied painting in Budapest, Munich, and Paris. He immigrated to the United States (probably 1920) and that year participated in a Whitney Studio Club exhibition. Gertrude Whitney showed his paintings in a two-man exhibition (1921). His earliest known canvases are boldly colored scenes of the docks at Gloucester, Massachusetts, where he began summering in 1921. He had solo exhibitions in Gloucester (1922, 1923) and New York City at Babcock Galleries (1924). The Doll and Richards gallery in Boston began devoting a series of exhibitions to his decorative paintings and batiks with religious motifs (1925). By the late 1920s he had turned his attention to sculpture, modeling in ceramics and carving wood and ivory figures in the round as well as panels in low relief.

Fulop was living in Los Angeles by 1927 but maintained a studio in Paris and frequently visited the East Coast. He established a school of decorative arts in his Los Angeles studio (1931). He was given solo exhibitions at the Los Angeles County Museum (1930, 1940) and continued to exhibit nationally and regionally. He received an award for work exhibited at the New York World's Fair (1939) and won the Snyder prize from the Fine Arts Gallery of San Diego (1940). Little is known about his career after that.

Fulop's sculpture is quite distinctive and as enigmatic as the artist himself. Throughout his career he demonstrated a synthesis of medieval art with the symbolist and expressionist tendencies of early twentieth-century Viennese painting. His elongated and mannered forms reflect the popular art deco aesthetic of the 1920s. Infused with an air of mysticism, the figures in his relief panels are set in elaborate and crowded interior scenes, usually involving processions, rituals, or other religious practices. Such themes were atypical of American sculpture of the period. Fulop was one of the sculptors in the United States who exploited an emerging interest in polychromy. Not only did he design ceramic sculpture of solitary females and mother and child groupings with colored glazes, but in his wood sculptures he added gold leaf, inlays of ivory, and pigments to impart sumptuous effects. He also was the only sculptor to design two-part works, consisting of a sculpture in the round placed on a pedestal before a thematically related, carved panel.

Sources

Doll and Richards papers, AAA.

Stendahl Gallery papers, AAA.

Decorative Paintings by Karoly Fulop. Exh. cat. New York: Babcock Galleries, 1924.

Fort, Ilene Susan, and Michael Quick. "Karoly Fulop." In *American Art: A Catalogue of the Los Angeles County Museum of Art Collection*, p. 425. Los Angeles: Los Angeles County Museum of Art, 1991.

Moure, Nancy. *Painting and Sculpture in Los Angeles, 1900–1945.* Exh. cat. Los Angeles: Los Angeles County Museum of Art, 1980.

Eugenie Gershoy

Born 1901 Krivoirog, Russia
Died 1986 New York City

THE WEIGHT LIFTER
1940
Polychromed plaster and wire
17½ x 13¾ x 11½ in. (44.5 x 34.9 x 29.2 cm)
Collection of Mrs. Daniel Cowin
Shown in New York City only
Plate 74

Eugenie Gershoy is most often identified with
the whimsical, polychromed sculpture that
first won her recognition in the 1930s.

Born into a family of Russian intellec-
tuals, Gershoy arrived in the United States
while still a child. At seventeen she won a
Saint-Gaudens medal for draftsmanship and
two years later earned a scholarship to the
Art Students League. She studied sculpture
with A. Stirling Calder but left after one year
to marry painter Harry Gottlieb (b. 1895).
The couple joined several league friends at
the Maverick.

At the Maverick Gershoy worked with
Hannah Small, who remained a lifelong
friend, and in addition was influenced by John
Flannagan. Gershoy began carving simplified
forms from apple wood, fieldstone, old grave-
stones, and other found materials, and her
sculpture from this period is characterized by
heavy, elemental forms.

She left Woodstock in 1935 and returned
to New York City to participate in the WPA/FAP.
During a trip to Europe she had begun model-
ing in terra-cotta (1932), and under the auspices
of the WPA she expanded her work in this
technique, adding the new adhesive dextrine
to her modeling plaster. She completed a
series of free-standing, tempera-painted figures,
which were used to decorate the interiors of
public buildings. After leaving the WPA (1939),
she used papier-mâché, which was inexpensive
and enabled her to continue using color. Her
humorous and brightly painted depictions of
circus performers and other genre characters

were her unique contribution to sculpture.
Robinson Galleries in New York showed
them (1940).

Gershoy moved to San Francisco (1942),
where she taught and won three resident
fellowships to Yaddo. She returned to New
York City (1966), spending summers in
Woodstock. Shortly before her death, Gershoy
was honored with a solo exhibition at the
National Museum of American Art.

Sources

Gershoy, Eugenie, interview with Mary McChesney, 1964,
OHC; and papers, AAA and GAR.

Gershoy, Eugenie. "Fantasy and Humor in Sculpture."
In *Art for the Millions: Essays from the 1930s by Artists and
Administrators of the WPA Federal Art Project*, ed. Francis V.
O'Connor, pp. 92–93. Greenwich, Connecticut.: New York
Graphic Society, 1973.

McCausland, E. "Sculptures by Eugenie Gershoy." *Parnassus*
12 (March 1940): 39.

Steiner, Raymond J. "Profile on: Eugenie Gershoy." *Art Times*
(Saugerties, N.Y.) 1 (November 1984): 8–11.

Wolf, Tom. "Eugenie Gershoy." In Woodstock Artists
Association, *Woodstock's Art Heritage: The Permanent
Collection of the Woodstock Artists Association*, pp. 92–93.
Woodstock: Overlook, 1987.

Aaron Goodelman

Born 1890 Ataki, Russia (Bessarabia)
Died 1978 New York City

THE DRILLERS
(also known as MEN LIFTING*)*
1933
Bronze
12½ x 9 x 11 in. (31.8 x 22.9 x 27.9 cm)
*Collection of Hebrew Union College
Skirball Museum, Los Angeles*
Plate 88

KULTUR
Exhibited 1940
Pear wood and metal chain
66½ x 12½ x 10¾ in. (168.8 x 31.8 x 27.3 cm)
*National Museum of American Art,
Smithsonian Institution, gift of
Mrs. Sarah Goodelman*
Plate 114

A devoted Communist for much of his life,
Aaron J. Goodelman used sculpture to express
his concern over the social and economic
conditions of the working class in the decade
before World War II. His expressive, often
brutal imagery ranks his art among the most
strident figurative sculpture created in the
United States.

During the decade that witnessed the
largest wave of immigrants—with six million
people fleeing southern and eastern Europe—
to arrive in the United States, Goodelman fled
anti-Jewish pogroms and settled in New York
City in 1905. He studied at Cooper Union
(1905–12) and the National Academy of Design
(1909–10), receiving instruction from Gutzon
Borglum, George Brewster (b. 1862), and
Jo Davidson. He pursued additional training
with Jean-Antoine Injalbert at the École des
Beaux-Arts in Paris (1914). After his return to
the United States, Goodelman won recogni-
tion for his Rodin-influenced work, which
led to commissions for portrait busts and archi-
tectural sculpture.

John Gregory

Born 1879 London, England
Died 1958 New York City

From a working-class background, Goodelman supported himself as a machinist during the 1920s and by the next decade had become an ardent Communist. Maturing late as a sculptor, it was only in 1928 that he began to use his art as a vehicle for social commentary, addressing the major issues of the day: workers' rights, poverty, and racial equality. Lynching too was a frequent theme in his work of this period. Using a variety of materials, styles, and techniques, he abandoned his earlier naturalism for cubism, eventually turning to expressionistic carving for his most penetrating sculpture. In the early 1940s he produced less passionate statements about man's relationship to machines, placing figures in environments constructed of metal beams. After World War II Goodelman expanded his focus to comment on the horrors of the war, particularly that aspect pertinent to his own background, the Holocaust.

Goodelman was an active exhibitor. In 1933 he was included in the first biennial of the Whitney Museum of American Art and was accorded his first solo exhibition, at the Eighth Street Gallery. His exhibition record also reflected his politics: he participated in John Reed Club exhibitions of the early 1930s, the Artists Union, the American Artists' Congress, and the exhibition of works presented by American artists to the State Museum of Birobidzhan (1936) in Russia. He was also a member of the national executive committee of the Artists' Congress against War and Fascism (1935), of the Jewish Art Center (the art section of the Yiddisher Kultur Farband, a Popular Front organization), and of United American Sculptors. In the 1940s A.C.A. Gallery accorded him several solo exhibitions.

Goodelman continued to exhibit regularly through the 1960s and to teach at the City College of New York and at the Jefferson School for Social Science. The Judah L. Magnes Museum in Berkeley organized his only museum retrospective exhibition (1965).

Sources

Goodelman, Aaron, papers, AAA.

Aaron J. Goodelman Retrospective, 1933–1963. Exh. cat. New York: A.C.A. Gallery, 1963.

Kleeblatt, Norman, and Susan Chevlowe. *Painting a Place in America: Jewish Artists in New York, 1900–1943.* Exh. cat. New York: Jewish Museum, 1991.

FANCY
1923
White marble on black marble socle
13¾ x 8 x 9 in. (34.9 x 20.3 x 22.9 cm)
Conner-Rosenkranz, New York City

John Clements Gregory's sculpture contributed to the transformation of classicism into a modernist aesthetic.

Gregory immigrated to the United States at age fourteen. He began an apprenticeship (1900) in the New York City studio of J. Massey Rhind (1860–1936) while attending classes at the Art Students League with George Grey Barnard. Gregory returned to London (1903) to study at Lambeth School of Art, an institution associated with advanced design of architectural sculpture, and the following year went to Paris, where he joined the atelier of Antonin Mercié (1845–1916) at the École des Beaux-Arts. He returned to New York (1906) and for the next five years served as a studio assistant for Hermon A. MacNeil, Gutzon Borglum, and Herbert Adams. He won the Prix de Rome, which allowed him to work as a fellow of the American Academy (1912–15).

Like other American Academy sculptors Gregory was essentially a modeler who depicted classical and literary themes in a style that he termed "the Playful Classic." His figures were praised for their harmonious design and rhythmic movement and especially for their frankness of form and silhouette. Gregory kept details simple, due to their secondary importance for him. He used archaistic elements and stylized forms more sparingly than Paul Manship and C. Paul Jennewein but like them found his sources in Greek, Egyptian, and West Asian art. One critic referred to the hint of abstraction in Gregory's approach to form as "emotional modernism of the classical idea," while another characterized his art as contemporary "modernism of a conservative type."

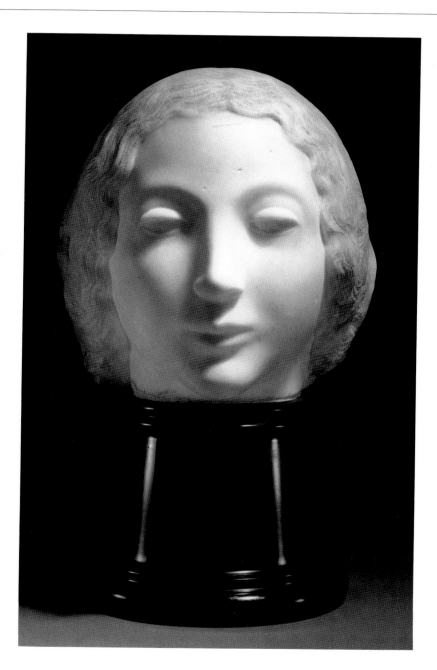

John Gregory, FANCY

Upon his return to the United States Gregory taught modeling at Columbia University (1916–25) and served as director of the sculpture department at the Beaux-Arts Institute of Design (1921–23).

While he won success in the 1920s for independent figures and heads—the most notable was *Philomela* (1921)—Gregory was best known for his commissioned work. He became a popular creator of garden sculpture but was hired (1922) to do the tympanum figures for the east pediment of the newly constructed Philadelphia Museum of Art. (Jennewein was assigned the west pediment.) The commission was the most prominent sculpture project in the United States during the 1920s. Historically the pediment sculptures were notable for their polychromy. The Philadelphia project marked a turning point in Gregory's career: from 1927, when he exhibited his model of the final design, he began receiving more significant commissions for architectural sculpture, such as the panels for the facade of the Folger Shakespeare Library in Washington, D.C.

Gregory continued to receive commissions for the next two decades, but his adherence to classical form in his independent work was at odds with the new aesthetics promoted by progressive sculptors of the 1930s.

Sources

Gregory, John, papers, AAA.

Bronson, Steven E. "John Gregory: The Philadelphia Museum of Art Pediment." Master's thesis, University of Delaware, 1977.

"John Gregory's Sculptures in Bronze." *Metal Arts* 2 (July 1929): 315–19, 322.

Parkes, Kineton. "A Classical Sculptor in America: John Gregory." *Apollo* 17 (February 1933): 28–31.

Solon, Leon V. "The Garden Sculpture of John Gregory." *Architectural Record* 55 (April 1924): 401–4.

Waylande Gregory

Born 1905 Baxter Springs, Kansas
Died 1971 Warren Township, New Jersey

EUROPA
1938
Unglazed earthenware
23¾ x 27 x 9½ in. (60.3 x 68.6 x 24.1 cm)
Everson Museum of Art, Syracuse
Plate 56

During the 1930s Waylande De Santis Gregory
brought the new field of ceramic sculpture to
national attention through his large outdoor
works.

Born into a successful Kansas ranching
family, the precocious Gregory while still a
teenager began receiving architectural sculp-
ture commissions in various midwestern cities
and was invited to study with Lorado Taft at
his Chicago Midway studio (1924). Modeling
directly with clay, Gregory was inculcated with
the importance of the figural and allegorical
tradition. He accompanied Taft to Europe
(1926) to visit museums and terra-cotta centers.
Upon his return, he apprenticed with the
Midland Terra Cotta Company in Cicero,
Illinois, and then attended college in Pittsburg,
Kansas, where he studied several scientific
disciplines that would form the technical foun-
dation of his later work with glazes.

Gregory accepted a position with Cowan
Pottery Studio (1928) in Rocky River, Ohio,
a Cleveland suburb. He designed models for
mass-produced plates and other functional
items as well as freestanding decorative fig-
urines in limited editions. For the latter he
depicted literary and dancing themes, utilizing
the rich colored glazes and art deco styles
developed by Cowan. With fellow ceramists
Alexander Blazys and Viktor Schreckengost,
Gregory made Cowan a leading producer
of art pottery. In the May annuals of the
Cleveland Museum of Art, he won prizes for
ceramic sculpture (1929, 1930).

After the close of Cowan Pottery (1931),
Gregory became artist-in-residence at
Cranbrook Academy of Art near Detroit. His
brief tenure there was one of significant tech-
nical innovation: he increased the size of his
sculptures and personally controlled every
aspect of the ceramic process. He also began to
invent personal symbolic imagery. Settling per-
manently (1933) in Bound Brook, New Jersey,
he created unique ceramic garden sculptures
that would establish his importance as a sculp-
tor rather than as a ceramist. Gregory was head
of the New Jersey sculpture division of the
WPA/FAP (1936–38); under its auspices he made
his monumental and thematically complex
fountain sculpture *Light Dispelling Darkness*
(1937) for Roosevelt Park in Edison. For the
New York World's Fair he executed *Fountain
of the Atoms* (1939), his largest work.

His contributions to the field of decora-
tive arts as well as to the fine arts were recog-
nized early; he was accorded one-man displays
at Cranbrook (1933) and at the Syracuse
Museum of Fine Arts and Montclair Art
Museum (both 1934). The remainder of his
accomplishments, however, did not generate
the same acclaim. As his popularity waned,
Gregory supported himself by designing
small, limited-edition ceramics that were sold
at exclusive specialty stores, such as Gump's
and Georg Jensen. He died in obscurity.

Sources

Gregory, Waylande, papers, Kansas Collection, Pittsburg
State University Library; and Waylande and Yolande Gregory
estate papers, collection of Bianca Brown, Coraopolis,
Pennsylvania.

DeGruson, Gene. "'No Greater Ecstasy': Waylande Gregory
and the Art of Ceramic Sculpture." *Kansas Quarterly* 14
(fall 1982): 65–82.

Levin, Elaine. "Monumental Ambitions: Waylande Gregory."
American Ceramics 5, no. 4 (1987): 40–49.

Watson, Ernest. "Waylande Gregory's Ceramic Art."
American Artist 8 (September 1944): 12–15.

Wolf, Cheryl Epstein. "Waylande Gregory's Ceramic
Sculpture." Master's thesis, Hunter College, 1991.

Chaim Gross

Born 1904 Wolowa, Austria-Hungary (Galicia)
Died 1991 New York City

HOOVER AND ROOSEVELT
IN A FIST FIGHT
c. 1932
Mahogany
72 x 20 x 1½ in. (182.9 x 50.8 x 3.8 cm)
*The Renee & Chaim Gross Foundation,
New York City*
Plate 11

THE LINDBERGH FAMILY
1932
Golden streak ipilwood
Charles Lindbergh:
66 x 11 x 6⅝ in. (167.6 x 27.9 x 16.8 cm)
Ann Lindbergh:
64½ x 6⅞ x 5½ in. (162.6 x 17.5 x 14 cm)
*Mimi Gross/The Renee & Chaim Gross
Foundation, New York City*
Plate 108

CIRCUS ACROBATS
1935
Lignum vitae
34½ x 11½ x 12 in. (87.6 x 29.2 x 30.5 cm)
Mimi Gross
Plate 101

One of the best known of America's first
generation of direct carvers, Chaim Gross was
highly respected both as an artist and as a
teacher.

Gross suffered extreme hardship during
World War I; in 1919 he was deported first
from Hungary, then from Austria due to the
anti-Semitic sentiment rampant in central and
eastern Europe. In 1921 he joined his brother,
Naftoli, a Yiddish poet who was living in the
United States. In Europe Gross had briefly
attended the Academy of Fine Arts in Budapest
and the school of applied arts in Vienna. In
New York City he enrolled in art classes at the
Educational Alliance, as did so many immi-
grants. Gross simultaneously was a student
at the Beaux-Arts Institute of Design, where
for two months in 1925 he studied with Elie

Charles Haag

Born 1867 Norrköping, Sweden
Died 1933 Winnetka, Illinois

Nadelman; the latter emphasized the beauty of simplified lines and the importance of folk art, two ideas that became significant in Gross's work. Although Gross had whittled as a boy, he did not carve sculpture until he enrolled at the Art Students League (1926) to learn the technique of direct carving from Robert Laurent. Carving became Gross's favorite technique and wood his favorite material for his mature work until 1957, when he switched to bronze casting.

Gross experimented with cubist and totemic forms (c. 1930), the latter inspired by African art, which he collected. He preferred figurative subject matter, however, and his hallmark motifs became exuberant circus figures. While his repertoire of subjects also included genre figures, such as shoppers, Gross claimed (1938) that subject matter was not important, only an avenue through which to express the medium. Typically for American direct carvings of the 1930s, his sculptures were not perforated, but solid and compact, with the marks of the chisel sometimes left visible.

Gross's work was well received. He exhibited widely and was given four one-man exhibitions during the decade 1932–42, beginning with a showing at the Gallery 144 in New York City. He won a Tiffany fellowship (1933). He sold several works from his exhibition at the Boyer Galleries (1937), including one to the Museum of Modern Art. Gross won several commissions from the Treasury Section (1936–42), including aluminum figures for the Apex and Post Office Department buildings and a relief for the Federal Trade Commission building, all in Washington, D.C.

Gross was active in the promotion of sculpture as an early member of the Sculptors Guild, teacher, and author. He spread the gospel of direct carving at a variety of institutions, but his most significant tenure was at the Educational Alliance, where he taught for six decades beginning in 1927. Gross brought his ideas to a larger public through his book, *The Technique of Wood Sculpture* (1957).

Sources

Gross, Chaim, papers, AAA, GAR, and Renee & Chaim Gross Foundation.

Getlein, Frank. *Chaim Gross.* New York: Abrams, 1974.

Gross, Chaim. "A Sculptor's Progress." *Magazine of Art* 31 (December 1938): 694–98.

Lombardo, Josef Vincent. *Chaim Gross: Sculptor.* New York: Dalton House, 1949.

Tarbell, Roberta K. *Chaim Gross, Retrospective Exhibition: Sculpture, Paintings, Drawings, Prints.* Exh. cat. New York: Jewish Museum, 1977.

THE IMMIGRANTS
c. 1905
Bronze
19 x 10 x 15 in. (48 x 25.5 x 38 cm)
American Swedish Historical Museum, Philadelphia
Plate 90

Carl Oskar Haag was one of the first artists in the United States to express social themes in sculpture.

Apprenticed to a potter (early 1880s), Haag began modeling in clay and at seventeen studied modeling at the School of Industrial Arts in Göteborg. He spent time in Stockholm during a period of labor unrest, and that experience, coupled with his impoverished childhood and interest in social democracy as promoted by August Palm, provided the themes for much of his mature art. After working in Germany, Haag moved to Switzerland, where a patron's support enabled him to maintain his own studio in Neuchâtel.

In the mid-1890s Haag moved to Paris, studied with Jean-Antoine Injalbert, and achieved success designing jewelry for the famous firm of René Lalique. He arrived in the United States (1903) to complete portrait commissions for several wealthy Americans he had met in Normandy. While in New York City he met his future wife, the Swedish immigrant artist Sofia Olsson (1878–1969), and decided to stay. Haag began modeling sculptures of laborers, which expressed his sympathy for the working class and the socialist cause. These figures, with their impressionistic surfaces, attracted favorable reviews when shown in his first American exhibition (1906), at the New Gallery.

Haag's arrival in the United States coincided with the progressive political reform movement. Since he repeatedly turned to themes of social justice and unionism, he

Cleo Hartwig

Born 1907 Weberville, Michigan
Died 1988 New York City

attracted the commission (1909) for the statue of the nineteenth-century social activist Henry Demarest Lloyd. Lloyd family members became Haag's friends and most important patrons when he came to Winnetka, Illinois, to oversee the installation of the monument on their estate. Thereafter Haag divided his time between Chicago art circles and a farm in the artist community of Silvermine, Connecticut. Lorado Taft praised Haag's fountain designs in an exhibition (1912) at the City Club in Chicago.

Haag abandoned socialist causes (1915) for pantheistic themes presented in allegories about the growth and spirits of trees and plants. His figures with their gently sweeping lines suggest the impact of the art nouveau designs he used in his decorative work for Lalique. When completed in 1917, the Spirit of the Woods series numbered nearly fifty figures carved of different types of wood. Exhibited widely, the carvings earned him praise.

Haag often alienated prospective patrons by the vehemence of his opinions. Consequently, despite the positive reviews his sculpture garnered, the artist rarely received the commissions he desired, and most of his work went unsold.

Sources

Haag, Charles, papers, Swenson Swedish Immigration Research Center, Augustana College, Rock Island, Illinois.

Emkirn, Mary, et al. *Härute—Out Here: Swedish Immigrant Artists in Midwest America.* Exh. cat. Rock Island, Ill.: Augustana College, 1985.

Spargo, John. "Charles Haag—Sculptor of Toil—Kindred Spirit to Millet and Meunier." *The Craftsman* 10 (July 1906): 432–42.

Von Ende, Amelia. "Charles Haag." *American-Scandinavian Review* 6 (1918): 28–35.

———. *Charles Haag: Sculptor.* N.p., c. 1928–32.

CHILD ASLEEP
1937
Indiana limestone
7 x 17½ x 6½ in. (17.8 x 44.5 x 16.5 cm)
Albert Glinsky and Linda Kobler Glinsky
Plate 142

Cleo M. Hartwig was a prominent second-generation direct carver, who demonstrated the continued vitality of the glyptic sculptural technique.

Hartwig received a bachelor's degree in art education at Western Michigan University (1932) and soon after completed a course in decorative design at the International School of Art in Piseco, New York. Sometime during the following few years she moved to New York City, where she began a long career teaching art and art appreciation at private schools. She enrolled at the New School for Social Research (1937) to study stone carving with José de Creeft, continuing her studies with him privately the following year. She spent the summers carving in stone in Portland, Michigan (1937–41), and traveled to France (1940) and Mexico (1941). By 1941 she had become active in the Clay Club, New York City, where she held solo exhibitions (1943, 1947) and began working in terra-cotta.

After a year at Cooper Union (1945–46), she began a twenty-five year association with Montclair Art Museum, teaching design, modeling, and other classes to children and adults. In 1945 she also became a member of the Sculptors Guild and the New York Society of Women Artists, serving as the executive secretary of the former (1947–54). She was honored with an exhibition that traveled throughout western Canada (1949). In 1951 she married fellow carver Vincent Glinsky (1895–1975).

Hartwig was primarily a carver in stone. She depicted both animals and human figures but seemed partial to the former, possibly as a result of her rural upbringing. Her carvings from the 1930s and early 1940s are characterized by compact, massive forms, crisp outlines, and minimal details. In their blockiness, extreme simplification of shape, and coarse surfaces they especially echo Mesoamerican sculpture. Unlike many of the other second-generation carvers, Hartwig did not restrict her treatment of surfaces to gleaming polishes but often left traces of her chisel or the original rough surface of stone, no doubt a tendency inherited from her teacher, de Creeft. Her nude figures of the 1940s occasionally suggest his fluid, somewhat romantic interpretations. During this decade she also experimented sporadically with abstraction. In her ceramic animals from the 1940s she began to emphasize stylized, painted patterning that suggests her familiarity with nineteenth-century American folk carvings. Her art changed only negligibly thereafter.

Sources

Hartwig, Cleo, papers, AAA.

Bell, Enid. "The Compatibles: Sculptors [Cleo] Hartwig and [Vincent] Glinsky." *American Artist* 32 (June 1968): 44–49, 91.

Berman, Douglas. "Cleo Hartwig: An Appreciation." *National Sculpture Review* 37, no. 4 (1988): 25.

Hays, Constance L. "Cleo Hartwig, 80, Dies of Cancer: Her Sculpture Featured Animals." *New York Times*, 19 June 1988, 26.

Khendry, Janak K. *Glinsky, Hartwig.* Exh. cat. New York: Sculpture Center, 1972.

Malvina Hoffman

Born 1885 New York City
Died 1966 New York City

COLUMN OF LIFE
1912/17
Bronze
26 x 7 x 7 in. (66.2 x 17.8 x 17.8 cm)
Los Angeles County Museum of Art,
gift of B. Gerald Cantor Art Foundation
Plate 39

MARTINIQUE WOMAN
1927
Belgian marble
20⅞ x 11⅜ x 15⅜ in. (53 x 28.9 x 39.1 cm)
The Brooklyn Museum, Dick S. Ramsay
Fund
Plate 150

Although best remembered for her ethnographic portraits, Malvina Hoffman was first inspired by the example of Auguste Rodin to create sensuous sculptures of lovers and dancers.

Hoffman began creating art as a teenager, but her first sculpture classes date from 1906, when she studied with Herbert Adams and George Grey Barnard at the Veltin School. Gutzon Borglum, a close family friend, gave her criticism on modeling and encouraged her to exhibit a portrait bust at the National Academy of Design annual (1909). The following year Hoffman, having resolved to become a sculptor, left for Europe.

Hoffman lived abroad off and on until the outbreak of World War I. During this period she completed her training and established a reputation as a progressive sculptor. Rodin agreed to give her regular criticism and allowed her to use his studio in his absence. Eventually Hoffman became one of his assistants, helping him with such projects as the installation of his retrospective exhibition in London (1914). The two remained close until his death in 1917. Under Rodin's tutelage Hoffman began to model figures that echo Rodin's combined naturalism and fluid surfaces and his sense of drama and poignancy. Her most sensuous expressions of lovers date from these early years.

In 1910, the year she met Rodin, Hoffman came under the spell of modern ballet. Enthralled by a performance of Anna Pavlova and Mikhail Mordkin, she began to depict dancers. Like Rodin, Hoffman was fascinated by movement and successfully conveyed the energy and freedom of modern dance. She met Pavlova in 1913 and the following year proposed to render the ballet *Bacchanale* in a bas-relief if Pavlova would model for her. For two years Hoffman devoted her work to dance-related sculpture but was not able to complete the frieze until 1924. Her dance sculptures were quite marketable, however, and brought Hoffman her first sustained public recognition when exhibited at the Panama-Pacific International Exposition and in small showings at galleries in the United States.

Hoffman's vigorous realism, encouraged by Rodin's example, made her a popular portraitist. During the war years and the decade that followed she supported herself in part with numerous commissions for portraits, monuments, and architectural sculpture. She held her first major solo exhibition at the Grand Central Art Galleries (1928). The next year she received her most important commission when the Field Museum of Natural History in Chicago asked her to do a series documenting the races of the world. She toured the five continents, modeling various ethnic groups as she encountered them. Cast in bronze at the Rudier foundry in Paris (1932) and exhibited at the Musée d'Ethnographie there, the 102 sculptures that constitute the series were permanently installed (1933) as the Hall of Man in Chicago. She then visited the Southwest to depict Native Americans. Hoffman became a celebrity and spent the remainder of the decade exhibiting. She also increased her reputation with the publication of *Heads and Tales* (1936), her autobiography, and *Sculpture Inside and Out* (1939), a technical book. Her productivity slackened thereafter.

Sources

Hoffman, Malvina, papers, AAA and Resource Collections, Getty Center, Santa Monica.

Conner, Janis C. *A Dancer in Relief: Works by Malvina Hoffman.* Exh. cat. Yonkers: Hudson River Museum of Westchester, 1984.

Hoffman, Malvina. *Heads and Tales.* New York: Scribner's, 1936.

————. *Yesterday Is Tomorrow: A Personal History.* New York: Crown, 1965.

Nochlin, Linda. "Malvina Hoffman: A Life in Sculpture." *Arts Magazine* 59 (November 1984): 106–10.

Donal Hord

Born 1902 Prentice, Wisconsin
Died 1966 San Diego, California

THE CORN GODDESS
By 1942
Lignum vitae
39½ x 9½ x 7 in. (100.3 x 24.1 x 17.8 cm)
Los Angeles County Museum of Art,
given anonymously
Plate 153

Donal Hord was San Diego's most famous sculptor and one of the nation's finest direct carvers of the 1930s.

Hord learned modeling from Anne Marie Valentien in San Diego and then was a pupil of Archibald Dawson (d. 1938) at the Santa Barbara School of the Arts (1926–28). He used a Gould fellowship to spend 1928 in Mexico, where he studied pre-Columbian sculpture as well as contemporary Mexican art. His interest in the region along with his fascination with Asian cultures, fostered by growing up in Seattle, would come to affect the character of his mature sculpture substantially.

Hord studied at the Pennsylvania Academy of the Fine Arts with Walker Hancock (1929), followed by a brief period at the Beaux-Arts Institute of Design. He returned permanently to San Diego (1930) and began carving, mostly out of hardwoods, beautifully crafted figures of Native Americans, which represent mythological personalities and the spirit of Mesoamerican culture. That year Hord won a prize for one of these carvings at the Los Angeles County Museum of History, Science and Art annual exhibition of California art and three years later was given his first solo exhibition by the Dalzell Hatfield Galleries. During the decade he worked steadily for the WPA/FAP and served as the sculpture supervisor for the San Diego region. The two commissions he completed under its auspices rank as his best-known works: the stone figures of *Aztec* (1936) and the fountain *Guardian of Water* (1937–39) for the San Diego Civic Center.

He received national attention for the first time when five of his stone carvings were included in *Americans 1942*.

Hord continued to garner awards; two Guggenheim fellowships in the early 1940s enabled him to travel again to Mexico. He began teaching (1947), first at the Coronado School of Fine Arts and later at the Art Center in La Jolla. Always in frail health, he was assisted throughout his career by Homer Dana, who did much of the strenuous manual labor involved in carving Hord's projects.

Sources

Hord, Donal, interview with Betty Hoag, 1964, OHC.

Ellsberg, Helen. "Donal Hord: Interpreter of the Southwest." *American Art Review* 4 (December 1977): 76–83, 126–30.

Hord, Donal. Artist's statement. In *Americans 1942: 18 Artists from 9 States,* ed. Dorothy C. Miller, pp. 67–74. Exh. cat. New York: Museum of Modern Art, 1942.

Kamerling, Bruce. "Like the Ancients: The Art of Donal Hord." *Journal of San Diego History* 31 (summer 1985): 164–209.

Sullivan, Catherine. "Donal Hord." *American Artist* 14 (October 1950): 49–52, 63.

C. Paul Jennewein

Born 1890 Stuttgart, Germany
Died 1978 New York City

GREEK DANCE
1925
Bronze
20½ x 16 x 6¼ in. (52.1 x 40.6 x 15.9 cm)
Los Angeles County Museum of Art, gift of
the 1994 Collectors Committee
Plate 3

GREEK DANCE
1925
Silvered and polychromed bronze on
polychromed wood base
20½ x 16⁷⁄₁₆ x 6½ in. (52.1 x 41.8 x 16.5 cm)
San Diego Museum of Art, gift of
Mrs. Henry A. Everett
Plate 4

MEMORY
1928
Glazed porcelain
9¾ x 9 x 6½ in. (24.8 x 22.9 x 16.5 cm)
Pennsylvania Academy of the Fine Arts,
Philadelphia, Joseph E. Temple Fund
Shown in Los Angeles, Montgomery, and
Wichita only
Plate 54

In the years following World War I Carl Paul Jennewein contributed to the transformation of the classical tradition into a modern aesthetic and was instrumental in reviving the interest in polychromy in sculpture.

Illustrations of buildings designed by the American firm of McKim, Mead, and White inspired Jennewein to move to New York City (1907). There he obtained an apprenticeship with a firm specializing in architectural sculptural decorations, while attending the Art Students League at night. (He had already received some technical training while apprenticed to the Stuttgart Museum.) By 1911 he was receiving his own commissions for ornamental sculpture and mural painting and was able to finance two years of travel in France, Germany, Italy, and Egypt.

Sargent Johnson

Born 1887 Boston, Massachusetts
Died 1967 San Francisco, California

Jennewein won the Prix de Rome in sculpture (1916) and spent most of the next four years at the American Academy. This fellowship determined his future course, for he abandoned painting. Exposure to classical art reaffirmed his early commitment to the purity of classical line and proportion.

In New York City during the 1920s Jennewein became famous for his bronze sculptures of classical subjects, usually female nudes, children, and cupids, conveying intimacy and tenderness. Jennewein, like Paul Manship, his predecessor at the American Academy, emphasized outline, movement, and drapery in a highly stylized manner similar to art deco. He also did several small sculptures in porcelain, which were displayed in solo exhibitions at the Grand Central Art Galleries (1927, 1935).

Jennewein achieved wide fame through numerous public commissions—architectural sculpture, fountains, and monuments—garnered over four decades. Beginning in 1920 with the Darling Memorial Fountain in Washington, D.C., these projects ultimately included some of the most desirable sculpture commissions of the day: decorative reliefs for the British Empire Building at Rockefeller Center in New York, two heroic statues in aluminum for the Department of Justice building in Washington, D.C., and decorative pylons for the Brooklyn Public Library.

The most important commission of his entire career (as well as the most significant sculptural project in the United States during the 1920s) was for the pedimental figures of the newly constructed Philadelphia Museum of Art; Jennewein was asked (1922) to create the west tympanum figures (John Gregory did the east). Jennewein and Gregory worked in association with Leon Solon, an authority on the ancients' use of color, to design glazed terra-cotta figures in the tradition of antique temples. His tympanum sculpture had a larger significance in encouraging a new taste for color in sculpture. Jennewein also experimented with patinas—gold, silver, black, and polychromy—in his smaller sculptures, in particular *Greek Dance*, created while he was working on the Philadelphia project.

Sources

Jennewein, C. Paul, interview with George Gurney, 1978, OHC; and papers, AAA and Tampa Museum.

Cunningham, John J., ed. *C. Paul Jennewein*. The American Sculptors series. Athens: University of Georgia Press with National Sculpture Society, 1950.

Hanofee, James S. "Creating Colossi in Terra-Cotta." *Art and Archaeology* 34 (November–December 1933): 298–311, 324.

Howarth, Shirley Reiff. *C. Paul Jennewein, Sculptor*. Exh. cat. Tampa: Tampa Museum, 1980.

NEGRO WOMAN
By 1936
Wood with lacquer on cloth
32 x 13½ x 11¾ in. (81.3 x 34.3 x 29.9 cm)
San Francisco Museum of Modern Art,
Albert M. Bender Collection, gift of
Albert M. Bender
Plate 166

A leading art figure in northern California during the 1930s and 1940s, Sargent Claude Johnson was also stylistically the most progressive African American sculptor working in the United States.

Johnson was born in Boston to a Swedish father and a Cherokee and African American mother. His parents died when he was a child, and for a time he lived in Washington, D.C., with his aunt, the African American sculptor May Howard Jackson (1877–1931), who encouraged him to model in clay.

Johnson was briefly a pupil at the Massachusetts Art School in Worcester then moved to San Francisco (1915). He studied drawing and painting at the avant-garde A. W. Best School of Art and by 1919 had won a scholarship to the California School of Fine Arts. There he studied (1919–23) with Ralph Stackpole and briefly with Beniamino Bufano, who later became his friend and colleague. Johnson won prizes for his student work and received critical recognition in 1925. By that time he was assuming a prominent place in the thriving North Beach art scene.

As part of the WPA/FAP Johnson designed several relief panels and sculptures in the Bay Area in a larger scale than he had previously worked. Two cast-stone figures of Incas for Golden Gate International Exposition Park (1939) were his largest sculptures. Johnson also completed private commissions, and by the end of the 1930s he was able to support himself solely with his art.

Despite his West Coast residence Johnson exhibited in the East, notably with the Harmon Foundation (1926–35). He won several awards and was honored by a Harmon Foundation-sponsored Delphic Studio exhibition (1933), which featured his work along with that of Richmond Barthé and Malvina Gray Johnson (1896–1934).

In the 1930s Johnson was notable for producing sculpture that proclaimed the dignity of African Americans and their history. He depicted them with a streamlined approach to form and surface, often echoing African tribal art in his emphasis on geometric shapes. The sculptor worked in a variety of materials but preferred to model, frequently using terra-cotta and incorporating polychromy into his designs.

From 1945 Johnson traveled widely. He visited Japan (1958), but it was his repeated trips to Mexico, including visits to archaeological sites, which strengthened his previous interest in ceramics.

Sources

Johnson, Sargent, interview with Mary McChesney, 1964, OHC.

Montgomery, Evangeline. "Sargent Johnson." *International Review of African-American Art* 6, no. 2 (1985): 4–17.

"San Francisco Artists." *San Francisco Chronicle*, 6 October 1935, sec. d, 3.

Sargent Johnson. Exh. bro. Richmond: Richmond (California) Art Center, 1987.

Montgomery, Evangeline J. *Sargent Johnson: Retrospective.* Exh. cat. Oakland: Oakland Museum, 1971.

Max Kalish

Born 1891 (?) Valozin, Russia (Lithuania)
Died 1945 New York City

STEEL INTO THE SKY
1932
Bronze
18¾ x 11 x 4½ in. (47.6 x 27.9 x 11.4 cm)
The Cleveland Museum of Art,
gift of friends of the artist
Plate 59

Max Kalish apotheosized the American industrial laborer in realistic bronzes created in the 1920s and 1930s.

Kalish's family immigrated to Cleveland when he was two years old. At age fifteen he won a scholarship to the Cleveland School of Art, where he studied sculpture with Herman Matzen (1861–1938). He moved to New York City (1910) to continue his training, studying at the National Academy of Design with A. Stirling Calder and assisting at times in the studios of Herbert Adams, Isadore Konti (1862–1938), and Caraino di Sciarrino Pietro (1886–1918). His academic training concluded in Paris, where he went (1912) to study at the Académie Colarossi with Paul Wayland Bartlett and later at the École des Beaux-Arts with Jean-Antoine Injalbert. He was fortunate to have two portrait busts selected for the salon of the Société Nationale des Beaux-Arts (1913).

He was employed in San Francisco (1913–14) enlarging plaster figure groupings, primarily by Konti, for the Panama-Pacific International Exposition. While serving in the military during World War I, Kalish modeled a series of officers and enlisted men as well as a few antiwar pieces expressing his dismay over the destruction he had witnessed as a medical corpsman in hospitals stateside. He initiated the practice of spending six months each year in Paris and six in Cleveland (1920). The following year he began the sculpture upon which his reputation is based: figures of American laborers modeled realistically but with a fluid, Rodin-like surface treatment. In the mid-1920s he also created several sculptures on pertinent issues, such as poverty and unemployment; these were not as well received as his depictions of laborers. In 1926 he was given solo exhibitions in Cleveland and New York City, and the following year another successful display was held at Milch Galleries.

Simultaneously with his realistic bronze laborers Kalish carved marble figures, often classical nude fragments and heads of babies. Now largely forgotten, these were included in his exhibition at the Grand Central Art Galleries (1933).

In 1932 Kalish decided to live and work permanently in New York and the following year opened a school for sculptors there. Unlike other artists, Kalish was not seriously affected by the Depression because his bronzes sold well. He continued to have significant exhibitions and to sculpt, although at a slower pace. He exhibited again at the Grand Central Art Galleries (1935), this time a series of personages prominent in the arts, sciences, and society. His last labor sculpture dated from 1938. In 1944 he began the Living Hall of Washington, a series of portraits of American statesmen and military leaders done from life for publisher Willard M. Kiplinger.

Sources

Kalish, Max, files, Cleveland Museum of Art; and scrapbook, private collection (photograph copy, collection of Conner-Rosenkranz, New York City).

"The American Worker Glorified in Bronze." *Literary Digest* 91 (18 December 1926): 26–27.

"Max Kalish." In Conner and Rosenkranz, pp. 87–94.

Genauer, Emily. *Labor Sculpture by Max Kalish*, A.N.A. New York: privately printed, 1938.

Kalish, Alice. *Max Kalish As I Knew Him.* Los Angeles: privately printed, 1969.

Mario Korbel

Born 1882 Osik, Austria-Hungary (Bohemia)
Died 1954 New York City

NOCTURNE
1920
Bronze
22¾ x 12¾ x 6³⁄₁₆ in. (57.8 x 32.4 x 15.7 cm)
Conner-Rosenkranz, New York City
Shown in Los Angeles and Montgomery only

NOCTURNE
1920
Bronze
22¾ x 12¾ x 6³⁄₁₆ in. (57.8 x 32.4 x 15.7 cm)
Dr. George Hollenberg
Shown in Wichita and New York City only

Working within the classical tradition, Josef Mario Korbel experimented with patination and texture to create exceptionally sensuous nudes.

Korbel studied ornamental sculpture before immigrating to America (1900). He eventually settled in Chicago, with its large Bohemian immigrant community, and found employment at Kunst and Pfaffke, a firm specializing in ornamental moldings. He returned to Europe (1905) to pursue formal study of the human figure, spending a short time in Berlin before attending the Royal Academy of Fine Arts in Munich for three years and thereafter the Académie Julian in Paris. When he returned to Chicago (1909), he opened a studio and had enormous success with wealthy midwesterners and westerners who commissioned garden sculpture and portraits.

Realizing that a New York City residence was necessary for widespread recognition, Korbel moved east (1913). He was immediately included in a two-man show at the Reinhardt Galleries and was honored with his first solo exhibition (1917), at Gorham Galleries. Except for his portrait commissions, Korbel's subject matter was the female nude, always idealized and presented with a classical sense of proportion, balance, and grace. Like many other sculptors of the early twentieth century, Korbel

Mario Korbel, NOCTURNE

was fascinated by modern dance. He often asked dancers to pose for him and even married a member of Ruth St. Denis's corps. His fascination with movement was demonstrated by the often languorous poses of his figures, reminiscent of art nouveau, and the manner in which he used drapery as an essential design element. His decorative motifs hinted of the influence of the Vienna Secession. Although Korbel worked occasionally in stone, especially for his large outdoor commissions, his smaller sculptures were usually in bronze. The sculptor contributed a new dimension to the medium through his experimentation with contrasting patinas and textures. His manipulation of bronze surfaces heightened the nude's sensuous quality.

While Korbel's bronze statuettes were a commercial success in the late 1910s and 1920s, he supported himself primarily through large commissions. While in Cuba for ten months representing the Bohemian provisional government (1917), he created a monumental figure for the University of Havana. His most significant patron was the Detroit collector George G. Booth, who bought Korbel's *Andante* in 1916 and six years later commissioned the artist to design the statuary for the garden of his residence (which later became Cranbrook Academy). In 1925 Korbel again visited Cuba; by then he was also summering in Paris. His exhibition at the gallery of Jacques Seligmann (1929) in New York City marked the pinnacle of his career. He was accorded another solo exhibition at Wildenstein (1933), but the Depression virtually ended his lucrative commissions.

Sources

"Josef Mario Korbel." In Conner and Rosenkranz, pp. 95–103.

Genthe, Arnold. "The Work of Mario Korbel and Walter D. Goldbeck." *International Studio* 57 (November 1915): xix–xxiii.

Patterson, Augusta Owen. "Mario Korbel and His Sculpture." *International Studio* 84 (July 1926): 51–55.

Proske, Beatrice Gilman. "Mario Korbel." In *Brookgreen Gardens Sculpture*, pp. 231–34. Rev. ed. Brookgreen, South Carolina: Brookgreen Gardens, 1968.

Gaston Lachaise

Born 1882 Paris, France
Died 1935 New York City

THE MOUNTAIN
1919
Sandstone
7¾ x 17½ x 5½ in. (19.7 x 44.5 x 14 cm)
The Metropolitan Museum of Art,
bequest of Scofield Thayer, 1982
Plate 174

TORSO
1933
Marble
11¾ x 12 x 9 in. (29.8 x 30.5 x 22.9 cm)
Smith College Museum of Art,
Northampton, given anonymously
Plates 48a–b

Gaston Lachaise pioneered avant-garde sculpture in America with his voluptuous nudes, investing a theme eternal to art with an erotic interpretation.

The son of a French cabinetmaker, as a teenager Lachaise trained at the École Bernard Palissy, a school for the applied arts, and studied with Gabriel-Jules Thomas (1824–1905) at the Académie Nationale des Beaux-Arts (1898). Sometime between 1900 and 1903 he met and fell in love with a married Canadian-American woman, Isabel Dutaud Nagle, and followed her to Boston (1906). Although Lachaise did not marry Nagle until 1917, she became the inspiration and model for most of his art.

Lachaise first worked as a studio assistant to Henry Hudson Kitson (1863–1947) in Boston, following him to New York City (1912), but soon afterwards he began assisting in Paul Manship's studio. With his first one-man show at the Bourgeois Gallery (1918) his career was launched. E. E. Cummings wrote an early article about him for *The Dial* (1920), and Lachaise developed a following among progressive writers and artists.

Lachaise supported himself with commissions for architectural sculpture and portraits. His most significant project for building

Robert Laurent

Born 1890 Concarneau, France
Died 1970 Cape Neddick, Maine

decoration was a series of four relief panels (1931) for the new RCA Building in Rockefeller Center. Portraiture was a major facet of Lachaise's oeuvre, and among the many people he depicted were friends and members of the intellectual elite, such as Carl Van Vechten and Edgard Varèse. His full-length male nudes were a radical departure from traditional portraiture.

It was the female nude, however, which Lachaise most fully explored, presenting her robust form in relief and in the round, standing, striding, reclining, and performing acrobatic feats. Beginning with *Elevation* (1912–27), he created an idealization that represented his conception of the eternal woman. His figures were at once monumental in character, neoclassical in surface, and delicate in decorative detail and outline. Lachaise's women were bursting with energy, more alive than the static figures of his contemporaries. The artist increasingly exaggerated and distorted anatomy for expressive effect. He veered closest to abstraction and eroticism in his isolation of breasts, buttocks, and pelvic region.

Lachaise was one of the 1920s modernists who made use of polychromy, applying gold or dark pigments to marbles and metals. He also explored the visual impact different media made by creating specific works as multiples, presenting some in stone and others in bronze.

In 1935 Lachaise became the second living American artist honored with a retrospective at the Museum of Modern Art.

Sources

Lachaise, Gaston, papers, AAA and Beinecke Rare Book and Manuscript Library, Yale University.

Carr, Carolyn Kinder, and Margaret C. S. Christman. *Gaston Lachaise: Portrait Sculpture.* Exh. cat. Washington, D.C.: National Portrait Gallery, 1985.

Gallatin, Albert E. *Gaston Lachaise.* New York: Dutton, 1924.

Kramer, Hilton, et al. *The Sculpture of Gaston Lachaise.* New York: Eakins, 1967.

Nordland, Gerald. *Gaston Lachaise: The Man and His Work.* New York: Braziller, 1974.

ABSTRACT HEAD
1915
Mahogany
15 x 8 x 6 in. (38.1 x 20.3 x 15.2 cm)
Amon Carter Museum, Fort Worth
Shown in Los Angeles, Montgomery, and Wichita only
Plate 135

SEATED NUDE
1930
Alabaster
14¼ x 16 x 15 in. (36.2 x 40.7 x 38.1 cm)
John P. Axelrod, Boston
Plate 144

Robert Laurent was the earliest practitioner of direct carving during its reemergence as an important technique in early twentieth-century American sculpture. He promoted the technique through his art, teaching, and patronage. Through his art and collection he was also crucial in the appreciation of American folk art.

While still a child in Brittany, Laurent's talent was discovered by the American painter, publisher, and critic Hamilton Easter Field. Field took charge of Laurent's artistic training, supervising his studies in New York City (1901–4) and for the following six years in Paris, London, and Rome. Attending the British Academy in Rome, Laurent worked with Field and the American modernist painter Maurice Sterne and learned to carve from the framemaker Giuseppe Doratori.

Laurent settled permanently in the United States (1910), continuing his work in wood, carving furniture and frames. Strongly impressed by the sculpture of Alexander Archipenko, Wilhelm Lehmbruck (1881–1919), and Aristide Maillol seen in Paris and in New York at the Armory Show and by African art, he resolved to make sculpture his career. Laurent first exhibited publicly at the Arden Gallery (1913) and with Field at the Daniel Gallery (1915). In later decades he was given solo exhibitions at the Bourgeois, Valentine, and Kraushaar galleries.

When Field died, Laurent was his sole heir, inheriting his mentor's Brooklyn and Maine residences. He continued Field's practice of exhibiting and promoting progressive artists at both his houses. The Ogunquit property became one of the best-known art colonies of the era. Laurent also continued Field's interest in folk art, and his American collection, which he began in the late 1910s, became famous among artists, critics, and collectors and contributed substantially to the rebirth of interest in naive art.

Laurent carved his earliest sculptures in wood; these consisted primarily of relief panels and heads inspired by African motifs. At this time he also experimented occasionally with pure abstraction. By the 1920s he was depicting animals and plants, usually in simplified terms reminiscent of folk art. During the 1920s, encouraged by the example of Gaston Lachaise, Laurent increasingly turned to the female nude, often depicting her in alabaster. Critics and scholars agree that it was in his work in alabaster that he attained his highest level of artistic achievement. Compact and closed in contour, his nudes possess a voluptuousness intensified by the translucency of the stone, which he polished so that it appeared soft and sensuous.

209

Arthur Lee

Born 1881 Trondjhem, Norway
Died 1961 Newtown, Connecticut

Laurent received several notable commissions during the 1930s, for Radio City Music Hall and for the Treasury Section. However, his most significant contribution during his later years was as a teacher. He taught intermittently at the Art Students League (1919–34) and sporadically at other East Coast institutions. In 1942 he joined the faculty of Indiana University, where he remained until his retirement in 1960.

Sources

Laurent, Robert, papers, AAA.

The Index of Twentieth Century Artists 2 (August 1935): 161–63; 3 (August–September 1936): 31.

Kent, Norman. "Robert Laurent, a Master Carver." *American Artist* 29 (May 1965): 42–47, 73–76.

Moak, Peter V., and Henry R. Hope. *The Robert Laurent Memorial Exhibition.* Exh. cat. Durham: University of New Hampshire, 1972.

Strawn, Arthur. "Robert Laurent." *Outlook and Independent* 157 (1 April 1931): 479.

VOLUPTÉ

1915

Marble

38⅜ x 15 x 10 in. (97.5 x 38.1 x 25.4 cm)

The Metropolitan Museum of Art,

given anonymously, 1924

Plate 61

Arthur Lee contributed to the revitalization of classicism in American sculpture during the 1910s and 1920s.

Immigrating with his family to Minnesota in 1888, Lee spent his childhood participating actively in outdoor sports, and it was during this time that he first became fascinated with the human body. In 1902 he entered the Art Students League in New York City, studying with Kenyon Cox (1856–1919), a staunch proponent of the classical tradition. To continue his classical training he traveled to Paris in 1905 to study at the École des Beaux-Arts. For the next five years he attended school and visited museums in London, Paris, and Italy, examining ancient Greek sculpture in particular. He credited his association with the modernists, however, for providing the most fruitful stimulation; he was a friend of Constantin Brancusi, Pablo Picasso, Morgan Russell, and Max Weber and frequented the salon of Gertrude Stein, where he immersed himself in discussions on aesthetics. He would return to Paris (1914) for three more years. During his studies abroad Lee received a monthly stipend from Gertrude Whitney.

In New York for the Armory Show, Lee exhibited four figurative sculptures, all nudes (1913). One, titled *Ethiopian* (1912), was probably a portrait of Jack Johnson, the first African American to win the world heavyweight boxing championship. Despite the contemporaneity of this theme, Lee became best known for nudes based on subjects from classical antiquity.

By the 1920s Lee had settled in New York City in a studio on Macdougal Alley, near his patron's studio. Wildenstein accorded him a solo exhibition (1921), which was well received. Always suggesting the softness of flesh in his modeling, Lee retained a serious concern for form and volume, simplifying torso, limbs, and head. Although he was considered one of the rising, young modernists at the Armory Show, his allegiance to classical themes and to the belief in ideal beauty intensified over the next decade. He occasionally exhibited in the 1930s, and at least one sculpture of an athletic male nude suggests affinities with the figurative art of Richmond Barthé, who was just beginning to be known.

Lee is presently better remembered as a teacher than a sculptor. He was an instructor at the Art Students League (1930–32, 1938–43), where he taught life and portrait modeling. In 1938 he opened his own drawing school.

Sources

Lee, Arthur, papers, AAA.

"Arthur Lee, an American Sculptor in the Classical Tradition." *Vanity Fair* 25 (September 1925): 58.

The Index of Twentieth Century Artists 3 (June 1936): 301–2.

Slusser, Jean Paul. "A Note on Arthur Lee." *International Studio* 79 (June 1924): 171–76.

Wescott, Glenway. "Picasso, Matisse, Brancusi, and Arthur Lee." *Vanity Fair* 24 (June 1925): 56, 86. Interview with Lee.

Seymour Lipton

Born 1903 New York City
Died 1986 Locust Valley, New York

COLD MAN
1938
Mahogany
23 x 7½ x 8½ in. (58.4 x 19.1 x 21.6 cm)
Courtesy, Maxwell Davidson Gallery,
New York City
Plate 109

SPIRITUAL
1942
Mahogany
26 x 9¾ x 13⅛ in. (66 x 24.8 x 33.3 cm)
Courtesy, Maxwell Davidson Gallery,
New York City
Plate 134

More than any other American carver of the years before World War II, Seymour Lipton created powerful, expressionist wood sculptures that decry the social injustices of the era.

As a teenager Lipton was interested in art, but it was around 1928–30, while practicing dentistry, that he began to model heads of friends and family in Plasticine. Completely self-taught, Lipton turned to direct wood carving (1933) and spent the next decade devoted to that technique. A great admirer of both primitive art and German expressionism, in particular the sculpture of Ernst Barlach (1870–1938), Lipton was inspired to convey power and brutality in his carved forms, often leaving the surfaces roughened with chisel marks.

Unlike most artists of the 1930s, Lipton did not need to support himself on any of the federal art projects because he maintained his dental practice until 1940. He did, however, participate actively in group exhibitions, especially those with political associations, beginning in 1933, when he contributed *Lynched*, his first direct carving, to an exhibition entitled *Hunger, Fascism, War* sponsored by the John Reed Club. Lipton's work accorded well with the temper of the times and the Marxist politics of the club, for he was primarily interested in commenting on domestic and international political problems. Lipton did occasionally depict innocuous subjects and around 1940 became increasingly interested in musical themes, in particular African American spirituals. He held his first solo exhibition at A.C.A. Gallery (1938). Two years later he began his teaching career at the New School for Social Research.

Stylistically the distortion in Lipton's figures expressed in formal terms the pathos of his subjects. In 1937 he made his first partial figure, the fragmentation increasing thereafter, so that by 1940 his figures verged on abstraction. By 1945 he had decided that the figure and social concerns were too constricting for art, and he abandoned both for broader themes, at first with references to biology and myth. The forms of his wood carvings had become increasingly elongated and abstract and formed a logical transition to the boldly charged lead and bronze abstract expressionist sculptures of his mature years. He also devoted considerable time to writing treatises on aesthetic experience.

Sources

Lipton, Seymour, interview with Sevim Fesci, 1968, OHC; and papers, AAA.

Driscoll, John, and Michael St. Clair. *Seymour Lipton: The First Decade.* Exh. cat. New York: Babcock Galleries, 1993.

Elsen, Albert. *Seymour Lipton.* New York: Abrams [1974].

Lipton, Seymour. "Experience and Sculptural Form." *College Art Journal* 9 (autumn 1949): 52–54.

Tarbell, Roberta K. "Seymour Lipton's Carvings: A New Anthropology for Sculpture." *Arts Magazine* 54 (October 1979): 78–84.

Boris Lovet-Lorski

Born 1899 Russia (Lithuania)
Died 1973 New York City

SALOME WITH HEAD OF
JOHN THE BAPTIST
By 1937
Belgian marble
17 x 29 x 11 in. (43.2 x 73.7 x 27.9 cm)
John P. Axelrod, Boston
Plate 7

During the 1920s and 1930s Boris Lovet-Lorski established the standard for art deco sculpture with his highly stylized figures presented in expensive and exotic materials.

Raised on his family's remote Lithuanian estate, Lovet-Lorski moved to St. Petersburg, where he attended the Conservatory of Music and the Royal St. Petersburg Academy of Fine Arts (1914–16), studying sculpture with Gugo Romanovich Zaleman (1859–1919) as well as painting and architecture. The chaos preceding the Bolshevik Revolution led him to leave Russia (1916) and eventually Europe, joining his brother in Boston (1920).

Within a few months of his arrival in America, Lovet-Lorski presented his sculpture and drawings in his first solo exhibition at the Grace Horne Gallery in Boston. The following year the Layton School of Art in Milwaukee hired him to head its sculpture department, and the Milwaukee Art Institute displayed his sculptures at another solo exhibition. After two years in the Midwest Lovet-Lorski settled in New York City, where he held his largest sculpture exhibition (1925) at the Reinhardt Galleries. For the next twenty years the artist would be accorded numerous exhibitions at commercial galleries and public institutions throughout the country, the plethora of solo displays indicative of his commercial success. Lovet-Lorski maintained a studio in Paris (1926–32), but he traveled frequently, often to complete portrait commissions. He lived intermittently in Los Angeles (1932–34), where he was popular with actors and musicians.

211

Paul Manship

Born 1885 St. Paul, Minnesota
Died 1966 New York City

He had moved to Paris to pursue his growing interest in direct carving. He was hailed for his technical virtuosity and well known for the rare and fragile stones that he preferred to use—onyx, jade, slate, and especially black marble—and for his highly polished surfaces. His handling of stone complimented the art deco designs that he had already begun to develop. In languorous female nudes he combined classical simplicity, elegance, and an archaism derived from the primitivism of Constantin Brancusi and Pablo Picasso. By the 1930s his work also partook of the popular fascination with exotic cultures; his women often have slanted eyes, broad, flat noses, and thick lips. While this stylization occasionally appeared in his portraits, it was more characteristic of his symbolic and imaginary figures, which were usually based on ancient mythology and pagan rituals. Lovet-Lorski also became known for his stylized horses, which were flat and linear, usually cast in metals and highly polished, emphasizing their Machine Age aesthetic.

Wildenstein gave Lovet-Lorski a twenty-year retrospective (1940), which marked the end of his significant work. Although he continued to receive portrait commissions, crippling arthritis resulted in the artist abandoning direct carving for modeling in 1939.

Sources

Armitage, Merle. *Sculpture of Boris Lovet-Lorski.* New York: Weyhe, 1937.

Bush, Martin H. *Boris Lovet-Lorski: The Language of Time.* Exh. cat. New York: Syracuse University School of Art, 1967.

Erskine, John. *Tribute to Woman: Boris Lovet-Lorski Sculpture.* New York: Barnes, 1965.

Kozol, Paula M. "Lovet-Lorski." In *American Figurative Sculpture in the Museum of Fine Arts, Boston,* p. 435–38. Boston: Museum of Fine Arts, 1986.

Lovet-Lorski, Boris. *Exhibition of Sculpture by Boris Lovet-Lorski.* Exh. cat. Milwaukee: Milwaukee Art Institute, 1921.

DANCER AND GAZELLES
1916
Bronze
32½ x 34¾ x 11¼ in. (82.6 x 88.3 x 28.6 cm)
National Gallery of Art, Washington, D.C.,
gift of Mrs. Houghton P. Metcalf
Plate 55

From 1915 to World War II Paul Manship was the outstanding disciple of the American Academy in Rome, commanding admiration with his modernist interpretation of classicism. His creation of a decorative, archaic style, heavily influenced by preclassical art, became a popular sculptural idiom during the 1920s.

Manship moved to New York City (1905) to study at the Art Students League. He also briefly attended Charles Grafly's class at the Pennsylvania Academy of the Fine Arts (1907–8). He served simultaneously as an assistant to Solon Borglum and Isidore Konti. Winning the Prix de Rome enabled him to study at the American Academy (1909–12).

Ancient art in Italy and Greece captured Manship's attention, though it was archaic sculpture rather than the sculpture of classical Greece that particularly attracted him. Using these preclassical works as well as examples from non-Western sculpture as his inspiration, Manship rejected naturalistic description for flattened form and simplified, abstract shapes. Relying more upon the elements of form and design, he created a streamlined and decorative style.

A solo exhibition at the Architectural League (1913) the year after his return to New York led to Manship's receiving several commissions for garden and architectural sculpture. He was given an exhibition at the Pennsylvania Academy of the Fine Arts (1914), and the Carnegie Institute organized a traveling show of his work (1915). A gold medal won at the Panama-Pacific International Exposition secured his reputation.

Manship returned to Europe (1921), living in Paris until 1926, with the exception of a year's professorship in sculpture at the American Academy in Rome. He took advantage of his residence abroad to travel to the countries of the Mediterranean; he returned to Europe several times in later years.

Throughout the 1920s and 1930s Manship created both large public works and tabletop sculpture. Private and public commissions, such as reliefs for the American Telephone and Telegraph Company in New York (1914) and the gates of the Bronx Zoo and *Prometheus Fountain* for Rockefeller Center (both completed 1934), consumed much of his time. His figures, frequently accompanied by animals, were nudes representing Greek gods, personalities, or themes. Most of Manship's clay models were cast in bronze: his polished surfaces complemented an emphasis on silhouette. Often his figures were mannered and flat like reliefs, while decorative details sometimes created a sense of opulence.

Manship taught at the Pennsylvania Academy of the Fine Arts (1943–47) and served as president of the National Sculpture Society (1939–42) and later as acting president (1945–46). By World War II his creativity had waned.

Sources

Manship, Paul, papers, AAA.

Manship, John. *Paul Manship.* New York: Abbeville, 1989.

Murtha, Edwin. *Paul Manship.* New York: Macmillan, 1957.

Rand, Harry. *Paul Manship.* Exh. cat. Washington, D.C.: Smithsonian Institution Press for National Museum of American Art, 1989.

Rather, Susan. *Archaism, Modernism, and the Art of Paul Manship.* Austin: University of Texas Press, 1993.

Berta Margoulies

Born 1907 Lowitz, Poland

MINE DISASTER
1942
Bronze
22¾ x 29⅛ x 12¼ in. (57.8 x 74 x 31.1 cm)
Whitney Museum of American Art,
purchase
Plate 73

Berta Margoulies explored the evocative potential of the simplified human figure in sculpture that expressed her compassionate regard for humankind.

After losing much of her family in World War I, Margoulies arrived in New York City (1921) a refugee. After graduation from Hunter College (1927), she modeled in clay at the Educational Alliance (1929), and realizing that she wanted to be a sculptor, she subsequently studied at the Art Students League (1929) on scholarship with Robert Laurent, Edward McCartan, and Eugene Steinhof. A fellowship enabled her to study abroad (1930). In Paris she pursued traditional training at the Académie Julian. Not until she returned to New York did she reject academicism for a more modernist interpretation of the human figure.

By the late 1930s Margoulies had developed her own simplified, figurative mode and thereafter did not deviate much from it. Although she was a close friend of William Zorach and other direct carvers and occasionally carved herself, Margoulies preferred modeling, especially in terra-cotta. While abroad she had become familiar with the simplified approach to human anatomy of Charles Despiau (1874–1946) and Aristide Maillol and the drama and expressionist distortion of Käthe Kollwitz (1867–1945). She also admired the sculpture of Ernst Barlach and Chana Orloff (1888–1968). These influences helped her to abstract and distort anatomy for expressive purpose. She often incorporated architectural elements into her figure groupings to enliven their compositions.

Margoulies's themes were usually of broad humanistic concerns or contained religious references. The artist had worked for a year during the Depression as a social worker, and marrying Eugene O'Hare, she became the daughter-in-law of a well-known social activist, Kate Richards O'Hare. Margoulies shared with Kollwitz a compassionate view of humanity, and like her depicted women more frequently than men. Women, she thought, were always waiting—for their husbands, for their children, for the end of war—and so she portrayed this theme throughout her career.

While Margoulies exhibited in museum annuals, she was most active with the newly formed Sculptors Guild, assisting in its organization and administration as its first secretary (1937) and exhibiting regularly with this group of artists. Margoulies's clear, figurative style accorded well with the aesthetics of the federal art projects. Consequently, she received three commissions (1936–41), the most important, a figure in aluminum for the Post Office Building in Washington, D.C. She created *Woman and Deer* (1939) for the garden court of the federal building at the World's Fair, the same year that she began her long teaching career at Finch College in New York City.

Sources

Margoulies, Berta, interview with Ilene Susan Fort, 4 September 1992.

Margoulies, Berta, lecture, 24 May 1989, Museum of Fine Arts, Boston (on tape, AAA).

"Berta Margoulies." In Rubinstein, pp. 263–66.

Octavio Medellin

Born 1907 Matehuala, Mexico

THE SPIRIT OF THE REVOLUTION
1932
Texas limestone
32 x 16 x 20 in. (81.3 x 40.6 x 50.8 cm)
Collection of Mrs. Octavio Medellin
Plate 115

Octavio Medellin derived the iconography of his bold, figurative carvings from his Hispanic heritage, becoming one of the most admired sculptors in Texas.

Seeking to escape the turmoil of civil war, the sculptor's father moved his family to San Antonio, then returned to Mexico, where he was killed. Social upheaval in his native country and the death of his father made a lasting impression on the young boy and determined much of the spirit of his mature sculpture of the 1930s and 1940s.

Medellin attended the San Antonio Art Institute as a teenager and the School of the Art Institute of Chicago (1928–29). In Chicago he became acquainted with the sculpture of John Flannagan and William Zorach. During the first of several study trips to Mexico he was spellbound by pre-Columbian and contemporary Mexican art, especially the carvings of Yucatan Indians. By the early 1930s in San Antonio he had adopted the direct-carving technique, hewing primitive-looking heads out of wood. Medellin would later turn to carving in stone, sometimes choosing native Texan materials.

The artist soon attracted regional attention. The Witte Museum of San Antonio held a one-man exhibition (1938), and the Dallas Museum of Art honored him with shows (1939, 1942). He exhibited at the World's Fair (1939). Medellin received national recognition when the Museum of Modern Art included him in its landmark exhibition *Americans 1942*. He also enjoyed a long teaching career at North Texas State Teachers College, Denton, beginning in 1938, and then at the Dallas Museum of Art (1945–66).

213

Of Otomi Indian descent, Medellin symbolized in many of his carvings the Indian people of Mexico and their age-old struggles for peace and independence. Though he sometimes gave a personal interpretation to motifs adopted from religion, especially Catholicism, and the mythology of Mesoamerican culture, he intended his themes to have universal import. His figures were massive and strong, but he often distorted anatomy to express the anguish of the Mexican peasantry.

Sources

Medellin, Octavio, papers, AAA and GAR.

Hendricks, Patricia D. "Texas Sculpture and the Figural Tradition (1860–1960)." In *A Century of Sculpture in Texas, 1889–1989*, eds. Hendricks and Becky Duval Reese, pp. 51–53, 75–76. Exh. cat. Austin: Archer M. Huntington Art Gallery, University of Texas, 1989.

Medellin, Octavio. Artist's statement. In *Americans 1942: 18 Artists from 9 States*, ed. Dorothy C. Miller, pp. 102–6. Exh. cat. New York: Museum of Modern Art, 1942.

Stewart, Rick. *Lone Star Regionalism: The Dallas Nine and Their Circle.* Exh. cat. Dallas: Dallas Museum of Art, 1985.

Walker, NaDeane. "Masters from Mexico." *Avesta* 20 (summer 1941): 8–11.

Ethel Myers

Born 1881 Brooklyn, New York
Died 1960 Cornwall, New York

FIFTH AVENUE GIRL
(also known as PORTRAIT IMPRESSION OF MRS. ADOLPH LEWISOHN)
1912
Bronze
8¾ x 2⁹⁄₁₆ x 2⁹⁄₁₆ in. (22.2 x 6.4 x 6.4 cm)
Gary and Brenda Ruttenberg
Plate 78

Ethel Myers created satirical bronzes in the Ashcan school tradition.

Orphaned at a young age, Mae Ethel Klinck was adopted by a wealthy couple, who encouraged her interest in art and music. She studied painting at the Chase School of Art (1898–1904), first with William Merritt Chase (1849–1916), then Robert Henri. It was the latter who urged her to go out in the street to observe the people. By the time her training ended, she had made hundreds of expressionist sketches of everyday subjects in the spirit of what would soon be referred to as the Ashcan school.

She met and married fellow Ashcan painter Jerome Myers (1867–1940) in 1905 and after their daughter's birth (1906) abandoned painting in favor of modeling small clay figures because of the limited space in the studio she shared with her husband. Her subjects continued to be the colorful types seen on the streets of New York City, haughty matrons, coquettes, and Broadway celebrities. Often in the tradition of Honoré Daumier (1808–79) she portrayed them satirically. Since she could only afford to cast a few examples in bronze, she painted many of her plasters and considered them finished works. Her reason for beginning to work in ceramics was probably financial. She produced brightly glazed terracottas and would eventually teach ceramics at the New York School of Art and in her own studio, where she had a kiln.

Fifteen of her sculptures were exhibited at Folsom Galleries to favorable reviews (1912), and nine were chosen for display at the Armory Show. There her subject matter was described as a "revelation."

Myers and her family went abroad in 1914, but the difficulties engendered by World War I forced their return. To help support the family, Myers became a dress designer. She also devoted much of her energy to promoting her husband's career. This did not leave much time for her sculpture, although she did exhibit occasionally, participating in shows at the Pennsylvania Academy of the Fine Arts (1920) and Carnegie Hall Gallery (1940).

Sources

Myers, Ethel, papers, AAA.

"Ethel Myers." In Rubinstein, pp. 211, 217–20.

Katz, Leslie. *Ethel Myers.* Exh. cat. New York: Schoelkopf Galleries, 1966.

"Notes of General Interest: At the Folsom Galleries." *Craftsman* 23 (March 1913): 724–26.

Ruthrauff, Florence. "Psychology of Clothes, as Shown in the Art of Ethel Myers." *Arts and Decoration* 4 (July 1914): 350–51.

Elie Nadelman

Born 1882 Warsaw, Russia (Poland)
Died 1946 New York City

DANCER
(also known as HIGH KICKER*)*
c. 1918–19
Painted and gessoed cherry wood
29½ x 26¾ x 13 in. (74.9 x 68 x 33 cm)
Private collection
Shown in Los Angeles only
Plate 99

CIRCUS PERFORMER
c. 1919
Painted and gessoed cherry wood with
graphite
31⅜ x 8¾ x 9⅜ in. (79.7 x 22.2 x 23.9 cm)
Hirshhorn Museum and Sculpture
Garden, Smithsonian Institution, gift of
Joseph H. Hirshhorn, 1966
Shown in New York City only

MARIE SCOTT
1919
Marble on bronze base
26½ x 8½ x 10 in. (67.3 x 21.6 x 25.4 cm)
Los Angeles County Museum of Art,
gift of Mrs. Stevenson Scott
Plate 2

SEATED GIRL WITH POODLE
1935
Glazed terra-cotta
8 x 6 x 4 in. (20.3 x 15.2 x 10.2 cm)
E. Jan Nadelman

STANDING WOMAN
1935
Plaster
9 x 4 x 3 in. (22.9 x 10.2 x 7.6 cm)
E. Jan Nadelman

Elie Nadelman was one of America's most
creative and innovative sculptors, locating the
sources of his art in classicism, cubism, and
folk art. His witty, painted wood figures epito-
mized the sophistication of his era.

The son of wealthy Polish Jews, Nadelman
attended the art academy in Warsaw before
and after service in the Russian imperial army.

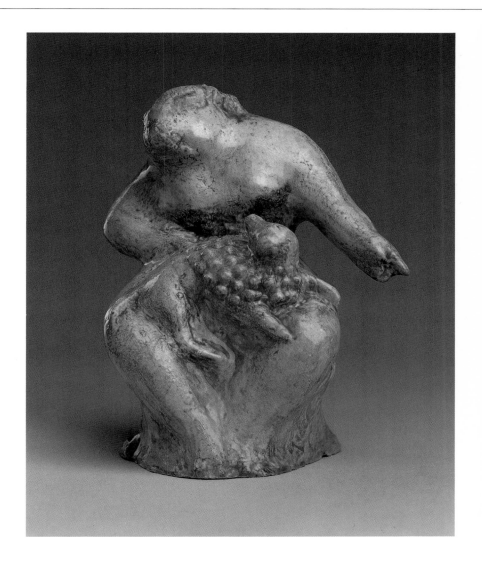

Elie Nadelman, SEATED GIRL
WITH POODLE

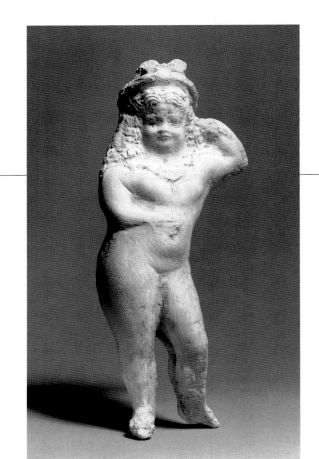

Elie Nadelman, STANDING WOMAN

He visited Munich (1904), then settled in Paris, where he remained for a decade, achieving initial recognition. In France he synthesized both traditional and progressive ideas, drawing at the Académie Colarossi, studying classical and Renaissance art and the sculpture of Rodin at the Louvre and other French collections, and participating in Gertrude Stein's avant-garde circle. Nadelman exhibited in Barcelona, London, and Paris and won critical success and patronage with a modern interpretation of classical elements: his idealized heads and full figures were reminiscent of antique sculpture but demonstrated a modernist interest in simplified geometric form. In low-relief panels he interpreted human anatomy as a series of rippling, crescent shapes and later claimed to have created the first cubist sculpture.

At the outbreak of World War I Nadelman, with the assistance of his first patron, Helena Rubinstein, sailed to New York City. Alfred Stieglitz gave Nadelman his first American solo exhibition (1915) the year after his arrival. Two years later Scott and Fowles accorded him another. Nadelman quickly attracted numerous wealthy patrons who longed to have him sculpt their portraits; in these commissioned works he utilized the soft, classical style of his Paris years. He married a New York socialite, Viola Spiess Flannery, and together they led an extravagant life, acquiring a fashionable Manhattan town house and country estate in Riverdale-on-Hudson, New York.

Nadelman and his wife pioneered the interest in American folk art, amassing a huge collection, which they displayed in a special building on their country property. His sculpture reflected this new interest; first in plaster and then wood he simplified and streamlined his figure type. Around 1918 he began a series of entertainers and socialites made from wood, usually polychromed, which were meant to look like folk figurines.

Satirical, these were not well received; today, however, they rank as his most significant contribution to American sculpture.

Between 1922 and 1924 Nadelman utilized the new technique of galvanoplasty (electroplating a thin layer of bronze over a plaster model) in place of bronze casting. The 1929 stock market crash ended Nadelman's commissions and luxurious lifestyle. He sold his folk art collection and moved permanently to Riverdale. Although he refused to exhibit publicly after 1930 and was consequently forgotten, Nadelman continued to sculpt. During the 1930s and 1940s he worked primarily on a small scale with terra-cotta, papier-mâché, and plaster, modeling hundreds of single and double figurines of stocky women standing and sitting in a variety of poses. Some of these he colored and glazed; on others he left pencil or scratch marks for details. They became a personal language for Nadelman, and as with Rodin, whom he greatly admired, demonstrated an obsessive fascination with the human body in all its myriad anatomical permutations.

Sources

Baur, John I. H. *The Sculpture and Drawings of Elie Nadelman, 1882–1946.* Exh. cat. New York: Whitney Museum of American Art, 1975.

Birnbaum, Martin, "Elie Nadelman," in *Introductions: Painters, Sculptors and Graphic Artists*, pp. 59–68. New York: Sherman, 1919.

Goodman, Jonathan. "The Idealism of Elie Nadelman." *Arts Magazine* 63 (February 1989): 54–59.

Kertess, Klaus. "Child's Play: The Late Work of Elie Nadelman," *Artforum* 23 (March 1985): 64–67.

Kirstein, Lincoln. *Elie Nadelman.* New York: Eakins, 1973.

Isamu Noguchi

Born 1904 Los Angeles, California
Died 1988 New York City

LEDA

1928 (reconstructed, 1985)
Brass on plastic base
23⅜ x 14¼ x 11 in. (59.4 x 36.2 x 27.9 cm)
The Isamu Noguchi Foundation, Inc.,
New York City
Plate 64

DEATH

(also known as LYNCHED FIGURE*)*
1934
Monel metal, wood, rope, and steel armature
Figure: 36 x 17 x 33½ in. (91.4 x 43.2 x 85.1 cm)
Armature: 88¼ x 44 x 33½ in.
(214 x 111.8 x 85.1 cm)
The Isamu Noguchi Foundation, Inc.,
New York City
Plates 76 and 112

One of the foremost American artists of the twentieth century, Isamu Noguchi emerged as a prominent sculptor in the period between the world wars. Fusing his Eastern and Western heritages, he combined tradition and modernity to produce extraordinary abstract sculpture.

Born in Los Angeles to a Japanese father and American mother, Noguchi spent his childhood in Japan, where as a boy he worked for a cabinetmaker. He returned to the United States (1917) and for a short time apprenticed with Gutzon Borglum (1921). In New York City to attend Columbia University Medical School (1923), Noguchi also enrolled at the Leonardo da Vinci Art School. Working there under Onorio Ruotolo, Noguchi determined to become a sculptor. A Guggenheim fellowship enabled him to travel to France (1927), where he met Alexander Calder and became Constantin Brancusi's studio assistant. He was given a one-man show at the Eugene Schoen Gallery immediately upon his return to New York City (1928) and two years later three more solo exhibitions in New York, Boston, and Chicago.

It was after his French sojourn that Noguchi began creating abstract constructions of metal rods, amorphous pieces of brass, wood, and stone. Failing to capture a following with his constructions, he turned to portrait commissions as a means not only of subsistence but of financing his more progressive projects and subsequent trips abroad. In heads of the early 1930s he transformed the academic realism of Ruotolo by simplifying human anatomy into generalized forms and rippling surfaces. Using a variety of materials and techniques (modeling, carving, construction), Noguchi won praise for his ability to capture his sitters' personalities.

After traveling to Asia to study brush drawing and ceramics (1931), he incorporated ideas from ancient Chinese and Japanese mortuary sculpture as well as European surrealism and constructivism into his abstract work. The late 1930s and early 1940s were years of great experimentation. The artist occasionally dealt with social themes and like many of his contemporaries was fascinated by modern dance. With his set design for *Frontier* (1935) he began a long association with Martha Graham. By the end of the decade he was planning the large environmental sculptures that, when constructed later, would establish his reputation internationally. He also initiated excursions into other art forms: designing furniture, lamps, and fountains.

Following World War II Noguchi was increasingly awarded commissions for large-scale public sculpture and environments in the United States and abroad. In 1967 the Whitney Museum of American Art gave him a retrospective exhibition.

Sources

Altshuler, Bruce. *Noguchi.* Modern Masters series, vol. 16. New York: Abbeville, 1994.

Ashton, Dore. *Noguchi: East and West.* New York: Knopf, 1992.

Grove, Nancy. *Isamu Noguchi: Portrait Sculpture.* Exh. cat. Washington, D.C.: Smithsonian Institution Press for National Portrait Gallery, 1989.

Grove, Nancy, and Diane Botnick. *The Sculpture of Isamu Noguchi, 1924–1979: A Catalogue.* New York: Garland, 1980.

Noguchi, Isamu. *A Sculptor's World.* New York: Harper & Row, 1968.

Nancy Prophet

Born 1890 Warwick, Rhode Island
Died 1960 Providence, Rhode Island

CONGOLAIS
1931
Wood
17⅛ x 6¾ x 8¹/₁₆ in. (43.5 x 17.2 x 20.5 cm)
Whitney Museum of American Art,
purchase
Plate 156

Heralded by W. E. B. DuBois as this nation's "greatest Negro sculptor," Nancy Elizabeth Prophet carved sensitive portrayals of African Americans during the 1920s and 1930s.

Born to a Narragansett Indian father and a mother who described herself as a "mixed Negro," Prophet was the only woman of color to be graduated in 1918 from the Rhode Island School of Design. Four years later she left for France with her husband, Francis Ford. In Paris Prophet enrolled at the École des Beaux-Arts under Victor Ségoffin (1867–1925). Despite a precarious financial situation that always threatened her mental and physical well-being, she was able to work and in the late 1920s began to exhibit at the Paris salons. Prophet received recognition from French critics. Raymond Selig and Jules de Saint-Hilaire described her carved heads as "vigorous and energetic…conceived in a nervous style, supple and sure." Eventually Henry Ossawa Tanner praised her work and nominated it for a Harmon Foundation prize (1929). That year, having separated from her husband, she briefly visited the United States to accept the Harmon Foundation's Otto Kahn award.

When Prophet returned permanently to America (1932), she immediately won praise and the Greenough Prize for *Discontent* (before 1930) when it was shown at the Newport (Rhode Island) Art Association. There she attracted the attention of Gertrude Whitney, who purchased her *Congolais* for the Whitney Museum of American Art. Whitney also offered the use of her Newport studio to Prophet.

Flamboyant, but private, Prophet preferred to be identified with her Indian rather than African heritage. She created heads and full-length figures of both European and African Americans, but whether she depicted Native Americans is not known. Despite her disclaimer about her racial background, Prophet conveyed a compelling empathy in her sculptures of African Americans. She stood apart from most of the direct carvers of her generation, who also demonstrated an interest in different races and ethnic groups but conceived of their figures as types rather than as individuals. Although the reductive carving technique encouraged her simplified, sometimes abstract approach to form, Prophet sometimes applied colored pigments to wood to heighten naturalism.

In an attempt to ease Prophet's financial situation, DuBois helped her obtain a teaching position in Atlanta (1933). There she remained for more than a decade, encouraging students at Spelman College to work in sculpture. She authored an article in *Phylon* (1940), the publication of Atlanta University, in which she discussed the role of art in society and the need for better education for African Americans. Teaching disrupted her own work, however, and she returned to Providence (1945), where she was hospitalized for a breakdown. Her continuing health problems ended her career, and she died in obscurity and poverty.

Sources

Prophet, Nancy, diaries, John Hay Library, Brown University.

Cullen, Countee. "Elizabeth Prophet: Sculptress." *Opportunity* 8 (July 1930): 204–5.

"Elizabeth Prophet, Sculptor." *The Crisis* (December 1929): 407, 427, 429.

Four from Providence: Bannister, Prophet, Alston, Jennings. Exh. cat. Providence: Edward M. Bannister Gallery, Rhode Island College, 1978.

Kirschenbaum, Blossom S. "Nancy Elizabeth Prophet, Sculptor." *Sage* 4 (spring 1987): 45–52.

Arthur Putnam

Born 1873 Waveland, Mississippi
Died 1930 Ville d'Avray, France

FLYING MESSENGER
1904
Bronze
15½ x 7¾ x 15½ in. (39.4 x 19.7 x 39.4 cm)
The Fine Arts Museums of San Francisco,
gift of Alma de Bretteville Spreckels
Plate 28

Arthur Putnam ranked among California's most significant sculptors of the early twentieth century. He was one of the first to reject idealism for naturalism, and in bronzes of animals and humans he exhibited powerful modeling inspired by the art of Rodin.

After moving to California (1894), Putnam took classes at the San Francisco Art Students League, where his teacher, Julie Heyneman (1867–1942), discovered his talent for sculpture. Putnam's various jobs included work as a surveyor, enabling him to observe animals in the wild and inspiring his later sculpture. He traveled to Chicago (1897) and served as an apprentice to animal sculptor Edward Kemeys (1843–1907), who had been greatly influenced by the French *animalier* Antoine-Louis Barye (1796–1875). Tiring of both Chicago city life and the academic approach to sculpture he encountered there, Putnam returned to San Francisco (1899). As part of a City Beautiful movement that preceded and followed the San Francisco earthquake and fire (1906), Putnam received numerous commissions to ornament buildings, especially in the Market Street district. While he established a successful career as an architectural sculptor, today he is better known for the smaller bronzes of wild animals that he created at the same time. Putnam modeled animals and to a lesser extent human figures that were quite dynamic in terms of surface handling and pose.

Richard Recchia

Born 1888 Quincy, Massachusetts
Died 1983 Rockport, Massachusetts

Financed by patrons E. W. Scripps and Mrs. W. H. Crocker, Putnam traveled to Europe (1905). He learned bronze casting in Rome, then went to Paris, where his sculpture was shown at the Salon of the Société Nationale des Beaux-Arts (1907) and brought to the attention of Auguste Rodin. Putnam had earlier demonstrated a Rodinesque surface treatment and interest in movement, but after his firsthand encounter with Rodin and his sculpture, these tendencies were accentuated. Putnam returned to San Francisco (1907) and started his own bronze foundry. Just as his work was winning wider acclaim, he was afflicted with a brain tumor. Surgery left him incapacitated (1911), and he produced little sculpture thereafter.

Putnam's friends undertook the casting, exhibition, and promotion of his work. Four of his bronzes were included in the Armory Show, and he was awarded a gold medal at the Panama-Pacific International Exposition. Alma de Bretteville (Mrs. Adolph) Spreckels, whose husband founded the California Palace of the Legion of Honor, bought fifty-five of Putnam's plasters (1921) and had them cast by Rudier in Paris. As a result of the sale Putnam was able to retire to France. He was honored by several posthumous solo exhibitions in San Francisco.

Sources

Macbeth Gallery papers, AAA.

"Arthur Putnam." *California Art Research* 6:1–59. San Francisco: Works Progress Administration Project, 1937.

Berry, Rose V. S. "Arthur Putnam—California Sculptor." *American Magazine of Art* 20 (May 1929): 276–82.

Heyneman, Julie Helen. *Arthur Putnam: Sculptor.* San Francisco: Johnck and Seeger, 1932.

Osborne, Carol. "Arthur Putnam: Animal Sculptor." *American Art Review* 3 (September–October 1976): 71–81.

ECHO
(also known as SIREN*)*
1914
Bronze
14 x 9⅛ x 15¼ in. (35.5 x 23.2 x 38.7 cm)
Museum of Fine Arts, Boston,
bequest of Richard H. Recchia
Plate 41

Richard Henry Recchia was a prominent, early figure in progressive art circles in Boston between the wars, experimenting with Auguste Rodin's evocative interpretation of the human figure and with abstract form.

Recchia, the son of an Italian immigrant stonecutter, was apprenticed to his father, who brought his son's work to the attention of Bela Pratt (1867–1917). Pratt encouraged the younger Recchia to study modeling with him at the School of the Museum of Fine Arts in Boston (1904–7) while assisting in his studio. With the financial assistance of Pratt and Daniel Chester French (1850–1931), Recchia studied in Rome and Paris (1912–13). In Paris he attended the Académie Julian, where he met John Storrs. It might have been Storrs, a friend of Auguste Rodin, who first introduced Recchia to the art of the French sculptor. After his return to Boston, Recchia modeled ideal figurative sculptures that hint of the influence of Rodin in their fluid surfaces, sinuous curves, and use of the human form for expressing emotional states. He was later praised for his ability to probe "the psychological possibilities of his art."

In the early 1920s Recchia left Pratt's studio to devote himself entirely to his own art. During most of that decade and the next Recchia executed portrait and garden statuary commissions, remaining faithful to his early beaux-arts training with its emphasis on the allegorical female nude. He was given solo exhibitions at the Guild of Boston Artists (1923, 1934) and at the St. Botolph Club (1926).

Nevertheless he began creating small-scale bronzes of birds and other animals (1929), often with a black patina and in simple geometric volumes, stylistically similar to the Machine Age aesthetics of art deco. Local commentators attributed Recchia's streamlining of form to his recent visit to New York City and exposure to its modernist trends. At first these sculptures were criticized as caricatures rather than serious art, but within a few years he was acknowledged as one of the first abstract sculptors working in the Boston area.

Recchia established his home and studio in nearby Rockport, Massachusetts (1928), where he lived the rest of his life. He continued active participation in Boston art circles, promoting the city as an art center. He also exhibited outside the region.

Sources

Recchia, Richard H., files, Boston Public Library; papers, Gloucester (Massachusetts) Lyceum and Sawyer Free Library.

Cooley, John. "The Recchias of Rockport." *North Shore Magazine* (Manhasset, New York), 19 October 1974, 10–12.

Kozol, Paula M. "Richard H. Recchia." In *American Figurative Sculpture in the Museum of Fine Arts, Boston*, pp. 416–26. Boston: Museum of Fine Arts, 1986.

Lantz, Michael, and Theodora Morgan. "Richard H. Recchia of Rockport." *National Sculpture Review* 27 (summer 1978): 20–22, 26–27.

Proske, Beatrice Gilman. "Richard Henry Recchia." In *Brookgreen Gardens Sculpture*, pp. 216–18. Rev. ed. Brookgreen, South Carolina: Brookgreen Gardens, 1968.

Hugo Robus

Born 1885 Cleveland, Ohio
Died 1964 New York City

SUMMER AFTERNOON
1925
Silver
7 x 32 x 13 in. (17.8 x 81.3 x 33 cm)
Estate of Marjorie Content
Plate 37

During the 1920s and 1930s Hugo Robus explored the expressive potential of the human form, creating some of the most enigmatic sculpture of the period.

Robus was first a painter and craftsman. Graduating from the Cleveland School of Design (1907), he spent two years studying painting and drawing at the National Academy of Design in New York City. Returning to Cleveland, he supported himself as a jewelry designer in the workshop of Horace E. Potter (1873–1948). The young artist traveled to Europe (1912), where he combined formal study with travel. In Paris he was attracted to avant-garde art, an interest that was encouraged by Frantisek Kupka (1871–1957), Stanton Macdonald-Wright (1890–1973), and Morgan Russell. The paintings he created in Europe were boldly colored, modern compositions, ranging in style from fauve to futurism. These works were featured in his first one-man exhibition, held at the Gage Gallery in Cleveland after his return to the United States (1914). Robus settled in New York City (1915). There he immersed himself in several progressive circles: the Modern Art School, where fellow Clevelander William Zorach, and later Robus himself, taught; the Sunwise Turn bookshop, where vanguard artists, writers, and philosophers met; and the Fourteenth Street area of Greenwich Village. He bought a home in New City (1918) north of New York City, where an informal art colony was forming. John Flannagan would later be one of his neighbors. New City, where he worked in relative isolation, increasingly became his retreat.

Despite Robus's early involvement with painting while in Paris, he had enrolled at the École de la Grande Chaumière to study with Antoine Bourdelle. Robus took up sculpture again (1920), abandoning painting for the rest of his career. He modeled in clay, distorting the nude form, elongating limbs, and twisting the body so that it seemed to be missing a skeletal structure. His figures would be almost abstract organic forms, were it not for the emotions they express. Grief, laughter, prayer, adoration, and song are conveyed through the rhythms of simple lines and bulbous masses. Encouraged by the sculpture of Alexander Archipenko and Constantin Brancusi, two sculptors he admired, Robus preferred smooth surfaces and sleek, simple shapes. While many of his works remained in plaster for decades, when they were cast, the bronzes usually were highly polished.

Robus's most evocative and distinctive sculpture was created prior to 1937. In that year he began participating in federal art projects, using the more narrative and illustrative style of much project art. When he returned to his own, imaginative work in the mid-1940s, he experimented with roughened surfaces. His sculpture for the next two decades appeared no more than variations on his earlier work.

Robus exhibited his sculpture publicly for the first time at the Whitney Museum of American Art's first biennial (1933). The Munson-Williams-Proctor Institute in Utica accorded Robus his first solo museum exhibition (1948).

Sources

Robus, Hugo, papers, AAA.

Cross, Louise. "The Sculpture of Hugo Robus." *Parnassus* 6 (April 1934): 13–15.

Robus, Hugo. "The Sculptor as Self Critic." *Magazine of Art* 36 (March 1943): 94–98.

Rothschild, Lincoln. *Hugo Robus.* Exh. cat. New York: American Federation of Arts, 1960.

Tarbell, Roberta K. *Hugo Robus (1885–1964).* Exh. cat. Washington, D.C.: National Collection of Fine Arts, Smithsonian Institution, 1980.

Onorio Ruotolo

Born 1888 Cervinara, Italy
Died 1966 New York City

BURIED ALIVE
(also known as WALLED IN)
1918
Painted plaster
17½ x 11 x 11½ in. (44.5 x 27.9 x 29.2 cm)
Los Angeles County Museum of Art,
gift of Lucio Ruotolo
Plate 15

Known as the Rodin of Little Italy, Onorio Ruotolo devoted his life to art and social activism, often combining the two.

Ruotolo studied at the Royal Academy of Fine Arts in Naples, near his hometown, for six years (1900–1906). In 1906 he became the protégé of Vincenzo Gemito (1852–1929), one of Italy's great sculptors, who was then in political disfavor. Ruotolo moved to New York City in 1908. With an immigrant's idealism he became involved in the social causes of the Italian community, raising funds, for instance, for a local hospital. In 1914 with poet-activist Arturo Giovannitti he coedited *Il Fuoco* (The fire), an Italian-language literary, art, and political journal, and in 1921 founded another, *Minosse* (Minos).

Most of Ruotolo's commissions were for portraits and came from Italian organizations. He was best known for the intense naturalism of the busts he created during the 1910s and 1920s: Dante (1921) for New York University, Enrico Caruso (1921) for the Metropolitan Opera House, and the Woodrow Wilson memorial (1929) for the University of Virginia. He also modeled realistic figures of ordinary people, such as immigrants and tenement dwellers. Simultaneously Ruotolo designed more romantic sculptures in plaster, which he hoped someday to enlarge as monuments; unfortunately no such commissions were forthcoming. These were almost always groups of figures, which usually conveyed fervid social commitment; Ruotolo became one of the first sculptors in America to attack capital

punishment, racism, and poverty. Reflecting his knowledge of Rodin, Ruotolo modeled these monuments manqués with rippling surfaces, the figures sometimes emerging from seemingly unfinished stone blocks. In the 1920s he turned his attention increasingly to religious themes and supported his family as a designer of gravestones. His later designs for monuments and chapels were visionary, with stylized, large-scale figurative sculptures dominating the architecture.

It was characteristic of Ruotolo's social commitment that he established the Leonardo da Vinci Art School on the Lower East Side as a tuition-free institution for immigrant children (1922). The school disbanded for lack of funds during World War II. Ruotolo, impaired by a stroke, spent his last twenty years writing poetry, working as an activist, and serving as education director of the Shirtmakers Joint Board of the Amalgamated Clothing Workers of America (1950–57). Today Ruotolo is best known as the teacher of Isamu Noguchi.

Sources

Ruotolo, Onorio, papers, AAA; Immigration History Research Center, University of Minnesota, St. Paul; and collection of Lucio Ruotolo, Palo Alto.

Jerome, Helen. "Ruotolo, the Messenger." *Art Review* 1, no. 6 (1922): 17, 29.

Macy, John. "Onorio Ruotolo: The Man and the Artist." *Town and Country* (London), 15 October 1931; reprint, New York: Leonardo da Vinci Art School, 1938.

Winwar, Frances. *Ruotolo: Man and Artist.* New York: Liveright, 1949.

Augusta Savage

Born 1892 Green Cove Springs, Florida
Died 1962 New York City

GREEN APPLES
1928
Bronze
15¾ x 5½ x 6¾ in. (40 x 14 x 17.2 cm)
James Weldon Johnson Memorial Collection,
Yale University Collection of American
Literature, Bienecke Rare Book and
Manuscript Library, New Haven
Plate 167

Augusta Christine Savage was a leading sculptor as well as a prominent teacher and spokesperson for black cultural recognition during the 1930s.

One of fourteen children born to a poor family, Savage was modeling in clay by age six. After high school she successfully showed her work regionally and then moved to New York City to pursue further training. At Cooper Union she studied with George Brewster (1921–24).

Savage became part of the battle for civil rights in 1923; in that year she was accepted and then denied admittance to the Fontainebleau School of Fine Arts when her race was revealed. As a consequence, Hermon A. MacNeil, president of the National Sculpture Society, invited her to study with him instead. She subsequently participated in exhibitions in Baltimore and Philadelphia as well as New York, where she was active in Harmon Foundation events. In 1929 she received the first of two Rosenwald fellowships to study in Paris. She first enrolled at the Académie de la Grande Chaumière and then received training from Charles Despiau. Her work was accepted for several exhibitions, including the Salon d'Automne (1930–31).

Upon her return to New York (1932) Savage became a prominent member of the Harlem cultural scene. She established the Savage Studio of Arts and Crafts (1932) and became an administrator for the WPA/FAP (1936), lobbying for more federal support

Jacques Schnier

Born 1898 Constanza, Russia
Died 1988 Walnut Creek, California

for African American artists. A year later she became the first director of the Harlem Community Art Center, where William Artis was one of her students.

Savage was among the first to portray African American subjects in sculpture. She was initially known as a portraitist, and one of her earliest commissions was a bust of W. E. B. DuBois. Savage's most important commission was for the New York World's Fair; the only black woman artist invited to participate, she created *Lift Every Voice and Sing* (1939), deriving the idea and title from the famous "black national anthem" written by James Weldon Johnson. The sculpture consisted of a black children's choir abstracted into the shape of a harp held by a giant hand. It was so popular that miniature replicas were sold. During this period she also did genre figures of local types.

Savage was honored with a one-woman show at Argent Galleries (1939) in New York City. By the 1940s she had moved to upstate New York, and thereafter her artistic production diminished considerably. Not much of Savage's work survives for she rarely had the money to have her plaster and clay models cast.

Sources

Savage, Augusta, files, Schomburg Center for Research in Black Culture, New York Public Library.

Bearden, Romare, and Harry Henderson. "Augusta Savage." In *Six Black Masters of American Art*, pp. 77–98. New York: Zenith; Doubleday, 1972.

Bibby, Deirdre L., et al. *Augusta Savage and the Art Schools of Harlem.* Exh. cat. New York: Schomburg Center for Research in Black Culture, New York Public Library, 1988.

Reynolds, Gary A., and Beryl J. Wright. *Against the Odds: African-American Artists and the Harmon Foundation.* Exh. cat. Newark: Newark Museum, 1989.

"Augusta Christine Fells Savage." In Rubinstein, pp. 283–86.

THE KISS
1933
Teak
26 x 20½ x 5 in. (66 x 52.1 x 12.7 cm)
Mrs. Jacques Schnier
Plate 151

A notable direct carver active in the San Francisco area beginning in the late 1920s, Jacques Schnier often infused his early wood sculpture with an element of exoticism.

Schnier emigrated to the United States with his family (1903), growing up in San Francisco and receiving a civil engineering degree from Stanford University (1920). During four years spent as an engineer in Oregon, Washington, and Hawaii, he became intrigued by Asian and Pacific region art, in particular Polynesian wood carvings. He enrolled in the graduate architecture program at the University of California, Berkeley (1924) but after two years left to pursue sculpture at the California School of Fine Arts with Ralph Stackpole. He used the studio of Ruth Cravath (1902–86) and received criticism from Ray Boynton (1883–1951).

During the late 1920s he carved directly in marble and wood and completed a number of commissioned architectural sculpture projects, mainly bas-relief panels. Early on Schnier was influenced by the sculpture of Aristide Maillol, always basing his own work on the figure and designing compositions that emphasized form, which he considered essential, as well as the purity of line and rhythmic design.

Schnier began exhibiting locally (c. 1927) and winning awards. Successful solo exhibitions at the Beaux Arts Galerie in San Francisco and at the Seattle Fine Arts Society (1928), Braxton Gallery in Hollywood (1929), and Courvoisier Gallery in San Francisco (1932) provided him the wherewithal to travel around the world for a year (1932–33). Because of his interest in Asian art, he began his trip in the Far East,

ultimately devoting much time to visiting museums and ancient sites in Japan, China, Cambodia, and India. Thereafter he often used Asian women as models and infused his figures with a greater sense of movement, having been entranced by the sensual dancers of Southeast Asia. The trip not only deepened his knowledge of Asian art and culture but initiated his interest in Buddhism.

In 1933 Schnier entered psychoanalysis. That year he also published his first article on art and expression. A prolific writer, he often incorporated his expertise in psychoanalytic theory—he became a practicing analyst (1949–55)—into aesthetic issues. His most significant writing was *Sculpture in Modern America* (1948), the first book on contemporary developments by a West coast sculptor. Schnier started a long teaching career, first as an instructor at the California College of Arts and Crafts in Oakland (1935), before beginning a thirty-year association with UCB (1936).

Schnier abandoned the figure for abstract geometries after World War II and from the late 1960s explored such technologically advanced industrial materials as acrylics and polymer tubing.

Sources

Schnier, Jacques, papers, collection of Dorothy Lilienthal (Mrs. Jacques) Schnier, Mill Valley, California.

"Jacques Schnier." *California Art Research* 20:28–47. San Francisco: Works Progress Administration Project, 1937.

Patterson, Vernon. "Jacques Schnier." *Jewish Journal* 5 (24 February 1932): 3, 16.

Schnier, Dorothy, interview with Ilene Susan Fort, 30 June 1992.

Schnier, Jacques, interview with Suzanne B. Reiss, 1986, published as *A Sculptor's Odyssey.* Berkeley: Regional Oral History Office, University of California, 1987.

Viktor Schreckengost

Born 1906 Sebring, Ohio

APOCALYPSE '42
1942
Glazed ceramic
15⅜ x 20⅜ x 8⅛ in. (39.1 x 51.8 x 20.6 cm)
National Museum of American Art,
Smithsonian Institution, gift of the artist
Plate 117

Viktor Schreckengost's innovative ceramic sculpture put him at the forefront of that medium's evolution from a craft to a fine art.

A fourth-generation Ohio potter, Schreckengost studied with Julius Mihalik (1874–1943) at the Cleveland School of Art (1924–29). At Mihalik's urging he went to Vienna (1929) to continue his studies with Michael Powolny (1871–1954), a leader among European ceramic sculptors, whose free handling of clay, which acknowledged the material itself as an integral part of the design of the sculpture, immediately appealed to Schreckengost, as it had to other sculptors in Powolny's milieu. While in Vienna Schreckengost met Guy Cowan, who convinced him to return to Cleveland (1930).

Schreckengost became a designer for the Cowan Pottery Studio and a faculty member at the Cleveland School of Art, where he remained for more than fifty years. At Cowan he designed utilitarian items, mass-produced figurines, and unique ceramic sculptures. By introducing a sophisticated style of surface decoration, using sgraffito, he energized Cowan's product. Using this approach, he designed three punch bowls that earned him a first prize for ceramics at the Cleveland Museum of Art (1931). Schreckengost's work validated the company's reputation for innovation.

Throughout the 1930s Schreckengost continued to use clay to execute freestanding sculptures, often presenting the human figure in a humorous or satirical vein. Fond of music, he depicted gospel singers and jazz musicians. Two of his larger, more complicated figurative sculptures were devoted to political issues and won him special praise for their witty commentary. During the decade he continued to win awards from the Cleveland Museum of Art. He was also awarded first prize at the *Ceramic National Exhibition* at Syracuse, New York (1938), and exhibited sculpture at the New York World's Fair. After serving in the Navy during World War II, Schreckengost shifted his attention to industrial design and architectural sculpture.

Sources

Schreckengost, Viktor, papers, AAA.

Anderson, Ross, and Barbara Perry. "Viktor Schreckengost." In *The Diversions of Keramos: American Clay Sculpture, 1925–1950*, pp. 37–48. Exh. cat. Syracuse: Everson Museum of Art, 1983.

Grafly, Dorothy. "Interview: Viktor Schreckengost, Sculptor of Form in Space." *American Artist* 13 (May 1949): 48–56.

Schreckengost, Viktor. "Viktor Schreckengost of Ohio." *Studio Potter* 11 (December 1982): 74–79.

Stubblebine, James, and Martin Eidelberg. "Viktor Schreckengost and the Cleveland School." *Craft Horizons* 35 (June 1975): 34, 52–53.

Eugenie Shonnard

Born 1886 Yonkers, New York
Died 1978 Santa Fe, New Mexico

PUEBLO INDIAN WOMAN
1926
Hardwood (satina)
17¼ x 6½ x 5⅛ in. (43.8 x 16.5 x 13 cm)
Taylor Museum for Southwestern Studies of the Colorado Springs Fine Arts Center
Plate 138

One of the few resident sculptors in New Mexico, Eugenie Frederica Shonnard achieved fame during the 1920s and 1930s for her figures of Southwest Indians.

Born into a prominent Yonkers family, this deaf artist studied art with Alphonse Mucha at the New York School of Applied Design for Women. After her father's death (1911) and subsequent loss of much of the family's wealth, Shonnard traveled to Paris, studying at the École de la Grand Chaumière (1911–12). She devoted herself solely to sculpture and later received criticism from Antoine Bourdelle and occasionally from Auguste Rodin. In New York City during the war she studied at the Art Students League with James Earle Fraser, then returned to France after the armistice. She exhibited regularly at the Paris salons until 1923 and had her first solo exhibition at the Galerie Allard (1926).

Shonnard worked in a variety of materials and both modeled and carved. Her initial sculptures were portrait reliefs, but she soon expanded her repertoire to include animals, a favored subject matter throughout her career. She visited Zbiroh, Mucha's hometown, to assist her former teacher in a commission to document the Czechoslovakian people (1912); this focus on peasant lifestyle would determine the course of her mature figurative art. Upon returning to France after the war, she spent three summers in the fishing village of Côte du Nord, modeling and carving in wood figures of the Breton peasants; one was acquired by the Metropolitan Museum of Art (1925).

223

Hannah Small

Born 1903 New York City
Died 1992 Woodstock, New York

In 1919 Shonnard was introduced to Dr. Edgar L. Hewett, director of the San Diego Museum, who, learning of her interest in American Indians, encouraged her to visit Santa Fe. Six years later she spent her first summer there, modeling heads of Pueblo Indians in plaster and terra-cotta. Hewett, by then director of the Archaeological Institute of America in Santa Fe, persuaded Shonnard to settle there (1927). Thereafter, her sculptures of the human figure were solely of the Southwest Indian, usually carved in wood or stone, sometimes modeled in terra-cotta; in heads and standing figures she conveyed what she perceived as the Native American's proud demeanor and erect bearing. During the 1930s she also began decorative work, carving wooden doors and furniture and stone garden sculpture. She did much architectural sculpture, obtaining commissions, such as the reredos, polychromed sculptures, and carved ceiling beams for a private chapel near Colorado Springs. The significance of her work was realized early, and she was honored with three solo exhibitions at the Museum of New Mexico (1928, 1937, 1954).

Sources

Shonnard, Eugenie, interview with Sylvia Loomis, 1964, OHP; papers, AAA and Historical Manuscript Collection, Museum of New Mexico, Santa Fe.

"Eugenie Shonnard—Sculptor Sincere." *Santa Fe Scene*, 10 June 1961, 4–7.

Fisher, Reginald. *An Exhibition of Sculpture by Eugenie Shonnard*. Exh. cat. Santa Fe: Museum of New Mexico Art Gallery, 1954.

THE PICNIC
c. 1935
Wood with gold and silver leaf
applied by Eugene Ludins
8½ x 10½ x 9 in. (21.6 x 26.7 x 22.9 cm)
Private collection, courtesy, Guggenheim, Asher Associates, Inc., New York City
Plate 104

For most of her career Hannah Small was an esteemed Woodstock sculptor in the direct-carving tradition.

The granddaughter of academic sculptor, Sir Moses Jacob Ezekiel, and a cousin of Alfred Stieglitz, Small first enrolled in the School of Applied Design for Women in New York City, before entering the Art Students League, where she studied modeling with A. Stirling Calder and drawing with Boardman Robinson (1876–1952). After her League studies she toured England and western Europe for a year and then spent another year teaching art in Portland, Oregon. In 1923 Arnold Blanch (1896–1968), a League friend, invited Small and her husband, artist Austin Mecklem (1894–1951), to visit him at the Maverick in Woodstock. They liked it and decided to stay. (Eugenie Gershoy settled there at about the same time.)

It was in Woodstock that Small abandoned her traditional training for a more avant-garde approach. She turned to direct carving, initially inspired by her neighbor, John Flannagan. Like him, Small carved in a variety of materials—ash, cherry, ebony, alabaster, and marble—letting the wood or stone grain suggest the character of her finished figures. Unlike Flannagan, but typical of the 1930s generation of carvers, Small often juxtaposed passages of polished surface with roughened rock. In 1934 she and her second husband, Woodstock painter Eugene Ludins (b. 1902), traveled to New Mexico, where she was commissioned by the Public Works of Art Project

to execute two sculptures for the Santa Fe Public Library. Following her return to Woodstock, her Southwestern experience was reflected in the strong influence of Meso-american art on her carvings. Around this time, the mid-1930s, Small also evinced the arts and crafts spirit of the Maverick, when she and her husband began to collaborate on what they called "family art," wood carvings by Small to which Ludins applied gold or silver leaf. Throughout her career the sculptor's favorite subjects remained the female figure, often with children, and animals, all usually delineated with graceful delicacy despite the monumental quality of the stone or wood. Her mature art was established by the 1930s and did not change substantially thereafter.

Small exhibited widely at New York galleries and at museum annuals throughout the country, but she had no solo exhibitions during the 1920s and 1930s. Although she achieved a solid reputation, she never became a major force. She preferred to continue using the direct-carving technique long after progressive artists had turned to direct welding and abstract expressionism.

Sources

Small, Hannah, interview with Karl Fortess, July 1969, Fortress collection, AAA.

Krotenberg, Lisa. "Hannah Small." Ms. New York: Graduate Center of the City University of New York, 1992.

Marling, Karal Ann. *Woodstock: An American Art Colony 1902–1977*. Exh. cat. Poughkeepsie: Vassar College Art Gallery, 1977.

Steiner, Raymond J. "Profile on: Hannah Small." *Art Times* 1 (September 1984): 8–9.

"Work of Hannah Small, Woodstock Sculptor." *Kingston (New York) Daily Freeman*, 4 March 1938, 10.

Cesare Stea

Born 1893 Bari, Italy
Died 1960 Chatham, New Jersey

MAN WITH BOOK
c. 1938
Cast aluminum
31 x 8½ x 8 in. (78.7 x 21.6 x 20.3 cm)
The Mitchell Wolfson, Jr., Collection,
courtesy, the Wolfsonian Foundation,
Miami Beach, Florida, and Genoa, Italy
Plate 8

Cesare Stea was a figure sculptor active in
New York City during the 1920s and 1930s.

An immigrant in New York, Stea pursued
a long course of training. To study and support
himself at the same time, he worked as an
assistant to a number of sculptors: A. Stirling
Calder, Carl Heber (1875–1956), Hermon A.
MacNeil, and Victor Salvatore (1885–1965).
He also studied at the National Academy of
Design (1911–12), Cooper Union (1912–13), and
the Beaux-Arts Institute of Design. In the 1920s
he received criticism from Antoine Bourdelle
at the Acadèmie de la Grande Chaumière
in Paris.

Beginning in 1915 with a relief panel
for the Educational Building at the Panama-
Pacific International Exposition in San
Francisco, Stea received numerous architec-
tural and portrait sculpture commissions.
His narrative, representational style was well
suited to the federal art projects, so during the
late 1930s he won two commissions from the
Treasury Section for panels in post offices and
served on the sculpture committee of the
New York division of the WPA. He also taught
during the late 1920s and early 1930s at the
Leonardo da Vinci Art School.

While retaining his allegiance to
the figure, Stea sometimes explored a simpli-
fied, even abstract approach in his freestanding
sculptures. In a series of mother-and-child
compositions created during the 1930s, he
eliminated details and presented body parts as
solid, geometric shapes in order to explore
form and structure. His numerous architectural
sculptures probably encouraged this architec-
tonic approach. In his most stylistically pro-
gressive interpretation, *Man with Book*, Stea's
use of tubular aluminum parts for the figure
suggests an affinity with industrial technology.

Stea's independent works did not sell.
Despite participation in major sculpture exhi-
bitions—*Contemporary American Sculpture* at
the California Palace of the Legion of Honor,
the New York World's Fair, and the annuals of
the Sculptors Guild—Stea turned increasingly
to painting in the 1940s.

Sources

Stea, Cesare, papers, private collection (on microfilm, AAA).

Ruotolo, Onorio. "Arte ed Artisti: Cesare Stea." *Il Fuoco*,
1 November 1914, 8.

Who's Who in American Art, s.v. "Cesare Stea." New York:
Bowker, 1959.

John Storrs

Born 1885 Chicago, Illinois
Died 1956 Mer, France

PIETA
c. 1919
Polychromed marble
11⅛ x 9¾ x 4¹⁵⁄₁₆ in. (28.3 x 24.8 x 12.5 cm)
Courtesy, Hirschl & Adler Galleries,
New York City
Plates 13a–b

CERES
1928
Cast copper alloy with chrome plating
26 x 6 x 5 in. (66 x 15.2 x 12.7 cm)
The Art Institute of Chicago, gift of
John N. Stern
Page 226

ABSTRACT FIGURE
c. 1934
Bronze
33¾ x 9¾ x 13 in. (85.7 x 24.8 x 33 cm)
Private collection
Page 226

John Storrs was the only American-born sculp-
tor who consistently used abstraction from 1915
through the 1930s.

Born into a prominent family, Storrs
was exposed to European modernism early in
his career. After high school graduation (1905),
he spent two years in Europe, meeting such
members of the avant-garde as Maud Allan
and Gino Severini (1883–1966). Storrs worked
briefly for his father, an architect, but soon
turned to drawing and sculpture, enrolling in
several traditional art schools. He studied
modeling briefly with Bela Pratt at the School
of the Museum of Fine Arts, Boston (1909).
Then, after studying with Charles Grafly at
the Pennsylvania Academy of the Fine Arts
(1910–11), he returned to Paris. There he
studied with Paul Wayland Bartlett and Jean-
Antoine Injalbert and received criticism from
Auguste Rodin, becoming his close friend.
In 1918 he became acquainted with the art of
the British vorticists.

225

John Storrs, CERES
and ABSTRACT FIGURE

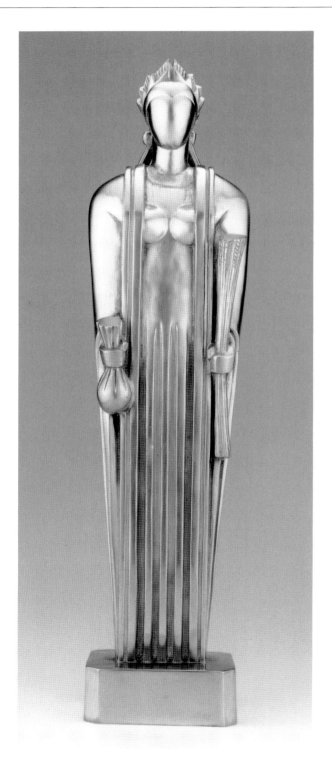

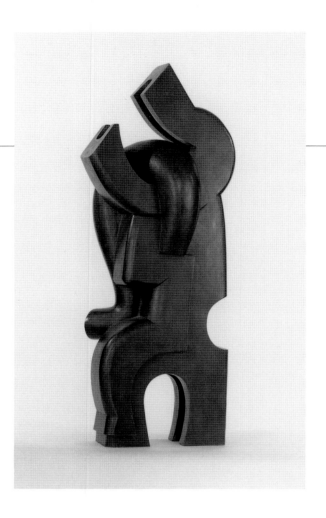

About that time Storrs began modeling and carving cubist figures in plaster, terracotta, and stone. In both his individual figures and groups he retained the semblance of the original rectangular block by placing nude figures and drapery into angular planes. Despite the architectonic appearance of the blocks, the concept of motion was important to many of his figures. Often planes or facets were painted with contrasting colors or with color against the stone, activating the figure visually. Storrs liked diagonal and zigzag motifs, and his use of these and other decorative patterns was inspired partly by Native American art, which he began collecting after his wedding trip to the West (1915).

The Folsom Galleries in New York City held Storrs's first one-man exhibition (1920), which traveled to the Arts Club of Chicago. By then the artist was creating nonobjective sculptures based on architecture. His stone, columnar forms suggest the influence of the

Lorado Taft

Born 1860 Elmwood, Illinois
Died 1936 Chicago, Illinois

architect Frank Lloyd Wright and the sculptor Alfonso Iannelli (1888–1965) in their overall narrow, block forms, inlaid panels, geometric cutouts, and angular detailing. His exhibition organized by the Société Anonyme (1923) established Storrs as one of the international avant-garde. The following year he began his most original work, combining metals of different colors in arrangements suggestive of clusters of buildings and miniature skyscraper cities.

The artist's interest in architecture naturally led to commissions for sculpture. He designed the quintessential art deco goddess, *Ceres* (c. 1929), for the Chicago Board of Trade and figures in the round as well as panels for the Century of Progress Exposition (1933). His commissioned work tended to be more conservative in a neoclassicism devoid of details.

Storrs began painting (1930), possibly because there was no commercial market for his sculpture. When the artist returned to noncommissioned sculpture (1934), he created machine-inspired figures and completely nonobjective abstractions that evince a sense of elegance. In some instances these sculptures relate to his abstract surreal paintings. Storrs divided his time between France and the United States beginning in 1920, but frustrated with the art scene at home, he moved permanently to France (1939). The war ended his career.

Sources

Storrs, John, papers, AAA.

Davidson, Abraham. "John Storrs, Early Sculptor of the Machine Age." *Artforum* 13 (November 1974): 41–45.

Dinin, Kenneth. "John Storrs: Organic Functionalism in a Modern Idiom." *Journal of Decorative and Propaganda Arts, 1875–1945* 6 (fall 1987): 48–73.

Frackman, Noel. *John Storrs.* Exh. cat. New York: Whitney Museum of American Art, 1986.

Storrs, John. "Museum of Artists." *Little Review* 9 (winter 1922): 63.

THE SOLITUDE OF THE SOUL
1901
Bronze
29 x 15 x 12 in. (73.7 x 38.1 x 30.5 cm)
Los Angeles County Museum of Art, purchased with funds provided by the American Art Council, Dr. and Mrs. Robert Carroll, Mr. and Mrs. John M. Liebes, Luppe H. and Kate Luppen in honor of Donald Reed, Brenda, Gary, and Harrison Ruttenberg, and Mr. and Mrs. William Lippman
Plate 25

One of America's most significant sculptors at the turn of the century and a leading teacher, Lorado Zadoc Taft fell under the spell of Auguste Rodin in 1900 and thereafter created poetic interpretations of the human figure.

The year after graduation from the University of Illinois (1879) Taft moved to Paris to study sculpture. He would remain six years. He was a pupil at the École des Beaux-Arts under Augustin Dumont (1801–84) and Garbriel-Jules Thomas and also worked briefly in the studio of Jean-Antoine Injalbert. One of his portraits was accepted to the Salon (1882). Upon his return to the United States (1886) he received a commission for a soldiers' monument in Winchester, Indiana, and began teaching sculpture at the School of the Art Institute of Chicago, an association that he would maintain for more than forty years. His career launched, Taft, admired for his realism, was highly sought after as a portrait sculptor during the 1890s. He also began receiving numerous commissions for statuary and fountains throughout Chicago, including his best known, the Ferguson Fountain (1913).

Rodin's influence is seen in Taft's works from the first decades of the twentieth century. Although he was in Paris during Rodin's initial rise to fame, Taft insisted he did not learn of him until the 1890s. Taft borrowed Rodin's

dramatic staging and emotive themes, sometimes even deriving his subjects from symbolist literature. He also adopted Rodin's innovative conception of public monuments, departing dramatically from previous American public sculpture. By the time of the Armory Show, however, Taft's art was considered conservative.

If Taft's art was soon out of fashion, his writings achieved lasting importance. Today he is best known as the author of *The History of American Sculpture* (1903), the first survey on the subject. His survey of European and American trends appeared as *Modern Tendencies in Sculpture* (1921).

Sources

Taft, Lorado, papers, AAA and archives, University of Illinois, Urbana-Champaign.

Garvey, Timothy J. *Public Sculptor: Lorado Taft and the Beautification of Chicago.* Urbana-Champaign: University of Illinois Press, 1988.

Taft, Ada Bartlett. *Lorado Taft: Sculptor and Citizen.* Greensboro, North Carolina: privately printed, 1946.

Weller, Allen Stuart. *Lorado in Paris: The Letters of Lorado Taft, 1880–1885.* Urbana: University of Illinois Press, 1985.

———. *Lorado Taft: The Blind.* Urbana-Champaign: Krannert Art Museum, University of Illinois, 1988.

Turku Trajan

Born 1887 Gyulafehérvár, Austria-Hungary
Died 1959 New York City

EAGLET
c. 1930s–40s
Polychromed Keen's cement
64 x 20 x 13 in. (162.6 x 50.8 x 33 cm)
Collection of Daniel J. Hirsch
Page 4

Upon hearing of Turku Trajan's death, Jacques Lipchitz asked, "How does it come that an American sculptor, absolutely original, could be unknown?" While Trajan achieved modest recognition in the 1930s, his insistence on pursuing his personal artistic vision relegated his sculpture to a place of obscurity.

Trajan immigrated to the United States (1908). His early years were typical of a sculptor in this country: study at the School of the Art Institute of Chicago with Albin Polasek, then with John Gregory and Elie Nadelman at the Beaux-Arts Institute of Design, and additional training at the Art Students League. During the 1930s he participated in group shows and served as vice-president of the newly formed Sculptors Guild.

Trajan's work differed from that of his contemporaries in several respects: his use of Keen's cement as his primary material, the unfinished appearance of his sculpture, and his incorporation of letters and words into the surface treatment. Despite references to Greek art in his classical titles and themes and the solidity of his figural pieces, his art was anything but classical or academic. Trajan simplified and expressively distorted the human form, while leaving the wet cement surfaces rough in a manner like Auguste Rodin's. In an interview (1954) the artist recounted how he would paint a sketch of each sculpture before modeling and then paint the sculpture with watercolor at various stages. As a modern classicist of the 1920s, he relied on examples of polychromed sculpture from ancient China, Egypt, and Greece and also injected a modernist note by applying the pigments

unevenly and in a manner reminiscent of careless brushwork. In addition, he sometimes added graffitilike lettering.

Because he preferred working alone and continued to create sculpture that remained within the parameters of a basically representational approach, Trajan and his art were largely neglected. His only solo exhibition during his lifetime was held at the Valentine Gallery (1944) in New York City. After his death Trajan's art received belated public recognition, and in the last thirty years his sculptures and works on paper have been accorded several exhibitions, the first at Albert Landry Galleries (1960) in New York. Chronologically part of the generation that worked between the classicism of the 1920s and the abstract expressionism of the 1940s, Trajan remained outside the mainstream. His sculpture continues to defy categorization.

Sources

Trajan, Turku, papers, AAA.

Homage to Trajan. Exh. cat. New York: Wollman Hall, New School Art Center, 1966.

Kramer, Hilton. "An Apology to Trajan." *Arts* 33 (June 1959): 26–33.

Schwartz, Paul W. "A Lost Generation." *Art and Antiques* 10 (November 1988): 91–97.

Turku Trajan: Sculpture, 1930s–1940s. Exh. cat. New York: Zabriskie Gallery, 1989.

Bessie Potter Vonnoh

Born 1872 St. Louis, Missouri
Died 1955 New York City

DAYDREAMS
1899
Bronze
10 x 20 x 12 in. (25.4 x 50.8 x 30.5 cm)
Louise and Alan Sellars Collection
Plate 50

Through her impressionistic depictions of contemporary life, Bessie Potter Vonnoh was highly influential in promoting genre themes in American sculpture.

Potter began modeling in clay as a teenager in Chicago. She showed such promise that Lorado Taft invited her (1887) to work in his studio on Saturdays. She enrolled at the School of the Art Institute of Chicago (1889) and under Taft's supervision remained there until 1892. She also served as one of his assistants, executing his sculptural decoration for the World's Columbian Exposition; at the fair she displayed two of her own portraits. Among the exhibits at the exposition she was particularly impressed by the small-scale impressionist portraits and genre figures of the Italian-born Russian aristocrat Paul Troubetzkoy (1866–1938).

Potter established her own studio in Chicago (1894). So popular were her colored plaster statuettes of society women that the revenue from their sale enabled her to tour Europe for several months with Taft and his sister. In France she visited Auguste Rodin's studio and became familiar with Jules Dalou's sculpture of contemporary maternal subjects. Thereafter her art would evince the thematic influences of Troubetzkoy and Dalou and the fluid surface treatment of Rodin.

Potter actively exhibited her modest-sized bronzes of upper-middle-class women at leisure and with their children to wide acclaim. Around the turn of the century she began dressing her figures in classical gowns inspired by modern dance. Critics remarked on the modernity of her themes. In 1899 she married

Carl Walters

Born 1883 Fort Madison, Iowa
Died 1955 Saugerties, New York

the American impressionist painter Robert Vonnoh (1858–1933). They maintained a joint studio on West 67th Street in New York City as well as a residence in Grez-sur-Loing, France, and a summer home in the artists' colony at Old Lyme, Connecticut. They also exhibited jointly. As early as 1913 the Brooklyn Museum accorded Vonnoh her first solo exhibition, and the Corcoran Gallery of Art in Washington, D.C., devoted a one-woman exhibition to her six years later. Vonnoh became the first woman sculptor to be elected an academician of the National Academy of Design (1921).

In the 1920s Vonnoh, like so many sculptors, especially women, received many commissions for large-scale garden sculpture. After the death of her husband (1933), her production sharply declined.

Sources

"Bessie Potter Vonnoh." In Conner and Rosenkranz, pp. 161–69.

Hill, May Brawley, *The Woman Sculptor: Malvina Hoffman and Her Contemporaries.* Exh. cat. New York: Berry-Hill Galleries, 1984.

Semple, Elizabeth Anna. "The Art of Bessie Potter Vonnoh." *Pictorial Review*, April 1911, 12–13.

"Some Sculpture by Mrs. Vonnoh." *International Studio* 38 (August 1909): 121–24.

Vonnoh, Bessie Potter. "Tears and Laughter Caught in Bronze: A Great Woman Sculptor Recalls Her Trials and Triumphs." *Delineator* 107 (October 1925): 8–9, 78, 80, 82.

ELLA
1927
Ceramic and metal chair
16¾ x 10¼ x 9⅜ in. (42.5 x 26.1 x 23.9 cm)
The Museum of Modern Art,
purchase, 1941
Shown in Los Angeles and
New York City only
Plate 102

WEIGHT LIFTER
1927
Ceramic
9 x 8 x 5½ in. (22.9 x 20.3 x 14 cm)
The Renee & Chaim Gross Foundation,
New York City
Shown in Montgomery and
Wichita only
Plate 103

With his humorous figures Carl Walters became one of America's most noted ceramic sculptors of the 1920s and 1930s.

Walters studied drawing and painting at the Minneapolis School of Fine Arts (1905–7). Moving to New York City (1908) to pursue a painting career, he studied with Robert Henri at the New York School of Art and then followed Henri when he left to form his own school. In 1912 Walters married artist Helen Lawrence (1878–1950), and together they moved to Portland, Oregon, where he continued his painting career.

Returning to New York (1919), Walters was inspired by the Egyptian ceramics he saw at the Metropolitan Museum of Art and began to experiment with colored glazes. By 1922 he had perfected the lost glazing method used to produce the lustrous blues found in Egyptian faience beads. During the summer of the previous year Walters had taught himself the potter's art and set up his first ceramic workshop in the artists' colony at Cornish, New Hampshire. A year later he joined the Maverick art colony, where he built a kiln and began to model ceramic sculpture, incorporating his knowledge of glazes.

The Whitney Studio Club exhibited his ceramic sculpture (1924). He had his first one-man show at the Dudensing Gallery (1927) in New York City. Beginning in 1930 he was represented by the Downtown Gallery, which held solo exhibitions of his work almost every year throughout the decade. Gertrude Whitney commissioned him to create the decorative glass panels for the inner doors of the new Whitney Museum of American Art building (1930–31). In addition, Walters received many prizes, including two Guggenheim fellowships (1935, 1936). Walters was asked to contribute the chapter on ceramic sculpture to Brenda Putnam's technical guide, *The Sculptor's Way* (1939).

Walters usually chose animals for his subjects, but he did occasionally create human figures, especially circus performers, and small figures set within shallow boxes, which he called figures-in-cabinets. His ceramics were never literal and descriptive, for he used color and surface ornament for their own sake, and there was a sense of whimsy in his figures, like those of his Maverick colony neighbor Eugenie Gershoy.

In the early 1950s, after thirty years at Woodstock, Walters moved to Palm Beach, Florida, where he established the ceramics department and taught at the Norton School of Art.

Sources

Anderson, Ross, and Barbara Perry. "Carl Walters." In *The Diversions of Keramos: American Clay Sculpture, 1925–1950*, pp. 86–95. Exh. cat. Syracuse: Everson Museum of Art, 1983.

Brace, Ernest. "Carl Walters." *Creative Art* 10 (June 1932): 431–36.

Homer, William I., comp. *A Catalogue of the Ceramic Sculpture of Carl Walters, 1883–1955.* Publications on American Art, no. 1. Ogunquit, Maine: Museum of Art of Ogunquit, 1958. Also Homer papers, AAA.

Marion Walton

Born 1899 New Rochelle, New York

ALONE
1932
Stained mahogany
32⅞ x 9 x 8 in. (83.5 x 22.9 x 20.3 cm)
The Mitchell Wolfson, Jr., collection,
courtesy, the Wolfsonian Foundation,
Miami Beach, Florida, and Genoa, Italy
Plate 75

Marion Walton won critical attention during the 1930s for her direct carvings in wood.

Walton began modeling in clay at an early age. During World War I she left Bryn Mawr College to nurse wounded soldiers. Later she studied with Leo Lentelli at the Art Students League. In France after the war to assist in the relocation of displaced refugees, she decided to remain in Paris to study sculpture. She enrolled at the Académie de la Grande Chaumière (c. 1921), working with Antoine Bourdelle. She remained in Paris until 1925, except for a brief period when she returned to the Art Students League, studying with Mahonri Young, and attended Solon Borglum's School of American Sculpture.

Despite her traditional training, when Walton resettled in New York City, she abandoned modeling for carving, preferring to work directly with her materials and believing that the technique would enable American artists to achieve independence from European traditions. Walton used the human body as a means of expressing an idea or emotion, such as the loneliness an artist might feel. Often she delineated anatomy as a series of architectonic forms. She experimented with various surface treatments: incising lines, leaving discrete passages rough, and staining the wood. Her carvings exude strength and permanence, and critics lauded her ability to retain the suggestion of the original block of wood or stone. Carl Zigrosser thought Walton's carvings indicated a "new and original turn" and gave her her first solo exhibition at Weyhe Gallery (1933).

That year she was invited to participate in the Museum of Modern Art's landmark exhibition *American Sources of Modern Art* because of her reliance on ancient Assyrian and Mesoamerican sculpture as well as African art.

Walton was to become a founding member of the Sculptors Guild (1937) and a regular exhibitor as well as a devoted participant in the exhibitions of the Whitney Museum of American Art (1938–41). She was awarded two Treasury Section commissions in the late 1930s and the honor of creating a large outdoor sculpture for the New York World's Fair. She was one of the few American artists to be included in Stanley Casson's *Sculpture of To-Day* (1939).

During the 1940s Walton worked primarily in bronze. In the early 1950s she destroyed much of her art shortly before moving to Paris.

Sources

Walton, Marion, papers, AAA.

"Marion Walton." In Rubinstein, pp. 273–75.

Walton, Marion. "A Sculptor Looks Ahead." *Magazine of Art* 33 (July 1940): 420–23.

Anita Weschler

Born 1903 New York City

From the ECCLESIASTES *series*
A TIME TO PLANT
1945
Cast aluminum
9 x 16 x 12 in. (22.9 x 40.6 x 30.5 cm)
Berman-Daferner Gallery, New York City
Plate 118

In the years prior to World War II Anita Weschler used serial sculpture innovatively to express her concern over the deteriorating situation in international politics.

After graduation from Parsons School of Design (1925), Weschler continued her studies with Robert Aitken and Charles Hinton (1869–1950) at the National Academy of Design (1925–28), with Albert Laessle at the Pennsylvania Academy of the Fine Arts' summer school at Chester Springs, Pennsylvania (1927–32), and with Edward McCartan, William Zorach, and Robert Laurent successively at the Art Students League (1929–34). She explored a variety of styles and techniques during these early years, but by the mid-1930s Weschler had developed her own reductive approach to form, often presenting her figures as clusters of cubic shapes.

After her first of four MacDowell Colony fellowships, Weyhe Gallery gave Weschler a solo exhibition (1937), at which she exhibited her first series, *Martial Music*: seven small sculptures that expressed her antiwar sentiments. The artist presented her work as thematic series because she felt that singly the sculptures were too fragmentary to communicate the universality of her political ideas. *Martial Music* included a group of robotic men marching off to war, an air raid, a frightened family, and the death of civilians by starvation and poison gas. Weschler continued to use sculpture series—*Martial Law* (1938), *Hail and Farewell* (c. 1940), and *Ecclesiastes* (also known as *Human Events*) (mid-1940s)— to express her dismay over militarization and

Warren Wheelock

Born 1880 Sutton, Massachusetts
Died 1960 Albuquerque, New Mexico

war and her belief in the collective spirit of humankind and the possibility of a peaceful future. She made the first three series in cast stone, but used a variety of materials, including aluminum, for *Ecclesiastes*. Each series was the subject of a solo exhibition: *Martial Law* at the New York Public Library (1938), *Hail and Farewell* at Weyhe Gallery (1940), and *Ecclesiastes* at Levitt Gallery (1947).

Weschler was active in art circles. She was appointed to the faculty of the Academy of Allied Arts (1936) in New York City. She was a founding member of the Sculptors Guild and became its first treasurer. Under the auspices of the Treasury Section she modeled a relief panel (1939) for the post office in Elkin, North Carolina.

Sources

Weschler, Anita, papers, AAA and GAR.

"Anita Weschler." In Rubinstein, pp. 271–73.

Weschler, Anita. "A Sculptor's Summary." *Magazine of Art* 32 (January 1939): 26–29.

MEDITATION
1935
Wood
21 x 9 x 8 in. (53.3 x 22.9 x 20.3 cm)
Ron and Jane Lerner
Plate 9

Working with geometric shapes, Warren Frank Wheelock created some of the most progressive figurative sculpture of his era, but because his work was so little appreciated, he abandoned experimentation for a more easily understood narrative style.

Wheelock enlisted in the army at age seventeen to fight in the Spanish-American War. Afterward he studied at Pratt Institute in Brooklyn (1902–5), staying on until 1910 as a drawing instructor. He supported himself for many years, beginning in 1910, with commercial work as an illustrator. Sometime in the mid-1910s he moved to the Blue Ridge Mountains of North Carolina to put his academic training behind him. He stayed five years, painting, studying local folklore, and learning to carve. From that point onward sculpture became a more significant aspect of his art. While Wheelock modeled, he preferred direct carving, for he thought wood and stone had the solid, architectonic qualities that he believed were the essence of sculpture. Wheelock was back in New York City and actively exhibiting by 1922. He became a founding member of the Society of Independent Artists. He was given his first solo exhibition (1925) in Woodstock, and the Western Museum Association circulated a show of his sculptures and paintings the following year. He continued to have one-man exhibitions periodically in New York: at Ehrich Galleries (1927), An American Group (1932), and Robinson Galleries (1940). Dartmouth College accorded him a comprehensive showing in 1940.

Exactly when Wheelock did most of his abstractions is unknown, since many of his works are undated. As early as 1923 he created the bronze *Le Coq d'or*, perhaps his most extreme step toward the nonobjective. His other abstractions were usually wood carvings that suggest seated figures, with human anatomy reduced to solid and open geometric forms: rings, spheres, and so forth. Wheelock's more representational sculpture consists of readable figures retaining strong ties with his abstract carvings through their simplification of planes and shapes. His carvings from the 1930s and early 1940s reveal the influence of folk art, and in his series of famous personalities from American history, this naive quality enhanced the element of Americana. He occasionally carved sculpture with contemporary political themes as well.

In the 1940s Wheelock continued to exhibit, participating frequently in Sculptors Guild activities. He headed the sculpture department at Cooper Union (1940–45) and wrote frequently for *American Artist*. Always intrigued by archaic, African, and Mesoamerican art, Wheelock moved to Santa Fe (1949).

Sources

Wheelock, Warren, file, Museum of Fine Arts, Museums of New Mexico, Santa Fe; papers, AAA; records and correspondence in American Artists Group, Inc.

"Warren Wheelock, Carver in Wood." *International Studio* 76 (November 1922): 140.

"Wheelock Carves with Yankee Wit." *Life*, 20 May 1940, pp. 114–17.

Wheelock, Warren. "Wood Sculpture: First in a Series on the Technic of Carving Wood." *Art Instruction* 1 (November 1937): 6–8.

Gertrude Vanderbilt Whitney

Born 1875 New York City
Died 1942 New York City

HOME AGAIN
c. 1918
Bronze
16¼ x 9 x 5½ in. (41.3 x 22.9 x 14 cm)
Collection of Mr. and Mrs. Whitney Tower
Plate 94

Although best known as a sculptor of large public monuments of a commemorative or allegorical nature, Gertrude Vanderbilt Whitney also modeled a series of smaller figures of soldiers in a strikingly realist style.

Born into one of New York City's wealthiest families and married into another, Whitney, encouraged by friends and other artists, pursued an artistic career. She studied privately (1900) with Hendrik Anderson (1872–1940) and three years later with James Earle Fraser at the Art Students League. In Paris, where she established a studio (1911), Whitney received criticism from her close friend Andrew O'Connor and Auguste Rodin. The diversity of her advisors' styles—some academic, others more romantic—often resulted in Whitney's departing from academic training in her ideal and realist figures.

Whitney had a sculpture accepted to the Pan-American Exposition (1900) in Buffalo, and by 1910 had won awards from the Architectural League and the National Academy of Design. In the international arena Whitney attained honorable mention at the Paris Salon (1913).

For the duration of World War I Whitney interrupted her career to finance and assist in a field hospital in France. While she would later be commissioned to design war memorials, her experience in France inspired a series of table-top figures of soldiers and nurses. She later incorporated some of these figures into her panels for the Victory Arch (1919) constructed in New York, and the group was exhibited that year as *Impressions of the War*. These fluidly modeled figures in realistic attire and poses rank, according to Conner and Rosenkranz, as "the most sustained body of work in her career."

After the war Whitney's academically based, idealized sculpture became dated. While she continued to work, her later contribution to American art was as a patron. She had begun exhibiting her colleagues' work in her Macdougal Alley studio in 1914 and by 1917 had founded the Whitney Studio Club. The latter would become the Whitney Museum of American Art (1931).

Sources

Whitney, Gertrude Vanderbilt, papers (on microfilm), AAA; and Whitney Museum of American Art papers, New York.

Force, Juliana. *Memorial Exhibition: Gertrude Vanderbilt Whitney*. Exh. cat. New York: Whitney Museum of American Art, 1943.

Friedman, B. H. *Gertrude Vanderbilt Whitney: A Biography*. New York: Doubleday, 1978.

"Gertrude Vanderbilt Whitney." In Conner and Rosenkranz, pp. 169–76.

Pène du Bois, Guy. "Mrs. Whitney's Journey in Art." *International Studio* 76 (January 1923): 351–54.

Adolf Wolff

Born 1883 Brussels, Belgium
Died 1944 New York City

THE SUPPLIANT
1914
Plaster
12 x 20 x 8 in. (30.5 x 50.8 x 20.3 cm)
Francis M. Naumann
Plate 91

A self-described "poet, sculptor, and revolutionist," Adolf Wolff sought to combine his radical political philosophy with the avant-garde sculptural expression of his time. He became one of the first artists in the United States to experiment with cubist and nonobjective forms.

Arriving in New York City shortly after 1900, Wolff studied briefly at the National Academy of Design and worked for the Spanish-born sculptor Fernando Miranda (1842–1925). He returned to Brussels, where he entered the workshop of Charles van der Stappen (1843–1910) and trained under Constantin Meunier (1831–1905), whose social themes would inspire Wolff to portray the working class sympathetically.

Back in New York by 1910, Wolff became actively associated with the Ferrer School. An institution promoting anarchist views in all aspects of modern life, the school offered adult education, a day school for children, art classes, and lectures; Emma Goldman, Robert Henri, and Wolff all spoke there. Wolff also participated in numerous demonstrations.

Wolff was strongly influenced by the modernist European sculpture he saw at the Armory Show. Shortly thereafter he began conceiving of figurative sculpture as highly simplified, reductive forms. He intentionally selected cubism, the most modern contemporary idiom, to express his vision of a new social order, and many of his small plasters are believed to have been models for large, unrealized public sculpture. Critics objected to the nonobjectivity of his forms when his sculpture

Alice Morgan Wright

Born 1881 Albany, New York
Died 1975 Albany, New York

was exhibited at the Modern Gallery (1915, 1916) but made little reference to his subjects, which, according to the titles—*Struggle, Revolt,* and *Repose*—expressed both political and apolitical themes.

In the 1920s Wolff's political orientation changed from anarchism to socialism; his art underwent a transformation too. In the late 1920s and 1930s he devoted his sculptures to such causes as equality, racism, and workers' rights. He modeled his figures in a simplified, but representational style analogous to Russian socialist realism and American federal art of the 1930s. He was one of a number of Americans who contributed work to the new State Museum of Birobidzhan in Russia (1936). Wolff also exhibited at the annuals of the Society of Independent Artists and the Sculptors Guild and with the American Artists' Congress.

Largely forgotten after his death, Wolff's work is known almost solely through photographs.

Sources

Sculptors Guild papers, AAA.

Kreymborg, Alfred. "Adolf Wolff—Man of Ideas." *(New York) Morning Telegraph,* 31 January 1915, magazine sec., 7.

Naumann, Francis, and Paul Avrich. "Adolf Wolff: 'Poet, Sculptor, and Revolutionist, but Mostly Revolutionist.'" *Art Bulletin* 67 (September 1985): 486–500.

Tridon, Andre. "Adolf Wolff: A Sculptor of To-Morrow." *The International: A Review of Two Worlds* 8 (March 1914): 86–87.

WIND FIGURE
1916
Bronze
10⅝ x 5 x 3¼ *in. (27.0 x 12.8 x 8.1 cm)*
Hirshhorn Museum and Sculpture Garden, Smithsonian Institution, gift of Elinor Fleming, 1983
Plate 12

Alice Morgan Wright was one of the most progressive American sculptors working in cubist and futurist idioms during the years immediately following the Armory Show.

Born into a wealthy merchant family, Wright began woodcarving as a child and by age twelve had decided to become a sculptor. She was graduated from Smith College (1904) and enrolled at the Art Students League in New York City, where her teachers included Hermon A. MacNeil and James Earle Fraser. Her work was first displayed publicly at the National Academy of Design in 1909, the year she won both the Borglum and Saint-Gaudens prizes at the League.

That year Wright left for Paris, where she enrolled at the École des Beaux-Arts and pursued additional training with Jean-Antoine Injalbert at the Académie Colarossi. She had sculptures accepted by the Royal Academy of Art (1911), the Salon of the Société Nationale des Beaux-Arts (1912), and Salon d'Automne (1913). Her work during this period, influenced by that of Auguste Rodin, was romantic; the figures, fluidly modeled and suggesting spiritual values.

Wright knew of more abstract currents in art in Paris, but it was only after her return to New York in 1914 that she began to take an interest in them. Retaining her allegiance to the figure, she began to simplify anatomy into fluid planes. Some of her figures, especially those with literary themes, such as *Lady Macbeth* (1918), were fraught with tension and analogous to symbolist art. Sometimes the

figures were wrapped in flowing drapery; the cloth, forming fluid, fractured, sometimes rippling planes. Often she explored motion through dancers or figures running. While Wright was not interested in theory, her most progressive works seem inspired by futurism. Marius de Zayas decided to exhibit examples of these at his Modern Gallery (1916) alongside avant-garde sculpture by Constantin Brancusi, Adelheid Roosevelt, and Adolf Wolff.

The period from 1916 to 1920 marked the high point of Wright's career. She maintained a studio on Macdougal Alley in New York City alongside other sculptors and helped found the Society of Independent Artists (1917). Wright lost momentum, however, and moved permanently back to Albany (1920). Thereafter she created more conventional pieces, including garden sculpture, medals, and portrait busts. While a student she had been involved in the movement for women's suffrage, and later in life she returned to political causes.

Sources

Wright, Alice Morgan, papers, Sophia Smith collection, Smith College.

Fahlman, Betsy. *Sculpture and Suffrage: The Art and Life of Alice Morgan Wright.* Exh. cat. Albany: Albany Institute of History and Art, 1978.

"Alice Morgan Wright." In Rubinstein, pp. 220–23.

Enid Yandell

Born 1870 Louisville, Kentucky
Died 1934 Boston, Massachusetts

KISS TANKARD
c. 1899
Bronze
11½ x 7 x 5½ in. (29.2 x 17.8 x 14 cm)
Museum of Art, Rhode Island
School of Design, Providence,
gift of Miss Elizabeth Hazard
Plate 66

Enid Yandell was a leading sculptor at the turn of the century. Working essentially within traditional bounds, she occasionally achieved a personal, evocative sense of beauty.

Yandell decided to become a sculptor when her father's death placed her socially prominent family in a financially precarious situation. At the Cincinnati Art Academy (1887–88) she studied wood carving with Ben Pitman (1822–1910) and sculpture with Louis T. Rebisso. After graduation she toured Europe for six weeks. Beginning in 1891 she worked in Chicago on sculpture for the World's Columbian Exposition: assisting Lorado Taft on the architectural sculpture for the Horticulture Building, designing twenty-four caryatids for the Women's Building, and executing a life-size statue of Daniel Boone for the Kentucky pavilion. Both her art at the fair and the book *Three Girls in a Flat* (1892), which she and her roommates (also sculptors) published about their experiences as unmarried professional women, boosted her reputation.

In Louisville she executed several portrait busts and then briefly worked in New York City as assistant to Karl Bitter (1867–1915), earning enough money to leave for Paris (1894). There she studied with Frederick MacMonnies (1863–1937) at the Académie Vittie and received criticism from Auguste Rodin. She exhibited at both salons (1896–99) and at the Exposition Universelle (1900). She returned to the United States (1898 or 1899) and won the commission for the Carrie Brown Memorial Fountain in Providence, Rhode

Island; she worked on the project in Paris (1899–1900) in order to avail herself of Rodin's counsel. She continued to exhibit at the Paris salons (1904–6, 1914). Although her major sculptural commissions for monuments after her return to the United States adhered to École des Beaux-Arts aesthetics, she sometimes demonstrated the influence of more progressive French aesthetics, especially symbolist art: occasionally she modeled looser, impressionist surfaces as did Rodin and chose themes of a more evocative and poetic character.

Yandell became one of the first women to be elected to the National Sculpture Society and helped organize the Branstock School of Art (1907) at Edgartown on Martha's Vineyard. As interest in public monuments, including portrait busts, waned, she turned increasingly to smaller commissions: decorative sculpture for private homes and gardens. Her work was included in the Armory Show, but after World War I her artistic production waned.

Sources

Yandell, Enid, papers, Filson Club, Louisville (on microfilm, AAA) and J. B. Speed Art Museum, Louisville.

Baird, Nancy. "Enid Yandell: Kentucky Sculptor." *Filson Club History Quarterly* 62 (January 1988): 5–31.

Caldwell, Désirée. *Enid Yandell and the Branstock School.* Exh. cat. Providence: Rhode Island School of Design, 1982.

"Enid Yandell (1870–1934)." In *The Voices of Women Artists,* ed. Wendy Slatkin, pp. 144–46. Englewood Cliffs, New Jersey: Prentice-Hall, 1993.

Ladegast, Richard. "Enid Yandell, the Sculptor." *Outlook* 70 (4 January 1902): 80–84.

Mahonri Young

Born 1877 Salt Lake City, Utah
Died 1957 Norwalk, Connecticut

LABORER
(also known as THE SHOVELER III)
1903
Bronze
10¼ x 9 x 7 in. (26 x 22.9 x 17.8 cm)
Sheldon Memorial Art Gallery,
University of Nebraska, Lincoln,
F. M. Hall Collection
Plates 58, 80

TIRED OUT
(also known as FATIGUE)
1903
Bronze
9 x 5¾ x 7 in. (22.9 x 14.6 x 17.8 cm),
Los Angeles County Museum of Art,
Mr. and Mrs. Allan C. Balch Collection
Plates 36, 79

RIGHT TO THE JAW
c. 1926–27
Bronze
14⅛ x 19¹¹⁄₁₆ x 8 in. (35.9 x 50 x 20.3 cm)
The Brooklyn Museum, Robert B.
Woodward Memorial Fund
Plate 57

Mahonri Mackintosh Young was one of the initiators of modern realist genre sculpture, specializing in depictions of laborers and prizefighters.

A grandson of Mormon leader Brigham Young, Mahonri Young's first six years were spent at the family woolen mill just outside Salt Lake City. Watching laborers there fascinated him and later would affect his art. Although he studied (1895) with Utah painter James Harwood (1860–1940), who was trained at the École des Beaux-Arts, Young soon became more interested in modeling clay than drawing academic studies. He enrolled at the Art Students League (1899), attending the classes of George Bridgman (1864–1943), Kenyon Cox, and Walter Appleton Clark (1876–1906). In both Utah and New York, Young supported himself as a newspaper illustrator.

William Zorach

Born 1889 Eurberick, Russia (Lithuania)
Died 1966 Bath, Maine

Young traveled to Paris (1901) to continue his training at the Académie Julian, where he worked under Jean-Paul Laurens (1838–1921). He became friends with fellow Americans Eugene Higgins (1874–1958), Alfred Maurer (1868–1932), and Leo Stein. While Young approved of experimentation in art, he was not enthusiastic about abstraction. His training was traditional, based on the study of the nude. He did, however, reject ideal subject matter to pursue contemporary subjects. The *Herald Tribune* took notice when he exhibited small plaster casts of laborers at the American Art Association in Paris (1903), launching his career as a genre specialist. Thereafter he studied briefly at the Académie Delecluse and the Académie Colarossi with Jean-Paul Injalbert. Four of his pastels of working men were accepted to the Salon d'Automne (1905).

Returning to Salt Lake City in the autumn of 1905, Young supported himself with painting and sculpture commissions, including the first of what would become several collaborations with the Mormon Church. He resolved that he could best further his career as a realist in New York City (1910). Two years later the Berlin Photographic Company there held his first one-man exhibition, which included watercolors and drawings as well as sculpture, and he received two major sculpture commissions: the Sea Gull Monument (1907–13) in Salt Lake City and Indian figures for dioramas in the Museum of Natural History in New York (1912–17). Six of his sculptures were accepted to the Armory Show. By 1913 Young had exhibited his small bronze sculptures of laborers to great acclaim, and the Sculptors' Gallery held a large retrospective exhibition of his art (1918), including fifty-two sculptures, many of workers.

During the first years of the next decade Young taught sculpture at the Art Students League. The 1920s were a financially secure period for him as he continued to receive commissions and was able to return to Paris several times, the longest residence, at mid-decade, lasting more than two years. During the late 1920s he turned to a new subject, prizefighters, for the tabletop genre sculpture that he created independently. They were first exhibited at his solo exhibition at Rehn Gallery (1928) in New York, and *Life* magazine called him "the George Bellows of realistic American sculpture." Young continued working in the same vein throughout the 1930s. The Addison Gallery at Andover, Massachusetts, accorded him a retrospective exhibition (1940).

Sources

Young, Mahonri, papers, Lee Library, Brigham Young University.

Hinton, Wayne Kendall. "A Biographical History of Mahonri M. Young: A Western American Artist." Ph.D. diss., Brigham Young University, 1974.

Lewine, J. Lewister. "The Bronzes of Mahonri Young." *International Studio* 47 (October 1912): lv–lviii.

Mather, Frank Jewett, Jr., and Mahonri Young. *Mahonri M. Young: Retrospective Exhibition.* Exh. cat. Andover, Massachusetts: Addison Gallery of American Art, Phillips Academy, 1940.

Tarbell, Roberta K. "Mahonri Young's Sculptures of Laboring Men, French and American Realism, and Walt Whitman's Poetics for Democracy." *Mickle Street Review* 12 (1990): 114–22.

FIGURE OF A CHILD
1921
Mahogany
23⅛ x 5¼ x 6½ in. (58.7 x 13.3 x 16.5 cm)
Whitney Museum of American Art,
gift of Dr. and Mrs. Edward J. Kempf
Plate 126

TORSO
1925
Sandstone
13½ x 7¼ x 7¼ in. (34.3 x 18.4 x 18.4 cm)
Lyman Allyn Art Museum, New London,
Connecticut
Plate 47

William Zorach (born Zorach Samovich) was a pioneer of direct carving, instrumental in popularizing the technique through his art and teaching.

Zorach's family immigrated to the United States (1892), settling in Ohio. Apprenticed to a Cleveland lithographer (1902), Zorach began studying painting at night (1905) with Henry Keller (1870–1949) at the Cleveland School of Art. He moved to New York City (1908), where he enrolled for two years at the National Academy of Design. Like so many American artists of his time, he went to Paris to continue his academic training (1910) but there was strongly influenced by postimpressionist and fauve painting and experimented with cubism. In Paris he met his future wife, American painter Marguerite Thompson, and exhibited several paintings (as William Finkelstein) in the Salon d'Automne (1911). Returning briefly to Cleveland, Zorach had his first one-man show of paintings at the Taylor Art Gallery (1912). By the end of the following year he had moved to New York and exhibited (as William Zorach) at the Armory Show. He and his family spent their summers at art colonies in New England and became acquainted with other American modernists.

Zorach explored sculpture in a group of wood relief panels and three-dimensional figures (1917) that reflect the impression made on him by African art. He abandoned painting altogether (1922) and turned to direct carving, working primarily in stone from 1923. Zorach's early sculptures bear similarities with marble nudes by his friend Gaston Lachaise, most notably in their curving outlines and surfaces. Zorach's mature sculpture was more severe than that of Lachaise, however; with the female nude Zorach tended to smooth surfaces and simplify forms as would a classicist and not suggest that the human body was fleshy with erotic overtones. He was also fond of depicting motifs of lovers and mothers and children as well as animals. The artist's favorite material was granite, hard and resistant and in accord with his delineation of anatomy as corpulent.

In 1929 Zorach began a thirty-year career at the Art Students League. It was as a teacher that he introduced the generation of the 1930s to direct carving. He had his first solo exhibition at C. W. Kraushaar (1924), but it was a solo display at the Downtown Gallery and a Logan prize from the Art Institute of Chicago (both 1931) that did much to enhance his reputation. In the late 1930s he participated in several federally sponsored art programs, served as a founder of the Sculptors Guild, and exhibited at the New York World's Fair. By the early 1940s museums too were according him solo exhibitions.

Sources

Zorach, William, papers, AAA.

Baur, John I. H. *William Zorach*. New York: Whitney Museum of American Art, 1959.

Tarbell, Roberta K. "A Catalogue Raisonné of William Zorach's Carved Sculpture." 2 vols. Ph.D. diss., University of Delaware, 1976.

Wingert, Paul S. *The Sculpture of William Zorach*. New York: Pitman, 1938.

Zorach, William. *Art Is My Life: The Autobiography of William Zorach*. Cleveland and New York: World, 1967.

Suggested Readings

Books and portions of books

The following list supplements the citations given throughout this volume.

Adams, Adeline. *The Spirit of American Sculpture*. New York: National Sculpture Society, 1923; rev. ed., 1929.

Ashton, Dore. *Modern American Sculpture*. New York: Abrams, 1968.

Brinton, Christian. "Sculpture Native and Foreign." In *Impressions of the Art at the Panama-Pacific Exposition*, pp. 66–83. New York: John Lane, 1916.

Brummé, C. Ludwig. *Contemporary American Sculpture*. Introduction by William Zorach. New York: Crown, 1948.

Caffin, Charles H. *American Masters of Sculpture*. New York: Doubleday, Page, 1903.

Casson, Stanley. *Sculpture of Today*. Edited by C. G. Holme. London and New York: Studio, 1939.

Cheney, Sheldon. "Sculpture: Expressionism." In *A Primer of Modern Art*. New York: Boni and Liveright, 1924. 10th ed., New York: Tudor, 1939.

Contreras, Belisario R. *Tradition and Innovation in New Deal Art*. Lewisburg, Pennsylvania: Bucknell University Press, [c. 1983].

Dover, Cedric. *American Negro Art*. London: Studio, 1960.

Gross, Chaim. *The Technique of Wood Sculpture*. New York: Vista House, 1957.

Harmon Foundation, Inc. *Negro Artists: An Illustrated Review of Their Achievements*, 1935. Reprint: Black Heritage Library Collection. Freeport, New York: Books for Libraries Press, 1971.

McSpadden, J. Walker. *Famous Sculptors of America*. New York: Dodd Mead, 1924. Reprint: Index Reprint Series. Freeport, New York: Books for Libraries Press, 1968.

Opitz, Glenn B., ed. *Dictionary of American Sculptors: "18th Century to the Present Day."* Poughkeepsie: Apollo, 1984.

Porter, James A. *Modern Negro Art*. N.p., 1943. Reprint, New York: Arno and *New York Times*, 1969.

Putnam, Brenda. *The Sculptor's Way: A Guide to Modelling and Sculpture*. New York: Farrar and Rinehart, 1939.

Reynolds, Donald Martin. *Masters of American Sculpture: The Figurative Tradition from the American Renaissance to the Millennium*. New York: Abbeville, 1994.

Ricker, Jewett E., ed., *Sculpture at a Century of Progress, Chicago, 1933, 1934*. Chicago: n.p., 1934.

Valentine, Lucia and Alan. *The American Academy in Rome 1894–1969*. Charlottesville: University Press of Virginia, 1973.

Exhibition and collection catalogues and brochures

Berman, Douglas, and Peter Daferner. *Sculpture in Modern America*. New York: Berman-Daferner, 1989.

Berstein [sic], Evelyn. *The Coming of Age of American Sculpture: The First Decades of the Sculptors Guild, 1930s–1950s*. Hempstead, New York: Hofstra Museum, Hofstra University, 1990.

[Cohen, Michele]. *The Figure in Sculpture*. New York: Graham Gallery, 1989.

Contemporary American Sculpture. New York: National Sculpture Society, 1929. Catalogue of an exhibition "held by" the National Sculpture Society in cooperation with the Trustees of the California Palace of the Legion of Honor, San Francisco.

Exhibition of American Sculpture: Catalogue. New York: National Sculpture Society, 1923.

Freedman, Paula B., with the assistance of Robin Jaffee Frank. *A Checklist of American Sculpture at Yale University*. New Haven: Yale University Art Gallery, 1992.

Gardner, Albert TenEyck. *American Sculpture: A Catalogue of the Collection of the Metropolitan Museum of Art*. New York: Metropolitan Museum of Art, 1965.

Gerdts, Abigail Booth. "Checklist: Sculptures in the Collection of the National Academy of Design." New York: National Academy of Design, 1984. Brochure.

Gerdts, William H. *A Survey of American Sculpture: Late 18th Century to 1962*. Newark: Newark Museum, 1962.

Goley, Mary Anne. *Beaux-Arts to Moderne: Roots of Modern Sculpture*. Washington, D.C.: Federal Reserve Board, [1993].

Hills, Patricia, and Roberta K. Tarbell. *The Figurative Tradition and the Whitney Museum of American Art: Paintings and Sculpture from the Permanent Collection*. New York: Whitney Museum of American Art, 1980.

O'Brien, Maureen C., et al. *Fauns and Fountains: American Garden Statuary, 1890–1930*. Southampton, New York: Parrish Art Museum, 1985.

Painting and Sculpture from Sixteen American Cities. New York: Museum of Modern Art, 1933.

Preato, Robert R., et al. *The Genius of the Fair Muse*. New York: Grand Central Art Galleries, 1987.

Reynolds, Gary A. *American Bronze Sculpture*. Newark: Newark Museum, 1984.

Salmon, Robin R. *Brookgreen Gardens Sculpture*. Vol. 2. Brookgreen, South Carolina: Brookgreen Gardens, 1993.

Solender, Katherine. *The American Way in Sculpture 1890–1930*. Cleveland: Cleveland Museum of Art, 1986.

Tomidy, Paul, et al. *100 Years of California Sculpture*. Oakland: Oakland Museum Art Department, 1982.

Valentiner, W. R. *Origins of Modern Sculpture*. New York: Wittenborn, 1946. Published in conjunction with an exhibition at Detroit Institute of Arts.

Wasserman, Jeanne L., with contributions by James B. Cuno. *Three American Sculptors and the Female Nude: Lachaise, Nadelman, Archipenko*. Cambridge: Fogg Art Museum, Harvard University, 1980.

Articles in periodicals

Berry, Rose V. S. "The Living American Sculptor and His Art." *The Argus* (five-part article) 4 (November 1928): 3, 20; (December 1928): 3, 20; (January 1929): 8; (February 1929): 8, 11; (March 1929): 8.

————. "American Sculpture at the Palace of the Legion of Honor." *University of California Chronicle* 31 (October 1929): 325–72.

Carr, Eleanor. "New York Sculpture during the Federal Project." *Art Journal* 31 (summer 1972): 397–403.

Conner, Janis C. "American Women Sculptors Break the Mold." *Art and Antiques* 3 (May–June 1980): 81–87.

Cox, George J. "The Sculptor's Forms." *American Magazine of Art* 27 (January 1934): 25–30.

Crissey, Forrest. "Women Sculptors of Chicago." *The Woman's Home Companion* (two-part article) 24 (January 1897): 7–8; (February 1897): 7–8.

Dabakis, Melissa. "The Individual vs. the Collective: Images of the American Worker in the 1920s." *Journal of the Society for Industrial Archeology* 12, no. 2 (1986): 51–62.

Dunwiddie, Charlotte. "All Creatures Great and Small…" *National Sculpture Review* 30 (spring 1981): 8–13.

Grafly, Dorothy. "How Modern Is 'Modern'?" *American Artist* 11 (October 1947): 36–39, 53.

Howlett, D. Roger. "Thirties Sculpture in the Manship Tradition Reborn in the Eighties." *Journal of Decorative and Propaganda Arts 1875–1945* 16 (summer 1990): 22–39.

King, Pauline. "American Women Sculptors." *Harper's Bazaar* 32 (4 March 1899): 180–81.

La Farge, C. Grant. "The American Academy in Rome," *Art and Archaeology* 19 (February 1925): 59–61. This issue was devoted to articles on the American Academy in Rome.

Levin, Gail. "'Primitivism' in American Art: Some Literary Parallels of the 1910s and 1920s." *Arts Magazine* 59 (November 1984): 101–5.

Mainardi, Patricia. "American Sculpture: Folk and Modern." *Arts Magazine* 51 (March 1977): 107–11.

Manship, Paul. "The Sculptor at the American Academy in Rome." *Art and Archaeology* 19 (February 1925): 89–92.

Metcalf, Eugene W. "Black Art, Folk Art, and Social Control." *Winterthur Portfolio* 18 (winter 1983): 271–89.

Muller, Valentine. "A Parallel between Late Roman and Modern Sculpture." *Art in America* 33 (July 1945): 140–48.

Proske, Beatrice Gilman. "Part II: American Women Sculptors." *National Sculpture Review* 24 (winter 1975–76): 8–17.

"Provocative Parallels." *Art in America* 57 (July–August 1969): 52–55.

Rainey, Ada. "A New Note in Art: A Review of Modern Sculpture." *Century Magazine* 90 (June 1915): 193–99.

Rather, Susan. "The Past Made Modern: Archaism in American Sculpture." *Arts Magazine* 59 (November 1984): 111–19.

———. "Toward a New Language of Form: Karl Bitter and the Beginnings of Archaism in American Sculpture." *Winterthur Portfolio* 25 (spring 1990): 1–19.

Roberts, Mary Fanton. "Modern Sculpture in America: Its Value to the Art History of the Nation." *The Touchstone* 7 (July 1920): 283–88.

Roper, Lanning. "Sculpture in a Broad Landscape." *Country Life* 161 (21 April 1977): 998–1000.

Ruge, Klara. "Amerikanische Bildhauer." *Kunst und Kunsthandwerk* 6 (June 1903): 229–52. In German.

Schack, William. "On Abstract Sculpture." *American Magazine of Art* 27 (November 1934): 580–88.

Shapiro, Michael Edward. "Twentieth-Century American Sculpture." *Bulletin of the Saint Louis Art Museum* 18 (Winter 1986).

Taft, Lorado. "Women Sculptors of America." *The Mentor* 6 (6 February 1919): 1–11. See also text by the Editorial Staff on pp. [12–23].

Teall, Gardner. "Women Sculptors of America." *Good Housekeeping Magazine* 53 (August 1911): 175–87.

"The Thirty-sixth Annual Exhibition of the Architectural League of New York." *The Architectural Review* 12 (April 1921): 97–106.

"A Timely Exhibition of American Sculpture." *American Magazine of Art* 8 (May 1918): 292–93.

Valentiner, W. R. "The Simile in Sculptural Composition." *Art Quarterly* 10 (autumn 1947): 262–77.

Walton, William. "Some Contemporary Young Women Sculptors." *Scribner's* 47 (May 1910): 637–40.

Wiesinger, Véronique. "Progrès, modernité, et loi du marché dans l'evolution de la sculpture américaine avant 1939." *Revue de l'Art* 104, no. 2 (1994): 55–61. Issue devoted to 19th-century sculpture. In French.

Zilczer, Judith. "Primitivism and New York Dada." *Arts Magazine* 51 (May 1977): 140–42.

Unpublished sources

American Academy in Rome archives, Rome and New York (also papers, partially microfilmed, Archives of American Art, Washington, D.C.).

American Artists Group, Inc., papers, Archives of American Art, Washington, D.C.

Harmon Foundation papers, Library of Congress, Washington, D.C.

Sculptors Guild papers, Archives of American Art, Washington, D.C.

Acknowledgments

THE ORGANIZATION OF *The Figure in American Sculpture: A Question of Modernity* took almost five years and involved the cooperation of many institutions and individuals. I am beholden to the board of trustees of the Los Angeles County Museum of Art and the museum's former director, Earl A. Powell III, for realizing the significance of such an exhibition.

The National Endowment for the Arts funded my initial research and travel to discover and examine literally hundreds of sculptures. I am pleased that the Lila Wallace-Reader's Digest Fund generously agreed to support a national tour, which will expose a large number of people to a forgotten phase of American art.

My sincere appreciation goes to the private collectors, universities, museums, and other owners for lending to this exhibition. Because of their generosity many sculptures that have not been seen by the public for decades can be enjoyed once again. In many cases the objects required conservation before they could be exhibited, and I am grateful for the cooperation that enabled restoring so many wonderful works of art to their former glory.

I am delighted that the Montgomery Museum of Fine Arts, Wichita Art Museum, and National Academy of Design are participating in the exhibition tour. I would like to thank the director and staff of each museum for their cooperation: in Montgomery, Mark Johnson, director, Pamela Bransford, registrar, and Margaret L. Ausfeld, curator; in Wichita, Inez S. Wolins, director, Barbara Odevseff, registrar, Novelene Ross, chief curator; and in New York City, Edward P. Gallagher, director, Liz Coleman, registrar, Dita Amory, curator, and David Dearinger, associate curator.

My interest in American modernist sculpture was born many years ago when I enrolled in a graduate course on twentieth-century academic sculpture taught by Robert Pincus-Witten at the City University of New York Graduate Center; his stimulating presentation of the material and the ensuing provocative class discussions spurred the initial digging that resulted in this exhibition. I am indebted to him and also pleased that he agreed to become one of the lenders.

This exhibition would not have been possible without the expertise and enthusiasm of several scholars in the field: George Gurney, curator, National Museum of American Art, Smithsonian Institution; Donna J. Hassler, former curatorial assistant, Metropolitan Museum of Art; Roberta K. Tarbell, professor, Rutgers University; Marlene Park, professor, City University of New York; and Donald L. Stover, curator, Fine Arts Museums of San Francisco.

Many other colleagues, too numerous to list, were generous in sharing their time and knowledge. Particularly helpful were Carol R. Alper, registrar, Wolfsonian Foundation; Valerie Fletcher, curator, Hirshhorn Museum and Sculpture Garden; Noel Frackman; Henry Hawley, chief curator, Cleveland Museum of Art; the late Daniel Hodgson, researcher, Mahonri Young Papers, Brigham Young University; Harvey Jones, curator, Oakland Museum; Bruce Kamerling, curator, San Diego Historical Society; Susan C. Larsen, former curator, Whitney Museum of American Art; Bruce Lineker, former curator of exhibitions, Montgomery Museum of Fine Arts; April Paul, director, Renee & Chaim Gross Foundation; Mark Rabinowitz, Central Park Conservancy; Samella Lewis; Ann Slimmon, assistant curator, Rhode Island School of Design; and David Witt, curator, Harwood Foundation.

In addition various art dealers and commercial galleries were most gracious in sharing information: Berman-Daferner, Conner-Rosenkranz, Graham and Sons, and Steve Newman deserve a hearty thank you. Laura O'Brien and her staff at Christie's and Alice Levi Duncan and her staff at Sotheby's as well as Rachel Adler Galleries, Babcock Galleries, Maxwell Davidson Galleries, Guggenheim, Asher Associates, Inc., Hirschl and Adler, Kraushaar Galleries, and Zabriskie Gallery should also be acknowledged for their assistance in the location of works of art.

New photography was required for more than half the exhibited sculptures. Thanks must be extended to Peter Brenner, supervising photographer at the Los Angeles County Museum of Art, for overseeing the quality of the illustrations, contributing some of the finest photographs herein displayed, and advising his colleagues (who are credited elsewhere in this volume). In addition I am indebted to the following for their help with the logistics of photography: Field Horn and Angel Tudor, National Museum of Racing; Judith Nyhus, Saint-Gaudens National Historic Site; Warren M. Robbins, Museum of African Art, Smithsonian Institution; Paul Tarver and Denise Klingman, New Orleans Museum of Art; and Gloria Williams, Norton Simon Museum.

Perhaps the most gratifying aspect of the research for and organization of such an exhibition was my meeting so many of the artists and their families. Robert Cronbach, Eugenia Everett, Berta Margoulies, Octavio Medellin, and Anita Weschler kindly shared with me remembrances about their careers, their archives, and their art. Jacqueline Anderson (Emma Lu Davis's niece), Bertha Blai (Boris Blai's widow), Jacques Davidson (Jo Davidson's son), Mrs. Paul Fitchen (Chester Beach's daughter), Solomon Fuller (Meta Warrick Fuller's son), Renee Gross (Chaim Gross's widow), James Jennewein (C. Paul Jennewein's son), Shirley Jones (William Artis's niece), Lucio Ruotolo (Onorio Ruotolo's son), Dorothy Schnier (Jacques Schnier's widow), and Connie Weinstock (Aaron Goodelman's niece) were also generous with their time.

My research was greatly facilitated by the staff of the Archives of American Art, in particular Barbara Bishop and Judith Throm, and the George Arents Research Library for Special Collections, Syracuse University Library. Also helpful were the Beinecke Rare Book and Manuscript Library, Yale University; Anne Bonham at the library of the School of the Museum of Fine Arts, Boston; Lawrence Campbell, Art Students League; Janice Chadbourne, curator, Boston Public Library; William Clark, archives, Cincinnati Art Museum; Cleveland Museum of Art library; David Dearinger, associate curator, National Academy of Design; Jeff Gunderson, library, San Francisco Art Institute; library, Museum of Modern Art, New York; Schomburg Center for Research in Black Culture, New York Public Library; and Tyler School of Art, Temple University.

Many staff members and volunteers at the Los Angeles County Museum of Art were supportive and helpful. Sheri Bernstein, Trudi Casamissima, Lisa Friedman, Leslie Furth, Mary L. Lenihan, and Laela Weisbaum contributed to the research and organization of the exhibition and writing of the catalogue; they each have my heartfelt gratitude. Cheryl Stone, curatorial secretary, must be commended for her persistence with the loans and obtaining photographs for the catalogue; she was assisted by Sien Oh, Larry Thomson, and Edna Todd. **241**

Eleanor Hartman and her wonderful library staff, in particular Anne Diederick, never failed our constant inquiries and demands for interlibrary loans. Steve Colton and Maureen Russell, objects conservators, patiently answered my numerous questions and taught me so much about materials and techniques; their interns were also quite helpful in conserving several of the works in the exhibition. June Li, assistant curator, Far Eastern art department; Mary Levkoff, associate curator, European painting and sculpture department; and Steven Markel, associate curator, Indian and Southeast Asian art department, were also generous in sharing their expertise with me.

I also extend my thanks to Tom Jacobson, head of grants and foundation giving; Renée Montgomery and her registrarial staff, in particular Tamra Yost and Thomas Sacco, for administering the details of the loans; John Passi, head of exhibitions, for orchestrating the national tour; Bernard Kester for his sympathetic installation; Lawrence Waung, Art Owens, and their technical staffs for handling the sculptures so carefully; museum educator Jane Burrell and her staff for planning related educational and outreach programming. Elvin Whitesides and his audio-visual staff were responsible for the fascinating video that accompanies the exhibition.

Mitch Tuchman, editor in chief, skillfully applied his craft to the catalogue's text, Leslie Furth was quite helpful with proofreading the catalogue, and Nancy Carcione and Britton Weiss assisted with various aspects of the manuscript. The catalogue's handsome design is the creation of Scott Taylor.

Thanks must also be given to my fellow scholars Mary L. Lenihan, Marlene Park, Susan Rather, and Roberta K. Tarbell for contributing insightful essays to the catalogue. It is their and my hope that the catalogue will inspire future research into the much neglected field of modern American figurative sculpture.

ILENE SUSAN FORT
Curator, American Art

Lenders to the Exhibition

Private lenders

John P. Axelrod, Boston
Estate of Marjorie Content
Mrs. Daniel Cowin
Estate of Jo Davidson
Gertrude Weyhe Dennis
Albert Glinsky and Linda Kobler Glinsky
Mr. and Mrs. Lawrence Goichman
Mimi Gross
Daniel J. Hirsch
Dr. George Hollenberg
Russell P. Jaiser
Ron and Jane Lerner
Mrs. Octavio Medellin
E. Jan Nadelman
Francis M. Naumann
Robert Pincus-Witten and Leon Hecht
Dorothy B. Porter Collection
Hughes and Sheila Potiker
The Regis Collection, Minneapolis
Gary and Brenda Ruttenberg
Mrs. Jacques Schnier
Louise and Alan Sellars Collection
Gloria and Larry Silver
Mr. and Mrs. Whitney Tower
Dr. James D. Zidell
Anonymous private lenders

Institutional lenders

American Swedish Historical Museum,
 Philadelphia
Amon Carter Museum, Fort Worth
The Art Institute of Chicago
Berman-Daferner Gallery, New York City
Bienecke Rare Book and Manuscript Library,
 Yale University, New Haven
The Brooklyn Museum
Childs Gallery, Ltd., Boston
The Cleveland Museum of Art
Conner-Rosenkranz, New York City
The Corcoran Gallery of Art,
 Washington, D.C.
Maxwell Davidson Gallery, New York City
Everson Museum of Art, Syracuse
The Fine Arts Museums of San Francisco
The Renee & Chaim Gross Foundation,
 New York City
The Harwood Foundation, Taos
Hebrew Union College Skirball Museum,
 Los Angeles
Hirschl & Adler Galleries, New York City
Hirshhorn Museum and Sculpture Garden,
 Smithsonian Institution
Honolulu Academy of Arts
Los Angeles County Museum of Art
Los Angeles Unified School District
Lyman Allyn Art Museum, New London,
 Connecticut
Maryhill Museum of Art, Goldendale,
 Washington
The Metropolitan Museum of Art
The Minneapolis Institute of Art
Museum of Art, Rhode Island School of
 Design, Providence

Museum of Fine Arts, Boston
The Museum of Fine Arts, Houston
The Museum of Modern Art
National Gallery of Art, Washington, D.C.
National Museum of American Art,
 Smithsonian Institution
The Newark Museum
The Isamu Noguchi Foundation, Inc.,
 New York City
Pennsylvania Academy of the Fine Arts,
 Philadelphia
Philadelphia Museum of Art
San Diego Museum of Art
San Francisco Museum of Modern Art
Sheldon Memorial Art Gallery, University of
 Nebraska, Lincoln
Smith College Museum of Art, Northampton
Taylor Museum for Southwestern Studies of
 the Colorado Springs Fine Arts Center
University Art Museum, University of
 California, Berkeley
University of New Mexico Art Museum,
 Albuquerque
Frances Lehman Loeb Art Center,
 Vassar College, Poughkeepsie
Virginia Museum of Fine Arts, Richmond
Wadsworth Atheneum, Hartford
The Wolfsonian Foundation, Miami Beach,
 Florida, and Genoa, Italy
Whitney Museum of American Art

Photo Sources and Credits

Page 4, courtesy, Zabriskie Gallery, New York City

Plates 5, 11, 74, 91, 101, 103, 108, 130, pages 215–16, Joseph Coscia, Jr.

Plate 7, page 207, courtesy, Christie's, New York City

Plate 9, Thomas R. Dubrock

Plate 16, Frank Wing

Plate 18, Bruno Jarret, © 1994 Artists Rights Society (ARS), New York/ADAGP

Plate 29, courtesy, National Park Service

Plate 33, William L. Schaeffer, © 1981 B. G. Cantor

Plate 34, Mayland Wilkins

Plate 37, Randl Bye

Plates 43, 177, Scott Bowron, courtesy Conner-Rosenkranz, New York City

Plates 48A–B, David Stansbury

Plate 50, Michael McKelvey

Plate 51, Larry Silver

Plates 52–53, Marlene Park

Plate 56, © Courtney Frissee, New York

Plates 58, 80, John Spence

Plate 64, Shigeo Anzai

Plate 67, courtesy, Berry-Hill Galleries, New York City

Plate 71, Manu Sassoonian

Plates 73, 156, Geoffrey Clements

Plates 76, 112, Sarah Wells

Plate 88, Susan Einstein

Plate 90, Pfaff Photography

Plate 93, Peter A. Juley & Son Collection, National Museum of American Art, Smithsonian Institution

Plate 94, Joseph Levy

Plate 98, Ron Jennings

Plates 105, 107, courtesy, Robert Cronbach

Plates 106, 119, courtesy, Berman-Daferner Gallery, New York City

Plate 111, Archives of American Art, Smithsonian Institution

Plate 115, Owen Murphy, New Orleans

Plate 121, Dallas Historical Society

Plate 125, courtesy, Roberta K. Tarbell

Plate 126, 141, Jerry L. Thompson

Plate 127, courtesy, Lane Collection

Plate 128, courtesy, Robert Forsyth

Plate 132, Delmar Lipp, courtesy, Eliot Elisofon Photographic Archives, National Museum of African Art, Smithsonian Institution

Plate 135, Rynda White

Plate 143, Rota (neg. no. 325926)

Plates 144, 162, Greg Heins, Boston

Plate 149, Michael Freeman

Plate 159, Jeffrey Nintzel, courtesy, U.S. Dept. of Interior, Saint-Gaudens National Historic Site, Cornish, New Hampshire

Plate 163, J. David Bohl

Plate 168, Vando L Rogers, Jr.

Plate 176, Hirmer Verlag, Munich

Plates 178–79, courtesy, Rockefeller Center, © Rockefeller Group, Inc. 1994

Plate 180, courtesy, Mitzi Landau

Page 191, Armen Photographers

Page 226 (left), Robert Hashimoto

Page 226 (right), Terry Pommett

Index

Index prepared by Andrew L. Christenson

Italic page numbers indicate illustrations without plate numbers.

Académie Colarossi, 190, 195, 206, 216, 233, 235
Académie de la Grande Chaumière, 185, 221, 225, 230
Académie Delecluse, 235
Académie Julian, 30, 178, 183, 189, 207, 213, 219, 235
Académie Rodin, 28, 195
Academy of Allied Arts, 231
A.C.A. Gallery, 100, 198, 211
Adams, Adeline, 57, 163
Adams, Herbert, 184, 198, 203, 206
Addison Gallery of American Art, 235
Aitken, Robert, 31, 128, 185, 230
Albert Landry Galleries, 228
Allen Memorial Art Museum, 177
Ambellan, Harold, 187
American Abstract Artists, 71
American Academy in Rome, 69, 159, 160, 185, 198, 205, 212
American Art Association, 78, 235
American Artists' Congress, 95, 187, 189, 198, 233
American Folk Art Gallery, 123
An American Group, 231
American Museum of Natural History, 117, 124, 125, 130, 189, 235
Anderson, Hendrik, 232
Archaeological Institute of America, 69, 122, 224
Archipenko, Alexander, 17, 160, 191, 209, 220; biography, 172–73; work, 14, 48, 63–64, 163, *171*, pl. 6
Architectural League, 212, 232
Arden Gallery, 177, 184, 186, 209
Ardsley Studios, 120
Arensberg, Mr. and Mrs. Walter, 124, 127
Argent Galleries, 222
Armory Show, 8, 10, 159, 162, 174, 227, 232; exhibiting sculptors, 27, 78, 172, 178, 188, 192, 209, 210, 214, 219, 234, 235
Arthur U. Newton Galleries, 100–101, 107–67
Art Institute of Chicago, 25, 236. *See also* School of the Art Institute of Chicago
Artis, William, 150, 151, 154, 173–74, 222, pl. 172
Artists' Congress against War and Fascism, 198
Artists Gallery, 175
Artists' Union, 95, 187, 198
Arts Club of Chicago, 194, 226

Art Students League: students, 110, 117, 173, 177, 184, 185, 188, 192, 195, 197, 198, 201, 204, 210, 212, 213, 223, 224, 228, 230, 232, 233, 234; teachers, 30, 176, 189, 210, 235, 236
Ashcan school, 74, 192, 214

Babcock Galleries, 196
Baizerman, Saul, 20, 78; on abstract art, 18; biography, 174–75; work, 48, 50, 81, 83–84, pls. 49, 83–87
Baker, Robert, 30–31, 40, 175, pl. 38
Ball, Thomas, 142–43, pl. 158
Barela, Patrociño, 136, 176, pl. 155
Barlach, Ernst, 97, 120, 211, 213
Barnard, George Grey, 52–49; biography, 176–77; as teacher, 30, 192, 198, 203; work, 20, 25–26, 31–32, 35, 37–38, 40, 46, pls. 19, 31
Barnes, Albert, 145
Barr, Alfred, 164, 192
Barthé, Richmond, 154, 206, 210; biography, 177; work, 91, 107–67, 150–52, pls. 168, 170–71
Bartlett, Paul Wayland, 25, 29, 206, 225
Bartlett, Truman H., 25
Barye, Antoine-Louis, 218
Beach, Chester, 29, 40, 41, 43, 46, 178, pl. 40
Beaux Arts Galerie, 222
Beaux-Arts Institute of Design: students, 174, 200–201, 204, 225, 228; teachers, 30, 178, 185, 190, 199
Beklemisheff, Sergei, 180
Ben-Shmuel, Ahron, 15, 125, 179, pl. 140
Berlin Photographic Company, 235
Bing, Samuel, 195
Bissell, George, 142–43
Bitter, Karl, 234
Blai, Boris, 64, 179–80, pl. 63
Blanch, Arnold, 224
Blazys, Alexander, 180–81, *181*, 200
Bolling, Leslie, 91, 154, 181–82, pls. 98, 173
Borglum, Gutzon, 183; assistants, 198, 217; biography, 182; and Rodin, 26, 29, 51n15; on Rodin, 23, 26, 32; as teacher, 30, 195, 197, 203; work, 32, 34, 37, 40, 47–48, pls. 29, 32, 46

Borglum, Solon, 30, 43, 45, 174, 183, 212, pl. 42
Bourdelle, Antoine, 28, 220, 223, 225, 230
Bourgeois, Louise, 72
Bourgeois Gallery, 208, 209
Boyer Galleries, 188–89, 201
Boynton, Ray, 222
Bracken, Clio Hinton, 195
Brancusi, Constantin, 47, 48, 113, 160, 210, 217; influence, 117, 120, 133, 212, 220; work, 70, 135, 163, 233, pl. 72
Braxton Gallery, 222
Brenner, Michael, 30
Brewster, George, 197, 221
Bridgman, George, 234
British Academy in Rome, 209
Brooklyn Museum, 114, 179, 229
Brummer, Joseph, 113
Bufano, Beniamino, 15, 148, 193, 205; biography, 184; work, 85, 127–28, pl. 145
Burke, Selma, 154, 173
Burnham, Roger Nobel, 193

Cahill, Holger, 111, 123
Calder, Alexander, 17–18, 72, 217; biography, 184–85; work, 17, 19, 71, 91, pls. 10, 14, 100
Calder, Alexander Milne, 184
Calder, A. Stirling, 137n4, 184, 225; as teacher, 197, 206, 224; work, 110, pl. 122
California College of Arts and Crafts, 184, 222
California School of Fine Arts, 184, 205, 222
Carnegie Hall Gallery, 214
Carnegie Institute, 212
Cavélier, Pierre, 176
Caz-Delbos Gallery, 177
Century of Progress Exposition, 132, 227
Ceramic National Exhibition, 223
Ceramic Studio, Portland, 189
Cézanne, Paul, 164–65
Chase, William Merritt, 214
Cincinnati Art Museum, 178
El Círculo de Bellas Artes, 189
City Club, Chicago, 202
City of Paris gallery, 184
Clark, Allan, 15, 127–28, 146, 185–86, pl. 148
Clark, Walter Appleton, 234
Claudel, Camille, 29
Cleveland Museum of Art, 27, 178, 180, 200, 223
Cleveland School of Art, 180, 206, 223, 235

Clews, Henry, 29, 47–48, 186–87, pl. 45
Coady, Robert, 113–14, 145
Coady Gallery, 113
Coomaraswamy, Ananda K., 128, 130, 139n47
Cooper Union, 58, 197, 202, 221, 225, 231
Copley Society, 27
Corcoran Gallery of Art, 229
Courvoisier Gallery, 222
Cowan, Guy, 223
Cowan Pottery Studio, 180, 200, 223
Cox, Kenyon, 210, 234
Cranbrook Academy of Art, 200, 208
Cravath, Ruth, 222
Cronbach, Robert: biography, 187; work, 63, 94–95, 97, 99, 154, pls. 105, 107, 110
Cummings, E. E., 164–68, 208
C. W. Kraushaar gallery, 209, 236

Dallas Museum of Fine Arts/Dallas Museum of Art, 109–10, 137n3, 213
Dalou, Aimé-Jules, 80, 83, 228, pl. 82
Dalzell Hatfield Galleries, 186, 204
Dana, Homer, 204
Daniel Gallery, 209
Dartmouth College, 231
Davidson, Jo, 30, 45, 48, 177, 188, 197, pl. 43
Davies, Arthur B., 162–63, 194
Davis, Emma Lu, 15, 70, 127–28, 188–89, pl. 147
Dawson, Archibald, 204
de Creeft, José, 17; biography 189–90; as teacher, 202; work, 63, 101, 125, 146, pls. 1, 113, 141
De Lue, Donald, 175
Demuth, Charles, 123
Derujinsky, Gleb, 13, 190, pl. 5
Desbois, Jules, 28
Despiau, Charles, 213, 221
de Zayas, Marius, 113, 114, 145, 233
Diederich, Hunt, 191, *191*
Doll and Richards gallery, 196
Dorien Leigh Galleries, 175
Downtown Gallery, 123, 229, 236
Dreier, Katherine, 173
DuBois, W. E. B., 145–46, 218, 222
Dudensing Gallery, 229
Dumont, Augustin, 227

Eastman-Bolton Galleries, 180
Eberle, Abastenia St. Leger, 59; biography, 192; work, 59, 67–69, 77–78, 154, pls. 51, 70
École de la Grande Chaumière, 220, 223
École des Beaux-Arts, 23, 55, 109, 234; students, 176, 178, 179, 188, 197, 198, 206, 210, 218, 227, 233, 234
Edmondson, William, 154; biography, 192–93; work, 89, 91, 135, 136, 155, 181, pl. 97
Educational Alliance, 188, 200, 201, 213
Ehrich Galleries, 231
Eighth Street Gallery, 175, 198
Eugene Schoen Gallery, 217
Everett, Eugenia, 2–3, 125–26, 193
Exposition Internationale des Arts Décoratifs et Industriels Modernes, 162–63
Exposition Universelle (1900), 25, 26, 29, 37, 183, 234
Ezekiel, Moses Jacob, 224

Fairbanks, Avard, 87
Ferargil Gallery, 189
Ferrer School, 232
Field, Hamilton Easter, 112, 120, 122, 123, 209
Field Museum of Natural History, 132, 203
Fine Arts Gallery of San Diego, 196
Flannagan, John, 111, 113, 125, 128, 139n47, 189, 220; biography, 194; and direct carving, 46, 117, 130, 155, 179; work, 60, 124, 135, pls. 120, 128–30, 139
Folsom Galleries, 214, 226
Fontainebleau School of Fine Arts, 58, 221
Fraser, James Earl, 184, 223, 232, 233
Frémiet, Emmanuel, 183, 191
French, Daniel Chester, 57, 87, 219
Friedlander, Leo, 160–61, pl. 177
Frishmuth, Harriet, 28, 29, 69, 51n32, 91; biography, 195; on Rodin, 52n35, 53n70; work, 32, 65–66, pls. 26, 68
Fry, Roger, 8
Fuller, Loïe, 27, 32
Fuller, Meta Warrick, 69; biography, 195–96; and Harlem Renaissance, 68, 146; and Rodin, 27, 29, 38–39, 146–47; work, 35, 38, 57, 68, 85, 89, 147–48, pls. 34, 71, 162–63
Fulop, Karoly, 7, 196

Gage Gallery, 220
Galerie Allard, 223
Galerie Georges Petit, 25
Gallery 144, 201
Garland, Hamlin, 74, 106n1
Gauguin, Paul, 68, 114, 117
Gauquié, Henri Desiré, 195
Gemito, Vincenzo, 221
Gershoy, Eugenie, 71, 91, 197, 224, 229, pl. 74
Gimpel and Wildenstein, 186, 187
Golden Gate International Exposition, 193
Goodelman, Aaron, 95–96; biography, 197–98; work, 31, 81, 83–84, 98–99, 101–2, pls. 88, 111, 114
Gorham Galleries, 207
Grace Horne Gallery, 211
Grafly, Charles, 25, 164; as teacher, 30, 160, 187, 188, 195, 212, 225
Grand Central Art Galleries, 179, 195, 203, 205, 206
Grand Rapids Art Gallery, 177
Greenberg, Clement, 8, 10, 167–68
Greene, Gertrude, 71
Gregory, John, 31, 160, 198–99, 199, 205, 228
Gregory, Waylande, 13, 60, 200, pl. 56
Gross, Chaim, 120, 179; and African art, 113, 117–19, 128, pl. 132; biography, 200–201; and direct carving, 69, 117–18; work, 18, 91, 94, 95, 97, 119, 124, 138n32, pls. 11, 101, 108, 131
Guild of Boston Artists, 219
Guild School, New York City, 173
Guillaume, Paul, 113, 138n19

Haag, Charles, 78, 106n10; biography, 201–2; work, 80–81, 83–84, 98, pls. 89–90
Halpert, Edith Gregor, 123
Hancock, Walker, 160, 204
Harkavay, Minna, 99, 103
Harlem Community Art Center, 150, 173, 222
Harmon, William, 145, 148
Harmon Foundation, 148–49, 154, 155, 173, 177, 181, 206, 218, 221
Hartley, Marsden, 145
Hartwig, Cleo, 125, 202, pl. 142
Haviland, Frank Burty, 112
Hayes, Laura, 55

Heber, Carl, 225
Henri, Robert, 74, 214, 229, 232
Hewett, Edgar L., 69, 122–23, 224
Heyneman, Julie, 218
Hill, Samuel, 27
Hinton, Charles, 230
Hirsch, Sidney, 155
Hoffman, Malvina, 69, 91, 130, 132, 195; and Rodin, 28–29, 32, 47; biography, 203; work, 35, 38, 43, 65, 68–69, 146, pls. 39, 67, 150
Holm, Victor, 187
Hord, Donal, 125–27, 135, 204, pl. 153
Hosmer, Harriet, 57, 64, 66, pls. 65, 69
Hovannes, John, 95, 103, pl. 106
Howard, Cecil, 91
Hudson D. Walker gallery, 187
Hunt, Clyde du Vernet, 40
Huntington, Anna Hyatt, 192, pl. 53

Indiana University, 210
Injalbert, Jean-Antoine: students of, 188, 190, 195, 197, 201, 206, 225, 227, 233, 235

Jackson, May Howard, 205
Jacques Seligmann gallery, 208
Jennewein, C. Paul, 60, 160, 198, 204–5, pls. 3–4, 54
Jewish Art Center, 96, 198
John Herron Art Institute, 178
John Reed Club, 95, 100, 102, 119, 187, 198, 211
Johnson, Adelaide, 55
Johnson, Malvina Gray, 206
Johnson, Sargent, 89, 148–50, 154, 184; 205–6, pls. 96, 164–66
Jones, Adrian, 175
Judah L. Magnes Museum, 198

Kalish, Max, 78; biography, 206; work, 31, 45, 63, 80–81, 83–84, 96–97, 107n63, pl. 59
Kanno, Gertrude Boyle, 31
Keller, Henry, 235
Kemeys, Edward, 218
Keppel Gallery, 183
Kingore Galleries, 191
Kitson, Henry Hudson, 208
Kollwitz, Käthe, 213
Konti, Isadore, 206, 212
Korbel, Mario, 207, 207–8
Kühn, Justus, 142, pl. 157
Kupka, Frantisek, 220

Lachaise, Gaston, 50, 128, 209, 236; and Manship, 164, 166–67; biography, 208–9; and Cummings, 164–68; work, 32, 48, 63, pls. 48a–b, 174, 180
Ladd, Anna Coleman, 29, 39, 45, pl. 35
Laessle, Albert, 187, 188, 230
Lambeth School of Art, 175, 198
Laurens, Jean-Paul, 235
Laurent, Robert, 50, 112–14, 189; biography, 209–10; and direct carving, 46, 114, 117, 127, 155, 189; and folk art, 120, 122–23, 209; as teacher, 154, 173, 201, 213, 230; work, 15, 63, 121, 124, 133, pls. 125, 135, 144
Lee, Arthur, 63, 210, pl. 61
Lehmbruck, Wilhelm, 120, 209
Lentelli, Leo, 110, 230, pl. 122
Leonardo da Vinci Art School, 217, 221, 225
Levitt Gallery, 231
Lewis, Edmonia, 144, 146, 157n5, pl. 161
Lipton, Seymour, 95–98, 101–3, 119–20, 211, pls. 98, 133–34
Little Galleries of the Photo-Secession, 113
Locke, Alain, 142, 145, 146
Los Angeles Museum of History, Science and Art/Los Angeles County Museum, 185, 196, 204
Loughborough, Jean, 55
Louisiana Purchase Exposition, 27, 183, 192
Lovet-Lorski, Boris, 13–14, 211–12, pl. 7
Ludins, Eugene, 224

Macbeth Gallery, 178, 190, 192
MacCameron, Robert, 29
Macdonald-Wright, Stanton, 220
MacMonnies, Frederick, 234
MacNeil, Hermon A., 188, 195, 198, 221, 225, 233
Maillol, Aristide, 114, 209, 213, 222
Maison Gréber, 189
Manship, Paul, 30, 146, 159, 191, 198, 205; assistants, 184, 187, 208; biography, 212; and Cummings, 164–68; work, 13, 60, 159–60, 162, 166, 169, 186, pls. 55, 175, 178, 181
Margoulies, Berta, 71, 99, 103, 213, pl. 73
Matisse, Henri, 47, 48, 112–13, 145
Matzen, Herman, 206
Maverick art colony, 111, 194, 197, 224, 229
McCartan, Edward, 110, 213, 230
McKenzie, R. Tait, 179

Medellin, Octavio, 102, 213–14, pl. 115
Memorial Art Gallery, University of Rochester, 178
Mercié, Antonin, 198
Merritt, Anna Lea, 56
Mestrovic, Ivan, 174
Metropolitan Museum of Art, 25, 27, 29, 57, 130, 177, 184, 192, 223, 229
Meunier, Constantin, 80–81, 83, 86, 232
Meyer, Agnes Ernst, 113
Michelangelo, influence of, 31, 176
Mihalik, Julius, 223
Milch Galleries, 190, 206
Milwaukee Art Institute, 211
Miranda, Fernando, 232
M. Knoedler gallery, 121
Modern Art School, 220
Modern Gallery, 86, 113, 233
Montclair Art Museum, 200, 202
Montross Gallery, 194
Mosby, William, 107n67
Mucha, Alphonse, 223
Munson-Williams-Proctor Institute, 220
Musée d'Ethnographie du Trocadéro/Musée de l'Homme, 113, 130, 203
Museum of Fine Arts, Boston, 27, 46, 177. See also School of the Museum of Fine Arts, Boston
Museum of Fine Arts, Houston, 186
Museum of Modern Art, 185, 201, 209; Americans 1942: 18 Artists from 9 States, 189, 204, 213; exhibitions, other, 16–17, 111, 176, 230; folk art at, 123, 155, 192
Museum of New Mexico, 186, 224
Museum of Primitive Art, 118
Myers, Ethel, 67, 69, 77, 214, pl. 78

Nadelman, Elie, 17, 191; biography, 215–16; and folk art, 91–92, 120–21, 128, 191; as teacher, 200–201, 228; work, 12, 91–92, 120–22, 163, 215–16, pls. 2, 99
Nadelman Museum of Folk Art, 121
National Academy of Design, 229; exhibitions, 188, 192, 203, 232, 233; students, 174, 197, 206, 220, 225, 230, 232, 235
National Arts Club, 27
National Association for the Advancement of Colored People, 100, 107n67
National Museum of American Art, 197
National Sculpture Society, 55–56, 192, 212, 221, 234; exhibition, 175, 225

Nevelson, Louise, 72
Newark Museum, 111, 123
New Gallery, 201
Newport Art Association, 218
New School for Social Research, 189, 202, 211
New Society of American Artists, 188
New York Cooperative Society, 188
New York Public Library, 231
New York School of Applied Design for Women, 223, 224
New York School of Art, 214, 229
New York Society of Women Artists, 202
New York State College of Ceramics, 174
New York World's Fair: exhibiting sculptors, 168, 176, 190, 196, 200, 213, 222, 223, 225, 230, 236
Noguchi, Isamu, 17, 95, 221; biography, 217; work, 17, 64, 101, pls. 64, 76, 112

O'Connor, Andrew, 30, 35, 40, 46, 232, pl. 30
Ogunquit School of Art, 120
O'Keeffe, Georgia, 69
Orloff, Chana, 213

Panama-Pacific International Exposition, 27, 110, 175, 184, 203, 206, 212, 219, 225
Pan-American Exposition, 232
Patigian, Haig, 29
Pennsylvania Academy of the Fine Arts: exhibitions, 179, 192, 212, 214; students, 160, 187, 188, 191, 195, 204, 212, 225, 230; teachers, 20, 30, 212
Philadelphia Museum of Art, 69, 177, 199, 205
Picasso, Pablo, 72, 112, 113, 145, 189, 210, 212
Pietro, Caraino di Sciarrino, 206
Pitman, Ben, 234
Polasek, Albin, 177, 185, 228
Porter, James, 145
Potter, Bessie. See Vonnoh, Bessie Potter
Powers, Hiram, 63, 78, pl. 60
Powolny, Michael, 223
Pratt, Bela, 219, 225
Pratt Institute, 178, 231
Prix de Rome, 15, 190, 198, 205, 212
Prophet, Nancy, 69; biography, 218; work, 57, 68–69, 132, 150–52, pls. 156, 169

Public Works of Art Project, 189, 193, 224
Puech, Denys, 183
Putnam, Arthur, 30; biography, 218–19; work, 31–32, 39, pl. 28

Querol, Augustin, 189

Raemisch, Waldemar, 103
Rebisso, Louis T., 183, 234
Recchia, Richard, 30; biography, 219; work, 31, 43, 46, pl. 41
Rehn Gallery, 235
Reinhardt Galleries, 106n43, 207, 211
Rhind, J. Massey, 198
Rhode Island School of Design, 178, 218
Richmond Academy of Arts, 181
Robinson, Boardman, 224
Robinson Galleries, 197, 231
Robus, Hugo, 50, 111, 128, 139n47; biography, 220; work, 40, 64, pls. 37, 62
Rodin, August, 23–53 passim, 228; influence on American sculpture, 8, 11, 175, 176, 178, 182, 183, 186, 188, 195, 197, 216, 218, 219, 225, 227, 228, 233; and roots of modernism, 10–11; and symbolism, 175, 176; as teacher and advisor, 146–47, 179, 190, 203, 223, 232, 234; works, 63, 83, 133, 183, pls. 16–18, 20–21, 27, 33, 44
Rogers, John, 74, 76, 143–44, pls. 77, 160
Rood, John, 103
Roosevelt, Adelheid, 120, 233
Rosso, Medardo, 30, 178
Roth, Frederick, 29, 110, pl. 122
Rude, François, 143
Ruotolo, Onorio, 86, 106n38; biography, 221; as teacher, 217; work, 30–31, 87, 89, pls. 15, 92–93
Russell, Morgan, 30, 210, 220

St. Botolph Club, 219
Saint-Gaudens, Augustus: as teacher, 183; on women artists, 56, 73n7; work, 59, 143, 160–61, pls. 52, 159
St. Paul's Guild Gallery, 190
Salon des Indépendents, 172, 180
Salon d'Automne, 221, 233, 235
Salons of America, 177
Salvatore, Victor, 225
Savage, Augusta, 58, 150–51, 154, 173, 221–22, pl. 167
Savage Studio of Arts and Crafts, 221

Schnakenberg, Henry, 123
Schnier, Jacques, 15–16, 127, 132–33, 135, 222, pl. 151
School of the Art Institute of Chicago: students, 176, 177, 185, 213, 228; teachers, 27, 30, 227
School of the Museum of Fine Arts, Boston, 191, 219, 225
Schreckengost, Viktor, 102–3, 146, 200, 223, pls. 116–17
Schroeder, Charles, 177
Scofield, Levi T., 143
Scott and Fowles, 216
Scudder, Janet, 59
Sculptors' Gallery, 235
Sculptors Guild: members, 72, 177, 201, 202, 213, 228, 231, 236; exhibitions, 71, 175, 179, 187, 225, 230, 233
Seattle Art Institute, 222
Seattle Art Museum, 189
Section d'Or exhibition, 172
Ségoffin, Victor, 218
Sheeler, Charles, 114, 123, pl. 127
Shonnard, Eugenie, 28–29, 68–69, 122–23, 223–24, pl. 138
Sixth International Exhibition of Paintings and Sculptures, 24
Sloan, John, 185
Small, Hannah, 92, 197, 224, pl. 104
Société Anonyme, 173, 227
Société des Artistes Français Salon, 23–24, 195, 227, 232
Société Nationale des Beaux-Arts Salon, 26, 183, 176, 195, 206, 219, 233
Society of Independent Artists, 189, 231, 233
Solon, Leon, 205
Spreckels, Alma de Bretteville, 27, 219
Stackpole, Ralph, 31, 205, 222
Stanley, George, 193
Stea, Cesare, 17, 225, pl. 8
Steichen, Edward, 27, 113, pl. 20
Steinhof, Eugene, 213
Sterne, Maurice, 112, 128, 209
Stieglitz, Alfred, 27, 113, 216, 224
Storrs, John, 17, 30, 146, 219; biography, 225–27; work, 19, 89, 226, pls. 13a–b, 95
Sunwise Turn bookstore, 128, 220
Syracuse Museum of Fine Arts, 200

Taft, Lorado, 26–27, 234; as art historian, 20, 32, 46, 56–57, 161, 202; biography, 227; as teacher, 28, 30, 200, 228; work, 31–32, 35, 37, pl. 24–25
Tanner, Henry Ossawa, 57, 146, 218
Taylor Art Gallery, 235
Tennant, Allie, 110, pl. 121
Texas Centennial Exposition, 110, 181
Thomas, Gabriel-Jules, 208, 227
Trajan, Turku, 4, 228
Treasury Relief Art Project, 177
Treasury Section, 179, 187, 189, 201, 225, 230, 231
Troubetzkoy, Paul, 228

United American Sculptors, 102, 187, 198

Valentien, Anne Marie, 29, 204
Valentine Gallery, 209, 228
van der Stappen, Charles, 232
Van Vechten, Carl, 145, 154–55, 181, 209
Verlet, Charles Raoul, 178, 190
Vogan, Frank, 192
Volnuchin, Sergei, 180
Vonnoh, Bessie Potter, 28; biography, 228–29; work, 45, 56, 66–67, 69, 77–78, 84, 103–4, pl. 50
von Uechtritz-Steinkirch, Cuno, 195

Walters, Carl, 91, 194, 229, pls. 102–3
Walton, Marion, 71, 230, pl. 75
Ward, John Quincy Adams, 142
Warrick, Meta Vaux. See Fuller, Meta Warrick
Washington Square Gallery, 113
Weber, Max, 112–14, 146, 210, pl. 123
Werner, Nat, 98
Weschler, Anita, 20, 71–72, 103–4, 230–31, pls. 118–19
Western Museum Association, 231
Weyhe Gallery, 117, 194, 230, 231
Wheelock, Warren, 17, 231, pl. 9
Whistler, James, 186
Whitman, Walt, 74, 81, 84
Whitney, Gertrude, 29, 43; biography, 232; as patron, 52n40, 85, 178, 184, 188, 196, 210, 218, 229; work, 32, 39, 41, 87, 89, pl. 94
Whitney, Sarah, 27, 29–30, 51n33
Whitney Museum of American Art, 232; exhibitions, 177, 179, 198, 217, 220, 230; folk art at, 123; purchases, 189, 218

Whitney Studio Club, 123, 191, 196, 229, 232
Wildenstein Galleries, 186, 190, 208, 210, 212
William D. Cox Gallery, 181
Wilson, John Woodrow, 156
Witte Museum, 213
Wolff, Adolf, 18, 86–87, 98–99, 106n38, 232–33, pl. 91
Works Progress Administration, Federal Art Project (WPA/FAP): 200, 221–22; commissions to sculptors, 176, 179, 180, 184, 187, 190, 192, 197, 200, 204, 205, 213, 220, 222; schools, 150; women in, 71
World's Columbian Exposition, 25, 55, 66, 228, 234
Worthington, James H., 175
Wright, Alice Morgan, 19, 59, 91, 233, pl. 12

Yale University Art School, 188
Yandell, Enid, 29, 31–32, 55, 64–65, 234, pl. 66
Yiddisher Kultur Farband, 96, 198
Young, Mahonri, 78, 230; biography, 234–35; work, 39–40, 45, 63, 78, 80–81, 83–84, 91, pls. 36, 57–58, 79–81

Zaleman, Gugo, 211
Zigrosser, Carl, 194, 230
Zorach, William, 113, 120, 128, 130, 166, 213; biography, 235–36; and direct carving, 46, 48, 114, 117, 155, 179; as teacher, 220, 230; work, 48, 122, 124, 133, 146, 165, pls. 47, 126

COUNTY OF LOS ANGELES
Board of Supervisors, 1995

Gloria Molina
Chair

Michael D. Antonovich
Yvonne Brathwaite Burke
Deane Dana
Zev Yaroslavsky

Chief Administrative Officer and
Director of Personnel

Sally Reed

LOS ANGELES COUNTY
MUSEUM OF ART
Board of Trustees, Fiscal Year 1994–95

Robert F. Maguire III
Chairman

William A. Mingst
President

Daniel N. Belin
Chairman of the Executive Committee

James R. Young
Secretary/Treasurer

Mrs. Howard Ahmanson
William H. Ahmanson
Robert O. Anderson
Mrs. Lionel Bell
Dr. George N. Boone
Donald L. Bren
Mrs. Willard Brown
Mrs. B. Gerald Cantor
Mrs. William M. Carpenter
Mrs. Edward W. Carter
Robert A. Day
Jeremy G. Fair
Michael R. Forman
Mrs. Camilla Chandler Frost
Julian Ganz, Jr.
Herbert M. Gelfand
Arthur Gilbert
Stanley Grinstein
Robert H. Halff
Felix Juda
Mrs. Dwight M. Kendall
Cleon T. Knapp
Mrs. Harry Lenart
Herbert L. Lucas, Jr.
Steve Martin
Sergio Muñoz
Mrs. David Murdock
Mrs. Barbara Pauley Pagen
Mrs. Stewart Resnick
Dr. Richard A. Simms
Michael G. Smooke
Ray Stark
Mrs. Jacob Y. Terner
Walter L. Weisman
Julius L. Zelman
Selim K. Zilkha

Honorary Life Trustees

Robert H. Ahmanson
The Honorable Walter H. Annenberg
Mrs. Anna Bing Arnold
R. Stanton Avery
B. Gerald Cantor
Edward W. Carter
Mrs. Freeman Gates
Joseph B. Koepfli
Eric Lidow
Mrs. Lucille Ellis Simon
Mrs. Lillian Apodaca Weiner

Past Presidents

Edward W. Carter, 1961–66
Sidney F. Brody, 1966–70
Dr. Franklin D. Murphy, 1970–74
Richard E. Sherwood, 1974–78
Mrs. F. Daniel Frost, 1978–82
Julian Ganz, Jr., 1982–86
Daniel N. Belin, 1986–90
Robert F. Maguire III, 1990–94

NB 1930 .F67 1995
Fort, Ilene Susan.
The figure in American
sculpture 83428

DEC 1 4 200.			
DEC 0 3 2008			

VILLA JULIE COLLEGE LIBRARY
STEVENSON, MD 21153